GLOBAL SOUTH ASIA

Padma Kaimal
K. Sivaramakrishnan
Anand A. Yang

SERIES EDITORS

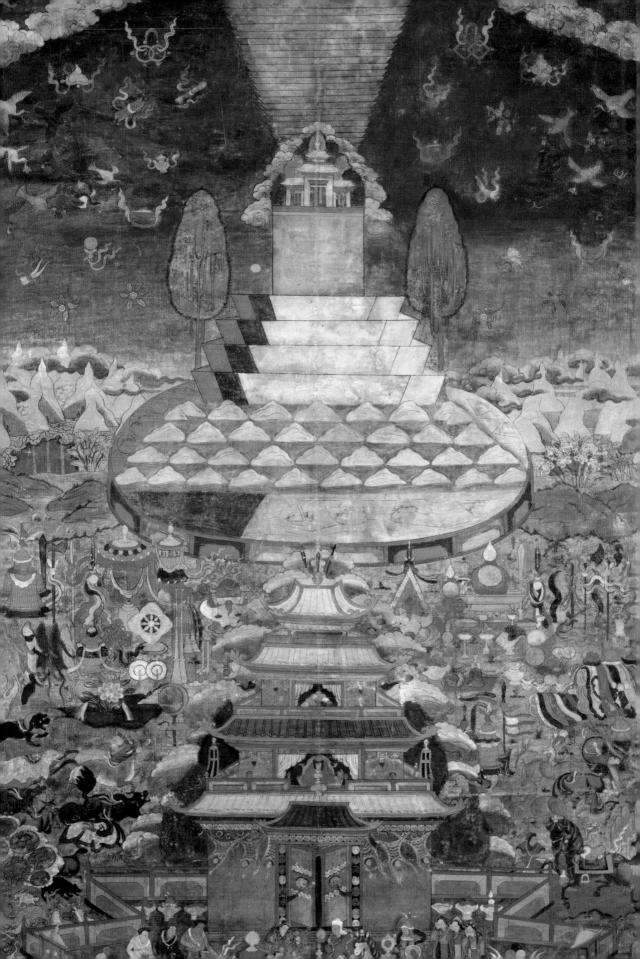

CREATING THE UNIVERSE

DEPICTIONS OF THE COSMOS IN HIMALAYAN BUDDHISM

ERIC HUNTINGTON

UNIVERSITY OF WASHINGTON PRESS
Seattle

Creating the Universe is made possible by a collaborative grant from the Andrew W. Mellon Foundation.

Publication of this book has been aided by a grant from the Millard Meiss Publication Fund of the College Art Association.

The Barr Ferree Foundation Fund for Publications of the Department of Art and Archaeology of Princeton University also supported this book.

FRONTISPIECE: Various offerings with the cosmos-as-heap. 19th century. Tibet. Collection of the Rubin Museum of Art, Gift of Shelley and Donald Rubin C2006.66.558 (HAR 1038), www.himalayanart .org/items/1038.

22 21 20 19 18 5 4 3 2 1

UNIVERSITY OF WASHINGTON PRESS
www.washington.edu/uwpress

LIBRARY OF CONGRESS CATALOGING-IN-PUBLICATION DATA
Names: Huntington, Eric, author.
Title: Creating the universe : depictions of the cosmos in Himalayan Buddhism / Eric Huntington.
Description: 1st [edition]. | Seattle : University of Washington Press, 2019. | Series: Global South Asia | Includes bibliographical references and index. |
Identifiers: LCCN 2018010421 (print) | LCCN 2018035344 (ebook) |
 ISBN 9780295744070 (ebook) | ISBN 9780295744063 (hardcover : alk. paper)
Subjects: LCSH: Buddhist cosmology.
Classification: LCC BQ4570.C6 (ebook) | LCC BQ4570.C6 H86 2019 (print) |
 DDC 294.3/424—dc23
LC record available at https://lccn.loc.gov/2018010421

AWARDED THE

*Edward Cameron Dimock, Jr. Prize
in the Indian Humanities*

by the American Institute of Indian Studies
and published with the Institute's generous support

CONTENTS

ACKNOWLEDGMENTS

While it is impossible to list everyone who has influenced and supported this book, my enormous gratitude goes to the following individuals and institutions.

First, I must thank the colleagues and friends who have supported my work most extensively, reading drafts of chapters and improving the project immeasurably. Stephen Teiser challenged me to sharpen my presentation and shared my excitement for Buddhist cosmology. Jonathan Gold broadened my view of this book's potential and listened with interest to my developing ideas. Rob Linrothe answered innumerable questions, supporting my work with patience and kindness. Jerome Silbergeld helped me make the topics more accessible to audiences outside Buddhist studies. Christian Wedemeyer offered sage counsel and encouragement. And Gary Tubb provided erudite guidance and insight.

Other individuals helped in more specific ways, providing conversation, guidance, answers to vexing questions, or access to their own research resources. My heartfelt gratitude goes especially to Dina Bangdel, Naresh Man Bajracharya, Deborah Klimburg-Salter, John Strong, Matthew Kapstein, Wendy Doniger, Therese Tse Bartholomew, Manik Bajracharya, Angela Howard, Jacqueline Stone, Satomi Hiyama, Bill Mak, Wen-shing Chou, Sarah Richardson, Benjamin Wood, Randy Kloetzli, Andy Rotman, Fletcher Coleman, and Daniel Tuzzeo.

The wonderful staff at the University of Washington Press also has my deep appreciation, especially my insightful and patient editors, Lorri Hagman and Margaret Sullivan. I would also like to thank my anonymous readers, who provided both encouragement and constructive suggestions in appropriate measure.

I wrote much of this book during fellowships at the Society of Fellows in the Liberal Arts at Princeton University and the Ho Center for Buddhist Studies at Stanford University, which I thank profusely for their funding and support. Without the time and resources these institutions provided, this book would not exist. For their guidance and friendship during these times, I thank especially John Kieschnick, Paul Harrison, Susan Stewart, Mary Harper, Tom Hare, and AnneMarie Luijendijk. Many other wonderful friends and colleagues at various institutions also deserve mention, including (alphabetically) Wendi Adamek, Dan Arnold, Elizabeth Childs, Dora Ching, Thomas Conlan, Bradin Cormack, Tineke D'Haeseleer, Sarah Fraser, Molly Greene, Philip Hu, Sonam Kachru, Alex Kaloyanides, Stefan Kamola, Joshua Katz, Michael Koortbojian,

Zoe Kwok, Anne Leonard, Irene Lin, Cary Liu, David Minto, Michaela Mross, Seth Perry, Daniel Sheffield, and Andrew Watsky. I would also like to thank my students, many of whom have seen some aspect of this project in the classroom over the years, and whose engagement and interrogation helped me shape the book into its final form. Much of the early research for this project was supported by the Provost's Fellowship, the Committee on Southern Asian Studies, and the Graduate Aid Initiative at the University of Chicago. Portions of my fieldwork were funded by the University Committee on Research in the Humanities and Social Sciences at Princeton University. I also received a grant from the Woodenfish Foundation for a workshop on the Mogao caves at Dunhuang, hosted by Ven. Yifa and managed by Guttorm Gundersen.

I must also thank those who helped me engage with museum, digital, and personal collections of artwork and photographs, including John Hirx and Nancy Fox at the Los Angeles County Museum of Art, Joe Dye and John Henry Rice at the Virginia Museum of Fine Arts, Oakin Kim at the Hwajeong Museum, Jeff Durham at the Asian Art Museum of San Francisco, the staff at the Saint Louis Art Museum, the Western Himalayan Archive Vienna, the Shelley & Donald Rubin Foundation, the Rubin Museum of Art, Himalayan Art Resources, the Huntington Archive of Buddhist and Asian Art, Asia Society New York, the Cincinnati Museum of Art, Helmut and Heidi Neumann, Niels Gutschow, Christian Luczanits, Dorji Yangki, and Konchog Lhadrepa. I would also like to thank the many guides and translators who assisted my research across numerous regions of Asia, especially Sangay Wangchuk and Narmandakh Tsegmid.

This last section of acknowledgments is reserved for those who are closest to me and who have provided the most enduring and long-term support. My wife, Yumi Park, has ceaselessly shared her time, encouragement, and understanding to promote the completion of this book. Her kind heart and devotion are truly remarkable. Her mother, Younghee Moon, unwaveringly provides strength and a home away from home. And finally, my eternal gratitude goes to my own parents, who have been unfailing sources of aid and encouragement my entire life. This book is a testament to their intellectual nurturing, material support, and every other way they have contributed to my growth and development.

A NOTE ON TRANSLATIONS, TRANSLITERATIONS, AND TITLES

I have endeavored to make this book as reader-friendly as possible while retaining the use of key foreign terms. Words that do not appear in English dictionaries are italicized (e.g., *caitya*). Sanskrit words that have been anglicized appear in roman type with diacritics (e.g., "maṇḍala"), following the same logic that applies to languages such as French and German. Where practical, Sanskrit compounds are hyphenated in order to reveal their component words, except for some common proper names and terms. Tibetan transliteration poses a greater problem because its romanized spellings do not closely track to pronunciation. In general, phonetic approximations are provided according to either the Lhasa or the relevant local dialect, with the scholarly transliteration in a note at the first occurrence.

Titles of texts are translated when it is possible to give a clear, literal rendition. For titles that occur frequently, intuitively obvious shortened forms are used (e.g., *Treasury of Abhidharma* becomes *Treasury*). Personal names and place-names generally are left untranslated, and well-established forms may be given without gloss or transliteration.

On the first use of any translated term, the original, romanized term is provided in a note or in parentheses in the text. In some cases, the words may be glossed in multiple relevant languages: Sanskrit (S), Tibetan (T), and Pāli (P).

Table 1 Titles of Texts

Title	Sanskrit / Pāli	Tibetan
Abridged Wheel of Time Tantra	Śrī-Kāla-cakra-laghu-tantra	dPal dus kyi 'khor lo bsdus pa'i rgyud
Array of the Blissful Sūtra	[Larger] Sukhāvatī-vyūha Sūtra	
Compendium of Principles of All Tathāgatas	Sarva-tathāgata-tattva-saṃgraha	De bzhin gshegs pa thams cad kyi de kho na nyid bsdus pa
Compendium of Rituals	Kriyā-saṃgraha	
Divine Stories	Divyāvadāna	
Encyclopedia of Knowledge		Shes bya kun khyab mdzod

Title	Sanskrit / Pāli	Tibetan
Enlightenment of Great Vairocana	Mahā-Vairocana-abhisaṃbodhi[-vikurvitādhiṣṭhāna-vaipulya-sūtrendra-rāja]	rNam par snang mdzad chen po mngon par rdzogs par byang chub pa [rnam par sprul pa byin gyis rlob pa shin tu rgyas pa mdo sde'i dbang po'i rgyal po]
Extensive Play	Lalita-vistara	rGya cher rol pa
Flower Array Sūtra	Gaṇḍa-vyūha Sūtra	sDong po bkod pa'i mdo
Flower Ornament Sūtra	Avataṃsaka Sūtra	Me tog rna rgyan phal mo che
Garland of Perfected Yogas	Niṣpanna-yogāvalī	rDzogs pa'i rnal 'byor gyi phreng ba
Garland of Vajras	Vajrāvalī	rDo rje phreng ba
Inflorescence of Light	Jyotirmañjarī	
Legend of Aśoka	Aśokāvadāna	
Lion's Roar on the Wheel Turner	Cakkavatti-Sīhanāda Sutta	
Numerical Discourses	Aṅguttara Nikāya	
Ornament of Stainless Light		Dri med 'od kyi rgyan
Path of Purification	Visuddhi-magga	
Purification of All Bad Transmigrations	Sarva-durgati-pariśodhana	Ngan song thams cad yongs su sbyong ba
Ṛg Veda	Ṛg Veda	
Stainless Light	Vimala-prabhā	Dri me 'od
Svayambhū Purāṇa	Svayambhū Purāṇa	
Teachings of Vimalakīrti	Vimalakīrti-nirdeśa	
Testimony of the dBa' Clan		dBa' bzhed
Treasury of Abhidharma	Abhidharmakośa[-bhāṣyam]	Chos mngon pa'i mdzod
Vāyu Purāṇa	Vāyu Purāṇa	
Vine of Stories	Avadāna-kalpalatā	
Wheel of Time	Kāla-cakra	Dus kyi 'khor lo
The Wise and the Foolish		mDzangs blun

ILLUSTRATIONS

Figures

Map

Tables

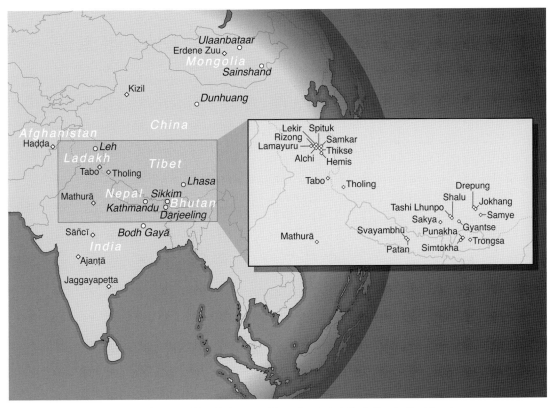

Map. Locations discussed in this book, with an inset detail of sites in the Himalayas

CREATING THE UNIVERSE

Introduction

ORIENTING SPACE AND SELF

WALK THROUGH THE OUTER DOOR AT ZURMANG SHEDRUP MONASTERY[1] in Sikkim, India, and the first images you see on either side of the entrance-way are two large murals depicting basic concepts of Buddhist cosmology. On the left, an existential diagram called the "wheel of existence"[2] shows the types of sentient beings that dwell in the world and the causes of their sufferings, the removal of which is the goal of Buddhism (fig. I.1). A demon of impermanence encircles the wheel, symbolizing the inescapability of death, and divided sections inside summarize processes of arising, living, and dying. On the right, an apparently simpler image shows a geographic map of the physical cosmos (fig. I.2). Oceans and continents represent the homes of animals and humans, while deities dwell on the peaks and terraces of an enormous mountain in the center of the world. The discoid surface of the earth is covered in jewels, and stacks of heavens spread outward and upward to the very top of the wall. Such images are hardly uncommon at the entrances of Tibetan-style Buddhist monasteries, with the wheel of existence and the geographic cosmos, or Cakravāla, frequently juxtaposed as they are here. Similar examples can be seen at major and minor sites across the Himalayas, including the reconstructed Samye[3] monastery in Tibet, Punakha Dzong[4] in Bhutan, and Spituk Gompa[5] in Ladakh.

Such prevalence of cosmological imagery at the entrances to monasteries is striking. Because of their prominent place in architecture and widespread use across the Himalayas, these paintings clearly hold importance in Buddhism. At the same time, no uniform tradition guides the appearance of these two images in this context. In other monasteries, one subject may appear without the other, or both may serve larger, more complex iconographic programs.

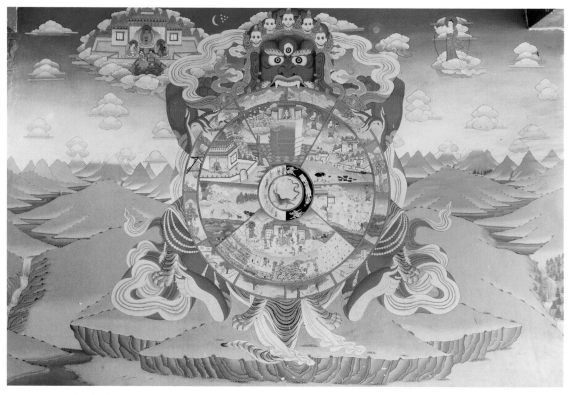

I.1. Wheel of existence. 20th–21st century. Zurmang Shedrup monastery, Sikkim, India

The details of how these cosmological subjects are portrayed also vary greatly. Compare the Cakravāla from Zurmang Shedrup (see fig. I.2) to a variation from Ganden Phelgay monastery[6] in Bodh Gayā, India (fig. I.3). This latter image, glazed onto a black background, compresses the sweeping disc of the world to a dense cluster of items below the enormous pillar of the central mountain. The rings of mountains and continents that supposedly surround the central peak seem almost crushed beneath the mass of the towering summit, which resembles a rectangular prism more than an inhabited geographic space.

One might assume that these two Cakravāla paintings differ mainly in artistic style, but this is only a small part of the story. In fact, they serve different purposes within the space of the monastery, despite their similar subject. On the one hand, the painting from Ganden Phelgay portrays the cosmos as it appears in a particular offering ritual (the subject of chap. 3), and its details purely express that singular purpose. The mural from Zurmang, on the other hand, further illustrates a combination of ideas about the dwelling places of beings, the enlightenment of the historical Buddha, and even the way in which visitors should experience the architectural space in which the painting is located (topics addressed in chaps. 1, 2, and 4).[7]

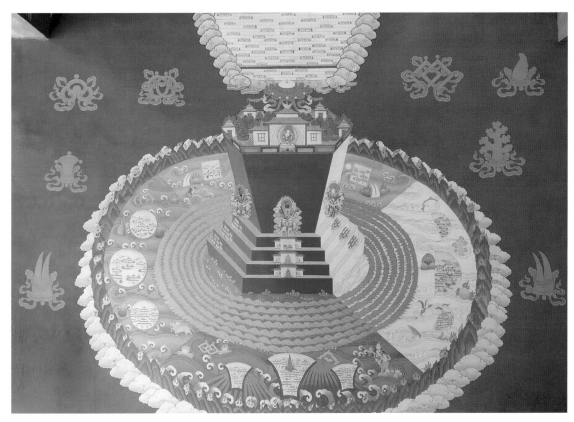

I.2. Cakravāla cosmos. 20th–21st century. Zurmang Shedrup monastery, Sikkim, India

Once one begins looking for such heterogeneous depictions of the cosmos, examples abound. While the Zurmang mural does have some didactic function, it does not compare to a poster available for sale at Hemis monastery and displayed at Mathok monastery, both in Ladakh (fig. I.4). This image forsakes the abundant treasures and deities in the Zurmang mural and instead labels the many geographic realms meticulously, especially emphasizing the vertical stack of heavens above the circular world. These realms correspond to distinct states of being and stages of meditation, giving the abstruse details of distant geography a practical relevance for personal development. Inside the shrine at Drug Sang-ngag monastery[8] in Darjeeling, a small sculpture represents the cosmos as an offering on an altar (fig. I.5). Invoking the same ritual as does the monolithic black mural at Ganden Phelgay, this artwork places small icons of cosmic objects (notice the yellow sun and crescent moon) atop seven white pillars on a circular metal platter. As a piece of ritual ephemera, this object emphasizes the re-creation of the cosmos through specific acts of liturgy, repeated over and over again during a lifetime of practice. At the other extreme of size and permanence, the vast architecture of Samye monastery in Tibet reproduces the geographic cosmos as an inhabitable space, with buildings representing continents and the central shrine

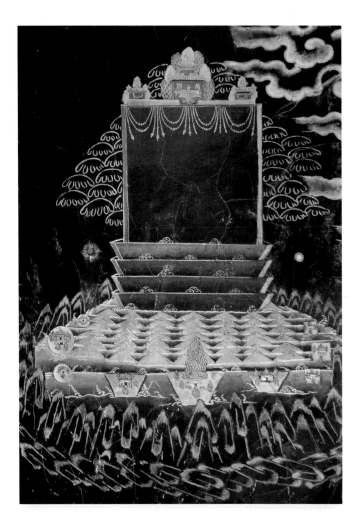

I.3. Cakravāla offering. 20th century. Protector chapel, Ganden Phelgay monastery, Bodh Gayā, India

standing for the axial mountain where deities dwell (fig. I.6). Here, the cosmic geography becomes the environment of lived experience, potentially relevant to anything that happens within the monastery walls.

The diversity of these examples reveals a remarkable interrelationship between Buddhist cosmology and numerous other aspects of the religion. Although scholars and practitioners traditionally trace notions of cosmology to a very limited set of textual sources, depictions of the world vary greatly in form and function based on the contexts in which they appear, revealing a deeper relevance of cosmology in Buddhism more broadly. Images of the universe participate in a vast network of ideas about soteriology, ritual, artistic form, and even knowledge itself.

This network of cosmological ideas is the subject of this book. The proposition that single images of the Buddhist world can function in vastly different ways and weave together complex ideologies is a new approach to cosmology in Buddhist studies. The

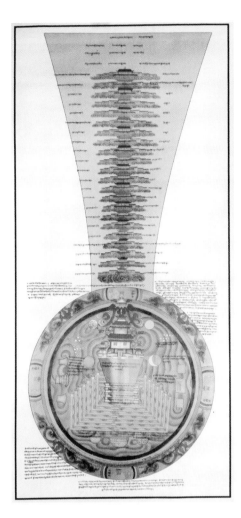

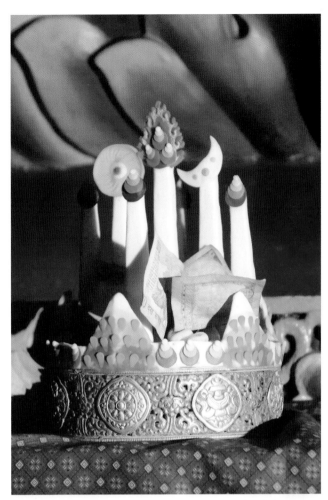

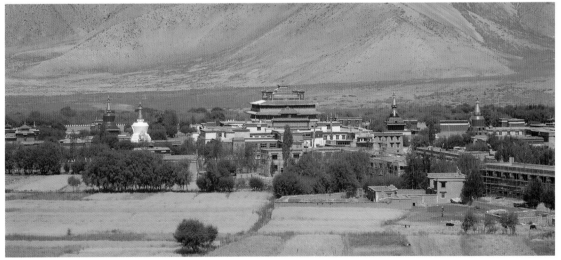

I.4. (*Top left*) Cakravāla poster available for purchase from Hemis monastery, Ladakh, on display at Mathok monastery, Ladakh

I.5. (*Top right*) Cakravāla *torma* (offering). 20th–21st century. Drug Sang-ngag monastery, Darjeeling, India

I.6. (*Bottom*) Samye monastery

examples in this volume show how individual portrayals of the cosmos express themes attuned to diverse textual, ritual, and artistic contexts. Although some models are more widely known, no portrayal of the world appears in the abstract or as a universal. Each instance, taken on its own terms and in its own context, serves a particular role in greater networks of ideas. Because of such structural connections to various ideologies, the cosmic model thus becomes a framework for the expression of numerous aspects of religion. Systems of knowledge and meaning are built into the spaces and places of the geographic world,[9] a way of using the cosmos as a medium for thought and practice. The flexibility of such cosmological thinking leads to its widespread use for disparate purposes in immensely different visual and textual portrayals.

The following chapters explore individual depictions of the cosmos in a diverse range of contexts, including scientific and poetic literature, the deity maṇḍala of tantric meditation, the material ephemera of offering rituals, architecture, furniture, and paintings. Along the way, we will begin to recognize fundamentally different modes of viewing and utilizing the world. As a space (an organized continuum), the cosmos can describe systems of hierarchy and ritual processes of transformation. As a set of places (specific locales related within a whole), the cosmos reflects the diversity of sentient beings. The cosmos can even appear as an object unto itself (a singular piece of a larger system), such as in the ritual presentation of the cosmos as an offering. While these modes unquestionably overlap, they also help us parse the complex ways of thinking about the cosmos in disparate functional contexts.

These diverse ways of thinking about the nature of the universe reflect an innate human impulse to understand our world and our place within it. This kind of cosmology (broadly defined) underlies many of the world's religions but holds special importance in Buddhism, where cosmology frames everything from the definition of life to the path toward enlightenment and the architecture of the temple. The next section introduces this basic cosmological impulse in human thought with a few examples from recent science before transitioning to the main subject of religious traditions. These cases illustrate the cross-cultural importance of cosmology, as well as some of the impact this book might have for questions of cosmology in Buddhist studies. Let us start with a simple example that many of us would have no trouble identifying in our own lives . . .

Place and Space in Human Culture

Imagine yourself at the very moment of waking in the morning. Many of us probably have an innate sense of exactly where we are at this time, even at the edge of consciousness. We can confirm this by remembering the shock we sometimes feel when, as we drift into wakefulness, we mistake our location for one we have visited in a dream. We may have awakened thinking that we were in our childhood bedrooms or some recently visited hotel, only to discover we were actually in our homes (or vice versa).

When our newly wakeful consciousness fails to confirm our dreamlike sense of location, we are thrown into confusion until we reestablish our sense of place.

This innate sense of our place in the world seems to have many levels: we identify not only in which bed we are lying, but in which room, in which building, on which street, in which city and country, and on which continent. In our normal, day-to-day lives, this awareness of place sits at the edges of our consciousness, coming to the fore when we need to perform tasks like navigation. But such a sense of personal place has an infinite number of other impacts on our daily lives. Think of how we determine our national identity or which news sources we choose to follow. Such decisions are, in differing ways, intimately connected to our sense of place in the physical world.

Because this sense of place is so internalized, it is easy not to realize that other people may not share our same understanding. Linguistic research has shown that a certain tribe in Australia expresses position almost exclusively in terms of absolute, cardinal directions ("the building to the west" rather than "the building on the left"). This feat is not merely a quirk of language but a different kind of cognition, requiring speakers to retain absolute certainty of their locations and orientations at all times, rather than merely relying on relative position.[10] In another example, members of an indigenous culture in Mexico express their spatial relationships largely in terms of the mountainous local topography ("uphill" or "downhill" rather than "north" or "south") and have difficulty recognizing relative left-to-right reflections of images.[11] Such studies reveal some of the disparate ways in which humans can conceive of navigation through the world. Regardless of such variation, however, it does seem that some sense of place remains fundamental to human cognition, a necessity of recognizing one's orientation within a larger context.

This larger context is the other half of the equation, the overall space in terms of which one's place can be understood. It is at this level, beyond the individual, that even grander questions can be asked about the nature of the world itself: What is the shape of the universe? What are its rules and organization? How do time and causality function? By understanding more about the world, we also understand more about our possibilities within it. Such questions are some of the most enduring and compelling in human history and are, at heart, questions of cosmology.

The term "cosmology" generally refers to the study of the ordering principles of the universe, whether in regard to space, time, matter, energy, karma, cyclic rebirth, or otherwise. Cosmological accounts, both religious and scientific, often involve explanations of the creation and eventual destruction of the universe, the structure and arrangement of celestial bodies, and the origins and types of living beings. Many of the great religious texts of the world give cosmological concerns their foremost places as the preambles or foundations of all that follows. From the biblical book of Genesis to the Mayan Popul Vuh and the Scandinavian Poetic Edda, a description of the creation or logic of the world precedes all the action that follows. In one sense, this could be considered merely setting the stage, until one considers why setting the stage is so

important. It is only by understanding the whole universe of the narrative that one can comprehend the significance of the characters and events within it. Our understanding of the world in which we live is part of our definition of ourselves.

This powerful relationship is easy to recognize when changing one's conception of the world results in a fundamental redefinition of the self, as well. Children learn in school about Galileo, whose discoveries in the heavens influenced society, religion, and his own personal freedom. Indeed, the conflict between his scientific findings and the interpretation of scripture eventually led to his sentence of house arrest. In a larger sense, however, his arguments for heliocentrism over geocentrism were not just about scriptural authority but about a more significant change in the structure of the world that decentralized, and thus trivialized, human beings on this earth.

A similar shift in understanding happened in 1990, when the *Voyager* space probe photographed the earth from billions of miles away, at a far greater distance than any photograph taken up to that time. This photograph, often referred to as the "Pale Blue Dot," showed our entire planet as one bluish pixel in a vast field of empty space—a tiny object in a much larger scope than people had ever experienced. While this image did not actually overturn the concurrent model of the solar system (indeed, it was possible only because of precise calculations using that model), it represented a similar emotional recalibration of our sense of place within the cosmos. While we humans tend to focus on the immediate concerns of our own lives, this image illustrates the triviality of our ordinary cares in the cosmic arena, engendering a sense of community that could lead to pacifism and environmentalism. Carl Sagan has stated that this emotional shift in perspective was one intention behind taking the photograph.[12] In this case, too, changing our vision of the world around us, our stage, also shifts our place within that world—potentially affecting our everyday concepts and behaviors.

While the preceding examples show the humanistic importance of cosmology in terms of Western science, the same holds true for religious traditions and non-Western cultures. Widely varying models of the universe explain, either literally or metaphorically, the nature of the world and humanity's place in it. A story of the creation of the world from the separation of earth and sky, for example, suggests a dualistic system into which other conceptual categories can align, reifying oppositions between female and male, dark and light, and so on. Other cultures characterize the creation of the world in terms of its gestation in a cosmic egg or its construction from the dismembered body of a humanoid colossus, implying alternative interpretive structures. Some notable works of religious literature build their entire message around a particular cosmological model, such as Dante Alighieri's *Divine Comedy*, which recounts a single individual's path to realization as a journey through hierarchical levels of hell, purgatory, and heaven.

In fact, a particular characterization of the universe can be among the most salient features of a religious tradition, as influential on ideology and practice as any other

factor. The *Ṛg Veda*'s story of the creation of the world through the sacrifice of an enormous cosmic man establishes not only the geographic features of the world but also the absolute division of humans into four social classes (based on where they originate in the cosmic man's body) and the fundamental role of sacrificial ritual.[13] In other words, the logic of the physical cosmos determines both the types of beings that live within it and the religious activities they are required to perform. Seeing examples such as this, it is natural to ask: What other constructions of the world have been accepted by other traditions? In what ways do space and place transcend simple geography to serve ideological, ritual, and soteriological functions? Can even small changes of cosmology in a single tradition express similar ranges and depths of meaning?

This book starts to answer such questions for the major cosmological traditions of the Buddhist Himalayas. The basic tenets of Buddhist cosmology arose in South Asia more than two thousand years ago and spread across the continent with the transmission of other Buddhist traditions. From Afghanistan to Japan, from Indonesia to Mongolia, this cosmology has informed numerous aspects of culture, including ritual, architecture, and scientific debate. Going beyond mere description of the world, geographic cosmology has been used to articulate ideas of where people belong in the world, how nature affects our lives, what constitutes ethical behavior, and how one should conceive of the goals of Buddhist practice.

In some accounts, the Buddhist cosmos can even become the framework upon which one explains the entire religion. The fourteenth-century Thai text *Three Worlds according to King Ruang*[14] uses cosmology in this way, communicating doctrine by laying out the structure and nature of the world.[15] Of course, not all treatments of Buddhist cosmology are so ambitious, and other sources reject cosmological thinking in favor of other modes, such as ethical analysis or ritual performance. In most cases, the language of the cosmos expresses not the entirety of the religion but rather specific concepts in particular circumstances. While cosmology may not be the single most important part of Buddhism (as if there were such a thing), it provides a ubiquitous foundation for numerous other aspects of culture.

The identification of this cosmological foundation for diverse forms of Buddhist religiosity provides the central thesis of this book. In short, Buddhist models of the world supply adaptable conceptual structures whereby individual depictions of the cosmos, whether in literature, ritual, or art, can express diverse content and perform various religious functions. This idea is easy to understand in terms of the functions of modern maps. A topographical map and a weather radar map communicate radically different information, even when they depict the same locale. The key is the context of their use: a topographical map is of no help to the office worker deciding whether to carry an umbrella, and a weather map does not warn a hiker of a dangerous cliff. Although the underlying arrangement of geographic locations remains the same, cartographers alter individual depictions to serve vastly different purposes.

We cannot take this analogy too far, of course, because even graphic portrayals of the Buddhist cosmos are not maps in the modern sense but rather depictions of ideas. They do not aid navigation or change based on measurement. Instead, they represent the ideologies of specific historical, ritual, or theological circumstances. While enlightened beings may know the truth of the world in full, human portrayals have always been created for specific purposes and based on preceding texts or images. In context, then, depictions of the Buddhist cosmos always tell us more than the mere structure of the world. The very notion of the cosmos becomes a way of expressing something beyond itself. Because of this, we must learn to understand Buddhist cosmology not as an isolated subject but as a means of engaging with diverse aspects of the religion.

Simply put, one's worldview (literally, an imagined picture of the world) is central to one's religious life. Despite the seeming obviousness of this statement, modern scholarship on Buddhist cosmology has only infrequently been brought into dialogue with other subjects — with some very important exceptions — even though the basics of Buddhist cosmology are well known to most scholars.[16] This book ties particular formulations of the cosmos to varied contexts and, more significantly, presents a broader overview of the importance of cosmology to Buddhist history, theory, and practice. Doing so provides evidence not only of the ubiquity of cosmological thinking in Buddhism but also of the deep relevance of cosmology to religious studies in general. A cosmological impulse lies at the heart of many of the world's religions — an innate tendency to use the world around us to shape religious practice, contextualize ideology, and understand ourselves. Once this effect becomes apparent, it becomes impossible to see the traditions under discussion without it.

An Interdisciplinary Approach

Regarding this very idea of making things visible, Carl Sagan and the "Pale Blue Dot" photograph illustrate another major theme of this book: an explicitly interdisciplinary method that brings a traditional corpus of texts into dialogue with varied images, constructions, and practices. Explaining the motivation for the famous photograph, Sagan writes, "It had been well understood by the scientists and philosophers of classical antiquity that the Earth was a mere point in a vast encompassing Cosmos, but no one had ever *seen* it as such."[17] Sagan's emphasis on sight, on a material (rather than intellectual) engagement with such an important concept, exemplifies why visual and material practices must be considered in this study. Aside from being worthy expressions in themselves, images, objects, and practices shape understanding differently than texts do. Indeed, many people probably encountered Buddhist cosmological thinking only through images and constructed forms, internalizing the cosmologies of these objects rather than textual accounts. It is not enough simply to engage with what people wrote about the Buddhist world. Rather, we must explore everything that people produced based on their ideas of that structure. By examining such disparate

sources as complements to the traditional authorities, we can investigate the less obvious ways in which cosmology shapes the experience and practice of Buddhism.

Early Western scholarship on Buddhism emphasizes the textual and scholastic, even portraying Buddhism as a rational alternative to religions of the West. Secularizing Buddhism to the point of being unrecognizable, this approach ignores vital practices, such as prayer to deities, and other non-textual sources of evidence.[18] Notions that were unpalatable to the Western audience, like a cosmological model completely disproved by contemporary science, were sometimes ignored in search of the "truth" of the religion. Turning a blind eye to such fundamental aspects of Buddhism as cosmology, however, inevitably impoverishes our understanding. Once the notion of the Buddhist universe is rejected, all the various ideas associated with life in that world must be reinterpreted, often in ways that distort their significance.

Fortunately, scholars in more recent decades have done much to overturn the textual and scholastic bias of previous generations, foregrounding ethnography, visual art, archaeology, and other subjects and reshaping the study of religion. While classical texts might cast monks as renunciant meditators seeking enlightenment, observations of life in a monastery reveal that very few monks actually pursue such a path, spending much of their time performing rituals by rote.[19] By examining different sources of evidence, we rewrite the very notion of a monk, redefining a basic category of Buddhist tradition. Examining cosmology from an interdisciplinary perspective can also reshape the study of Buddhism in just such a way. We will recognize cosmology as a fundamental category of engagement with the world, as demonstrated through the ubiquitous materials of art, architecture, and ritual.

Non-textual materials are also essential to Buddhist studies in a number of more practical ways. This book begins with a chapter on textual sources in part to reveal precisely how limited they are for explaining visual depictions of the cosmos. Material objects simply form a different body of evidence than texts do, oftentimes expressing unique ideas, surviving from periods from which no texts endure, or remaining unchanged in the archaeological record while manuscript traditions transform with each successive recopying. Two very different stories of the origin of tantric deity-maṇḍala cosmology emerge, for example, depending on whether one looks at texts or images. The essential experience of material culture also differs from the experience of texts, such that divergent ways of constructing the ephemera of offering rituals correlate with notably dissimilar ways of imagining the structure of the cosmos. Without reading a word, practitioners in such traditions can develop sophisticated ideas about cosmology that affect the rest of their lives, including the very architecture they inhabit.

In short, the so-called authoritative texts to which scholars habitually turn for cosmology are not necessarily the best places to look when trying to understand its cultural and religious significance. Like any given painting or sculpture, each of these texts is just a single expression of the cosmological impulse in a particular context. While Buddhist practitioners consider some of the textual sources to be sources of

valid knowledge about the universe, this does not mean that other visions of the world depend on these sources, or that alternative portrayals do not become sources in their own right for new traditions of cosmological thought.

Scope and Outline

While Buddhist cosmology addresses everything from the creation and destruction of the universe to the fundamental elements and mechanisms of cause and effect, this book focuses on one pervasive cosmological subject, the static physical model of the universe. This model describes the geographic structure of the world, from the locations of continents and oceans to the numbers and types of heavens and hells. The logic of this inhabited world defines human existence and provides the framework for Buddhist spiritual practice. If for no other reason than this, the geographic world is a subject worthy of significant study. In addition, however, focusing on this subject allows us to identify a particularly wide range of expressions in visual and material culture, revealing the physical cosmos as a key component of many Buddhist traditions. While more technical topics of cosmology might be relegated to philosophical debates or esoteric practices, the geographic world appears frequently in art and ritual. Easily understood and highly adaptable, models of the physical world evince the ubiquity of cosmological thinking.

Such widespread usage also reveals the diverse functions of cosmology from one context to the next. Juxtaposing text to text, text to image, image to practice, and image to image exposes the unique cosmological thinking of various authors, ideologies, liturgical traditions, artistic forms, and more. Cross-cultural and historical comparisons are also useful, particularly regarding the Buddhist traditions of Nepal and Tibet. These neighboring cultures have had strong contacts with each other during many periods of history but retain some remarkable differences in their deployment of cosmological imagery in ritual and material culture. When engaging in such comparisons, it is important to resist essentializing any of these cultures or traditions and to ground each comparison in specific examples rather than broad generalizations. In exploring all these contexts of function, history, and culture, the goal is not to reify any particular analytic construction but rather to uncover a diversity of ways of thinking.

In broad outline, this book shifts from dealing with purely textual sources at the beginning, to studies of ritual ideology and performance in the middle, to almost entirely visual and material sources at the end. Each topic contextualizes particular depictions of the cosmos within larger frames in order to explore the ways in which cosmological thinking provides a means for expressing diverse aspects of religious life. First, showing that the texts often cited as authoritative sources for cosmology, like any painting or sculpture, are themselves merely specific instances of cosmological thought adapted to their own purposes, the book examines a broad spectrum of major Indic religious texts, including but not limited to the most well-known descriptions of

Buddhist cosmology. Then, taking up tantric subject of the maṇḍala, emphasis shifts to ritual ideology as expressed in both text and artwork, pursuing the complex and transformative implications of understanding the maṇḍala as a geographic cosmogram. Investigation proceeds next to the actual performance and material ephemera of ritual by considering a rite in which the practitioner physically assembles a detailed simulacrum of all the treasures in the world as an offering to a teacher. Finally, viewing artistic depictions in their own right, constructed forms and painted murals are addressed in their contexts of architectural space and historical development.

A Place for Structure

The methods applied here to the subject of cosmology, while interdisciplinary, are not the only possible approaches, nor do they capture everything that scholars and practitioners might think about the subject. I have chosen to combine techniques and evidence drawn especially from the disciplines of Buddhist studies, textual analysis, art history, and material culture studies because of my own interest in these realms and the broad range of topics they allow me to address. Another method, such as ethnography, would undoubtedly provide an entirely different perspective on the role of cosmology in religion and the ways that people think cosmologically in their everyday lives.

Would traditional Buddhist practitioners interpret things in the same way that I explain? I have no doubt that, in some cases, scholars, ritualists, and artists would, even if the general public might not. Philosophers who emphasized cosmology in their own systems of thought (such as Vasubandhu) also would likely have seen value in carefully parsing the significance of cosmological ideas. I am the first to admit, however, that many would not be consciously aware of the interpretations I suggest and that some might actively disagree with them.

At its foundation, this book does not actually ask what individual people in history believed. Rather, it tries to identify thematic and structural connections across wide swaths of Buddhist culture and history that reveal something deeper about religious activity than the convictions of any single person or group. In some ways, this approach shares features with Structuralism, a school of thought that addresses conceptual relationships largely in isolation from human agency. Unlike proponents of strong Structuralism, however, I do not argue that there is any universality to my interpretations or for any single abstract model of the cosmos that shapes all others (in the manner of a Platonic ideal). While the examples selected here illustrate certain essential themes, potential counterexamples simply provide more evidence that cosmological thinking permits radically variant possibilities. Generalizing from specific examples, then, does not reveal a single abstract truth but rather reveals a diversity of cosmological thinking.

At times, controversies have accompanied previous scholarship on religious cosmology, which has been strongly influenced by Structuralism and its opponents.

Mircea Eliade, in particular, drew broadly from cultures across the world to posit certain universal cosmological principles, especially a vertical axis through the horizontal center of the world that connects our middle plane with the realms above and below (such as heavens and hells).[20] Contemporary scholars have complex attitudes about Eliade, alternatively accepting his notion of the so-called *axis mundi* uncritically or lambasting him for generalizing too broadly. This controversy has resulted in a reluctance to deal in structural models of sacred space at all. Without directly addressing Eliade's theories, I hope to retrieve the topic of cosmology from the debate surrounding him by grounding my work in deeply contextualized examples, interrogating the full complexity of the subject.

More directly in the realm of Buddhist studies, the work of Paul Mus has also been incredibly influential for cosmological analysis but deserves further theorization and expansion. His important term "mesocosm," for example, appears in this book in analyses of tantric geography.[21] At the same time, Mus uses some terms inconsistently and addresses only the limited range of examples available from his sources.[22] Expanding beyond his writings through the use of specific, contextualized cases, then, is worthwhile.

The very idea of conceptual structure is worth reclaiming from the implicit grasp of Structural-*ism*. Many of the examples here show that indigenous Buddhist practitioners used various kinds of structural thinking for their own purposes, without being Structuralists in the modern sense. The authors of the *Treasury of Abhidharma* and the Wheel of Time corpus certainly did so, and this book is as much in dialogue with them as with Eliade or Mus. Although cosmological models provide structural modes of thinking about religion, these are not the only ways to speak about the subject or the purview of any specific interpreter or school of thought.

Deep engagement with cosmological thinking helps us understand a variety of aspects of Buddhist culture, and we must be open to as many methods and sources of evidence as possible. For too long, cosmology been an isolated subfield of Buddhist studies, and too often we find it easiest to rest in the materials of a single discipline or body of knowledge. Charting some of these new, connected realms, let us now embark on an exploration of Buddhist cosmology.

1

Cosmos in Texts

EXPLAINING THE BLUENESS OF THE SKY

CLASSICAL TEXTS ARE THE SOURCES MOST OFTEN CITED BY BUDDHISTS and other scholars regarding cosmological thinking, so they must be addressed in any argument about the role of cosmology in religion or art. Even in so-called authoritative texts, however, cosmological models are individuated to perform specific ideological and ritual functions beyond any objective presentation in the abstract. The use of cosmology as a framework for various kinds of religious activities is not a process of adapting a primary textual source to different functions. Rather, the textual sources themselves are simply additional instances of cosmological thinking tailored to particular agendas.

The alteration of cosmology to achieve specific goals can be illustrated by one simple example that is both literally and figuratively at the center of the world. In most Indic cosmologies, an enormous mountain known as Meru or Sumeru[1] rises from the very center of the circular earth, providing a home to major worldly deities. Meru has four faces, each turned toward one of the cardinal directions (east, south, west, and north). At the same time, Purāṇic, early Buddhist, and later Buddhist textual sources give radically different explanations of the composition of these four faces and their related symbolism for the religious tradition (fig. 1.1). The oft-cited *Vāyu Purāṇa* lists the colors as white, yellow, black, and red,[2] corresponding to the four social classes[3] of Brahmanism: priest, merchant/farmer, servant, and warrior/ruler.[4] In this way, the social order of human society is built into the structure of the world itself. The Buddhist *Treasury of Abhidharma*[5] alters this scheme to consider the nature of causality and empirical proof in the world. The text describes the faces not simply in terms of their colors but as being composed of specific minerals that provide a reason for the

colors: gold, silver, blue beryl,[6] and quartz.[7] The same natural force that instigates the physical creation of the universe (namely, the intentional actions[8] of sentient beings) produces heaps of these four types of jewels that grow to form the faces of the mountain.[9] Their composition is ostensibly verified by observation — our sky is blue because the blue beryl facet of Meru reflects its color into the sky of the southern quadrant where we live. In the other quadrants of the world, the sky has different colors that match the other precious substances. A third major textual source, the later Buddhist Wheel of Time[10] literature, provides a different scheme for the directional colors that identifies the basis of ritual practice in the world. It describes the facets of Meru as blue sapphire[11] in the east, ruby red in the south, yellow topaz in the west, white crystal in the north, and green emerald in the center.[12] This five-directional system corresponds to the five fundamental elements in the Wheel of Time, which also find expression in the major continents that surround Meru. Four continents in the cardinal directions are identified with elemental maṇḍalas, each of which has an associated shape and color. East is a blue-black semicircle (connoting the wind element), south is a red triangle (connoting fire), west is a golden-yellow square (earth), and north is a white circle (water).[13] Central Meru has the nature of the fifth element (void or space), the shape of a *bindu* (dot), and the color green. As a set, these five geographic bodies symbolize not only the five elements but also other important groups of five, including the five buddha-families. Such overlapping symbolism establishes the universe itself as a complete ritual system, rather than emphasizing human social order or scientific explanation.

The idea that numerous other traditions of literature, ritual, and visual art simply repeat the cosmological ideas of these texts is thus inherently problematic. The cosmologies of these texts are not general-purpose descriptions that can be applied to other contexts. The texts do not even provide the necessary details for accurately depicting the world in other circumstances. The *Treasury*, for example, does not specify which direction each of the four colored sides of Meru faces (only the blue beryl side is said to face in our direction, because our sky is blue). Many of the most well-known details of these cosmologies cannot be traced directly to the texts typically understood as their sources, which are themselves individual expressions of cosmological thinking.

Varieties of Indic Thinking about the Physical World

The overview of cosmological thought in the texts of ancient India presented here comprises examples from Hinduism, Jainism, and several traditions of Buddhism. With the exception of the *Ṛg Veda* being first, they are not presented in chronological order or with the goal of tracing cosmological ideas to their earliest textual descriptions. Rather, these accounts reveal the scope of cosmological thinking in the Indic textual/religious sphere. The *Ṛg Veda* uses cosmology to glorify its central deities, the Purāṇas match cosmology to human history and social structure, and Buddhaghosa's *Path of*

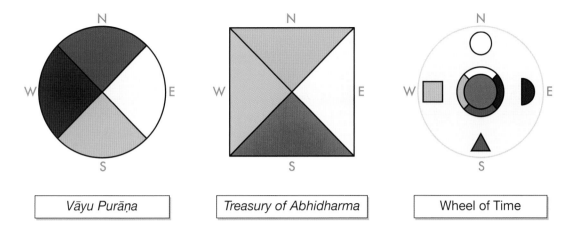

| Vāyu Purāṇa | Treasury of Abhidharma | Wheel of Time |

1.1. Three color schemes of Meru's quadrants according to the *Vāyu Purāṇa*, *Treasury of Abhidharma*, and Wheel of Time

Purification[14] portrays cosmological knowledge as one of many factors of enlightenment. As the most influential cosmological texts of Himalayan Buddhism, Vasubandhu's *Treasury of Abhidharma* and the Wheel of Time corpus are granted significantly more attention. The former emphasizes a cosmology of causation in relation to karma, while the latter interconnects physics, astronomy, cosmology, biology, meditation, and enlightenment in a single logical structure, the explicit purpose of which is to serve as a frame for soteriological ritual. Both are commonly cited as sources for numerous kinds of cosmological artwork and ritual, but both also lack the specificity and clarity needed to make their models generally applicable to these other purposes. Indeed, non-cosmological textual sources, such as the narrative of the Buddha's life known as *Extensive Play*,[15] have at least as much influence on Buddhist artistic representations of the world.

THE *ṚG VEDA*

Cosmological thinking has been a theme in numerous religious texts in India, starting with the earliest source available, the *Ṛg Veda*, a collection of hymns for sacrificial ritual.[16] While scholars look to these early texts for cosmological models, the cosmologies they describe are not given in the abstract but are applied through literary devices toward rhetorical and ritual goals. The *Ṛg Veda* mentions cosmology most clearly in metaphors of praise to its deities. Although we can learn from these passages something of the basic geometric and spatial principles through which the authors viewed the universe, we cannot take them at face value as stated cosmological models.

1.2. Two descriptions of the cosmos in the *R̥g Veda*, the earth and sky as two bowls and the earth and sky as wheels on an axle

In the abstract, the physical world of the *R̥g Veda* comprises three vertical layers of space: the earth, the sky or heaven, and the intermediate space or atmosphere that separates earth and sky.[17] Theologically and cosmogonically, this can be considered a dualistic system of father Heaven and mother Earth, the separation of which by the god Indra creates an intermediate space in which life occurs.[18] Two metaphors give some sense of this arrangement in the text, although they are not entirely consistent (fig. 1.2). The first describes the earth and sky as "two great bowls turned towards each other,"[19] with the sun understood to travel in the space between the layers of earth and sky.[20] Another characterizes the earth and heaven as two wheels on a chariot axle.[21] Both metaphors suggest further structural principles in the cosmic model, such as a circular boundary and an implied center, in the latter case, at the axle. Horizontally, the *R̥g Veda* divides space into the familiar four cardinal directions of east, west, north, and south.[22] These basic structural principles create a sense of the universe as an organized space and remain influential in later Indic traditions.

At the same time, the cosmology of the *R̥g Veda* is not given as a list of spatial principles. Rather, these descriptions of the world occur as metaphors related to the worship of particular deities, stories of creation, or specific ritual practices. The example of the world as two wheels occurs thus:

> For Indra I have raised my songs, (like) waters in restless surges from the
> depths of the sea,
> for him who propped asunder earth and heaven with his powers, like wheels
> with an axle.[23]

The primary function of this verse is to praise the deity Indra. His manipulation of the earth and sky like chariot wheels is a metaphor for his power and his creative activity, not a literal description of geometry. Later Vedic traditions continue this layering of meaning into space, developing correspondences between tripartite space, the

cardinal directions, specific deities, natural elements, parts of the body, metaphysical powers, poetic meters, seasons, animals, and social classes.[24] Cosmological structures described in these texts provide more of a framework for expression and analysis than they do an abstract, independent model.

While cosmological thought remains a major factor in religious texts from the *Ṛg Veda* onward,[25] cosmological models became a major subject of scholastic attention more than two millennia later. In the fourth to fifth centuries, a cultural shift seems to have prompted commentators in all traditions to organize knowledge in new ways, composing entire chapters of encyclopedic treatises on the shape and function of the world (although presumably adapting their work from previous sources that no longer survive). By examining the Hindu Purāṇas, Jain sources, and Buddhaghosa's *Path of Purification*, we can see both the broad scope of cosmological thinking in Indic traditions and the specific stances taken by Vasubandhu's *Treasury of Abhidharma* and the Wheel of Time corpus in relation to these other systems.

THE PURĀṆAS

The Purāṇas, as a body of literature, can be difficult to historicize, since various texts given the designation *purāṇa* (ancient) were composed over an extended period of at least one thousand years. Several important Purāṇas date to the fourth to fifth centuries, around the same time as the *Path of Purification* and the *Treasury*. While they further develop the circular/axial model of Vedic conception, the key principle behind Purāṇic cosmology is not glorification of the deities but integration into human history and geography. The cosmos is still a place of deities, but its descriptions blend seamlessly into human family lineages, local geography, and historical narratives. In comparison to the *Treasury*, the Purāṇas present humans as radically more central to the cosmos, in terms of both their apparent importance and their actual geographic location.

Broadly speaking, the Purāṇas describe two different but related models of the universe, with explanations sometimes overlapping even within a single text. In the apparently earlier formulation,[26] the world has four continents arrayed in the cardinal directions around a central mountain, like the petals of a lotus flower around the carpellary receptacle (fig. 1.3). In the second, more complicated version, the axial mountain lies at the center of Jambudvīpa, a circular landmass surrounded by six additional continents formed as concentric rings separated by concentric oceans (fig. 1.4). Each of these lands contains vast complexes of mountain peaks, valleys, rivers, and forests.

As is typical of the fourth- to fifth-century emphasis on cosmology, the *Vāyu Purāṇa*[27] describes the first model, the four-continent universe-as-lotus-flower, in great detail.[28] Meru, the axial mountain considered the central pericarp of the universal lotus, has a height of 84,000 *yojanas*[29] and is sunk into the earth to a depth of 16,000 *yojanas*. The section above the surface of the earth has the shape of a bowl and

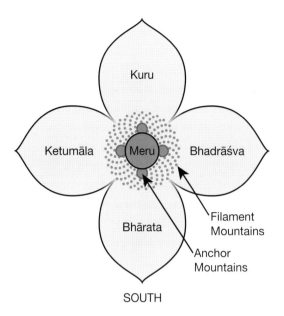

SOUTH

1.3. World-as-lotus cosmology
of the Purāṇas

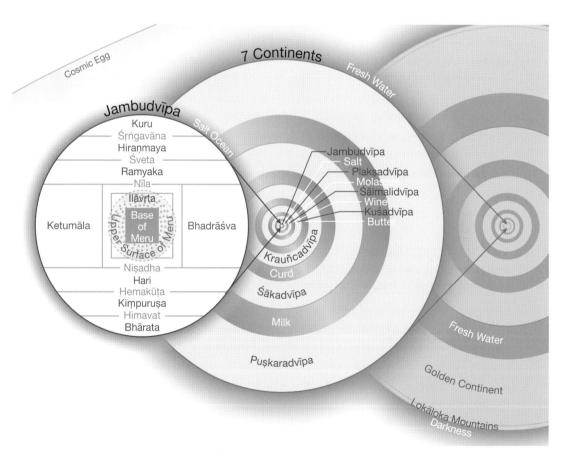

1.4. Seven-continent cosmology of the Purāṇas

is narrower in breadth at the base (16,000 *yojanas*) than at the top (32,000 *yojanas*). Or, in an equivocation typical of this type of description, it might be triangular, quadrangular, octangular, one-hundred-angled, or one-thousand-angled or shaped like a saucer, a twisted braid of hair, or a sphere.[30] Like the carpellary receptacle of a real lotus, Meru is surrounded by small mountains akin to the filaments (or stamens) of a flower. Four medium-size mountains located in the cardinal directions anchor the earth to immovable Meru. Four continents extend from these mountains, also in the cardinal directions, having the shape of lotus petals. These continents are (clockwise from the south) Bhārata, Ketumāla, Kuru, and Bhadrāśva (see fig. 1.3). Each is 100,000 *yojanas* in length and 80,000 in breadth.[31] The various gods live in mansions on the peak of Meru, divided between the center, cardinal, and intermediate directions. An emphasis on the four cardinal directions profoundly undergirds the geography of this text, to the point that a complete survey of the world is considered to be summarized with "the four great continents, the four pleasure gardens, the four great banner-like trees, the four excellent [holy] rivers, the four great mountains, the four serpents for support, the eight superior great mountains, [and] the eight excellent mountains."[32]

The alternative Purāṇic model, while still concerned with cardinal directionality, adds even more complexity to the major divisions and details of the world. The *Vāyu, Matsya,* and *Viṣṇu Purāṇas,* among others, explain this second model.[33] The basic size and shape of the central mountain are similar to those of the first model, but land surrounds Meru in a complete circle forming the island of Jambudvīpa, which is divided mainly into regions stretching east to west with separate names (see fig. 1.4). Still, aspects of the division into the four lotus-petal continents remain; the most peripheral regions of Jambudvīpa in each of the four directions retain the names Bhārata, Ketumāla, Kuru, and Bhadrāśva. On the one hand, this subsumption of the previous model suggests that a sense of consistency was important. After all, both are meant to describe an enduring geographic reality. On the other hand, this point of comparison also reveals the extent to which the later model vastly expands upon the former. Six additional (and much larger) continents surround central Jambudvīpa, making a total of seven major continents separated by oceans filled with sacred liquids such as clarified butter, milk, and fresh water. It is also noted that "there are thousands of types of islands but they come under the purview of the main seven islands; it is not possible to describe the entire universe in detail."[34] Despite this omission, the descriptions of the world are striking precisely for the extreme detail they do include, meticulously recording the mountain ranges, rivers, forests, and special features of each region. If nothing else, such specificity may give a greater sense of the authoritativeness of these descriptions.

More importantly, however, these descriptions of the world transition seamlessly into explanations of particular places that are ritually or historically important to the social and theological worlds of these texts. Among the geographic descriptions are explanations of Kailāśa (the sacred mountain of Śiva)[35] and the sacred river Gaṅgā (whose course is narrated from its origin in the sky down to the peak of Meru and

through four branches to the ocean).[36] Passages on Jambudvīpa list the names of dozens upon dozens of tribes and peoples alongside those of mountains and rivers. The chapters surrounding these descriptions, too, address primarily the generational lineages of various beings, including *devas* (gods) and human beings going back to the original progenitor of humankind.

In essence, the cosmology of the Purāṇas sets the geographic stage for broader mytho-historical narratives. Just as cosmology can set the stage for narrative action, here, the cosmic geography provides a structural framework for human and divine characters, lineages, and sacred sites of the Purāṇic worldview. Unlike cosmological descriptions that open texts, however, the geographic cosmologies of the *Vāyu* and *Viṣṇu Purāṇas* occur toward the middle, signaling that they are viewed as parts of larger histories. Although shorter descriptions of the world do appear in the preceding accounts of the creation of the world,[37] the detailed geographies occur within overviews of human and divine history. This context for cosmological presentation is vastly different from that of other sources, such as the *Path of Purification*, which emphasizes meditational development toward enlightenment, or the *Treasury*, which emphasizes scientific analysis and causal explanation. In these cases, extended treatments of topics like Kailāsa and the Gaṅgā are not necessary—not only because these are Buddhist texts, but because their purposes are different.

The Purāṇic system even ingrains the importance of humans into the very structure of the world it describes by placing human beings near the geometric center of the cosmos. In the seven-continent model, humankind as we know it is confined to the southern region of Bhārata in the central continent of Jambudvīpa.[38] Despite being located at this local southern extreme, humans lie close to the center of the whole cosmic system, with numerous expansive continents surrounding them. In the four-continent Purāṇic model, by comparison, humans simply live in one of the four quadrants, with all four continents at an equal distance from the center. The centrality of the human location in the Purāṇic system becomes even more apparent in comparison with the *Treasury*, which places humans near the periphery of the cosmic disc (fig. 1.5).[39] This difference has real meaning for the two religious traditions. In the Purāṇas, the human story is central to the cosmic narrative history. The Buddhist model, in emphasizing humankind's distance from the divine center, becomes a framework for imagining the long and difficult path toward enlightenment. Such themes of the expansive nature of geographic space and its relationship to enlightenment also play important roles in Jain cosmology.

JAIN COSMOLOGY

Jain cosmology takes the Jambudvīpa-centered, concentric ring model and exponentially increases its size and complexity, making it the centerpiece of numerous doctrines, rituals, and artworks. Because of the immensity of this subject, a brief overview

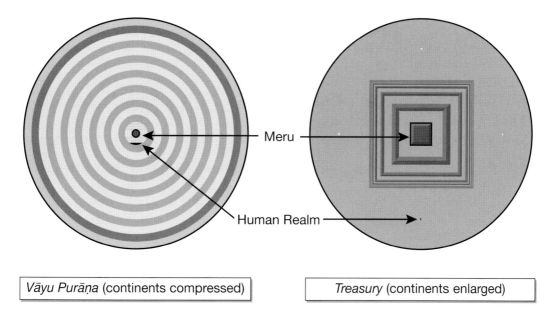

Meru

Human Realm

Vāyu Purāṇa (continents compressed) Treasury (continents enlarged)

1.5. Locations of the human realms in the *Vāyu Purāṇa* and the *Treasury of Abhidharma*

of key relationships to other traditions must suffice.[40] Indeed, several features of the Jain model directly influenced the formation of the later Buddhist Wheel of Time cosmology, particularly its conflation of the cosmic geography with the figure of the cosmic human. In general, the expansiveness and detail of the Jain cosmology correlate to soteriological and theological agendas of Jain thought, in contrast to Buddhist and other versions.

The clearest evidence that the Jain cosmology emphasizes a spatial and numerical expansion beyond other systems is its use of a different unit of measure for length. The *rajju* (also *rāju*) is defined as the distance traveled by a god in six continuous months at the rate of 2,057,152 *yojanas* per second.[41] The difference between a *rajju* and a *yojana* is one order of magnitude greater than the difference between a light-year and a kilometer or mile.[42] Using the *rajju* as a unit, the cosmos takes on a much greater scale and can be articulated to much more depth into space, especially into the realms of heavens and hells above and below our middle world. Jambudvīpa, the circular continent with Meru at its center, has generally the same structure as it does in the Purāṇas. The outer continents also follow the same concentric pattern as in the Purāṇas, similarly doubling in width with every iteration outward,[43] but in the Jain system, the continents are innumerable. Human civilization expands beyond Jambudvīpa to include all of the first ring continent and the inner half of the second one (fig. 1.6).[44] Each of these two ring continents possesses its own Meru mountains along an east-west axis, making for

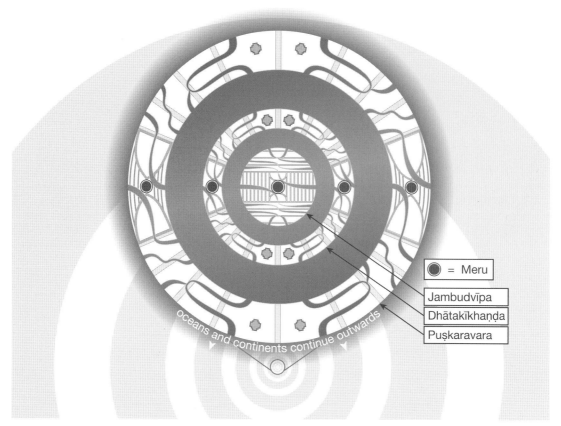

1.6. Human-inhabited continents of the Jain cosmology

a total of five.[45] Meru can be envisioned as three truncated cones stacked on top of one another, with larger bases at the bottom (see fig. 1.22).

Aside from its size and complexity, another key feature of the Jain model is its portrayal of the entire universe within the body of a cosmic man. This humanoid figure, fourteen *rajjus* tall, embodies the vertical organization of realms, with our middle world at its waist, the hells descending toward its feet, and the heavens rising toward its crown.[46] This organization invokes Indic notions of hierarchical purity within the human body, which runs on a scale from the purest at the crown of the head to the most impure at the soles of the feet. While reminiscent of the creation of the universe from the body of the cosmic man described in the *Ṛg Veda* (which divided humanity into four classes), in this version, the cosmic man is seen as a connected whole, and ascent through the realms correlates with the process of enlightenment.

The innumerability of the continents and the immensity of the Jain system served multiple purposes in Jain philosophy, from strongly emphasizing the rare opportunity of human birth within the vastness of the cosmos to reassuring the practitioner that

the universe is large enough to allow multiple enlightened teachers to exist simultaneously.[47] This latter point opposes the Buddhist idea that there can be only one buddha in the world at a time.[48] For the most part, these features of the Jain system again emphasize the human place in the cosmic realm and the larger spatial principles that help define it. Turning to Buddhist traditions and especially the Pāli *Path of Purification*, we find a cosmology articulated to very different effect in a treatise on meditation.

PĀLI SOURCES: THE NIKĀYAS AND BUDDHAGHOSA'S *PATH OF PURIFICATION*

Like the *Ṛg Veda*, the early Pāli Nikāyas[49] scatter details about the structure of the universe without explaining systematically.[50] They mention cosmic geography primarily in relation to the various beings that dwell within the hierarchically arranged realms.[51] This arrangement becomes a model for the path to enlightenment, with the practitioner ascending through stages until transcending even the heavens.[52] This and other important features, like the division of the world into cardinal directions and the names of particular continents, are carried through by later authors who organize these details more coherently. These self-conscious systematizations are particularly relevant for comparison with other cosmological models. Let us again skip forward in time, then, to the cosmology of the fifth-century *Path of Purification* by Buddhaghosa.[53]

The *Path of Purification* does contain a coherent description of the world, but Buddhaghosa's main purpose was to provide a manual for meditation.[54] He wished to describe the states of mental and behavioral practice that deliver enlightenment and its release from the sufferings of the world. While he probably drew on some of the same sources as Vasubandhu did, and indeed many of the details of their models are similar, his passage on cosmology reflects an emphasis on the awareness of the enlightened mind. Knowledge of cosmology is presented as little more than a characteristic of the Buddha's omniscience, meditation on which helps the practitioner develop. Once again, the details of the cosmological description subtly reinforce this agenda by implicitly reflecting qualities of the Buddha's mind.

The coherent description of the physical world occurs in chapter 7, which enumerates six types of recollection[55] that meditators can use to cleanse their minds.[56] Recollection of the Buddha requires bringing to mind specific qualities of his perfection, such as that he is accomplished, fully enlightened, endowed with clear vision and virtuous conduct, and sublime.[57] After enumerating these characteristics, the *Path of Purification* describes the Buddha as a knower of worlds,[58] which is taken as an opportunity to expand on exactly what knowledge of the world should mean. In one sense, this is complete knowledge of the causal cycle of the world, including its essence, arising, cessation, and the means of cessation. It also means knowledge of all beings and their qualities, so that the Buddha may best be able to teach them. Finally, just as he knows the world of all beings, the Buddha also knows the world of all locations, that

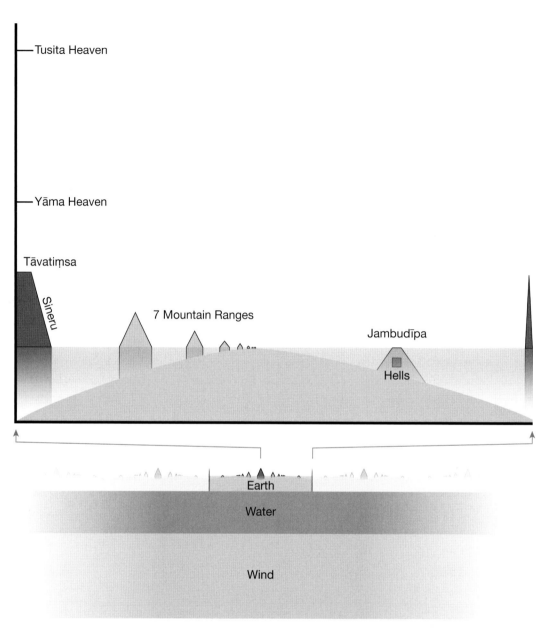

1.7. Speculative elevation of the cosmos described in Buddhaghosa's *Path of Purification*

is, the geographic cosmos. This correlation between the world of beings and the world of locations is also a major theme in the *Treasury*.

The *Path of Purification* summarizes the geographic cosmos very succinctly, leaving many questions unanswered. With only the given information, it would be impossible to make a measured diagram, but since there is considerable overlap between

this system and that of the *Treasury* , one can tentatively illustrate the basic features of this account (fig. 1.7). The text describes a disc-shaped world 1,203,450 *yojanas* across, composed of successively denser layers of matter. The flat, circular earth floats on water resting on air in empty space. The central place is occupied by the axial mountain (in Pāli, "Sineru"), which has a height of 84,000 *yojanas*. Several rings of mountains surround it, each ring half the height and depth into the ocean of its more central neighbor. Outside of these, the inhabited continents sit in the vast ocean, itself surrounded by a ring of mountains that delimits the world.

Comparing the brief description in the *Path of Purification* to the one in the *Treasury*, a few major differences are immediately noticeable (for comparison, see figs. 1.7 and 1.8). For one, the ring of mountains that surrounds the circular cosmos is described in the *Path of Purification* as being nearly as tall (82,000 *yojanas*) as the central mount Meru, while in other systems, Meru stands out radically as the greatest object in the universe. Meru's shape is also given with less specificity, while the *Treasury* embellishes its cosmic hierarchy with stepped terraces on the body of Meru itself. Buddhaghosa also notes that our disc-shaped world is not unique but rather one of an infinite number of similar worlds adjacent to one another in the flat plane of space.[59] In this description, the layer of water beneath the world is considered to extend outward infinitely so that the individual disc-worlds are like islands rising out of a common ocean.[60] Because of the contiguity of separate universes, people on Jambudvīpa actually live closer to beings on other continents in an adjacent universe than to major geographic features of their own.

All these details merely support the recollection of the Buddha as a knower of worlds for the purpose of achieving enlightenment. Indeed, the cosmological passage begins with a verse that describes its purpose, not as knowledge of the world, but as transcendence of it:

> 'Tis utterly impossible
> to reach by travel the world's end;
> But there is no escape from pain
> until the world's end has been reached.
> It is a sage, a knower of the worlds,
> who gets to the world's end, and it is he
> whose life divine is lived out to its term;
> He is at peace who the world's end has known
> and hopes for neither this world nor the next.[61]

The first lines of this passage reorient the reader toward thinking of the "world's end" as a soteriological goal rather than a navigational one. The lines that follow establish an equivalence between the final conquering of suffering and omniscient knowledge of the world.

As the section on the Buddha as a knower of worlds continues, two distinct characterizations of this worldly omniscience become apparent, each related to different aspects of Buddhaghosa's cosmological model. First, omniscient knowledge is complete, including everything in existence to the very ends of the world. Buddhaghosa's summary description of the world, rather than attempting to convey every detail of the geography, provides an outline of this complete understanding. Although it may be just coincidence, Buddhaghosa's uniquely towering mountains at the world's edge, almost as tall as Meru, seem to reinforce the contained completeness of this kind of omniscience. By walling off the edge of the world like the sides of a shallow bowl, they imply that the world is a bounded container, a finite system that can be known in its entirety. The second characterization of omniscience, in direct contrast to the first, is that it is infinite, or without boundary. This arises in direct reference to Buddhaghosa's description of the infinite number of individual world-systems that lie next to one another in the flat plane of space.

In general, Buddhaghosa used cosmology as a way of characterizing the knowledge of the Buddha, not the world. Even his enumeration of the major features of mountains and continents can be considered shorthand for more-detailed scholastic accounts that were probably available in other texts. For Buddhaghosa, the features and workings of the world are less significant than what they represent about the path toward liberating realization.

The *Treasury of Abhidharma*: The Usual Suspect

The *Treasury of Abhidharma* is the single most influential source for Himalayan Buddhist cosmology. Despite being cited as a source for the cosmology of meditations, rituals, and narratives explored in the rest of this book, Vasubandhu's model serves his own agenda and lacks the specificity required for use toward other purposes. His central arguments concern the nature of causality in the Buddhist worldview, an essential basis for understanding enlightenment. While other textual sources, rituals, and paintings do refer directly to elements of the *Treasury*'s cosmology and appear similar in the abstract, all are independent formulations with details appropriate to their own functions and contexts. Vasubandhu's descriptions emphasize the features that fit his agenda, while his omissions make the unmediated use of his text in other contexts problematic.

VASUBANDHU'S *ABHIDHARMA*: CAUSATION AND SENTIENT BEINGS

Vasubandhu's fourth- to fifth-century *Treasury of Abhidharma*[62] encompasses his views on the topic of *abhidharma*, a kind of scholastic knowledge that "is intended to draw upon, and reason with, the Buddha's teachings in order to shape a coherent, comprehensive account of the basic, elemental truths of reality."[63] Not only an extended

commentary on the Buddha's teachings (Dharma), then, *abhidharma* is a discriminating analysis of all the elements of reality (*dharmas*). As an encyclopedic treatment[64] of this topic, the *Treasury* includes analyses of the natural elements, sense perception, karma, rebirth, sentient beings, the geographic world, causality, stages of meditation, kinds of knowledge, the qualities of a buddha, and more. The *Treasury* became one of the primary sources for this type of knowledge in Himalayan and especially Tibetan Buddhism.[65] Its popularity has led both scholars and practitioners to cite the *Treasury* as the primary model of Buddhist cosmology, attributing other instances of cosmological depiction to reliance on it as a source. While certainly more influential than other Buddhist models, such as the Wheel of Time, the *Treasury* contains a unique cosmological description determined by Vasubandhu's own agenda, not directly translatable to disparate contexts.

Vasubandhu's primary concern in the *Treasury* is the nature of causality, especially its deep implications for Buddhist systems of thought. At times, he even engages in a kind of reductionism to show that the causal process is sufficient to explain other elements of reality that falsely appear to us as independent entities.[66] Arguments about causality occur repeatedly in the *Treasury*, including in the cosmological section. Vasubandhu's description of the jewels that make up Meru is a perfect example (see fig. 1.1), explaining both the cause of their arising and the observable effects they have in the world.

The second major theme that governs the geographic cosmology is the relationship between the physical cosmos and the living beings that dwell within it. The cosmos essentially functions as a container for dividing sentient beings into different realms, a division that is naturally determined by the causal consequences of their previous actions (*karmas*).[67] Even this second theme, then, is an offshoot of Vasubandhu's consideration of causality in the Buddhist universe. Deepening the relationships between living beings and geography represented in other texts, such as the Purāṇas and the *Path of Purification*, Vasubandhu describes an innate interdependence between types of beings and the locations they inhabit. For him, explaining the physical cosmos provides a way of understanding the nature of all life within it.

Vasubandhu's teaching on the world[68] even opens with the correlations between types of sentient beings and specific places in the universe in a description of the three vertical realms[69] that divide the world. The lowest level, the Desire Realm,[70] contains the geographic world and most of the five paths of birth[71] that Vasubandhu acknowledges: hell beings, animals, *pretas*, humans, and many of the *devas*. Above that is the Form Realm,[72] which has ascending heavens of *devas* above the Desire Realm that correspond to ascending stages of meditation. The third, the Formless Realm,[73] having no form, "is not a place"[74] and connotes meditative achievement that transcends the body. Given Vasubandhu's concern for causality, one of the major questions about the Formless Realm is how sentient beings without physical existence can have mental events. As they are for Buddhaghosa, the number of such triple-realms is infinite.

These worlds rest against one another contiguously in the cardinal and intermediate directions, as well as, according to some of Vasubandhu's sources, above and below.[75]

Before describing the geography of such a world, Vasubandhu addresses other factors of life, including different types of consciousness, the biological processes of birth, and the intermediate state of existence between death and (re)birth. This leads to his examination of the fundamental causal process that underlies life, the twelvefold chain of dependent origination.[76] With this basis, he discusses other more specific causal processes of life, such as sense perception. Of course, not all the arguments in these sections deal with causality. Vasubandhu also describes etymologies of important terms, arguments with other schools of thought, and the specific teachings of the Buddha on certain topics. Part of his goal is also a completeness that corresponds to the *abhidharma* concern for understanding all elements of reality.

Having addressed life of all kinds and the processes that govern it, Vasubandhu next describes the physical world. The text marks this transition by noting that the preceding is a discussion of the world of beings (*sattva-loka*), and the following is a treatment of the shared physical world as a container for sentient beings (*bhājana-loka*). While the main subject turns to the geography of the cosmos, however, the topic of beings is never far removed from the conversation. The world exists solely as a consequence of the actions of beings and as a setting in which the processes of karma occur.

The relationship between the actions of beings and the physical world is the basis for the first elements that arise in the cosmos, starting with a circle of wind on which our shared physical world rests. This disc of wind is immeasurable in diameter, with a height of 1,600,000 *yojanas* (fig. 1.8).[77] This subtlest of the elements is established in empty space as a result of the intentional actions of sentient beings. In the upper reaches of this air, clouds form (through the actions of beings) and condense into a disc of water. Concerned with how this cylinder of water could retain its shape rather than simply spilling outward, Vasubandhu locates the ultimate cause again in the actions of beings.[78] Churned by winds "combined with the power of the actions of beings,"[79] the water becomes gold on top, as boiling milk produces cream. The diameter of these cylinders of water and gold is 1,203,450 *yojanas*. The layer of gold settles into a circle of earth, forming the flat disc on top of the world where beings dwell. The three layers of wind, water, and golden earth are known as the three discs,[80] the bases of the physical world. Within this system, Vasubandhu then addresses major geographic features, dwelling places of beings of the five paths of birth, motions of the sun and moon, and spans of time (including cosmic cycles of time and the life spans of beings).

The form and location of each geographic part of the world results from the actions of the sentient beings who dwell there. The heavens are pleasant and elevated because of the previous actions of their inhabitants, and the hells are torturous and base for the same reason. Birth as a certain type of being is equivalent to birth in a particular location, since the physical world exists only as a result of (and medium for) the causal actions of sentient beings. Vasubandhu makes this point most explicitly when discussing

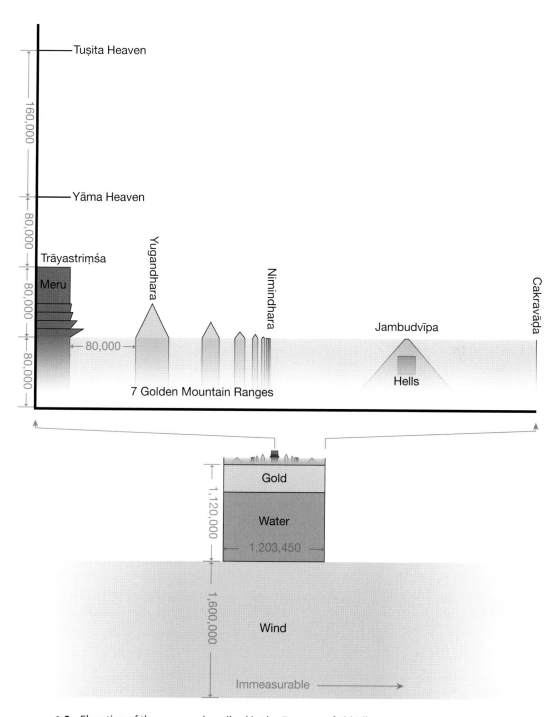

1.8. Elevation of the cosmos described in the *Treasury of Abhidharma*

the status of the guardians[81] who torture evildoers during their births in hell. The sole activity of these entities is inflicting suffering on others, so if they were sentient beings, they would perform such innumerably evil deeds that they would never escape hell themselves. Since it is possible for all sentient beings to move through the realms of birth by producing both good and bad actions, the logic goes, these guardians of hell must be mere apparitions, generated through natural law by the previous actions of the creatures they torture.[82] The physical regions of the cosmos, along with their joys and sufferings, are nothing more than extensions, through causal law, of the beings who dwell within them.

In a sense, this account reverses the metaphor of cosmology setting the stage for narratives of important beings. Here, it is instead the actions of sentient beings that set the stage for (and directly cause) the existence of the world. While the physical geography is still an arena in which actions take place, it may be better understood as stage dressing—the props and apparatuses that appear to the actors and audience for their benefit, but for which there is no underlying reality. This does not mean that geography is any less important for Vasubandhu, however. The intimate connections between the physical cosmos and the types of life within it mean that its topology is that much more relevant for understanding fundamental Buddhist truths about the nature of existence. Since life and location are defined together, a comprehensive map of the cosmos is absolutely necessary to describing sentient existence.

PARSING VASUBANDHU'S GEOGRAPHY

Because the geography of the *Treasury* relates to many cosmological images and rituals, Vasubandhu's descriptions of the physical cosmos merit examination in detail. Many artists and practitioners explicitly claim the *Treasury* as the ultimate source of the model they employ. Indeed, Vasubandhu's text clearly realizes some of the basic structural principles of Buddhist space that appear in many other aspects of the religion, including the deity maṇḍala, offering maṇḍala, and architecture. Essential ideas about symmetry, centrality, and vertical hierarchy that appear in the *Treasury* pervade Buddhist ritual and imagery, as do more particular features such as Meru. At the same time, Vasubandhu's exposition either lacks or directly contradicts many other characteristics seen in rituals and art. For example, the *Treasury* does not describe the orientations and colors of the continents as they appear in most visual depictions. In later artworks, artists are relying on previous depictions or other oral and textual traditions. The *Treasury* also contains internal contradictions and confusions that make employing the cosmic geography in other contexts more difficult. Let us now look in detail at Vasubandhu's description of the world, for both its idiosyncrasies and its broader influence. The following analysis largely follows the sequence of Vasubandhu's exposition while problematizing the use of his text as a source for other (especially visual) depictions, revealing the full depth of Vasubandhu's correlation between types

of beings and locations in the world, and enumerating the essential structural features of his cosmology that transcend his text to form a widespread framework for visual art and ritual performance.

Vasubandhu begins his geographic description with central Meru and its jeweled facets, but even this simple structure is not described sufficiently for the needs of artists. The central mountain is made of four jewels — gold, silver, blue beryl, and quartz — on the four sides. These stones contribute to the color of the sky in each of the four quadrants, but other than blue beryl being in the southern direction of our continent Jambudvīpa, the orientation of the stones in the three remaining directions is not clearly specified.[83] The artistic tradition is generally consistent about the arrangement of colors, with gold (yellow) in the north, silver (white) in the east, and quartz (usually depicted as red in later traditions)[84] in the west. While the visual representations are consistent with descriptions in the *Treasury*, they clearly do not employ the *Treasury* as their primary source, rather depending on commentaries, oral tradition, or most likely other artistic precedents for their details.

The very edge of the cosmos is ringed by the Cakravāḍa (also Cakravāla),[85] a range of iron mountains that poses a different problem for artists in terms of scale. These mountains are just 312.5 *yojanas*[86] in height and width, making their size in relation to the cosmos as a whole difficult to portray in visual media. Estimating that the smallest consistently depictable mark by an average traditional artist might be around half a millimeter (about 0.02 in.) across (although miniaturists can achieve far smaller), this would mean that the minimum size of a scale portrayal of the Meru cosmos would be about 1.9 meters across (6 ft. 4 in.). This is around the size of the largest murals of the Meru cosmos in Tibetan monasteries, and certainly larger than anything that can be drawn in a manuscript. As shown in figure 1.9, the Cakravāḍa mountains are difficult to distinguish even in a digitally generated image printed to the size of this book, as are the outermost ranges of the seven golden mountains.

Even when artists had the chance to depict the cosmos to scale in large paintings or sculptures, however, most images prioritize other sorts of narrative, ritual, or didactic concerns. In these cases, there are strong visual reasons for not making all the elements to scale, such as the need to show important features of the cosmos clearly to the viewer. Like the Cakravāḍa, the four major continents are also nearly imperceptibly small when drawn to scale with the rest of the world (see fig. 1.9), but they are a major focus of attention as the dwelling places of beings. Their typical dimension of about 2,000 *yojanas* on a side is only 2.5 percent the size of Meru and less than 0.2 percent the entire width of the cosmos. Because of the importance of life on these continents, however, they are almost always shown much larger.

Seven golden ranges of mountains immediately surround Meru and create additional confusion in both their scale and their shape. Each range is half the height and width of its interior neighbor (see figs. 1.8 and 1.9), making the most-exterior range only twice the size of the Cakravāḍa. The mountain ranges are separated by oceans

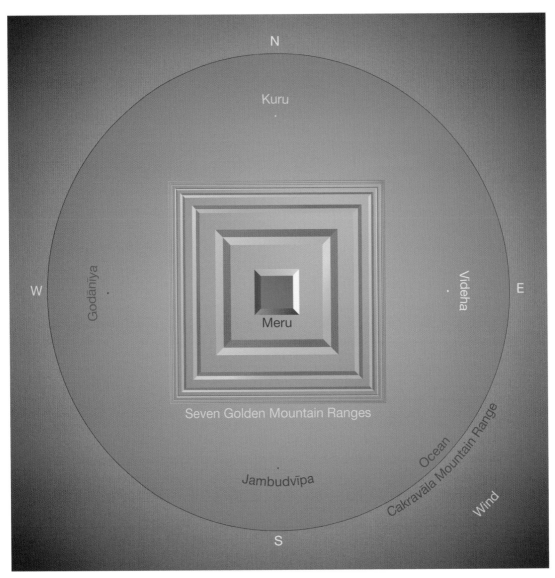

1.9. Plan of the cosmos described in the *Treasury of Abhidharma*

that also decrease in width by half as they iterate to the periphery, matching the width of the mountains they surround. In artwork, these mountain ranges are frequently depicted as circular rings or scattered individual mountains (see fig. I.2 or 4.19, for example), but the text suggests that they are square—albeit in a language that could be the very reason for the confusion as to their shape. Regarding the central ocean that surrounds Meru up to the Yugandhara, the first ring of golden mountains, the *Treasury* describes it as follows (root text in **bold**):

The first [ocean] has 80,000.
In between Sumeru and Yugandhara, the first ocean is 80,000 *yojanas* in breadth. . . .

But across [the ocean] is triple.
The breadth is explained as 80,000 *yojanas*. But across, it becomes triple, counting from the banks of the Yugandhara — 200,000 + 40,000 [=240,000].[87]

In other words, the breadth between Meru and Yugandhara is 80,000 *yojanas*, but the total length of the ocean between opposite shores of the Yugandhara is triple that, 240,000 *yojanas* (fig. 1.10).[88] The tripling in this calculation is an artifact of Meru having the same width as the ocean, but similar tripling also occurs in calculating the perimeter of a circle (where what we know as π is approximated as 3, and the circumference is equal to π times the diameter). Therefore, it is possible to misinterpret this section as calculating the perimeter of a circular ocean. If this were the case, however, the 80,000-*yojana* width of the ocean would lead to a much greater circumference (see fig. 1.10). This tripling may be one reason why circular mountain ranges often appear in artwork, or the circularity of the mountains may be assumed without reference to the *Treasury* at all. In some examples, artists clearly paid no attention to its descriptions, depicting the so-called seven mountains not as ranges surrounding Meru but as individual, unconnected peaks in the cosmic ocean.

Outside the square ranges of golden mountains, the great salt ocean (where the continents lie) presents a problem of contradiction in the *Treasury* itself. Vasubandhu describes measurements here that do not match the size of the cosmos as a whole given earlier. As he relates:

Outside is the remainder of the great ocean.
. . . As is well known, this is, in width of *yojanas* —
300,000 + 22,000 [=322,000][89]

While Vasubandhu described the cosmos as 1,203,450 *yojanas* across, adding the widths of all the mountains and seas together gives a total diameter that is 1,287.5 *yojanas* greater. The sizes of the other elements are given by a mathematical progression, but the width of the great ocean is simply cited as "well-known" (probably from Vasubandhu's source texts), unfortunately contradicting the rest of the carefully laid-out system.[90]

In next describing the four major continents in the great salt ocean, Vasubandhu glosses over details of shape and orientation, leading to diverse representations in later tradition. The continents — respectively Jambudvīpa, Godānīya, (Uttara)Kuru,

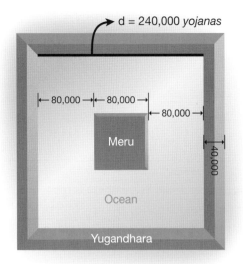
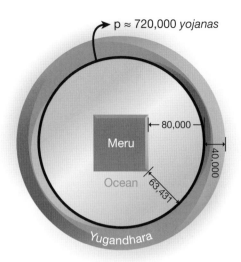

1.10. Comparison of measurements of a square or circular ring of mountains against the *Treasury of Abhidharma*

and (Pūrva)Videha — lie in the cardinal directions of south, west, north, and east. Jambudvīpa is described as having the shape of a *śakaṭa*, often translated as "cart," "chariot," or "wedge," with three sides of 2,000 *yojanas* each and one very short side of 3.5 *yojanas*. Several variant ways of understanding this shape are depicted in figure 1.11. One question concerns the type of cart or chariot intended, with the semantic range of the word *śakaṭa* including both military chariots and utility carts. The former might have had a square or rectangular platform, possibly with a rounded front end. Examples of such chariots are depicted in early sculptures (admittedly not precisely from Vasubandhu's milieu) such as on the gateways[91] at Sāñcī stūpa 1. Early sculptures also depict the utility cart, such as in the scene of the donation of Jetavana on the Bhārhut railing in the Indian Museum, Kolkata. Unlike the military chariot, these carts continued in use to the present day, providing more direct evidence of their shape. They are constructed on an A-frame, with a platform mounted above a single axle, generally matching the nearly triangular shape suggested by Vasubandhu's measurements.[92]

As the *Treasury* was transmitted to regions where local cart and chariot shapes differed (if they existed at all), the confusion of Vasubandhu's readers may have increased. In these cases, and for modern scholarship, comparison of the *śakaṭa* shape with persistent natural formations provides important evidence. For one, Sanskrit authors also used the metaphor of the *śakaṭa* to describe the Rohiṇī asterism.[93] This group of stars (also considered part of the constellation Taurus) forms a wedge in the sky that has remained unchanged over the centuries and closely resembles the triangular

Military Chariot	Utility Cart	Treasury of Abhidharma
View from above	View from above	

| Rohiṇī Asterism | Scapula | Indian Subcontinent |

1.11. Referents and descriptions of the shape of the southern continent, Jambudvīpa

cart. Rohiṇī may thus be the most reliable referent for the shape of Jambudvīpa, but still others appear in literature as authors grappled with the continent's form. When Buddhist cosmology was transmitted to Tibet, comparison with the scapula became common — probably the scapula of a sheep or goat that fairly mimics the shape of both the cart and Rohiṇī.[94] Because of Jambudvīpa's essentially triangular shape, the continent has also been identified by modern scholars with the actual geography of the Indian subcontinent.[95] Even in early artwork, the short (3.5 *yojana*) side often appears toward the south, effectively making a southward-pointing triangle akin to the Indian subcontinent, although it is not uncommon to see the short side toward the north, as well. No orientation is given in the *Treasury*.[96]

Similar ambiguity occurs with the eastern continent, but not the northern and western ones. Vasubandhu describes eastern Videha as a half-moon (i.e., a semicircle), but also as having four sides, three of 2,000 *yojanas* each and one of 350 *yojanas*. There is no obvious way to rectify the discrepancy between the shape and the measurements given. Artists frequently depict Videha as a semicircle, semi-oval, or rectangle with

two corners rounded into a single arc. Without a description of orientation in the *Treasury*, the curved side can be depicted facing any of the cardinal directions. Western Godānīya and northern Kuru avoid any problems of configuration, being shaped respectively as a circle 2,500 *yojanas* in diameter and a square with 2,000-*yojana* sides and therefore unaffected by orthogonal rotation.[97] In addition to the four major continents, eight smaller continents lie in the intermediate regions. Since the *Treasury* does not specify shapes, sizes, or orientations for these, they can be depicted with the same shapes and orientations as the major continents they neighbor (but smaller) or simply as circles.

After giving some details of the local geography of Jambudvīpa (but far less than the Purāṇic accounts) and proceeding to the hell realms, Vasubandhu's account simultaneously evinces an awkward borrowing from another cosmological system and a sophisticated embellishment of the *Treasury*'s own correlations between the status and location of sentient beings. Rather than placing the hell realms directly below Meru as a reflection of the heavens above, Vasubandhu locates them underneath Jambudvīpa, at great distance from the cosmic center. Such a placement below the human continent may linger from an earlier model in which Jambudvīpa itself lay at the cosmic center (as the circular continent surrounding Meru), in which case the hells would have been in a symmetrical arrangement with the heavens above. This would explain a variety of other thorny details about the model in the *Treasury*, including the fact that the measurements of the hells are significantly bigger than the diameter of Jambudvīpa, inside which they supposedly rest.[98] At the same time, placing the hells away from the center of the universe perfectly expresses a subtle structural theme in the *Treasury* — that the status of sentient beings within the cosmic system correlates to both the altitude and the centrality of their abodes. The *devas* at the center and peak of the cosmos have the most pleasurable realm of birth. Hell beings, as the lowest form of sentient existence, live not only in the most subterranean location but at the outer periphery. Vasubandhu also localizes the other two lowest paths of birth to the outer and lower realms of the cosmos, even while admitting that these beings travel away from their paradigmatic abodes. Animals originate in the great salt ocean and spread to the earth, water, and sky. The king of the *pretas*, Yama, dwells in a palace beneath Jambudvīpa, but *pretas* themselves disperse from that place.

Finished with the peripheral and lower sections of the world, Vasubandhu proceeds back toward the center and up into the sky, first addressing the locations and motions of the sun and moon. These discs, a relatively tiny fifty-one and fifty *yojanas* in diameter, are set on a course of wind that makes them revolve around Meru, held aloft at a height equal to the peaks of the Yugandhara mountains. The diameter of their orbit is not given, with some sources placing them more or less above the continents,[99] and many artistic depictions locating them directly above the Yugandhara peaks or even closer to central Meru. In artwork, the sun and moon are almost always paired

on opposite sides of Meru, but in the *Treasury* (as in reality), they move continuously through space.

This shift from describing the static arrangements of the continents and oceans to describing the dynamic system of the sun and moon poses a slew of problems that are far more complicated than the confusion regarding shape, size, and orientation that we have seen so far. The rising, peaking, and setting of the sun and moon are explained by their orbit around Meru, which occludes them at night. Thus, different times of day are experienced simultaneously in the four continents: "When in northern Kuru it is midnight, at that time in eastern Videha there is the setting of the sun, in [southern] Jambudvīpa it is noon, in [western] Godānīya it is rising."[100] The *Treasury* explains the seasonal lengthening and shortening of days and nights by noting that the circular path of the sun travels to the north and south, causing it to spend more or less time behind Meru. "When the sun goes to the south side of Jambudvīpa, there is an increase of night; when [it] goes to the north, an increase in day."[101] If more of the orbit of the sun is to the south (in the same direction as Jambudvīpa), however, the nights should get shorter, not longer. Commentators have addressed such problems by suggesting further complications to the model, including variations in the speed of the sun over its course. The confusion is only compounded when the *Treasury* travels outside India, where seasonal observations differ. Turning to the changes of the moon, Vasubandhu explains its phases only vaguely:

> **The appearance of the moon is reduced by its own shadow, due to its proximity to the sun.**[102]

Without providing clear geometric logic, Vasubandhu merely cites the teachings of another school, the Prājñaptikas.

Continuing his rhetorical movement inward and upward through the cosmos, Vasubandhu next addresses the details of Meru and the heavens above, once again tying particular beings to specific places and structures:

> **[Sumeru] has four terraces, each with an interval [between them] of 10,000 [yojanas].**
> . . . With these [terraces], half [the height of] Sumeru is laid down. . . . And they are . . . **extended sixteen, eight, four, and two thousand [*yojanas* out from the faces of Sumeru].**
> . . . **On these [dwell] the Vessel-Bearers, the Garland-Holders, the Always-Intoxicated, and the Great Kings.**[103]

These four classes of *devas* are apportioned respectively to the first, second, third, and fourth terraces of Sumeru, each of which is raised 10,000 *yojanas* above the previous

1.12. Detail of figure I.2 showing the four terraces of Meru and their inhabitants. 20th–21st century. Zurmang Shedrup monastery, Sikkim, India

one so that the Great Kings dwell at 40,000 *yojanas* in altitude, half the height of Meru (fig. 1.12). The term "Great Kings" refers especially to four guardian kings that each protect one of the four cardinal directions (clockwise from east): Dhṛtarāṣṭra, Virūḍhaka, Virūpākṣa, and Vaiśravaṇa.[104] These figures reappear repeatedly in other contexts as important indicators of cosmic space. In simplest terms, they represent fundamental principles of Buddhist spatial logic — division into four directional quadrants and separation between center and periphery. Not only do they guard the four quadrants, but because their scope extends from their homes to the edge of the Cakravāḍa, they also represent a conceptual boundary between central Meru and everything that surrounds it.

Proceeding upward again, Vasubandhu completes his discussion of the places and beings of the Desire Realm, the first of the three tiers of the world, by describing heavens atop Meru.[105] Like many of the heavens, the realm of *devas* at Meru's peak is literally named after its inhabitants as the heaven of the Thirty-Three.[106] This number is a cipher for the primary *devas* of the world, led by Indra/Śakra, although the actual list and number of these deities vary between sources. The peak itself is said to be the same

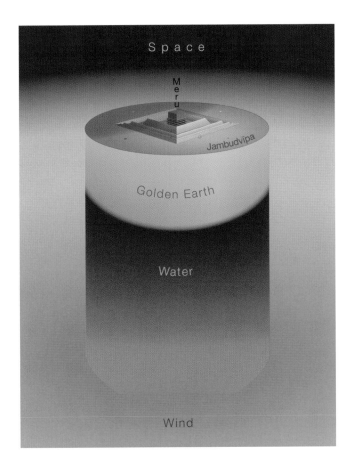

Space

Meru

Jambudvīpa

Golden Earth

Water

Wind

1.13. Perspective view of the geographic cosmos described in the *Treasury of Abhidharma*

width as the base, 80,000 *yojanas* on a side, meaning that the portion of Meru above the ocean is essentially cubical, rather than tapered like a typical mountain — although Vasubandhu does acknowledge an alternative view of 80,000 *yojanas* as the circumference rather than the breadth. In the middle of the peak lies the golden city Sudarśana that houses the palace of Śakra.[107] Although four additional heavens that rise above the level of the Thirty-Three are included within the Desire Realm, this first tier of the cosmos is essentially equivalent to the physical and geographic cosmos (fig. 1.13).

The remaining Realms of Form and Formlessness comprise increasingly ethereal heavens about which less and less physical detail can be articulated and that therefore also appear somewhat less frequently in artwork (except for depictions that emphasize the *abhidharma* cosmology [see figs. 2.2, 4.23, 4.27, 4.44, and 4.45]). These heavens progress upward from the levels immediately above Meru in a way that is "not easy to calculate"[108] but is essentially exponential:

> As much [distance] as there is from one place downward, so much [distance] there is from there upward [to the next higher place]. [109]

In other words, the distance between one heaven and the next one above it is equal to the distance between the first and the surface of the earth. As the terrace of the Great Kings is 40,000 *yojanas* above the earth, so the next level up, the heaven of the Thirty-Three, rests 40,000 *yojanas* above it. The heaven of the Thirty-Three is thus 80,000 *yojanas* high, and the next heaven, of the Yāmas, lies at 160,000 *yojanas*.

The uppermost heaven of this system, Akaniṣṭha (which figures importantly in chap. 2), rises a full 167,772,160,000 *yojanas* above the surface of the earth, and there is nothing higher. The lateral dimensions of these incredibly elevated heavens are a matter of disagreement, with some saying they extend the same breadth as the summit of Meru and others claiming they surpass the diameter of the physical cosmos (possibly causing a problem of overlap if one considers neighboring cosmoses). Once again connecting geography and biology, Vasubandhu notes that the sizes of the beings that dwell in the various realms increase along with the dimensions of the realms themselves.[110]

Continuing the theme of exponential increase, multiple cosmoses are grouped into world-systems by factors of one thousand, creating vast multiverses that figure prominently in hyperbolic literary analogies. A group of one thousand Cakravāda worlds is called a "small thousand world-system."[111] One thousand of those is a "medium double-thousand world-system." One thousand of those (1,000,000,000 Cakravāda world-systems) is a "triple-thousand-great-thousand world-system." This last and largest is a classic unit of measurement that expresses enormity in many contexts, including offering rituals.

The last major theme of Vasubandhu's chapter on the world is time, which also carries close relationships to the types and locations of sentient beings. In general, *devas* live much longer than humans, and hell beings live that much longer than *devas*, such that their torments must seem interminable. The passage of time also differs between realms. For example, the hell beings of Saṃjīva have, "like the [four Great Kings], a life of five hundred years of twelve months of thirty days; but each of these days has the length of the total lifespan of the [four Great Kings]," whose own lives in turn are made up of days that last "fifty human days."[112] In Jambudvīpa, the life spans of beings also change depending on when they live during the cosmic cycle of the creation and destruction of the universe. This cosmic cycle is described in some detail but rarely depicted in artwork.[113] Instead, most images of the cosmos show the static, physical geography.

Through the hierarchical organization of the beings and locations of the universe, the cycles of cosmic time also correspond to deconstructive and constructive processes of meditation. Destruction of the world begins with the hells, after beings cease to be reborn there (beings whose actions require them to be born in hells are relocated to the hells of another cosmos). Then animals and *pretas* disappear, as do their realms. Humans and *devas* both begin to reach meditative attainments that promote them to higher stages of birth in the cosmos, whereupon their depopulated realms also

Symmetry

Center and Periphery

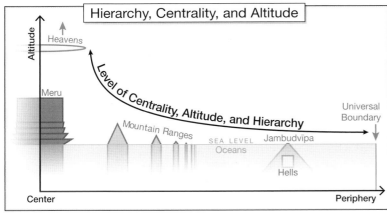

Hierarchy, Centrality, and Altitude

Altitude

Heavens

Meru

Level of Centrality, Altitude, and Hierarchy

Mountain Ranges

SEA LEVEL
Oceans

Jambudvīpa

Universal
Boundary

Hells

Center

Periphery

1.14. Structural principles of the *Treasury of Abhidharma* cosmology

disappear — no realm of the cosmos has cause to exist without its defined inhabitants. When all the actions of beings in the world are exhausted, the world itself is destroyed. The progression here clearly matches the cessation of action and release from the world sought in individual meditative practice. Because cosmic time is cyclical, however, the world arises anew. It begins with the coalescing of wind into a giant disc, inside which water condenses and precipitates into a layer of golden earth, and so on. Beings repopulate the realms in the reverse order in which they disappeared from the previous cosmos.[114] The ascending creation of the world through these elemental layers becomes a basis of purificatory meditation.

Indeed, such basic features of the cosmos are fundamental to the paradigms of numerous rituals and visual representations. Figure 1.14 summarizes three structural principles that commonly reappear. To begin, the cosmos is symmetrically divided into four quadrants in the cardinal directions. The only remarkable visual differences between the quadrants are the colors of Meru's sides and the shapes of the continents. Furthermore, there is a diametric opposition between the center and the periphery. The center is where the *devas* and higher beings dwell, while the periphery is the realm of humans and hell beings below them. The outermost periphery is girded by

the Cakravāḍa mountains, a boundary so significant that its name also applies to the entire world-system. The linear progression of sizes of mountains from the center to the periphery also suggests an essential hierarchy to the cosmic space. Motion inward toward the center implies motion upward toward the heavens of the *devas*; indeed, the removal of hell beings to the periphery makes this pattern consistent. These are not the only significant structural principles of the cosmos — one could also add the tripartite division into vertical tiers evinced in the three realms, for example — but they are the defining characteristics of the geographic Desire Realm that concerns us. The landscape of this geography, with its principles of symmetry, centrality, and hierarchy, informs all the other cosmologies in this book.

At the same time, many of the details of Vasubandhu's cosmological model cannot directly translate to other circumstances. Because he is interested primarily in causal explanations and states of being, Vasubandhu omits or obscures descriptions that would serve ritual and visual depictions, such as the colors, shapes, and orientations of the continents. The cosmology of the *Treasury* is a particular instance of cosmological thinking that makes sense only within Vasubandhu's larger project, just as the cosmologies of the other textual sources uniquely fit into their own contexts. While the *Treasury* may be cited by later authors, ritualists, and artists as the ultimate source of their cosmological traditions, other examples of cosmological thinking diverge significantly from Vasubandhu's scope.

The Wheel of Time: A Ritualized Cosmology

Originating in the eleventh century in India,[115] the Buddhist Wheel of Time corpus borrows from Vasubandhu, Jain texts, and other sources, radically recasting the cosmos as a basis for ritual performance and meditative purification leading to enlightenment. Although the supposed root text of the Wheel of Time has not survived,[116] many of the details are known from other eleventh-century texts,[117] such as the *Abridged Wheel of Time Tantra*[118] and the commentary on it, *Stainless Light*.[119] Since the tradition lacks its own purported source and its teachings are complex, scholars generally rely heavily on such commentaries, understanding the tradition as based in a corpus rather than a single text. In this regard, the fifteenth-century commentary *Ornament of Stainless Light*[120] by Khedrup Norsang Gyatso[121] and a nineteenth-century treatment by Jamgon Kongtrul Lodro Taye[122] in his *Encyclopedia of Knowledge*[123] are also especially helpful.

The Wheel of Time system seeks to present a kind of grand unified theory of Buddhist science, philosophy, and practice with the explicit goal of providing a means for enlightenment. By articulating parallel accounts of the fundamental elements, the cosmos, the human body, and other subjects,[124] the Wheel of Time establishes a unifying logic for all knowledge that also suggests powerfully overlapping symbolism. For example, the physical body of the practitioner becomes a microcosm of the universe:

"Here in the body, earth is firmness, water is fluidity, fire is heat, and wind is swiftness because it causes contraction and expansion. A bodily aperture is space. A hard bone, or the backbone that extends from the hips up to the shoulders, is Mt. Meru, the best among the immortal mountains. . . . The heavenly bodies, or [the ten] planets, beginning with the sun, and so on, are the ten types of bodily apertures."[125]

These kinds of parallel explanations are divided into three basic categories[126] in a classificatory system that is unique to the Wheel of Time and reveals its prioritization of soteriology.[127] The Outer Wheel of Time deals with the physical world, including geography and the cycles of time. The Inner Wheel of Time deals with the human body, including the subtle body that is used in yoga.[128] Together, the Outer and the Inner Wheel of Time describe the foundations for purifying the practitioner through meditation. The third analysis, the Other or Alternative Wheel of Time, describes the method of purification, including generation- and completion-stage meditations.[129] This overall structure reveals that even the geometry of the world in the Outer Wheel of Time is little more than a foundation for tantric meditation: "The reasons [for concentrating on the presentation of the dimensions of this world] . . . are firstly to bring about correspondence between the inner world of the practitioner's body and the outer world, which form the two bases for purification in the deity mandala meditation, and secondly to bring about correspondence between these two bases of purification and the mandala itself, which is the actual purifier."[130]

The complete unification of microcosm (body) and macrocosm (world) for the goal of purification results in a cosmology that is so radically different from other traditions that its variance must be justified. *Stainless Light* explains one reason why the Wheel of Time contradicts the well-known *Treasury*: "[Various] measurements of the cosmos are taught, and appear, to sentient beings from the point of view of worldly phenomenal (truth), in accordance with the dispositions of sentient beings who have various inclinations. . . . Ultimately, the cosmos does not have measure and altitude, [because they appear variously] in accordance with the merits and sins of sentient beings."[131] While Vasubandhu presented a physical world generated by the actions of beings, the Wheel of Time describes a cosmos that is nothing more than illusory perceptions determined by the propensities of the individuals who experience it. Agreement between individuals on one particular description results from psychological similarities among groups.[132] The inherent subjectivity of cosmology also explains why the omniscient Buddha could seem to teach conflicting measurements for the cosmos in different contexts: "Do not make this mistake with regard to the measurements here: 'Since the [Buddha] said [in the view of the *Treasury*] that the measurement [of the] cosmos is [3,610,350 *yojanas* in circumference], how can the cosmos [in the Wheel of Time] measure [400,000 *yojanas*] (in diameter) [and 1,200,000 in circumference]? Isn't the [Buddha] a liar here?' Some will think [that he is a liar], (but) [scholars] should not accept that statement; [he did not state the measurement as a result of having measured it but] due to the dispositions of sentient beings."[133] The Buddha accommodates

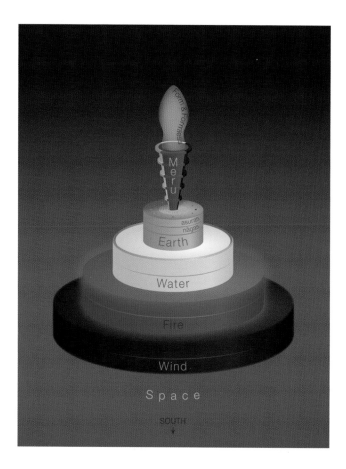

1.15. Perspective view of the cosmos described in the Wheel of Time

his audience by teaching measurements that are appropriate to their perceptions and abilities.[134] Despite the apparent subjectivity of cosmological description, however, commentators spend considerable effort trying to reconcile differences between the Wheel of Time and the *Treasury*.

The Wheel of Time's unique emphasis on parallel analysis as a foundation for transformation clearly determines many essential features of its model. As in the five-colored Meru, the Wheel of Time cosmos closely comports with the natural elements of space, wind, fire, water, and earth that form the basis of tantric practice. These same five elements also make up the substrata on which the surface of the earth rests (fig. 1.15). Within the empty element of space lies a maṇḍala of wind 50,000 *yojanas* high and 400,000 *yojanas* in diameter. Above this are concentric, elemental maṇḍalas of fire, water, and earth, each the same height but decreasing in diameter by 100,000 *yojanas* each. As in the *Treasury*, each region of space also contains a specific type of being. Stacked within the four elemental maṇḍalas are eight abodes, each 25,000 *yojanas* high, containing hell beings (in the bottom seven) and *asuras* and *nāgas*[135] (in the upper and lower halves of the eighth).[136]

The Wheel of Time cosmos and the human body correspond not only in their elemental composition but also in their proportional measurements. The four elemental maṇḍalas below the surface of the earth, which take up half the height of the cosmos (200,000 out of 400,000 *yojanas*), compare to the human figure below the waist.[137] Meru rises from the center of the earth maṇḍala and represents the spine in the human body. Its height of 100,000 *yojanas* corresponds to the length of the spine at one cubit. Above Meru for another 100,000 *yojanas* are the (slightly less proportional) "neck" (25,000 *yojanas*), "face" (50,000 *yojanas*), and "crown" (25,000 *yojanas*) of the cosmic body, the Form and Formless Realms. The total height of this universe is 400,000 *yojanas*, the same as its width, much as the height of a human figure approximates the distance between its outstretched fingertips. In simplifying the dimensions of the cosmos (and the body) to these easily divisible measurements, the Wheel of Time restructures the world so as to create precise correspondences between its Outer and Inner levels of description.[138]

INTEGRATING SYSTEMS: COMPLEXITY AND CONTRADICTION

Despite the straightforward nature of these particular correspondences, the continued layering of such relationships creates overwhelming complexity to the point of self-contradiction, making both interpretation and depiction problematic. One example of how the integration of multiple systems in the Wheel of Time obscures its cosmological thinking is its adoption of the central, circular Jambudvīpa and hells of the Jain system, which contradicts simultaneous notions of a peripheral Jambudvīpa and surrounding oceans (as seen in the *Treasury*) and thereby creates confusion about the locations and sizes of the oceans, continents, and even the elemental substrata of the world. Another such example is the famous ten-syllable mantra of the Wheel of Time system, which, even though diagrammed as a cosmological model, does not admit a single, coherent interpretation.

The Wheel of Time cosmology borrows heavily from Jain sources,[139] which places it in direct conflict with other features of its own model that are more in line with the *Treasury*. In the Wheel of Time, Meru and its immediately surrounding rings of mountains and oceans, each the same height and width, rather than progressively smaller,[140] sit at the center of an enormous, circular Jambudvīpa that extends to the edge of the earth maṇḍala. This Greater Jambudvīpa contains twelve smaller continents reminiscent of the *Treasury* system, with the southern one distinguished as Lesser Jambudvīpa (fig. 1.16). Commentators address this problem of continents within continents by claiming that the shapes given for the smaller landmasses are actually the outlines of regions, or perhaps marks that appear in those lands, or that the shaped continents are surrounded by seas connecting to a great outer ocean, with the underlying seafloor considered to be Greater Jambudvīpa.[141] Unfortunately, these seas cannot easily connect to the outer ocean of the water maṇḍala. The vertically stacked abodes

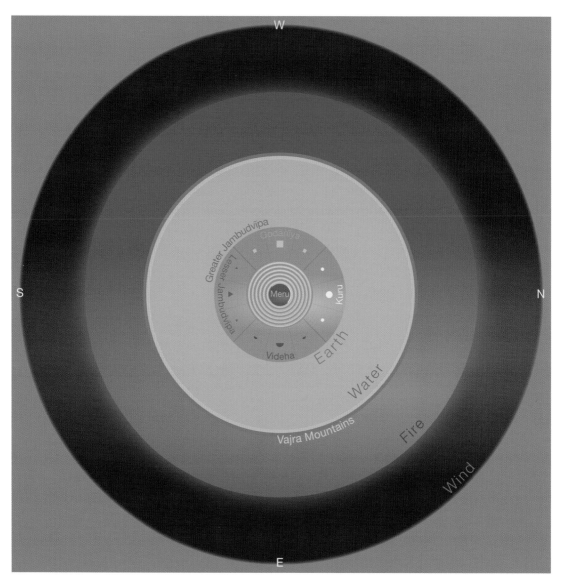

1.16. Plan of the cosmos described in the Wheel of Time

in the four elemental sublayers place the water maṇḍala 50,000 *yojanas* below the surface of Greater Jambudvīpa. Some commentators solve this problem by suggesting that the air, fire, and water maṇḍalas, though described as stacked discs, must extend upward to the level of the earth in areas where they are not blocked by the maṇḍala above, just as flames and winds are known to spread upward. This brings the great salt ocean and its encircling Vajra mountains (akin to the Cakravāla) into accord with the expected planar view of the world.

Despite the difficulties posed by such rigid stacking, the same basic principle applies to a second example, a vertically arranged series of graphemes known as the All Powerful Ten[142] mantra (fig. 1.17) that implicitly depicts the cosmic hierarchy.[143] In this image, single seed[144] syllables stand for the basic elements of the cosmos according to their vertical arrangement in space — where in normal writing they would appear from left to right:

> Here is the birthplace of the mantras: from moon, [*bindu*]; from sun, *visarga*; from the space element, A; from the wind element, I; from the fire element, Ṛ; from the water element, U; from the earth element, Ḷ; from the inanimate element [Meru], the consonant MA; from the animate element [the desire and form realms], the consonant KṢA; and from the formless realm, the consonant HA. These mantra words should be placed in the reverse order [i.e., in an ascending sequence].
>
> Then, the former consonant goes on top of the latter consonant. The letter Ḷ and so forth become semivowels because it says: "*iko yaṇaci*";[145] the letter A is joined to the end of them. *Visarga* is shaped like a half moon. *Bindu* is a circle. Gnosis is shaped like a crest.[146]

The ten elements of the mantra are described in the first paragraph: *bindu* (*anusvāra*), *visarga*,[147] A, I, Ṛ, U, Ḷ, MA, KṢA, HA. The second paragraph describes how these elements change in order to appear graphically in the All Powerful Ten. Since the A vowel is considered to be part of the other syllables, it is not shown. It does produce phonetic changes in the other seeds that are pure vowels (see n. 145), which leads to their being written as semivowels with a subsequent A. Gnosis appears at the end, not as one of the ten or part of the cosmology, but as an additional, eleventh element of the mantra diagram.

While interpretations of the ten-syllable diagram vary widely, the seed syllables of the mantra are essentially stacked vertically to match the arrangement of elements and realms in physical geography. The rightmost column of the table in figure 1.18 (bold outline) shows the exact same vertical arrangement of realms as in the cosmic model (except the altitude of the sun and moon). Cementing this cosmological identification, the syllable "ma" even splits into five colors just as Meru appears in the five directions (the four cardinal directions and the center). The two elements above Meru, the lotus and deities, appear as central elements of deity-maṇḍala cosmology.[148]

Of course, it would not be the Wheel of Time if these syllables, colors, and elements did not also correspond with the anatomical body, the subtle body, and numerous other systems of analysis, obfuscating any single, clear interpretation. These overlapping layers of linguistic symbolism, cosmic hierarchy, and elemental transformation make even the simplest parsing of the diagram impossible, such as distinguishing the

1.17. Mantra of the Wheel of Time

	Letter and Color	Sound	Element	Realm
(11)			gnosis	awareness
10		*anusvāra* (nasal continuation)	moon	moon
9		*visarga* (unvoiced continuation)	sun	sun
8		ha	formless	Formless Realm (gods)
7		kṣa	animate	Desire and Form Realms (lotus)
6		ma	inanimate	Meru
5		la	earth	earth maṇḍala
4		va	water	water maṇḍala
3		ra	fire	fire maṇḍala
2		ya	wind	wind maṇḍala
1	[not shown]	a [inherent]	space	space

1.18. Items in the Wheel of Time mantra

sun from the moon or identifying the ten items intended. In the image, a crescent shape represents the sun and a circle the moon, reversing a nearly universal graphic convention.[149] Further, the ten elements depicted are not the ten sounds, with the inherent A vowel assimilated into other syllables and the unpronounced gnosis crest added. Though the simple diagrammatic structure of the mantra image could clarify the complex details of the cosmological model, its overlapping systems of symbolism produce the opposite result.

For such reasons, the Wheel of Time is one of the most challenging systems of thought in Himalayan Buddhism. While Vasubandhu's *Treasury of Abhidharma* is a standard part of monastic curriculum in Tibet and rather accessible to a literate monk,[150] the Wheel of Time is abstruse and rarely studied.[151] At the same time, it is also widely understood as particularly efficacious, with the Dalai Lama often granting large, public initiations.[152] Despite such popularity, the cosmology of the Wheel of Time did not displace the *abhidharma* model in art and ritual. Neither, however, is the *Treasury* an unproblematic source for instances of cosmological imagery in other contexts that do not precisely match its quirks and agenda. We must continue to look at other examples to see the variety of cosmic expressions in the Himalayan Buddhist world.

Cosmology in Other Literature

Although systematic treatises express cosmology most directly, other types of Buddhist literature express independent cosmological thinking. These formulations can strongly influence visual depictions and cosmology in other contexts. Episodes from the life of the Buddha, for example, were so popular in both art and literature that some were undoubtedly better known than the systematic cosmologies. These narrative examples also show how one particular way of thinking about the cosmos can appear outside a comprehensive view in order to serve narrative or rhetorical functions. The three cases presented here relate to, respectively, the immensity and stability of Meru, the division of space into directions, and cosmic scale as a measure of spiritual attainment. The first two examples come from *Extensive Play*,[153] a popular biography of the Buddha that inspires readers with Mahāyāna notions of enlightenment. The third comes from a collection of stories known as *The Wise and the Foolish*.[154]

To begin, comparisons with Mount Meru's unique size and stability within the cosmic system highlight the unexcelled nature of the Buddha's accomplishments. For example, in a passage in which the prince who is to become the Buddha decides to leave home to seek awakening, he states:

> Listen, Chandaka, to my resolve,
> poised for the salvation of souls and (their) welfare,
> unshakeable, unbreakable, firm
> and unmoving as Lord Meru.[155]

As in the four-petaled-lotus Purāṇic model of the cosmos, with smaller mountains anchoring the continents to the stable center, here Meru is immovable by definition. A related metaphor suggestively transgresses Meru's absolute immobility:

> Someone could, having uprooted great Meru, hold it in the sky,
> but no one can draw up the "Meru" [i.e., the great mountain] of the qualities
> of a Jina (Buddha), [which is] heavy with rocks, a refuge for those with
> knowledge of virtue.[156]

In other words, the Buddha's virtues outweigh the largest physical object in the universe. Such overpowering of Meru's near-perfect stability appears again when the mountain moves of its own accord to show respect to the Buddha's place of enlightenment: "And even all the mountains in this triple-thousand-great-thousand world-system, with Sumeru foremost, bowed to the seat of awakening."[157] All these examples derive their literary power from the fact that Meru, under ordinary circumstances, is the most stable and sizable object in the universe. The surpassing of these qualities by the enlightenment of the Buddha restructures the cosmic order around his person.

Such metaphors do more than extol the Buddha, however, and a passage comparing demonic weapons to Meru results in artistic depictions that illustrate further assumptions about Meru's role in the universe. In the scene in which Māra's demons attack the bodhisattva as he is about to become enlightened, the Sanskrit edition compares the size of the demon's weapons to Meru: "[Māra], having turned back once more with his followers, loosed manifold weapons and mountains the measure of Sumeru upon the bodhisattva."[158] The Tibetan version from the Derge[159] canon, however, inserts a passage describing the individual weapons quite literally: "One [demon] holds Mount Meru in his hand."[160] This line has become a popular subject in paintings of the Buddha's defeat of Māra. Figure 1.19 shows three modern Tibetan treatments of this subject,[161] in which the artists depicted the weaponized Sumeru surrounded by additional cosmic geography, including Śakra's palace, the cosmic ocean, the Cakravāla mountains, and sometimes even the twelve continents and seven rings of golden mountains. Whether the literary reference to Meru serves as a synecdoche for the entire cosmos (in the same way that the word "Cakravāla" can also refer to the entire universe) or the artists visually identified the mountain by placing it in context, Meru stands irrevocably interrelated to its cosmic surroundings.

On a purely visual level, these images also suggest that the demons might wield entire universes (not just Meru) as weapons, extending the logic by which immensity metaphors operate in text. While authors cite Meru as the greatest physical object in the universe, artists have recourse to the Cakravāla cosmos as the largest coherently depictable single object in Buddhist iconography.[162] Imagery of the Cakravāla cosmos here performs exactly the same function as the invocation of Meru in text, comparing the demon's weapon to the largest object in the vocabulary of the medium.

1.19. Examples of the Cakravāla cosmos being used as a weapon by Māra's demons. 20th–21st centuries. Left to right: Duidul Jyangchub monastery (T: bDud 'dul byang chub chos gling), Ganden Phelgay monastery, and Shechen Tennyi Dargyeling (T: sNga 'gyur ring lugs rgyal ba zhe chen pa), Bodh Gayā, India

The second example from the life of the Buddha similarly uses the division of the cosmos into four cardinal directions and three vertical tiers as a way of communicating the Buddha's status in the world, providing a simplified alternative to the complex spatial hierarchies in sources like the *Treasury*. After the Buddha's awakening, the four Great Kings offer him four begging bowls, which he accepts and fuses into a single bowl. Ostensibly, the Buddha performs this magical action out of a desire not to offend the other three kings by accepting a bowl from only one: "Four stone vessels are not appropriate for me. But if I will take from one, three would be dejected. So, having accepted these four vessels, I will transform them into one vessel."[163] Despite the modesty of this claim, such a gift from the kings of the four cardinal directions suggests a bestowal of allegiance to the Buddha from the four quadrants of the universe.[164] His fusing of the four bowls into one thus represents his unifying the quarters of the world under the single authority of his enlightenment.

One can also interpret the scenes before and after the four Great Kings present their gifts as representing the Buddha taking command of the universe vertically, as well as horizontally. Just before the kings offer their bowls, *nāga* kings from the four quarters appear and protect the Buddha from heavy rains with their hoods, indicating deference from their underworld domains.[165] Soon after the presentation from the four Great Kings, the *devas* of the heavens approach the Buddha to acknowledge his supreme wisdom and ask him to teach.[166] While these scenes admittedly unfold across two chapters that contain numerous other scenes, the overall structure suggests the Buddha progressively taking command of all directions of space: below, in the four horizontal directions, and above. This simple arrangement reveals a common alternative conception of space as defined by directions relative to the center (here, the Buddha), in contrast to the abstract hierarchy of numerous hells and heavens in the scholastic systems.

The third example illustrates the cosmic stature of the Buddha more directly by having him literally extend himself to the height of the heavens and the size of the universe. He performs these miraculous feats over several days in the city of Śrāvastī in order to overcome the false views of a group of heretical teachers. On each day, someone makes an offering to the Buddha, and in response he performs a miracle that expresses his power. On the ninth day, the four Great Kings make an offering, after which "the great assembly saw the Lord's body extend to the realm of the [Great Kings] and fill all space as far as the extreme limits of the [sic] Samsara. From it, there streamed a great light and the people saw and heard the Dharma, rejoiced and believed, and attained blessings."[167] It cannot be a coincidence that the gift of the four Great Kings prompts the Buddha to extend himself and his teachings in all directions of the world, much in the same way that he takes command of the directions in *Extensive Play*. A similar miracle, likewise attuned to the particular donor, occurs on the eighth day when Brahmā makes an offering and the Buddha projects "a beam of clear light as far as the realm of Brahmā (the Brahmā heaven)."[168] In fact, there is some thematic overlap between these two episodes, since the latter can also be interpreted as the Buddha extending his body to Brahmā heaven,[169] taking command of the vertical axis in bodily form just as he does the four directions.

Due to the association of these miracles with Tsongkhapa's[170] Great Prayer Festival[171] in Tibet, these stories have become popular subjects in visual artwork. Since both the eighth- and ninth-day miracles involve the Buddha extending his body through cosmic space, they are often depicted similarly, with the Buddha seated or standing directly in front of Mount Meru, rising to about the same height in the picture plane (figs. 1.20 and 1.21; in both images, the blue face of terraced Meru appears directly behind the Buddha's circular halo, with layers of heavenly abodes rising in clouds above his head). Once again, there is a visual metonymy between Meru and the cosmos as a whole, with the Buddha's filling of the universe depicted as a visual overlap with central Meru. In both image and text, the Buddha's extension of his body through space actively demonstrates the same dominance of the universe that is only passively illustrated by the gift of the four bowls in *Extensive Play*.

These three examples from the life of the Buddha show that even relatively simple literary topoi reveal deep cosmological thinking. While this literary cosmology does not explicitly contradict the systematic cosmologies, it is not identical either. Where systematic cosmologies might name and define the cosmos through its boundary at the Cakravāla, the literary examples employ central Meru as its determining feature. Such a conceptual overlap between Meru and the cosmos becomes particularly apparent in the visual examples of the attack of Māra's demons and the miracles at Śrāvasti, in which cosmos and Meru stand in for each other. The literary examples also illustrate alternative ways of thinking about spatial structure and hierarchy, such as an emphasis on the Buddha at the center of six relative directions rather than in a hierarchy of numerous heavens, hells, and regions of earth. These examples further demonstrate

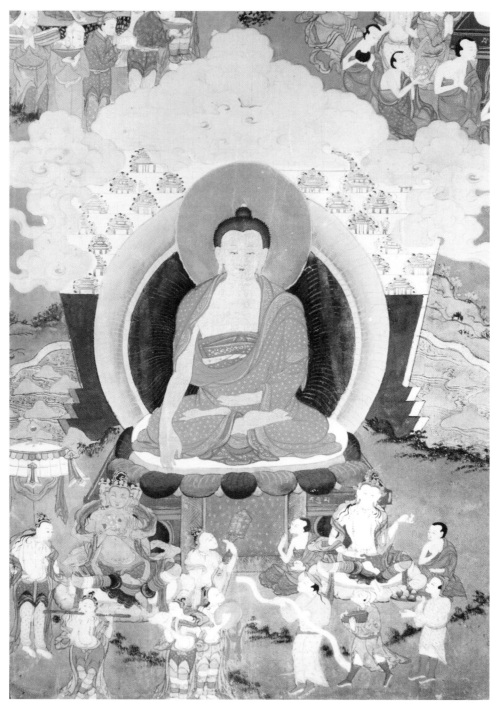

1.20. Scene of one of the Buddha's miracles at Śrāvastī, with an offering by Brahmā (golden-skinned figure on bottom left). 19th century. Erdene Zuu, Mongolia

1.21. Scene of one of the Buddha's miracles at Śrāvastī, with an offering by the four Great Kings (red-, blue-, yellow-, and white-skinned figures at bottom right). 19th century. Erdene Zuu, Mongolia

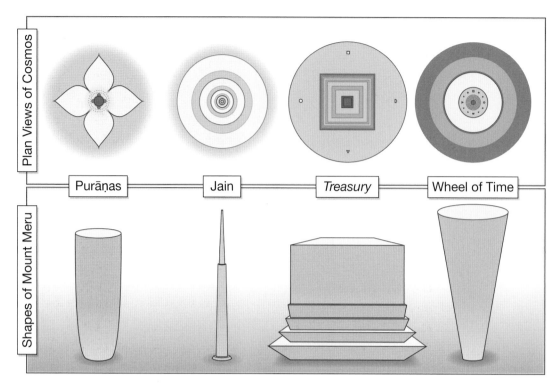

Plan Views of Cosmos

Shapes of Mount Meru

Purāṇas | Jain | *Treasury* | Wheel of Time

1.22. Variations in the shape of the cosmos and Meru in four Indic traditions. Left to right: the Purāṇas, Jainism, the *Treasury of Abhidharma*, and the Wheel of Time. Top row: plan views of the cosmos. Bottom row: shapes of the central cosmic mountain

the rhetorical use of specific cosmological ideas to reveal the new world order imposed by the Buddha's awakening, in which the cosmos itself becomes smaller and less imposing in relation to the accomplishment of an enlightened being.

Conclusion

Physical geography can be put to diverse uses in textual sources of cosmology. Like the three different accounts of the composition of Meru that begin this chapter, cosmology changes in service to its context. These adaptations take place at all levels of description, from the basic directions that divide space to the details of specific beings who dwell in each realm. From the elemental composition of the substrata of the world to the orbital paths of astral bodies, each detail holds potential significance in the larger projects in which cosmological thinking occurs.

While certain structures seem common to all the Indic models, such as a vertical hierarchy and a division between center and periphery, these similarities should not obscure the important differences that underlie the various articulations (fig. 1.22). To a modern reader, the decision as to whether the diameter of a(n obviously erroneous)

disc-shaped world is 1,203,450 or 400,000 *yojanas* might seem entirely arbitrary, but in context, these numbers are dramatically significant. The first number, in that it conflicts with the sum of measurements given for all the separate pieces of the cosmos in the *Treasury*, gives us some sense of the sources Vasubandhu may have drawn on for the dimensions of his model. The second, because it is a rounded number and identical to the height of the cosmos in the Wheel of Time, allows ritual correspondences between the world and the human body that serve soteriology. While such cosmological accounts undoubtedly draw on related textual precedents and frequently claim consistency with broadly accepted knowledge of the world, even such minor changes to a description matter.

With the importance of comparative cosmology established through examination of textual sources, it becomes obvious that similar differences in description and function must exist in other expressions of cosmology as well. Although traditions of ritual and image-making sometimes cite the texts investigated in this chapter, these textual descriptions often fail to withstand comparison against representations in other forms. Rather, Buddhist cosmological thought is equally informed by unsystematic texts, rituals, and visual art. Depictions of the cosmos in the deity maṇḍala, ritual offerings, and murals also adapt to unique roles, with unique cosmological processes even enforcing the efficacy of specific ritual transformations. Because these rituals are performed and instantiated in material culture, it is vital to study artwork and practice along with textual sources.

2

Cosmos in the Maṇḍala

SALVATION THROUGH GEOGRAPHY

T HE MAṆḌALA IS ONE OF THE MOST RECOGNIZABLE SUBJECTS IN HIMA-
layan Buddhism. Whether in text, ritual, or artwork, a maṇḍala may be
defined as a formalized grouping of deities (an imprecise term that can include
buddhas, bodhisattvas, protectors, and *devas*). Maṇḍala diagrams represent this ar-
rangement of figures spatially, usually with a primary deity in the center surrounded
by a retinue of others. In general, these figures appear within a square architectural
space, considered to be the palace of the central deity, which in turn is surrounded by
a circular protective boundary, giving the maṇḍala an overall circular shape.[1] Figure
2.1 illustrates how the figures and the gateways of the palace typically appear in a front-
on, elevation view. The gateways are rotated 90 degrees into each of the four quadrants
so that they visually enclose the perfectly square courtyard of the palace. This square
courtyard, then, is represented in a plan view, along with the four-sided *vajra* that
forms the palace foundation and the various elements of the circular boundary.[2]

Although the representation of these figures and their arrangement in architec-
tural space are rather straightforward, the interpretation of the meaning and use of
maṇḍalas is complex and open to various approaches. A royal metaphor for the central
deity of the maṇḍala as the emperor over kings[3] has proved useful for understanding
the early development of tantric Buddhism in India,[4] as well as the function and sym-
bolism of the maṇḍala itself. The empowerment granted in maṇḍala practice is under-
stood as a royal enthronement, granting dominance over reality through enlighten-
ment. Equally important are the ethnography of ritual procedures surrounding the
construction of a maṇḍala[5] and the ways that various parts of the maṇḍala symbolize

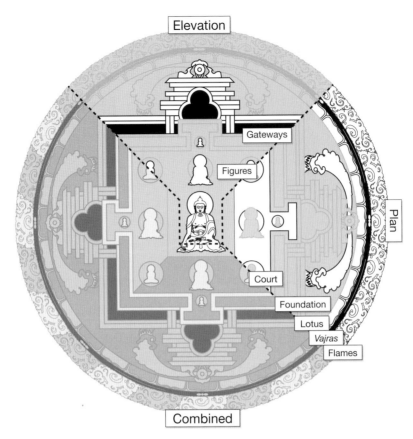

2.1. Diagram of a generic maṇḍala. The top quadrant highlights the features that are depicted in elevation view, including the figures and gateways to the palace. The right quadrant shows the features portrayed in plan view, from the square architectural court to the layers below the palace, including the *vajra* foundation, lotus, *vajra* fence, and ring of flames

aspects of the meditating mind.[6] One recurring theme across various interpretations is that the maṇḍala is a type of cosmogram, but the specifics of what is meant by this can vary significantly, referring to anything from the cosmos as the perfected realm of the deity to the microcosmic world of the practitioner's psychological states.[7] Sometimes overlooked in these discussions is the actual cosmology of the maṇḍala, especially in terms of physical geography.

The geographic cosmology of maṇḍalas is central to their practice and symbolism. Paradigmatically considered a tool for personal enlightenment, the maṇḍala meditation that transforms the practitioner into an enlightened buddha is also a relocation within the Cakravāla world to the place of that buddha, specifically the peak of Meru. Because the nature and status of beings in the universe are inextricably linked to their place in the hierarchical structure of that universe, transformation in type and

movement in space must in a sense occur together. At the same time, tantric cosmology tends to emphasize dynamic relationships between places rather than the importance of any single geographic location. Ritually creating a maṇḍala in the here and now collapses the separation between local and cosmic, transcending notions of space and place precisely by invoking them. Since all locations in the world can participate in such dynamic relational systems, the tantric view of the world provides a powerful framework for expressions of sacred geography and architecture even within the local landscape.

Although the notion of placing the enlightened Buddha atop the peak of Meru at the center of the universe appears in one of the earliest and most influential texts associated with maṇḍala practice, the seventh-century *Compendium of Principles of All Tathāgatas,*[8] the implications of this cosmology receive less attention, partially because recognizable geography appears only rarely in painted or sculpted maṇḍalas. Noteworthy images, however, do illustrate maṇḍalas as true geographic cosmograms that communicate the transformative power of geographic thinking, often in very different ways than texts. And while later tantras sometimes present very different locational settings,[9] the buddha-maṇḍala atop Meru's peak becomes a widespread theme across a variety of textual, ritual, and artistic productions.

This maṇḍalic association between the buddha and the peak of Meru is so strong that some might think of it as a unique development of tantrism, but depictions of the buddha atop Meru predate tantric maṇḍalas in South Asia and continue to occur in non-tantric contexts. Early artistic depictions show imagery of the historical Buddha atop Meru in relation to simple narrative episodes from his life. Far from being a specialized application of cosmology in tantric maṇḍala traditions, the general idea that the buddha is locationally associated with the peak of Meru is a basic concept of the early Buddhist worldview.

The major development of early Buddhist tantrism, then, is its establishment of a dynamic relationship between the buddha at the peak of Meru and the rest of the world through processes of translocation. Two basic directions of translocation to Meru correlate to the tantric ideology of the *Compendium of Principles,* for example, although neither involves actual motion. The first is a narrative ascent from Jambudvīpa to the peak of Meru that accompanies the process of personal enlightenment. This translocation redefines the human meditator as a cosmic buddha in the center of the universe, applying the geographic association of place and being discussed in chapter 1 to the process of personal transformation. The second is a rhetorical descent of a fully enlightened buddha from the highest heaven Akaniṣṭha to the peak of Meru. Although not explicitly stated, the narrative frame story of the *Compendium of Principles* hints at this translocation by explaining that the buddha who teaches the *Compendium of Principles* resides in Akaniṣṭha even as he expresses his teaching at the peak of Meru, the most prestigious point in physical geography. This pairing of descending and

ascending translocations allows simultaneous emphasis on the absolute supremacy of the maṇḍala practice and its practicality for beings who still have worldly existence.

Such analysis of the maṇḍala in terms of three geographic locations differs in key ways from other accounts of maṇḍala cosmology, which often focus on three distinct bodies[10] of the buddha. Put simply, buddhas who appear in the physical world or in meditative visions are apparitional emanations of a non-physical body of the buddha that is nothing other than the corpus of truth itself. According to this analysis, buddhas in Jambudvīpa and atop Meru are merely contingent appearances of something higher. Because the three-body theory does not distinguish among locations in the physical world, it fails to account for the importance of the peak of Meru as a geographic place. The summit of Sumeru is a unique location in the tantric cosmology, forming a mesocosm,[11] or middle ground, between the heavenly and the worldly that makes tantric enlightenment possible. It is only this mesocosm at the peak of the physical universe that can connect the ascending and descending translocations of tantric rhetoric, making highest enlightenment possible for worldly beings. Thus, the summit of Sumeru is not simply the proper cosmic place of enlightened buddhas but also a geographic focal point for tantric ideology.

By emphasizing place rather than person, this model of tantric cosmology further provides explanatory power for other aspects of tantric ritual and art. With it, the maṇḍalic cosmos can operate not only at the level of the meditator but also for sacred sites, architecture, and other features of the Buddhist world. By constructing the maṇḍala in specific monumental or artistic forms, practitioners have direct, physical access to the location of enlightenment they seek through maṇḍala meditation. Such recentering of the cosmos to one's immediate place is in fact a fundamental part of tantric practice, and the ability of the maṇḍala atop Meru to be re-created locally is precisely what makes it a useful ritual tool.

The interpenetration of this maṇḍala with other geography is perhaps nowhere more evident than when considering other mountaintop abodes, such as Avalokiteśvara's Potalaka or Padmasambhava's Glorious Copper Mountain.[12] On the one hand, the maṇḍala palace that is paradigmatically envisioned atop Meru finds reflection at innumerable other mountains throughout the cosmic system. On the other, Meru makes sense as a paradigm only because it is the centralized case of more general traditions of sacred landscape, which view peaked mountains as divine abodes. Ultimately, it is such close relationships between maṇḍala cosmology and local geography that make tantric practice so powerful.

This chapter addresses at least one indigenous artistic product for each theme discussed, a shift from the largely textual approach of chapter 1. These visual artworks do not merely illustrate textual paradigms but rather balance and complement them. In other words, they are not the classic art historical examples of archetypal maṇḍala depiction but instructive cases that define the limits of maṇḍala cosmology in new and unusual ways. The juxtaposition of such elements here, though perhaps not in line with

traditional explanations, exposes various themes of maṇḍala cosmology across several different geographies and time periods.

All these examples make visible the broad applicability of cosmology to the religious sphere as well as the specific ways in which cosmological thinking about structure, place, and geographic hierarchy is employed to practical ritual, meditative, and material effect. By developing ways of thinking about cosmological geography in ritual systems, we can see the importance of cosmology not just as a topic unto itself but as a means for engaging with other primary aspects of religion, such as soteriology and ritual structure.

The Place of Buddhas in the World

In narratives of the life of the buddha Śākyamuni, the event of his enlightenment occurs at a unique adamantine seat[13] (at what is now Bodh Gayā, India) in Jamudvīpa. This location is not arbitrary. Rather it is the only location in the universe that is stable enough to survive the Buddha's literally earth-shaking feat.[14] In *Extensive Play*, even immovable Meru bows to the location where Śākyamuni would become enlightened as he approaches it,[15] an indication of its primary importance in the universe. As long as Śākyamuni is associated solely with Jambudvīpa in the cosmological scheme, however, it could be difficult to see him as fully transcending the status of a human in that realm. This is one reason why the gifts of the four guardian kings and the accompanying traversal of vertical space in the cosmos express his dominance of the entire universe, not just the human world. Even this rhetoric is ambiguous, however — an uncertainty that can be removed by conceptually relocating the Buddha to the peak and center of the physical universe, its crowning location. This is not a denial of the narrative versions of history, and indeed even contemporary paintings of the cosmos (fig. 2.2) sometimes include an image of the Buddha at Bodh Gayā as the central feature of Jambudvīpa (fig. 2.3). Rather, it is an acknowledgment that, in some instances, the cosmological status of a buddha at the center of the universe is more relevant than the biographical details of Śākyamuni's human history. Despite the specificity of the biographical narrative, the hierarchical structure of the cosmos is too powerful not to deploy more broadly.

LOCATING ENLIGHTENMENT IN AN EARLY TANTRIC TEXT

In terms of the textual record, the best early evidence of a turn toward the geographic centrality of the buddha comes in the seventh-century development of early tantrism in the *Compendium of Principles*.[16] This text is part of a shift in thinking about the buddha, from a figure of historical narratives to a hypostasized cosmic representation of enlightenment, in this case known as Vairocana.[17] The buddha Vairocana is the enlightened characterization of Śākyamuni, who is referred to in the text as Sarvārthasiddhi,[18] a

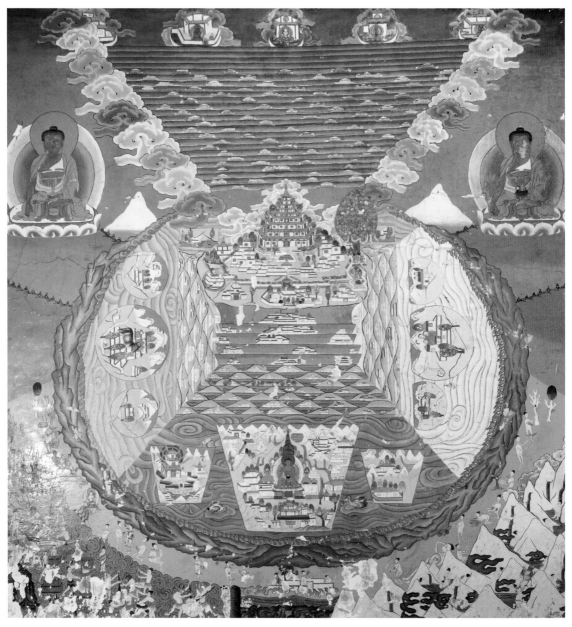

2.2. Mural of the Cakravāla cosmos. Sonada Gompa, Darjeeling, India

variation on his given name, Siddhārtha. Like more literal narratives of the Buddha's life, the *Compendium of Principles* presents an account of Sarvārthasiddhi's enlightenment, but "recast ... in tantric terms,"[19] more specifically as an esoteric meditative — and cosmological — process.

Excluding the opening frame of the text, this biographical narrative begins with Sarvārthasiddhi at the seat of enlightenment[20] in Jambudvīpa, moments before he

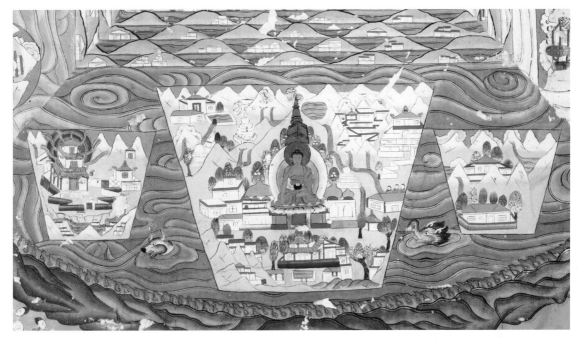

2.3. Detail of figure 2.2 showing the Buddha at Bodh Gayā in Jambudvīpa (center) and Padmasambhava's Lotus Light Palace (left). Sonada Gompa, Darjeeling, India

is to become fully enlightened. An infinite gathering of buddhas approaches Sarvār-thasiddhi and asks him how he intends to achieve awakening, in response to which he requests their teachings. After a series of esoteric meditation instructions and prac-tices, Sarvārthasiddhi is consecrated by the buddhas with the name Vajradhātu and realizes his enlightenment, whereupon he proceeds directly to the summit of Meru. There he takes the central position on the lion throne at the center of a diamond-and-jewel-spired palace and becomes identified as Vairocana. Four other buddhas (Akṣobhya, Ratnasambhava, Lokeśvararāja, and Amoghasiddhi) surround him in the cardinal directions, forming an assembly of five buddhas that becomes the center of a larger group of deities known as the Vajradhātu maṇḍala (with Lokeśvararāja later being understood as Amitābha). Subsequent passages detail the creation of this maṇḍala through Vairocana's meditative trance and can be read as cryptic instruc-tions to the meditative practitioner. It is clear, however, that the reader should consider the cosmological location of the entire Vajradhātu maṇḍala to be the peak of Meru.[21]

Commentarial instructions for the meditative practice of the Vajradhātu explic-itly acknowledge this fact. The influential eleventh- to twelfth-century scholar Abha-yākaragupta, who was abbot of the Vikramaśīla and Nālandā monasteries, wrote extensive manuals on maṇḍala practice, including the practice of the Vajradhātu of the *Compendium of Principles*. In the *Garland of Perfected Yogas*,[22] he provides spe-cific instructions on how and where Vairocana should be visualized by the meditator,

namely, in a palace surmounting Meru: "In the Vajradhātu maṇḍala, in the middle of the diamond-enclosure, on top of Sumeru furnished with the continents, subcontinents, seven oceans, and so forth, there is a palace. In the middle of that, on top of a lion [throne], on the pericarp of a universal lotus, there is the Lord Vairocana."[23] The text proceeds to describe Vairocana's features, enumerate the other deities of the maṇḍala, and explain their arrangement around Vairocana in the cardinal and intermediate directions.

Interestingly, Abhayākaragupta also provides a variant set of instructions for the Vajradhātu maṇḍala in the *Garland of Vajras*.[24] While the *Garland of Perfected Yogas* describes maṇḍalas in terms of how they should be envisioned during meditation,[25] the *Garland of Vajras* notes how they should be drawn[26] during ritual performance.[27] Here, the text simply says, "In the Vajradhātu maṇḍala, on a moon[-disc] on the pericarp of the universal lotus, the shining five-pointed *vajra* of Lord Vajradhātu,"[28] before moving on to list the other deities in the various directions, doing little more than providing the arrangement of the parts of a drawing. The only detail that is retained is the lotus, as the rest of the cosmological imagery is omitted. While physical maṇḍalas from Abhayākaragupta's milieu have not been found, this question of the relationship between envisioned and depicted maṇḍalas is an important one. Not only is the depicted maṇḍala the form that is reified in ritual and artwork, but visual evidence from the artistic record gives scholars a vastly different window on how cosmological function is conceived in the maṇḍala.

A PICTORIAL MAṆḌALA GEOGRAPHY AT ALCHI

An excellent example of the cosmology of maṇḍala imagery from a similar period, and indeed some of the earliest painted maṇḍala imagery extant in the Himalayas, can be seen at Alchi, in Ladakh. The mural in question demonstrates the relationships between the maṇḍala and the cosmos quite differently from the textual sources examined so far, depicting a somewhat unusual arrangement of continents containing recognizable *devas*. The configuration of these elements presents the maṇḍala palace as a displacing or superseding of the normal cosmic order, even as the maṇḍala supplies a direct connection between the mundane world and the state of enlightenment. Although the iconography of this painting at Alchi may be unique, such eloquent visual and material statements are essential to understanding the scope and complexity of Buddhist cosmological thinking. The historical context of this single example from Alchi underlines its place in the history of Buddhism.

Ladakh is important to modern scholars because the dry climate of the region has allowed paintings and monuments to survive from as early as the late tenth to eleventh centuries. The Alchi religious complex[29] was constructed during the so-called Second Diffusion[30] of Buddhism to Tibet, which began with King Yeshe O[31] of Guge[32] (Western Tibet) around the turn of the eleventh century. Seeking authentic teachings,

Yeshe O sent missions to India, including the famous translator Rinchen Zangpo,[33] who transmitted Vairocana-centered teachings related to the ones under discussion.[34] Although the Alchi complex may not be directly traced to Rinchen Zangpo,[35] its construction is also centered around Vairocana. The main assembly hall is dedicated to Vairocana, and the walls are illustrated with several different maṇḍalas related to Vairocana practice.

By the time of Alchi's construction, ritual traditions related to Vairocana depended largely on two foundational texts, the aforementioned *Compendium of Principles* and another tantra, the *Purification of All Bad Transmigrations*.[36] Based on these two texts and other influences, a relatively large number of different maṇḍalas were in use, but later traditions group these texts into a single set due in part to their focus on Vairocana. The New Schools of Tibetan Buddhism call this set the "Yoga Tantras," in contrast to several other classes of tantric texts that emphasize alternative deities and practices, some of which are considered more powerful than the early texts.[37] Such circumscription could suggest that these early maṇḍalas might have limited influence, but numerous examples show that the cosmology of such maṇḍalas appears pervasively as a structuring framework for ritual, artwork, and architecture, even when the maṇḍalas themselves are not invoked.[38] Of particular interest among these early sources and their key buddha Vairocana is an important form known as Omniscient Vairocana.[39]

Like Abhayākaragupta's instructions for drawn maṇḍalas, most of the maṇḍala murals at Alchi seem to ignore the cosmological imagery that is so apparent in the envisioned meditation. One, however, stands out as having clearly identifiable geography—a maṇḍala on the northeast wall of the Vairocana hall (the right wall when facing the main image), closest to the central shrine (fig. 2.4). Although the accompanying photograph focuses on the maṇḍala's top-right quadrant, the large circular border and inset square perimeter of the palace are clearly visible. The basis of this maṇḍala has been identified in the *Purification of All Bad Transmigrations*, centering on a version of Omniscient Vairocana with white skin, two arms, and one face (partially visible at the bottom left of the photograph).[40]

While it does not illustrate the Vajradhātu of the *Compendium of Principles*, then, this painting does visually exemplify similar cosmological thinking about the place of buddhas in the world. Specifically, it includes the major continents and subcontinents of the Cakravāla system in its plan view from above, locating the maṇḍala in geographic space.[41] Outside the walls of the maṇḍala palace, but inside the circular boundary of the edge of the diagram, several geometric shapes represent the continents of the world. Figure 2.5 shows one set, the three blue trapezoids at the very top and bottom of the image (and slightly left of center) that portray the continents in the southern quadrant. On each side of the maṇḍala, one large geometric shape, representing the main continent, is paired with two smaller iterations of the same shape, representing the subcontinents (fig. 2.6). The continents in the east, at the bottom of the maṇḍala, are

2.4. Maṇḍala with continents. Ca. 12th century. Vairocana hall, northeast wall, Alchi, Ladakh. Photograph by John C. Huntington, 1980, and courtesy of the Huntington Archive of Buddhist and Asian Art

semicircular and white. In the south (to the left), Jambudvīpa and its subsidiaries are wedge-shaped and blue. In the west, at the top of the diagram, the continents are circular and red. The one deviation occurs in the north, where, instead of the typical yellow squares, we see the same blue wedge-shape as in the south — presumably a reflection prompted by the overall symmetry of the maṇḍala. In the accompanying diagram, the colored circles inside the continents represent the colors of the deities found therein.

While the shapes and colors of the continents closely parallel other depictions, the visual priority of representing the complete and perfect maṇḍala palace results in the continents being moved from their correct cosmic locations. The maṇḍala doorways placed directly in the four cardinal directions occupy the proper places of the major continents, which are therefore depicted off center, as satellites of the doorways rather than as the preeminent features of the cardinal directions. Lacking space to show the two subsidiary continents on either side of the major continents, then, these smaller islands appear together on the opposite side of each gateway from the main continents, maintaining a generally symmetrical effect. The subordination of the continents to the palace visually suggests a hierarchical relationship between the palace and the rest of

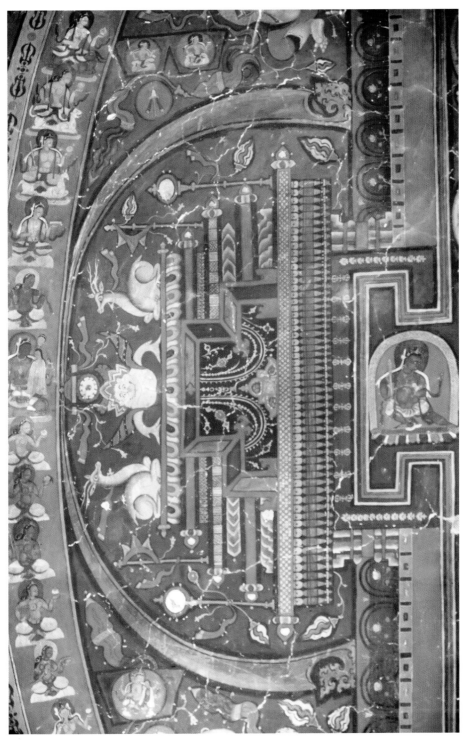

2.5. Detail of the painting in figure 2.4 showing the southern continents in the maṇḍala. Ca. 12th century. Vairocana hall (northeast wall), Alchi, Ladakh. Photograph by John C. Huntington, 1980, and courtesy of the Huntington Archive of Buddhist and Asian Art

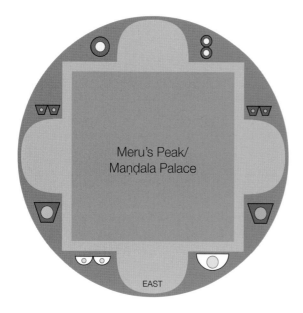

Meru's Peak/
Maṇḍala Palace

EAST

2.6. Continents at the perimeter of the maṇḍala on the northeast wall of the Vairocana hall at Alchi

the world. The buddha at the center of the maṇḍala occupies the chief position in all reality and displaces the rest of cosmic space. Because the maṇḍala is not isolated from the physical cosmos, however, but rather established at its peak, the painting also emphasizes a connection between the maṇḍala and the geographic world, perhaps even giving it a greater sense of accessibility than a maṇḍala that does not include these recognizable features.

The figures depicted in each of the primary continents also emphasize this connection between the lower levels of the geographic world and the maṇḍala palace. They are *devas* typically associated with Hinduism who have been adopted in the maṇḍala diagram in a location normally associated with humans, emphasizing both the supremacy of the buddha in the cosmic hierarchy and the traversable connections between the peak of Meru and the human realms (fig. 2.7). In the white, semicircular eastern continent, Indra rides his white elephant. Inside southern Jambudvīpa, Brahmā appears with multiple heads and two white geese. The identification of the western figure is uncertain because the image has clearly been repainted, but his pale color and the snake in his proper left hand are consistent with an identification as Śiva. Finally, in the north, the green-skinned deity is the regional form of Viṣṇu known as Vaikuṇṭha Caturmurtī, having secondary animal faces and riding his winged mount, Garuḍa.

While these *devas* commonly appear in Buddhist practice in the role of guardians of the directions[42] outside the maṇḍala proper, such traditional explanations do not entirely account for their appearance here. With the exception of Indra being in the east, the placement of the *devas* in the Alchi painting does not correspond to common arrangements of the directional guardians.[43] Likewise these *devas* do not clearly relate

2.7. Details of all the continents at the perimeter of the maṇḍala in figure 2.4. Ca. 12th century. Vairocana hall (northeast wall), Alchi, Ladakh. Photographs by John C. Huntington, 1980, and courtesy of the Huntington Archive of Buddhist and Asian Art

to the families of the five buddhas in the center of the maṇḍala through their color or iconography. The elephant and Garuḍa mounts of Indra and Viṣṇu in the east and north do correspond to the animals associated with the buddhas of those directions, Akṣobhya and Amoghasiddhi, as do the yellow and green colors of Brahmā and Viṣṇu with Ratnasambhava and Amoghasiddhi, but these correspondences seem accidental.

Whatever their ritual role, the placement of these *devas* in a middle ground between the exterior of the maṇḍala and the central palace — specifically in the continents normally associated with humans — makes a powerful cosmological statement. In the *abhidharma* literature, these same *devas* nominally dwell in the heaven of the Thirty-Three atop the peak of Meru, so the maṇḍala at Alchi displaces them from their home in order to establish the maṇḍala palace there. Retaining them at a lower level within the system simultaneously gestures at inclusivity and proves the dominance of the Buddhist maṇḍala system. Moreover, it models the fluid connection between the human world and the peak of Meru, once cast as the heaven of the Thirty-Three and now reinvented as a buddha-maṇḍala. The *devas* are shifted from the peak of Meru to the continents precisely by the reverse motion of the Buddha becoming enlightened and ascending from the human realms. The recasting of structural hierarchy in the Buddhist cosmos in such ways, specifically to laud the accomplishment of the Buddha while emphasizing a connection to the geographic world, is undoubtedly an important facet of these early tantric traditions.[44]

PRE-TANTRIC BUDDHAS ATOP MERU

Although it may seem that the mere placement of a buddha at the center of the universe (and concomitant displacement of the ordinary hierarchy) is the key cosmic logic of the tantric maṇḍala, it is not at all unique to the tantric tradition. The artistic record

shows that a conception of the Buddha atop
Meru existed well before tantric ideology
and continued to appear separately alongside
tantric cosmology in later traditions.[45] While
Mahāyāna, early tantric, and later tantric
texts seems to show a gradual elevation of
buddhas from human figures to cosmic ones,
earlier artistic sources show the Buddha liter-
ally seated atop Meru as his throne. This con-
trast between the artistic and textual records
suggests that the true innovation of tantrism
was not enthroning the buddha at the center
of the cosmos but rather creating a dynamic
relationship between the cosmic center and
the rest of the world.

Based on the texts alone, the develop-
ment of tantrism around the seventh century
would seem to represent a shift in rhetoric
about the cosmological status of the buddha,
emphasizing his centering atop Meru. This
version of cosmological history might be sim-
plified into a few overlapping stages, start-
ing with biographical narratives that dem-
onstrate the human Buddha's status in the
universe more symbolically, as with the gifts
from the Great Kings in *Extensive Play*. The
pre-tantric Mahāyāna period also promoted
an idea of the buddha as an explicitly cosmic
figure, one who purifies the entire world in
which he exists.[46] Texts like the *Flower Array
Sūtra*[47] portray such buddhas as dwelling in
multistory palaces from which they purify
the entire world—an image with undoubt-
edly royal connotations but not systemati-

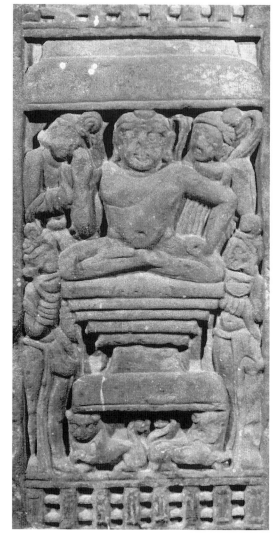

2.8. Relief sculpture depicting the buddha Śāk-
yamuni seated atop a Meru platform. 1st century
BCE. Mathurā, India. Photograph by John C.
Huntington, courtesy of the Huntington Archive
of Buddhist and Asian Art

cally cosmological.[48] The early tantric *Enlightenment of Great Vairocana*,[49] which just
predates the *Compendium of Principles*, expands on this world-defining role in order to
characterize the enlightenment of the buddha Vairocana as pervading all of reality.[50]
In contrast to this, the *Compendium of Principles* presents a very literal and geographi-
cally specific enthronement of Sarvārthasiddhi atop Meru. From a textual perspective,
at least, this explicit concretization of the buddha's cosmic status at the center and peak
of the universe seems to be an innovation.

The artistic record, however, reveals a very different history. Not only do pre-tantric images of the Buddha from Mathurā and Haḍḍa employ Meru as his throne, but this type of throne imagery continues to exist at Alchi and other sites alongside and distinct from the maṇḍala iconography. Perhaps the earliest image that has been identified as portraying the Buddha atop Meru comes from the first century BCE, a low-relief stone carving from the Indian site of Mathurā (fig. 2.8).[51] This sculpture portrays the Buddha seated atop a lion throne, the terraces of which closely resemble later depictions of Meru. Others sculptures at Mathurā also show a similar terraced platform being used for the Buddha's hair relic, which was housed in the heaven of the Thirty-Three,[52] as well as the wheel that represents his teachings.[53] The interpretation of this terraced platform as Meru eventually would become widespread, prevailing as far as Japan, where the term for such a terraced seat is literally translated as "Sumeru throne."[54] Because of the close resemblance of this imagery to an ordinary terraced platform (seat/altar), however, these examples may remain unconvincing to some.

Other images show the Buddha decisively atop a mountain identifiable as Meru, again predating tantrism and surviving well into the tantric period. One of the earliest examples of this form comes from the Gandhāran period of about the first to third centuries CE in Haḍḍa, Afghanistan (fig. 2.9). This now defaced image of the Buddha sits atop a wide pillar with a narrow base that is encircled by two intertwined *nāgas*, Nanda and Upananda, girdling Meru. These same two *nāgas* encircle Meru and the Buddha's seat in a variety of very different narratives (in both text and art), so it is difficult to say when and how their associations with the cosmic mountain and the seat of the Buddha first appear. The Mūlasarvāstivāda code of discipline for the monastic order[55] contains at least one passage describing their place in the cosmos.

> The king of mountains Meru has 80,000 *yojanas* [height]. Disappearing into the water, there are 80,000 [more]. Elevated out of the water, then, there are 160,000 *yojanas* [total]. Each of the sides of the mountain king Meru has 80,000 *yojanas*. Together, this makes 320,000 *yojanas* [circumference]. The four sides of the mountain king Meru are made from jewels, beautiful in form, pleasing to see, resplendent. There, starting from their birth, the *nāga* kings Nanda and Upananda both thrice encircle that [mountain] with their bodies, settling [there] and holding onto that place for an eon. The king of birds (Garuḍa) is not able to remove them.[56]

Ironically, their appearance in this story begins rather negatively, in that they harass a group of monks who have gone to Meru for their summer meditation retreat. The monks eventually receive help from Śākyamuni's disciple Maudgalyāyana, who transforms into an even greater *nāga* and convinces the troublemakers to patronize the Buddha. This scene is later repeated in the famous eleventh-century *Vine of Stories*[57] by Kṣemendra, through which it would become a frequent subject in art.[58]

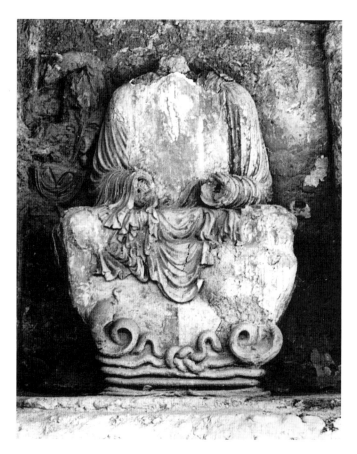

2.9. Buddha on a Meru throne encircled by *nāgas*. 1st–3rd century CE. Main stūpa court, Haḍḍa, Afghanistan. Photograph by John C. Huntington, courtesy of the Huntington Archive of Buddhist and Asian Art

Several other texts tell alternative stories of the two *nāgas* encircling either Meru or the Buddha's seat, so it is not entirely clear how imagery conflating the throne with Meru arose or why the *nāga* kings are associated with both. In a story from the Chinese *Sūtra of Cosmology*,[59] the *asuras* who dwell below Meru decide to war with the *devas* who live at its peak, with the *nāgas* eventually joining the fray. Nanda and Upananda coil their bodies around Meru and shake it, causing panic, as it is the foundation of the heaven of the *devas*.[60] In the *Divine Stories*[61] account of the miracles at Śrāvastī, the two *nāga* kings honor the Buddha by miraculously creating an enormous bejeweled lotus where he may sit. Then, seated on the lotus, the Buddha emanates an infinite assembly of similar buddhas on lotuses up to Akaniṣṭha heaven (again repeating the theme of pervasion upward to the apex of the universe).[62] Although it is difficult to say precisely how imagery of Meru and the Buddha's seat came to overlap, they bear strong connections not only through the cosmic status of the Buddha himself but through stories like those of the *nāga* kings.

While making an early appearance in the art at Haḍḍa, imagery of the buddha atop Meru encircled by two *nāgas* spread widely and continues to exist alongside tantric

2.10. Śākyamuni seated atop a Meru platform with encircling *nāgas*, painted on the lower garment of the large Maitreya sculpture. 12th–13th centuries. Sumtsek, Alchi, Ladakh. Photograph by John C. Huntington, 1980, and courtesy of the Huntington Archive of Buddhist and Asian Art

cosmologies.[63] In the Sumtsek[64] at Alchi (a building separate from the Vairocana hall), a two-story-tall sculpture of the bodhisattva Maitreya wears a lower garment painted with scenes from the life of the Buddha. Among these, several images portray the Buddha seated atop a terraced blue Meru throne. Figure 2.10, for example, shows the Buddha perched on a stepped rock formation, abstractly similar to the designs from Mathurā and Haḍḍa, that is girdled by two *nāgas*. The fact that the Buddha rests on a Meru platform in these examples does not have anything to do with the cosmological hypostization of Vairocana in the *Compendium of Principles*; rather, it is simply an aspect of his biographical narrative.

In short, the association of the buddha's location atop Meru with the cosmological turn in tantrism fails to capture the cosmic logic behind maṇḍala ideology and practice. The true innovation of tantrism is not in identifying the buddha with the cosmic center but rather in recasting the activity of enlightenment as a cosmic process of translocation and transformation. In this sense, the tantric maṇḍala does not break with tradition in envisioning the buddha in a cosmic role but rather more deeply theorizes the cosmological mechanisms behind this role as a model for specific ritual and meditative practices.

Translocation and Transformation, Meru as Mesocosm

The translocative-transformative innovation of tantra depends on the relation between cosmological geography and the tantric maṇḍala. When the *Compendium of Principles* establishes the place of the buddha at the cosmic center atop Meru, it does so in two opposing directions. The first involves Sarvārthasiddhi's narrative ascent and enthronement atop Sumeru as part of his transformation into an enlightened being. In the second, the fully enlightened buddha Vairocana rhetorically descends from the highest heaven Akaniṣṭha, where he dwells a priori, to validate the teachings of the *Compendium of Principles*. Together, these two movements establish a mesocosm between the highest teaching in Akaniṣṭha and the lowly practitioner in Jambudvīpa, a meeting at the focal point of the cosmos, the peak of Meru.[65]

Rather than simply establishing the buddha at the center of the cosmos, tantric ideology thus connects Jambudvīpa, Meru, and Akaniṣṭha in a dynamically interrelated tripartite system. The central mountain becomes a geographic middle ground between the realms of the fully human and the fully enlightened, a focal point for both translocations and transformations. The traditional analysis of the maṇḍala in terms of the buddha's three bodies also has a middle figure, but this mediating figure explicitly dwells in Akaniṣṭha, obscuring the geographic significance of Meru. The geographically conceived account of mediation provides an effective model for analyzing other maṇḍalic forms in which geography is key, such as the Nepalese *caitya* or other examples of sacred space and Buddhist geography. An important concept in this account is how the opposing motions of ascent and descent in tantric ideology make the peak of Sumeru into a focal point of the universe.

THE RHETORIC OF DESCENT AND A GEOGRAPHIC MODEL OF MEDIATION

The preamble to the *Compendium of Principles*, which precedes the narrative of Sarvārthasiddhi, completes its model of tantric translocation. This opening frame establishes the buddha Vairocana in the highest heaven Akaniṣṭha as the teacher of the *Compendium of Principles* itself, validating its teachings from a place far more elevated than even the peak of Meru. Implicitly identifying this Vairocana with the Vairocana atop Meru into whom Sarvārthasiddhi in Jambudvīpa transforms, the preamble further guarantees that the enlightenment achieved through the practices described in the *Compendium of Principles* far exceeds any status in our worldly geography.

The very first words of the *Compendium of Principles* establish the rhetorical frame of the descent of Vairocana from Akaniṣṭha. The text opens with a standard formula, "Thus I have heard at one time . . . ,"[66] which was originally intended to mark the subsequent text as recited by Śākyamuni's disciple Ānanda at the great council of disciples who standardized his teachings for posterity. In this case, however, rather than Ānanda reporting that he heard the historical Buddha give a teaching at some

site in Jambudvīpa, the *Compendium of Principles* tells us that the teacher is the lord Vairocana, dwelling in the palace of the divine king of Akaniṣṭha.[67] In other words, the teacher of the *Compendium of Principles* is the personification of the Buddha's enlightenment (Vairocana) at the peak heaven of the universe, a location specifically associated with the highest level of meditative attainment.[68] To reinforce this paramount identity, the *Compendium of Principles* goes on to list the nearly innumerable perfected qualities of Vairocana, including his encapsulation of the perfections of all other buddhas within himself.

After this preamble, there is an abrupt transition to the narrative of Sarvārthasiddhi, starting at the seat of his enlightenment, being consecrated as Vajradhātu, and appearing at the peak of Meru. Strictly at the level of this narrative, it seems as though the operative translocation is simply Sarvārthasiddhi's relocation from Jambudvīpa to Meru. Indeed, his cosmic enthronement as Vairocana there is a powerful image of ascent in status and location. This relocation is complicated, however, by the fact that the narrative is framed by the preamble in which Vairocana is already residing in Akaniṣṭha heaven and providing the basis of the teachings of the *Compendium of Principles*. For the reader, Vairocana's placement in Akaniṣṭha is the epistemically prior and more unmediated description, a lens through which Sarvārthasiddhi's actions are transmitted. The use of physical geography in the Sarvārthasiddhi narrative, then, makes sense of his enlightenment as an ascent from the human perspective. By first establishing Vairocana in Akaniṣṭha and then atop Meru (via Sarvārthasiddhi), however, the enlightenment offered through the *Compendium of Principles* seems to transcend even Meru. This may seem convoluted, but similar rhetorical strategies exist in other Buddhist texts, even non-tantric ones.

Examining a corresponding frame from a source well outside the tantric genre may reveal some of the power of such a rhetorical strategy. There is a parallelism between the descent of Vairocana in the *Compendium of Principles* and the rhetoric of Dharmākara's vows in the longer *Array of the Blissful Sūtra*,[69] a key text of Pure Land Buddhism. Both narrate the enlightenment of personages who are important not so much for their particular paths as for their status as already enlightened teachers. In the *Array of the Blissful Sūtra*, the bodhisattva Dharmākara, intending to become a buddha who encompasses all the wonderful qualities of every great buddha, vows not to become a buddha unless he can guarantee that his realm of teaching would express specific fantastic characteristics. While it would seem like a contradiction for a bodhisattva to vow "not" to become a buddha (since bodhisattvas are defined precisely by their vows to become buddhas), the text's audience would have understood Dharmākara to have already become the fully enlightened buddha Amitābha whom they worship, and so "there could be no question in their minds that the vows had been fulfilled."[70] At the narrative level, the tension in the *Array of the Blissful Sūtra* seems to surround the bodhisattva Dharmākara becoming the buddha Amitābha, parallel to the bodhisattva Sarvārthasiddhi becoming Vairocana. The power of the story,

however, comes from the frame in which the buddha Amitābha or Vairocana is understood to already exist. The narrative is thus not actually about the journey of a particular bodhisattva to buddhahood but about the efficacy of the methods that are offered in the text by that very figure as an already existent buddha. It is in this sense that the *Compendium of Principles* can be seen to represent a kind of rhetorical descent from Akaniṣṭha to the physical world of Jambudvīpa and then to Meru's peak — a bringing of Akaniṣṭha-level enlightenment to our worldly geography through the words of the teacher who frames his own story.

The idea that a buddha could reside in a higher realm, like Vairocana in Akaniṣṭha, but become accessible in the physical world, such as at the peak of Meru, already existed at the time of the *Compendium of Principles* and quickly became a key way of interpreting the complex processes of this early tantric text. Even in pre-tantric, Mahāyāna Buddhism, scholastics argued that the identity of the Buddha was separate from his physical, historical personhood. The fourth-century[71] Yogācāra philosopher Asaṅga articulated an influential theory in which there are three bodies of the buddha,[72] each corresponding to a different degree of access to enlightened truth. The highest level, Truth-body,[73] is the buddha as embodied in his teachings and understood as his perfected qualities or the true nature of reality.[74] Such a body has no physical form unto itself. The middle level, Enjoyment-body,[75] exemplifies a vision of reality purified through meditation or other activities. This body is not quite physical but appears as a perfected human to the advanced practitioner under the right circumstances. The most accessible of the three, the Emanation-body,[76] is a buddha physically manifested into history as a living being. A walking, talking person, this body is available to all, no matter the individual's level of realization. It is merely temporary, however, and therefore does not possess any ultimate reality. In fact, both the Enjoyment-body and the Emanation-body, being apparitional and contingent, depend on the Truth-body as their ultimate, underlying support.

Although not developed with tantric ideology in mind, this system of multiple, simultaneous embodiments of the buddha provides a powerful tool for explaining the various transformations of identity in the tantras. In regard to the *Compendium of Principles*, it provides a way of explaining the simultaneous descent of Vairocana from Akaniṣṭha and ascent of Sarvārthasiddhi/Vairocana from Jambudvīpa. Although his work dates from a much later period in the fifteenth century, the Tibetan commentator Khedrup[77] provides one clear and concise analysis: "Vairocana, dwelling in the Akaniṣṭha Heaven, does not proceed elsewhere because he is the [Enjoyment-body] possessing the five certainties.[78] But with the magical apparition . . . of a Vairocana [Emanation-body] having four heads, he proceeded to the summit of Mt. Sumeru and took his place in the eaved palace. . . . Thereupon, he set in motion the Wheel of the Law of the Yoga Tantra. . . . Among them, the fundamental one of all the Yoga Tantras is the [*Compendium of Principles*]."[79] As an Enjoyment-body, Vairocana resides permanently in Akaniṣṭha and presents a purified vision of reality, possessing all the marks

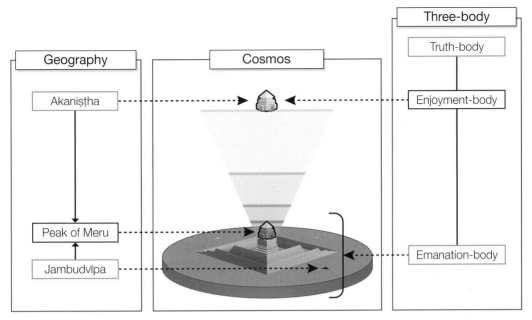

2.11. Comparison of the geographic mesocosm and the three-body system

of a buddha and the perfect place and audience for the teachings. As an Emanation-body, Vairocana takes birth as the physical/historical Sarvārthasiddhi in Jambudvīpa, pursues the life of a bodhisattva, and is later enthroned as Vairocana atop Sumeru at the moment of his enlightenment. By relying on these two different bodies of the buddha for two different layers of interpretation, the narrative can simultaneously express both descent and ascent to the summit of Sumeru.[80]

Where the three-body system falters, however, is in recognizing the geographic significance of the peak of Meru in relation to the rest of the cosmos, since all levels of the world below Akaniṣṭha are the purview of the Emanation-body. While the Enjoyment-body assuredly resides in Akaniṣṭha, the Emanation-body appears in various parts of the physical world, including both Jambudvīpa and Meru (fig. 2.11). For the three-body theory, which emphasizes personhood, both of these locations are merely sites where Emanation-bodies manifest. Conceived geographically, however, there is a vast difference between Jambudvīpa, as the nominal location of humans, and the peak of Meru, the mostly lofty physical place in the cosmos. The summit of Meru possesses singular importance as the prime location to act as a mesocosm between Akaniṣṭha and the human realm in Jambudvīpa. Vairocana's appearance precisely at the summit of Meru establishes the complementary ascending and descending translocations of the maṇḍala cosmology. Sarvārthasiddhi must ascend to Meru and be enthroned as Vairocana if he is to express the elevated status and cosmic hypostization of the buddha, while Akaniṣṭha-Vairocana must descend to that same place in order to assure us of the authenticity and profundity of his teachings.

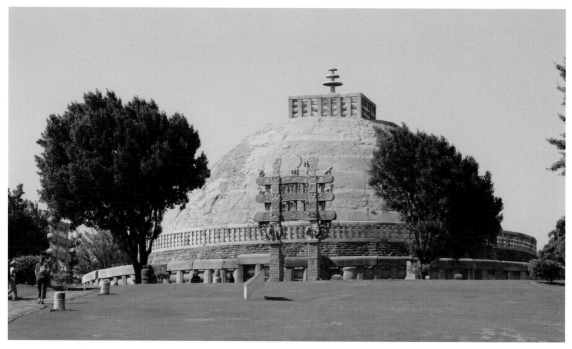

2.12. Sāñcī stūpa 1. 3rd century BCE–1st century CE. Sāñcī, India

The three-body theory is often taken to assume that the middle, Enjoyment-body functions as the mesocosm between ordinary existence and enlightenment,[81] but a geographic analysis provides a different model. The summit of Meru, as mesocosm, is explicitly a part of the Emanation-body narrative, and it is also rhetorically a place where Emanation-body and Enjoyment-body intersect.[82] The geographic mesocosm of the peak of Meru does not precisely overlap with the personal mesocosm of the Enjoyment-body in Akaniṣṭha, however, and therefore provides an alternative model for analyzing mediation that can be applied more broadly to other subjects that invoke geography (rather than personhood), such as the Newar *caitya* or Padmasambhava's Copper Mountain paradise.

LAYERED PLACES: A NEWAR *CAITYA*

Stūpas and *caityas* are some of the most important artistic and architectural objects in the Buddhist world.[83] Based on early reliquary mounds in India, especially reliquaries of the historical buddha Śākyamuni, they take on central symbolism in nearly every Buddhist tradition. While the designs of stūpas and *caityas* can differ greatly, they might be said most essentially to consist of a dome shape (or sometimes a cube) built around an axial pillar that is often topped by a finial (fig. 2.12). Typically, regional

traditions require numerous other features, including a base or plinth on which the dome rests, symbolic ornaments on the finial, and so on. These elements are usually arranged along axes that reflect the four cardinal directions, suggesting at least the possibility that stūpas could bear comparison with maṇḍalas and the Buddhist cosmos. Indeed, the stūpa has sometimes been interpreted as representing cosmology in regions ranging from Java and Sri Lanka[84] to Nepal and Tibet, and it seems that this idea arose early in the history of Buddhism.[85]

The questions of whether and how a stūpa may actually be considered a cosmogram, however, do not have simple answers. For some historical contexts, there are significant debates over whether stūpas would have been understood as cosmograms at all.[86] The wide variety of designs for stūpas created at different places and times also makes more-generalized analysis difficult. Furthermore, the potential symbolism of each part of a stūpa is often disputed or multivalent, given that stūpas are usually constructed using abstract geometric or architectural shapes rather than strictly representational features. Attempts to make direct correlations between the Buddhist cosmos and the design of the stūpa rely on parallels in structure rather than recognizable imagery. For example, "the four continents . . . are the [four-sided] foundation, [the] golden mountains and the mount Sumeru are the steps [on which the dome rests]," and so on.[87] Such identifications are acts of interpretation, not absolutes. In Nepal, the most unambiguously cosmological features represented are the four Great Kings in the cardinal directions around the central dome (fig. 2.13) and elements like the sun and moon, which can appear at the upper levels.

Importantly, however, these constructions in Nepal are explicitly distinguished from other stūpas in that they are Vajrayāna *caityas*, which means that they are consecrated through the installation of a maṇḍala rather than through the encapsulation of relics of deceased teachers. This maṇḍala, usually a derivative of Vajradhātu, gives the *caitya* specific form and relationship to the cosmic geography. As the various levels of the *caitya* are installed, from the foundation to the dome, the maṇḍala is re-created again and again in order to empower the object.[88] The Vajradhātu (or derivative thereof) is installed within the *caitya* during the laying of the guide threads[89] for building the foundation, as well as when the foundation itself is established.[90] Just before the dome is placed on top of the base, precious substances are deposited[91] into a grid of small receptacles inside (fig. 2.14). These objects also form an explicit Vajradhātu maṇḍala within the *caitya* (fig. 2.15). In many cases, the imagery on the outside of the completed *caitya* reiterates this identification with the Vajradhātu. It is common for the four exterior buddhas (Akṣobhya, Ratnasambhava, Amitābha, and Amoghasiddhi) to be depicted in the four cardinal directions around the central dome, which itself represents Vairocana (see the overview in fig. 2.13). There are many different types of *caityas* in Nepal, with some filling out the imagery of the maṇḍala with other recognizable elements, such as a supporting lotus surrounded by rings of *vajras* and flames, which are seen in two-dimensional representations of maṇḍalas.[92] In a basic sense,

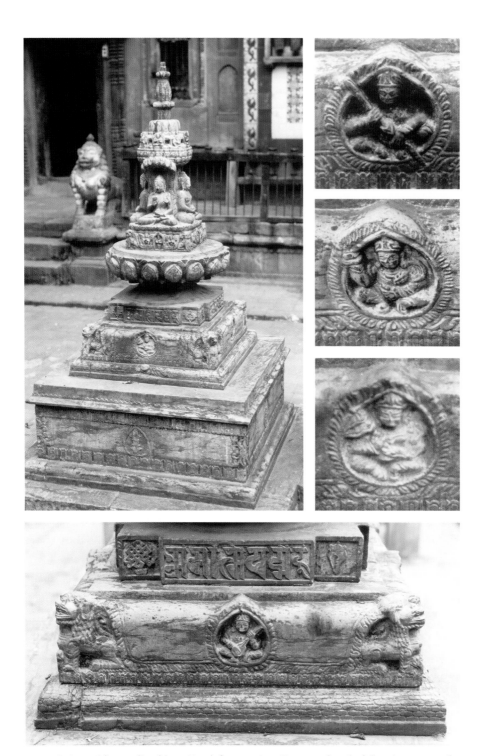

2.13. *Caitya* with guardian kings. Top left: overview. Bottom: detail of the placement of the eastern guardian king, Dhṛtarāṣṭra. Right: three details of the other guardian kings. Hakha bāhā, Patan, Nepal. Photographs by John C. Huntington, courtesy of the Huntington Archive of Buddhist and Asian Art

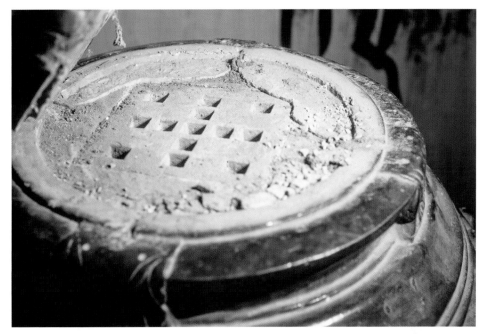

2.14. Receptacles for the deposit of precious substances inside a *caitya* during its consecration. Third level, interior, Mahābuddha Temple, Patan, Nepal. Photograph by John C. Huntington, courtesy of the Huntington Archive of Buddhist and Asian Art

then, the Vajrayāna *caitya* in Nepal typically embodies the Vajradhātu maṇḍala and implicitly invokes the cosmology of the maṇḍala that we have already seen.

The situation is complicated, however, by the fact that many *caityas* in Kathmandu are understood as simulacra of one particular local *caitya*, the great Svayambhū *caitya* that provides authority and empowerment to the smaller versions (fig. 2.16).[93] While the site now known as the Svayambhū *caitya* was probably founded in the early fifth century,[94] an approximately fourteenth-century[95] text known as the *Svayambhū Purāṇā* redefined the nature of Svayambhū as it consolidated and established traditions for Newar Buddhism in Nepal after the Buddhism of India had died out.[96] Its historical narrative casts Svayambhū as the *ādi-buddha*,[97] the primordial essence of Buddhist truth from which all Buddhist teachers and teachings originate. Even the historical buddha Śākyamuni, ostensibly the originator of Buddhism in our era, becomes merely one of many pilgrims to Svayambhū.[98] These features of the *Svayambhū Purāṇā* allowed Newar tradition to find authority for Buddhism in its own geography rather than in the inaccessible India of the past.[99] Not only does this recenter Buddhism at Svayambhū in the Kathmandu valley, but the Svayambhū *caitya* becomes the model on which other *caityas* in the valley are based, empowering each local temple that possesses such a *caitya* with a simulacrum of the "ontological center"[100] that is Svayambhū.[101]

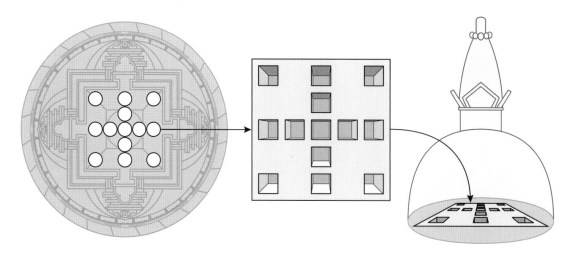

2.15. Relationship between the arrangement of deities in the Vajradhātu maṇḍala and the consecration receptacles inside a *caitya*. Left to right: simplified Vajradhātu maṇḍala with places of major deities highlighted, matching arrangement of receptacles inside the *caitya*, location of receptacle maṇḍala inside *caitya*

Significantly for maṇḍala cosmology, the nature of Svayambhū as the *ādi-buddha* is represented in terms of its relation to the five central buddhas of the Vajradhātu maṇḍala. The key points of the origins of Svayambhū in the *Svayambhū Purāṇa* are summarized as follows:

> In pre-historic times Nepal was a lake . . . attracting many great saints. Upon the blossom of a beautiful lotus flower (which according to later tradition had sprouted from a seed that the past Buddha Vipaśvin had cast into the lake when he came there on pilgrimage), a *dharmadhātu*, that is a *caitya*, consisting of crystal (*sphaṭikamaya*) and having the form of light (*jyotīrūpa*), arose of its own accord (*svayam abhūt samutpannaḥ*). It is qualified as the home of the Jinas (*jinālaya*), as the ontological basis of the five Tathāgatas (*pañcatathāgatāśraya*). . . . Fittingly, the light emanating from Svayambhū came to be seen as consisting of five rays, white, blue, yellow, red and green in color, in accordance with the colors of the *pañcabuddhas*.[102]

These five buddhas (*pañcatathāgata*, *pañcabuddha*) are of course none other than the five central buddhas of the Vajradhātu maṇḍala. The fact that other Vajrayāna *caityas* in Nepal invoke and depict these same five buddhas is a reference not merely to the Vajradhātu maṇḍala atop Meru but specifically to the Svayambhū *jyotī-rūpa*, the luminous, self-arisen form that originates Buddhism in Nepal. In other words, while

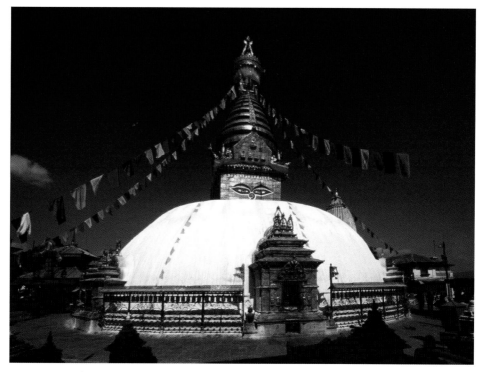

2.16. Svayambhū *caitya*. Kathmandu, Nepal. Photograph by John C. Huntington, courtesy of the Huntington Archive of Buddhist and Asian Art

the *Compendium of Principles* places the five buddhas of the Vajradhātu maṇḍala atop Meru, the *Svayambhū Purāṇa* localizes them to the Kathmandu valley.

Not only does the *Svayambhū Purāṇa* tell the story of the origin of Buddhism in the Kathmandu valley, but it explicitly links these events with the geological origins of the valley itself.[103] According to the text, what is now the valley had long ago been a lake surrounded by four mountain peaks located in the four cardinal directions. After the former buddha Vipaśvin plants a lotus seed there, the lotus grows to support the emanation of the self-arisen light-form (*svayambhū jyotī-rūpa*) described above, into which the subsequent buddha Śikkhin dissolves himself. Eventually, Mañjuśrī visits the lake and cleaves the ring of mountains with his sword, draining the lake and creating a valley so that humans can make pilgrimages to this site. He then creates an earthen mound to cover the lotus, in other words, the hill atop which the Svayambhū *caitya* rests. Later, the human Pracaṇḍadeva encases the light-form in a massive *caitya* to protect it from later humans in degenerate times. The human population swells in the new valley, and its members worship the *caitya* as part of their origin. Thus, not only is Svayambhū decidedly centered in the Kathmandu valley, but the origins of the *caitya* are intimately intertwined with the creation of the valley itself, unifying the maṇḍala of the five buddhas and the geography of the valley on multiple levels.

The Nepalese *caitya* therefore has a dual geographic nature — one aspect capturing the entire Cakravāla cosmology of the Vajradhātu maṇḍala and another expressing the local geography of Svayambhū in the Kathmandu valley. Far from being confounding, this dualism can be spelled out in the iconography of specific artistic objects, such as a sculpted-stone *caitya* housed at Bū bāhā[104] in Patan. This *caitya* was created in 1971,[105] making it quite recent compared to others in the valley. Just as in the case of the Alchi maṇḍala, the iconography is unusual, but it opens a fascinating window onto the religious uses of cosmological geography. Indeed, this particular *caitya* makes for a excellent comparison with the Alchi maṇḍala examined above, precisely because it relates the central maṇḍala to peripheral geographic sites in a similar arrangement, substituting local sites in Nepal for the cosmic continents depicted at Alchi.

Generally speaking, the *caitya* at Bū bāhā takes the form of a large pillar, topped by a dome and resting on a square base (fig. 2.17). Just atop the base, a *nāga* encircles a square mountain range, inside of which rests a lotus. On this lotus stand four figures arrayed around the central pillar and facing the cardinal directions. Above them, a larger lotus holds a stūpa dome similar to the Svayambhū *caitya* with four buddhas on its quadrants.

Iconographic elements related to the local geography of Kathmandu and the origin story of the *Svayambhū Purāṇa* are immediately apparent in the sculpture (fig. 2.18). Above the large, square base platform, a square perimeter of mountains surrounds a lake from which a lotus springs, recalling the origin of the Kathmandu valley in the *Svayambhū Purāṇa*. Topping the ring of mountains are small emblems in the cardinal and intermediate directions that have been identified as markers of the four peaks and four holy sites of the Kathmandu valley (fig. 2.19).[106] A waterspout in the shape of a *makara* (a mythical animal) on the northern face of the base, at the level of the mountains, may represent the draining of the lake through the gorge cut by Mañjuśrī. While the site commonly associated with Mañjurśrī's draining of the lake, Chobar gorge, is actually in the southern section of the valley, the location of the *makara* spout on the north side of the *caitya* may relate to the strong association between the northern buddha, Amoghasiddhi, and *nāgas*, the serpent deities who control water.[107]

Proceeding upward from the lotus in this lake we see elements from the traditional cosmology that are more familiar but never fully divorced from the local geography and the story of the *Svayambhū Purāṇa*. A vertical shaft is surrounded by four bodhisattvas facing the cardinal directions: (clockwise from the east) Maitreya, Vajrapāṇi, Avalokiteśvara, and Mañjuśrī. Such pillar shafts typically represent the body of Sumeru in Nepal,[108] and these bodhisattvas are placed appropriately so as to symbolize their worldly activity below the idealized maṇḍala that tops the peak. At the apex of this shaft, a larger, double-lotus makes a platform for the dome of the Vajradhātu maṇḍala, essentially a small model of the Svayambhū *caitya* with the four directional buddhas placed on its outer face.

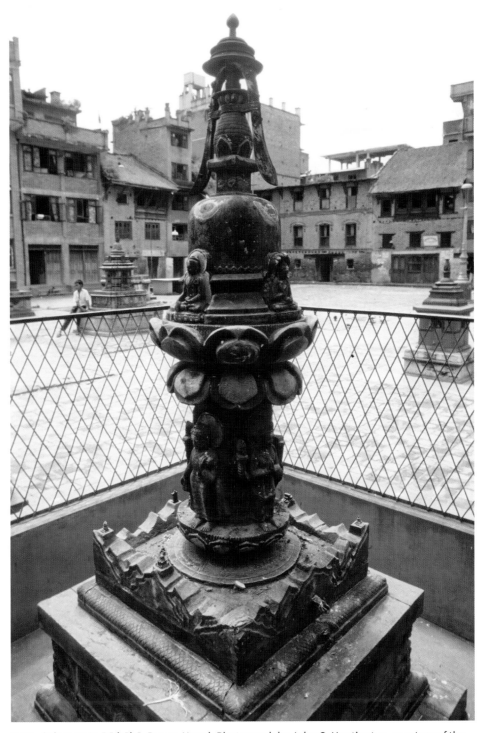

2.17. *Caitya.* 1971. Bū bāhā, Patan, Nepal. Photograph by John C. Huntington, courtesy of the Huntington Archive of Buddhist and Asian Art

What are we to make of the fact that this *caitya* apparently invokes two distinct geographic models simultaneously, one in which the Svayambhū *jyotī-rūpa* emanates atop a lotus in the lake that became the Kathmandu valley and another in which the Vajradhātu maṇḍala appears on a lotus atop the peak of Meru in the center of the cosmos? Such dualistic imagery precisely collapses the distinction between these two spaces. Where the *Svayambhū Purāṇa* re-locates the ontological center of Buddhism from the person of Śākyamuni to the site of the Kathmandu valley,[109] objects like the Bū bāhā *caitya* conflate the geography of the Kathamandu valley with the center of the Buddhist universe. The maṇḍala atop Mount Sumeru visibly grows out of the lotus at the center of the valley, surrounded by identifiable markers of the holy sites on the local mountains. Or these mark-ers of the Kathmandu valley replace the identifiable geography of the Cakravāla cosmos, such as the con-tinents that appear in the maṇḍala at Alchi. Com-paring the illustration of the Alchi continents with a plan diagram of the Bū bāhā *caitya* (see figs. 2.6 and 2.19) shows that the geographic imagery of the valley effectively replaces the Cakravāla continents as the exterior perimeter of the maṇḍala, redefining the Buddhist cosmos as the Kathmandu valley. This

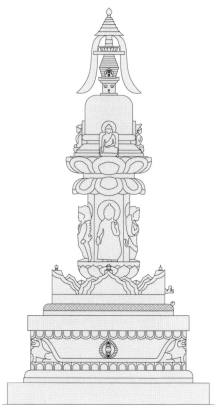

2.18. Elevation of the *caitya* at Bū bāhā. Adapted from Niels Gutschow, *The Nepa-lese Caitya*, fig. 561, 300

cosmological interpretation of the valley is further supported by the presence of the *nāga* wrapped around the exterior of the mountain perimeter, a figure that can be interpreted to represent the waters of the cosmic ocean.[110]

Where personal theories of transformative mediation (such as the three-body theory) would fall short in accounting for the complex iconography here, the idea of Meru as a geographic mesocosm provides a straightforward way of thinking about the assimilation of the geography of Kathmandu into the Cakravāla cosmic model. Because the Svayambhū *caitya* is identified with the five-buddha maṇḍala, Svayambhū stands in the same spatial relationship to the Nepal valley that Meru does to the entire cosmos. Kathmandu and the Cakravāla are therefore interchangeable in the iconogra-phy of the Bū bāhā *caitya*—Kathmandu becomes the Buddhist universe.[111] Although the maṇḍala is paradigmatically treated as a mode of personal transformation, such geographic theorization allows us to see how the maṇḍala relates the cosmos to local geography and architecture.

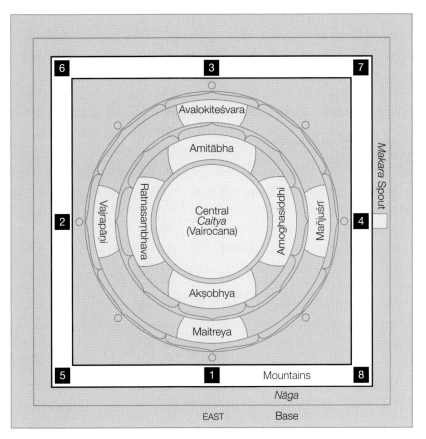

2.19. Iconographic plan of the Bū bāhā *caitya*

Transformations and Translocations of the Cosmos Itself

While the example of the Newar *caitya* at Bū bāhā may seem like a radical co-opting of the cosmos into local geography, this kind of transformation of local space into a maṇḍala forms the heart of tantric practice. As a cosmologically conceived process, maṇḍala meditation seeks to dissolve the ordinary appearances of the mundane world and create a pure vision of the cosmos as experienced at the apex of Sumeru, essentially re-creating in the here and now the enlightenment process of Sarvārthasiddhi ascending Meru in the *Compendium of Principles*. The dissolution and re-creation of a purified cosmos become an explicit part of the maṇḍala liturgy, which tends to emphasize the elemental substrata of the cosmos and central Meru as tokens of the transformation of the cosmos and the stable centrality of meditation, respectively. In this sense, all maṇḍala practice simultaneously transforms and translocates the cosmos to be centered on the immediate practitioner.

This transportability of the cosmic center is precisely the power of the maṇḍala ritual. The tantric maṇḍala can be re-created anywhere and anytime, generating an experience of the mesocosm and the purified vision of reality that constitutes enlightenment. If practitioners had to climb an actual Mount Meru to achieve their goals, Buddhism would flounder—although Buddhism is certainly not without its mountain cults. Indeed, the notion of Meru as a sacred mountain relies on a much more basic idea of mountains as sacred spaces in the Himalayas, the axial mountain being only the fully realized cosmological theorization of a widespread attitude. Meru, as the paradigm, then becomes a model that can be applied to other mountain systems. In the case of Padmasambhava's Lotus Light Palace, another deity assembly, it is not even Meru that is envisioned as the purified site but a mountaintop residence on the peripheral island of Cāmara. Ultimately, it is the very portability of the concept of the maṇḍala-peaked mountain that makes its use so pervasive and powerful.

ELEMENTAL GENERATION OF THE COSMOS AS PURIFIED VISION

The goal of maṇḍala meditation is, in one important sense, to generate the experience of the maṇḍala atop Meru as perceived by the enlightened being at its center.[112] Later liturgies accomplish this creation ex nihilo, beginning with the dissolution of the ordinary universe before generating a perfected cosmic substructure and finally the deity palace. Proceeding from the foundational, elemental layers of the cosmos upward, this process represents another kind of ascent that establishes a purified vision of the cosmos without dwelling on its geography as such. The details of this process of cosmic creation highlight the stability and centrality of the maṇḍala atop Meru, as well as the elemental transformation of the cosmos itself.

A thirteenth-century Tibetan edition of the *Purification of All Bad Transmigrations* instructs the practitioner in the production of the maṇḍala:

> OṂ THE SYLLABLE A, THE SOURCE OF ALL THE *DHARMAS* ON ACCOUNT OF THEIR NON-ORIGINATION FROM THE BEGINNING. From the application of its meaning and intent on the sixteenfold voidness of the whole universe in the ten directions, he should see himself as void in his own selfhood.
>
> Then by means of the *vajra* produced from the syllable HUṂ (there arises) the Air-*Maṇḍala*; on top of it the Fire-*Maṇḍala* from the syllable RĀṂ; on top of it the Great Waters from the syllable VAṂ; on top of them the Gold-*Maṇḍala* from the syllable KAṂ; in its center he says: HUṂ SUṂ HUṂ. By saying it he produces Mouth *Sumeru* made of jewels, square and adorned with all kinds of gems. He should empower it by means of the *vajra*-bond gesture and by saying: OṂ VAJRA BE FIRM and so forth. On top of (*Sumeru*) by means of the *karma-mudrā* of the *vajra*-causation (there arises) a palace

produced from the white syllable BHŪM. It has a top storey made of *vajras*, gems, and jewels. It is square, having four gates adorned with four tympanums. On four corners, on the doors, and on the pinnacles it has the emblems of the *vajras*, the sun and the moon. It is adorned with strings of pearls and necklaces, with banners and garlands, and with four threads attached.[113]

In short, meditators realize both themselves and the universe as empty of inherent existence, construct a new universe from the four basic elements (wind, fire, water, and [golden] earth), establish and empower jeweled Sumeru at its center, and decorate and populate a palace at its summit.

In many tantric systems, this elemental structure is said to correspond directly to the anatomy of the meditator,[114] but the leap to such an interpretation is often taken too quickly, ignoring the significance of the literal geography. By focusing on analogs in the human body or mental states, one loses sight of the ways in which cosmological thinking shapes the description of this process, reformulating the details of the cosmos for the specific task at hand. The cosmic model in this meditative generation mentions only the elemental substrata of the world and central Meru, emphasizing processes of elemental transformation and the stable center on which the remaining visualization rests (fig. 2.20). Indeed, the elemental substrata are expanded to include fire, contradicting Vasubandhu's *Treasury of Abhidharma*, precisely to round out the elemental completeness of the meditative transformation. The peripheral components of the cosmos, such as the continents and subcontinents, are deemphasized in order to focus on the pure vision atop Meru. One may compare the account from the *Purification of All Bad Transmigrations* with the *Garland of Perfected Yogas* of a century earlier, which calls for the visualization of "Sumeru furnished with the continents, subcontinents, seven oceans, and so forth."[115]

That being said, an important point must be made regarding the difference between these textual sources and received tradition. These passages do not indicate that practitioners would not have visualized the entire cosmos during their meditation, or even that followers of these two texts would have visualized the cosmos differently. Eidetic visualization is at the heart of such meditative practices, and minutely detailed imagery of the cosmos would have made the practice more effective in establishing the verisimilitude of this vision. Disciples also receive oral instructions from their teachers that complement and expand on the sparse information found in the texts. At the same time, these textual sources do communicate different outlines of what might be considered the salient features of the meditative practice. The cosmology reproduced in the *Purification of All Bad Transmigrations* seems to focus on separating this vision from ordinary experience, while the *Garland of Perfected Yogas* seems to promote eidetic vision of the entire world in all its detail.

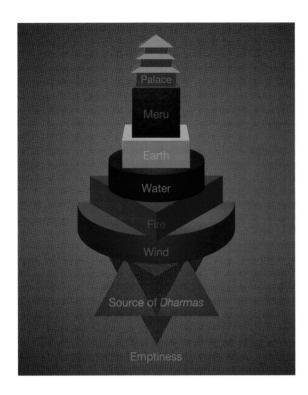

2.20. Elemental generation of Meru and the maṇḍala palace

The transformative language of elemental generation is also applied to architectural space, not just the person of the meditator. A concurrent thirteenth-century Sanskrit manuscript[116] of a text known as the *Compendium of Rituals*[117] prescribes a very similar cosmology for the construction of monastic architecture as a site of worship, summarized as follows:

> Next, on the ground, [the teacher] envisages the four elements (wind, fire, water, earth) and Mt Sumeru, respectively generated from the syllables *Yaṃ Raṃ Vaṃ Laṃ Suṃ*. Mt Sumeru is surmounted by the syllable *Hūṃ* from which there arises a crossed *vajra*. Then from the variegated rays dispersed from the crossed *vajra*, there arise in succession the *vajra*-earth . . . surmounted by a *vajra*-enclosure . . . , a *vajra*-tent . . . , and a canopy. . . . Then, on a balcony made of crossed *vajras* . . . , he envisages a wheel . . . which becomes transformed into Vairocana, and then in turn, Vairocana becomes transformed into the monastic space.[118]

The same basic components of maṇḍala generation, focusing on the elemental substrata and central Sumeru, apply to a specific local site of architecture in the construction of a monastic space. The transformative-translocative function of maṇḍala

cosmology, rather than being an abstract ideal, provides an explicit way of re-creating a perfected cosmos in the here and now, either in the pure vision of a meditator or in the ritual purification of a particular locale. The power of Meru as the universal meso-cosm comes precisely from the fact that it can be re-created locally by an individual.

ALTERNATIVE MOUNTAINTOP PALACES

The Glorious Copper Mountain of Padmasambhava, one of the founding figures of Tibetan Buddhism, exemplifies many of the most powerful transformations of sacred geography, even as it extends them to the periphery of the cosmos. While the Vajradhātu maṇḍala centers on the cosmic hypostization Vairocana and the Svayambhū *caitya* is constructed around the *ādi-buddha*, the Copper Mountain palace houses the historical figure of Padmasambhava, an eighth-century ritual master who aided in the founding of Samye monastery during the First Diffusion[119] of Buddhism to Tibet. Padmasam-bhava achieved greater fame only centuries later, however, when the introduction of new schools of Buddhism in the Second Diffusion prompted the conservative develop-ment of an Old (Nyingma) School[120] that looked back to the eighth-century founders for their lineage. Padmasambhava's great renown was fostered by the revelation of his biography in the twelfth century by Nyang Ral Nyima Oser.[121] According to this nar-rative, when Padmasambhava's work in Tibet was finished, he departed for a new mis-sion, to subjugate demons in the southwest lest they rise up and threaten the human lands.[122] Once there, he defeated the king of the demons and created the Lotus Light Palace[123] atop the Copper Mountain, where he continues to reside, teach, and protect the human world from demons.[124]

The Copper Mountain is explicitly not Meru and not at the center of the universe. It does, however, reinforce the basic structure and function of the maṇḍala, established at an alternate center of sacred space. While it is the centrality of the maṇḍala atop Meru that provides its status and efficacy, it is the portability of the maṇḍala to all places in the cosmos that makes it useful. At the same time, the existence of a deity palace atop a mountain other than Meru also points toward ideas of sacred mountains and mountain cults that are unfortunately beyond our scope here. Indeed, the idea of Meru as the chief and central mountaintop abode of the cosmos makes sense only in an ideology that already considers mountains sacred sites. If not, there would be no collection of mountains among which Meru could be considered the chief and central one. Mountaintop abodes of deities were an extremely important feature of Indic and Himalayan culture well before Buddhism arose.[125] In this context, Meru matures into an abstraction of the idealized sacred mountain, which is then reapplied to other spe-cific mountains. Such sites, including the Kathmandu valley and the Copper Moun-tain, embody the notion of a mesocosmic center even as they mark their distance from the geographic center of the universe.

Among the numerous mountaintop (maṇḍala) palaces in Buddhist art and literature, the example of Padmasambhava's Glorious Copper Mountain is especially revealing because Tibetan artwork makes so explicit not only its role as a recentered mesocosm but also its precise location at the far periphery of the world. In the painting of the Cakravāla cosmos with Śākyamuni at Bodh Gayā in Jambudvīpa (see fig. 2.3), the southern quadrant also depicts smaller subcontinents to the west and east of Jambudvīpa: Cāmara and Avaracāmara (or Aparacāmara). In western Cāmara is a three-story palace emanating a rainbow aura—this is Padmasambhava's Lotus Light Palace. While Padmasambhava's biography describes his travels in ways that are difficult to reconcile with any single geographic model,[126] the idea of his residence in a land to the west is eventually incorporated into a five-part system of sacred places in the five directions around Jambudvīpa, forming another kind of five-part maṇḍala in the geography of the southern quarter.[127] In this system, Bodh Gayā lies at the center within Jambudvīpa, Avalokiteśvara's Potalaka on an island in the south, Mañjuśrī's Wutaishan in the east (identified with a site in present-day China), and the Wheel of Time's hidden kingdom of Shambala in the north.[128] This quincunx of sacred sites presents an alternative centering of Buddhist geography around Bodh Gayā in Jambudvīpa, rather than around Meru (as in the *Compendium of Principles*) or around the Kathmandu valley (as seen in the Newar *caitya*). In addition, each specific site presents its own unique geography of sacred space.

Illustrations of the Copper Mountain in the subcontinent Cāmara abound in later Tibetan painting. A modern example at Mak Dhog[129] monastery in Darjeeling (fig. 2.21) depicts iconography that is noticeably different from the familiar maṇḍalic circle, even while it expresses several key features of maṇḍalic space. Forgoing the mixed plan-elevation view of the typical maṇḍala, the Lotus Light Palace is rendered in a single coherent perspective, akin to narrative illustrations in which people and architecture can be read together. Numerous figures fill the palace around the main figure of Padmasambhava, who is depicted in the geometric center in hieratic scale. Eight emanations of Padmasambhava occupy the courtyard of the palace. Additional figures are also common, including his two female consorts depicted immediately to his right and left. As is the case with the Newar *caitya*, perhaps the most notable features connecting this landscape with the cosmic model are the depictions of the Great Kings at the directional entrances to the palace, making an explicit equation between this landscape and central Meru (fig. 2.22) (see also chap. 4). In this sense, at least, the iconography suggests a recentering of the cosmos from Meru to Cāmara, even though the two places are geographically distinct.

Perhaps more powerful, however, is the depiction of all three bodies of the three-body theory in the three stories of the palace itself, making the palace's role as a mesocosm quite explicit. Like Sarvārthasiddhi-Vairocana, Padmasambhava is conceived as an Emanation-body at the lowest level of the palace—even though, like Vairocana

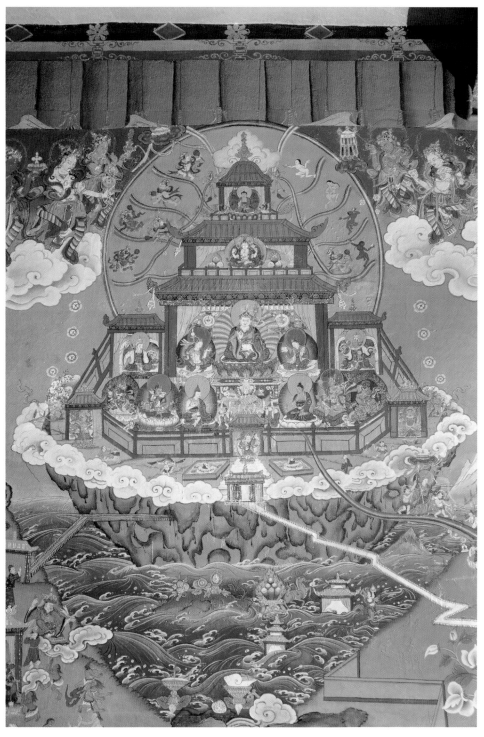

2.21. Padmasambhava's Copper Mountain Lotus Light Palace. 20th–21st century. Mak Dhog Aloobari, Darjeeling, India

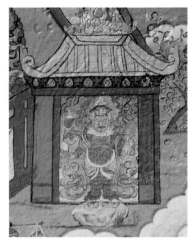

2.22. Details of figure 2.21 showing three of the Great Kings at the gates of Padmasambhava's Lotus Light Palace. 20th–21st century. Mak Dhog Aloobari, Darjeeling, India

in the Vajradhātu, he is also the central figure of the palace. Above him appears the associated Enjoyment-body, a four-armed Avalokiteśvara, while the top story shows the Truth-body in the form of the buddha Amitābha (fig. 2.23).[130] Amitābha is the same buddha who occupies the western quadrant of the Vajradhātu maṇḍala, and indeed his association with the west, correlated with Padmasambhava's arrival from and departure to the west, seems to be the reason for their association. Avalokiteśvara, nominally a bodhisattva attendant of Amitābha's, is also considered his emanation and therefore an intermediate between Amitābha and Padmasambhava. The transposition of these figures into the three-body arrangement makes explicit the function of Padmasambhava's Copper Mountain palace as a mesocosm between the mundane and the ultimate while simultaneously emphasizing the peripherality of these figures to the normal cosmic geography. Amitābha's very association with the west crystallizes the distance of these figures from the center, while he also represents absolute truth. Even in peripheral Cāmara, ascent leads directly to the Truth-body.

Like the relationship between Svayambhū and the Newar *caitya*, the Lotus Light Palace also serves as a model for producing simulacra in local Tibetan geography. Many monasteries are explicitly built on the three-story plan of the Copper Mountain palace, such as one in Sikkim, the name of which translates as "Great Akaniṣṭha Cāmara Copper Mountain Lotus Light Palace" (fig. 2.24).[131] This name emphasizes the connection between Akaniṣṭha and Cāmara, as mediated through the Lotus Light Palace. The three-story plan of this temple parallels the structure of the Lotus Light Palace, with the central shrines of each level dedicated in turn to Padmasambhava, Avalokiteśvara (this time a thousand-armed form), and Amitāyus (a figure identified with Amitābha).[132]

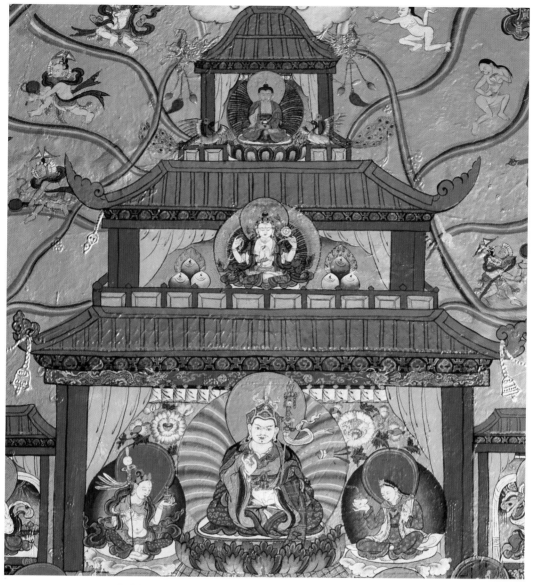

2.23. Detail of figure 2.21 showing the three-body system in Padmasambhava's Lotus Light Palace. 20th–21st century. Mak Dhog Aloobari, Darjeeling, India

Remarkably, the second story also contains a three-dimensional model of the entire Lotus Light Palace, rendered in painted wood (fig. 2.25). Like the three stories of the building in which it is held, the three tiers of this model correspond to the three bodies associated with Padmasambhava's emanation. The presence of this model specifically on the second story only serves to reinforce the interpretation of the palace as a maṇḍalic mesocosm between the local and the ultimate. The Lotus Light Palace

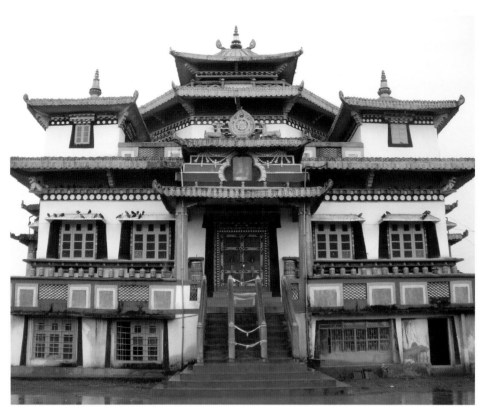

2.24. Akaniṣṭha Cāmara Copper Mountain Lotus Light Palace monastery. Sikkim, India. Photograph by Susan L. Huntington, courtesy of the Huntington Archive of Buddhist and Asian Art

is precisely where one transcends the geographic locale (Cāmara, inhabited by Padmasambhava in the first story) to access the Enjoyment-body (on the second story) and gain enlightenment (Truth-body on the third story). In addition to the image of Amitāyus representing the Truth-body on the third story, there is also a central image of the buddha Samantabhadra in union with consort Samantabhadrī (fig. 2.26), the more generally invoked Truth-body of the Old School tradition, reminding the viewer that this transition to the ultimate is not specific to Padmasambhava's three-body forms.

This site in Sikkim is just one example among many. Modern artistic productions in Bhutan make the relationship between the Lotus Light Palace and the generalized maṇḍala even more explicit by portraying the palace atop elemental circles of wind, fire, water, and earth, precisely as in the transformative elemental meditations described above.[133] Avalokiteśvara's Mount Potalaka palace can be depicted in precisely the same visual idiom as Padmasambhava's Copper Mountain at Mak Dhog, as a palace atop a mountain-island surrounded by oceans.[134] Neither is the relationship

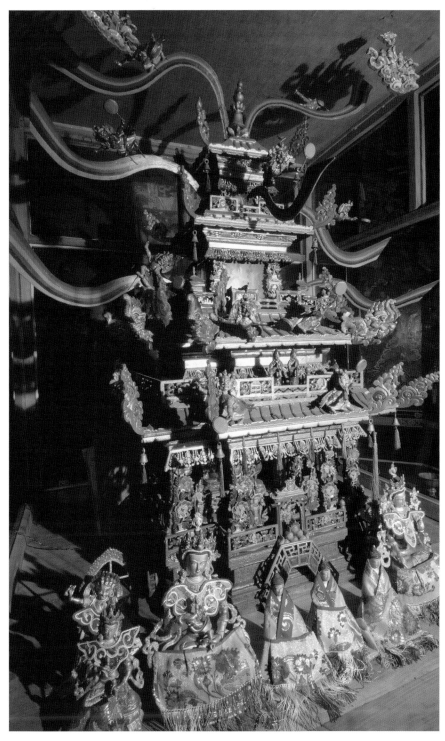

2.25. Model of Padmasambhava's Lotus Light Palace. Second story, Akaniṣṭha Cāmara Copper Mountain Lotus Light Palace monastery, Sikkim, India

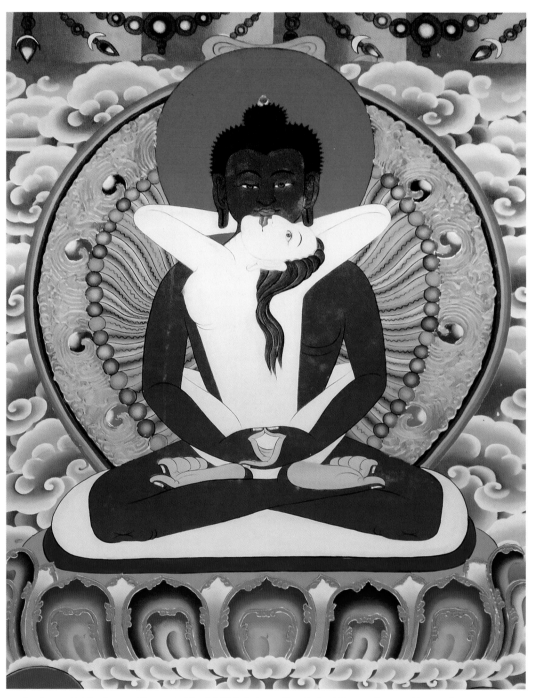

2.26. Samantabhadra and Samantabhadrī. Third story, Akaniṣṭha Cāmara Copper Mountain Lotus Light Palace monastery, Sikkim, India. 20th–21st century

between the maṇḍala palace and actual architecture unique to the Lotus Light Palace. Rather, this is a general principle of a great deal of Buddhist architecture, and these are just a few specific examples of generalizable overlaps between maṇḍala palace, sacred mountain, and cosmos. Each case bridges the gap between local reality and ultimate truth in its own way. Whether in the paradigmatic maṇḍala of the Vajradhātu atop central Meru or the peripheral Lotus Light Palace in Cāmara, the ideology of the maṇḍala creates a mesocosmic space wherein one transcends the local by transforming and translocating it into the ultimate. Local mountains of various deities can be modeled on central Meru, just as Sumeru can be recognized as the chief among mountains only because other peaks are already considered the abodes of deities. In conceiving of one's place in the cosmic system of the maṇḍala, it is the negotiation of local particular and cosmic ultimate that makes the system work.

Conclusion

Local place is radically important precisely as it is transcended. Each example here has been about one particular place within the Buddhist cosmos and how conceptions of that place relate to the achievement of enlightenment — how, given the basic structure of the cosmos, particular places within that structure are deployed to express specific ideas about the process of awakening, the nature of enlightenment, and the individual's relationship to these in particular places and times.

The simplest possible answer is that the site of the Buddha's enlightenment at Bodh Gayā is an important symbol of that enlightenment. Very quickly, however, the Buddha's supreme status in the cosmos suggested a vision of him at the peak and center of the universe, as portrayed in images from Mathurā and Haḍḍa. In these cases, the place of the buddha is simply a sign of his cosmic stature, a static vision of the buddha enthroned atop Meru. Although this cosmic centrality is sometimes associated with the development of tantrism, it is actually the mediating practice of translocation that makes tantric Buddhism unique, not its granting of cosmic status to the buddha. Translocations both up and down in the cosmic model form a mesocosm at the peak of Meru that allows transition between mundane existence (Jambudvīpa) and enlightened existence (Akaniṣṭha). This idea of the peak of Meru as mesocosm provides an alternative, geographic understanding of what is often conceived as a personal process of transformation, particularly in relation to the three-body theory. Here, the relationships between places in the cosmos provide an active system for personal transformation, rather than a static vision of hierarchical status. Aside from the foundations of this idea in canonical texts such as the *Compendium of Principles*, visual artworks like the maṇḍala from Alchi also demonstrate complex expressions of the importance of place.

In addition to being transforming, the cosmos itself can be transformed, especially in ways that include translocation or generation of the cosmos into specific locales.

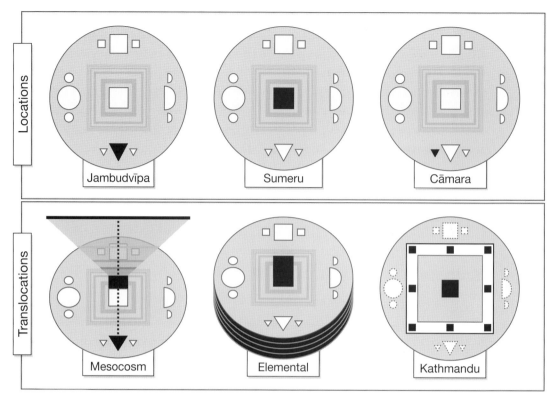

2.27. Locations and translocations described in the chapter. Left to right, top row: the geographic locations of Jambudvīpa, Sumeru, and Cāmara; bottom row: translocative processes involving mesocosm (with Akaniṣṭha, the peak of Sumeru, and Jambudvīpa as a three-part system), meditative generation of the elemental substrata of the cosmos with Meru, and relocation of the maṇḍala to the sacred geography of the Kathmandu valley

Tantric ritual involves meditatively dissolving and re-creating the cosmos as a pure vision of enlightened reality centered around the practitioner's location. The cosmic model invoked in this practice particularly emphasizes the elemental substrata of the cosmos and the enormous central Meru, foregrounding themes of elemental transformation and the centered stability of the meditative process itself over local geography. At the same time, the Newar *caitya* shows how relocating the cosmic maṇḍala specifically within local geography and history can be its most important application. The Lotus Light Palace of Padmasambhava in Cāmara also instantiates the structural and soteriological symbolism of a deity maṇḍala in a specific geographic locale, one that simply cannot be considered the center of the universe. Figure 2.27 summarizes some of the essential locations and translocations of maṇḍalas, giving a sense of the diverse roles that geographic space and cosmic structure play in tantric ideology.

These examples represent only a fraction of the ways of thinking about sacred space and sacred geography in Buddhism. One could devote entire books to single

sites of negotiation between cosmology and sacred landscape.[135] Ethnographies of pilgrimage and sacred geography also have much to say about how geography and cosmology intersect. Our concern has been how the geographic cosmology of enlightenment is portrayed in key works of literature and art, rather than how it is enacted in thought and deed. We next turn to a very different kind of practice associated with the cosmic model, in which the actual, physical activity of performing the ritual has dramatic effects on the way that the cosmos is conceptualized and represented in culture and art.

3

Cosmos in Offering

PILING A MOUNTAIN OF TREASURES

IN ADDITION TO ITS TEXTUAL AND MEDITATIVE FORMULATIONS, THE BUD-
dhist cosmos appears as an object of material culture, perhaps most commonly in a
ritual in which a model of the cosmos is presented to a teacher or deity (fig. 3.1). This
practice is understood as an essential basis for the tantric path, laying the foundation
for personal development and more advanced ritual performances. The repetition of
such offerings habituates the performer toward the perfection of generosity,[1] one of the
Buddhist virtues essential to enlightenment. The act also symbolizes an exchange of
material wealth for a treasure that is even greater — the teachings that lead to enlighten-
ment.[2] In this sense, it signifies the devotion of the student to the teacher, the essential
basis of all tantric practice.

While numerous types of offerings exist in Buddhism, the offering of the cosmos
is unsurprisingly among the most all-encompassing. Other rituals might call for giv-
ing food and perfume,[3] but this one theoretically includes everything in the entire
universe. The completeness of the offering is an essential feature, determining the
structure and parts of the cosmos that are invoked. Specific aspects of geography and
emblems of universal wealth stand in for all the other details that cannot be incorpo-
rated into a finite object. Because of the tension inherent in such a simplification, some
traditions also incorporate a re-expansion of this object back to the unimaginable scale
of the full universe, either through envisioning infinite offerings filling all of space or
through multiplying the cosmic offering to create a full multiverse of triple-thousand-
great-thousand world-system offerings.

Given such considerations, the offering ritual deploys cosmological thinking in a
remarkably different way than the deity maṇḍala or a scholastic ideology. While the

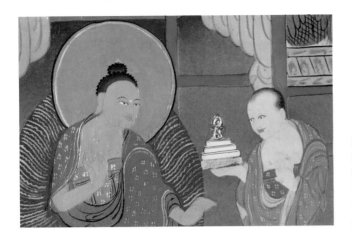

3.1. Monk presenting an offering maṇḍala to the buddha Śākyamuni. 20th–21st century. Dungon Samten monastery (T: Dung dgon bsam gtan chos gling), Darjeeling, India

deity maṇḍala employs translocation between places in a cosmic space, the offering maṇḍala fills the entire cosmos with wealth and transfers it, as a whole, to another being. The most important hierarchical relationship here is not between mundane and enlightened selves but between donor and recipient. Further, while both the deity maṇḍala and the cosmic offering stipulate the creation of a purified and idealized cosmos, the offering cosmos amasses material wealth and objects of sensory enjoyment, rather than simplifying the world to its purest elements. The offering model also differs from scholastic cosmologies, for example, in not having any hells, which would be unsuitable for a pleasurable gift.

Because these offerings are physical objects, their form and symbolism are also determined by the particular materials and techniques used in their construction, not just their ideological functions. Comparing the performances and ephemera of Newar and Tibetan offerings reveals that a single difference in the order of operations within the ritual correlates to changes in the structure of the offering, the material objects that are produced, and the ways those objects are represented in artwork. Figure 3.2 summarizes this argument (explained in more detail after the Newar and Tibetan traditions are discussed individually). In short, Newar tradition creates an offering maṇḍala that spirals outward from the center (top left of diagram) into a flat, disc-shaped structure (second left). The material product is a circular array of small heaps of offerings on a flat plane (third left), which can be represented in plan view in painting (fourth left). The easy enumerability and closed structure of this offering do not emphasize its expansiveness; rather, the particular items that are offered symbolize its cosmic scope. The Tibetan ritual, by contrast, piles offerings from the periphery inward (top right of diagram), creating an ever higher center (second right). The materially produced vertical pile (third right) has a height and tiered structure that recall the terraced, jeweled facets of Mount Meru (fourth right), a veritable mountain of treasures emphasizing

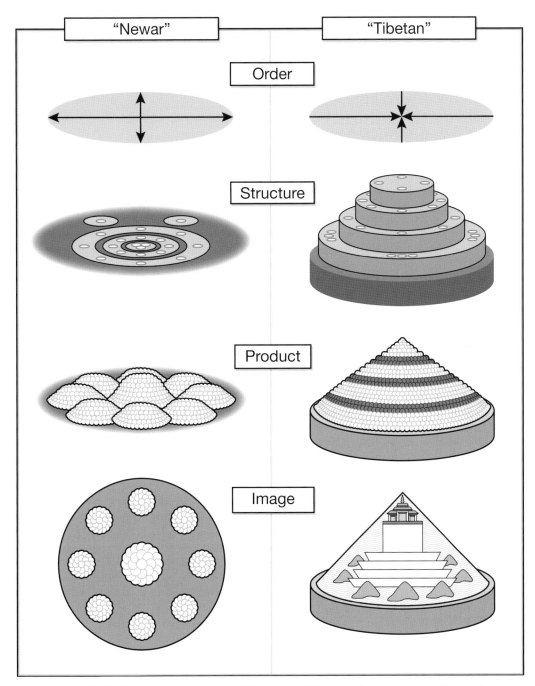

3.2. Distinctions between the typical Newar and Tibetan styles of maṇḍala offering. Top row: procedural order; second row: three-dimensional structure; third row: material product; fourth row: depiction in painting

its own immensity. Representations of this heaped cosmos have become so common that they affect the way the world is depicted in Tibetan art more generally, especially regarding its vertical structure.

While depictions of the Newar and Tibetan offerings diverge, this does not mean that Newars and Tibetans have different cosmologies. It is a mistake to essentialize either of these cultures or pretend that there was not significant overlap and mutual influence between their traditions over time. Indeed, there are cases of the "Newar" offering in Tibetan culture and the "Tibetan" offering in Newar culture. These terms are merely convenient labels based on liturgical systems, rather than inherent cultural identifications. There are also deeper questions about what it means for these depictions and cosmologies to be divergent at all. Both groups quite explicitly trace the cosmic model underlying this ritual to Vasubandhu's *Treasury of Abhidharma*.

At the same time, the differences in Newar and Tibetan depictions are not simply arbitrary variations in idiom. Rather, they represent key moments of mediation between conception, practice, and representation that reveal a new perspective on cosmological thinking in Buddhist ritual. We have already seen cosmic portrayals mediated through the intentions of specific authors and the rhetoric of enlightenment, with different uses for the cosmos resulting in contrasting expressions of the cosmology. In the offering, all the depictions of the cosmos are adapted to essentially the same purpose, but they are mediated through different traditions of material culture.

Examining the conceptual environment out of which the tantric offering developed is also fruitful, especially for comparing against offerings and cosmologies of pretantric sources. It is ironic that the tantric ritual claims the *Treasury of Abhidharma* as a source, as Vasubandhu's text seems to reject relationships between cosmos and offering found in the Vedic and Purāṇic traditions. Offering practices remain connected with cosmology in Buddhism, however, and the *Legend of Aśoka*[4] tells the story of the great king Aśoka donating the entire world to the Buddhist community at the end of his life. The story of Aśoka correlates this type of offering with the king's status as a *cakravartin*,[5] a universal monarch who literally owns the world — a logical prerequisite to giving it away. Imagery of the *cakravartin* pervades the ritual of offering the cosmos, especially a specific set of treasures that are emblems of his rule. By including these treasures among the items that are offered, ritualists imply that they have the same authority as the *cakravartin* to give away the cosmos, validating the ritual.

Indeed, the cosmology expressed in the ritual precisely adapts to its purpose of offering at many levels, including its procedures, products in material culture, and representation in artwork. The Newar version is simpler than the Tibetan, and while not necessarily earlier, there are resonances between its performance and depictions of similar rituals dating back to the eleventh century. The Tibetan offering, in turn, has a significantly more complicated internal structure that emphasizes the towering height of a cosmos overflowing with wealth. This symbolism of abundance becomes a key

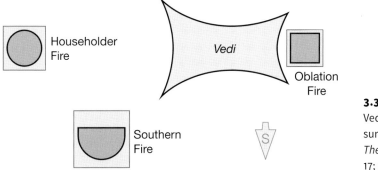

3.3. Altars in the Vedic ritual enclosure. After Olivelle, *The Early Upaniṣads*, 17; Staal, *Agni*, 44

feature of the Tibetan ritual, encoded by many aspects of its liturgy, performance, and materiality. Imagining the cosmos as a veritable mountain of treasure also suggests a comparison with Mount Meru, itself made of jewels. Greatly increasing in popularity after the seventeenth century, the Tibetan version appears so frequently in artistic depictions that it alters cosmic imagery more generally, exemplifying the ways in which constructed material objects can mediate concept and form.

Early Relationships between Cosmos and Offering

Although both Newar and Tibetan traditions trace the cosmology of the offering ritual to the *Treasury of Abhidharma*, Vasubandhu's text contains elements that may have been formulated in direct opposition to Vedic and Purāṇic connections between cosmos and offering. Direct proof is lacking, but the continents described in the *Treasury* seem to co-opt the significance of the Vedic altar, and Vasubandhu's oceans provide a specific alternative to their ritualized description in the Purāṇas. Even if these connections are mere coincidence, the relationship between cosmology and sacrifice in these other traditions gives a sense of the conceptual environment in which Buddhist traditions of cosmology in offering developed.

Early Buddhism was in some ways defined in contrast to Vedic sacrifice. Until the time of the Buddha, Vedic rituals dominated Indic religious practice,[6] especially rituals centered around offering substances into fire, such as daily oblations of milk,[7] offering (and drinking) juice from the sacred *soma* plant, or presenting rare and extravagant fire-pilings.[8] The more elaborate of these practices required the construction of a ritual enclosure dominated by a *vedi* (platform for ritual implements) and three fire pits used for specific acts of offering (fig. 3.3).[9] These fire altars were constructed in the shapes of a square, a circle, and a semicircle in the cardinal directions of east, west, and south, respectively. Since sacrifices functioned as the mesocosm of Vedic practice,[10] through which humans interacted with the greater cosmos,

Buddhists simultaneously challenged Vedic tradition and promoted their own beliefs by co-opting symbolism from such elements. In one example from the *Numerical Discourses*,[11] the Buddha interprets the three Vedic fires to represent specific groups of people in society, turning the Vedic emphasis on feeding the fires into an ethical statement about supporting other humans.[12] The geometric shapes of the Vedic altars might have similarly inspired Vasubandhu's antecedents to describe the four major continents of Buddhist cosmology as a square, circle, semicircle, and triangle[13] in the north, west, east, and south. Although the shapes and directions of the continents do not precisely match those of the Vedic altars, and the *Treasury* gives its own, unrelated reasons for the shapes,[14] it would be hard for anyone familiar with Vedic sacrifice to miss the similarities. It is noteworthy that, of the major Indic cosmologies, only the Buddhist models contain these geometric continents so similar to the Vedic altars.

Indeed, although there is an early denial of Vedic sacrifice, fire rituals do appear in Buddhism with an arrangement of altars nearly identical to the *abhidharma* cosmology. The seventh-century *Enlightenment of Great Vairocana* is among the earliest Buddhist texts to describe the performance of *homa* rites (a variation of the *soma* ritual).[15] Abhayākaragupta (11th–12th century) wrote a third major ritual manual specifically for fire offerings,[16] the *Inflorescence of Light*,[17] which lists the four main types of *homa* altars in shapes and colors similar to those of the continents: a white circle for peaceful rites, a yellow square for enriching, a red semicircle for subduing, and a blue-black triangle for fierce rites.[18] These four altars are placed in the four cardinal directions around a deity maṇḍala, and although sources differ as to the exact arrangement, they often parallel the continents around Meru.[19] A modern example can be found at Khamsum Yulley Namgyal Chorten[20] in Punakha, Bhutan, which has the four altars surrounding a central temple that represents Mount Meru with a sculptural deity maṇḍala inside (fig. 3.4).[21]

Vasubandhu's text also lacks certain relationships between cosmos and offering evident in the seven-continent Purāṇic cosmology (see fig. 1.4), which has oceans filled with sacred substances like milk and clarified butter, clearly establishing a relationship between sacrificial rites and cosmic structure. Vasubandhu's model, rejecting this symbolism, has oceans of merely salt water or fresh water.[22]

Despite some details of Vasubandhu's model that apparently present clear alternatives to sacrifice, the later tantric ritual remakes his world into an idealized gift, filled with substances appropriate to such a use and omitting specific negative elements he describes. Still, the fact that this model is consistently attributed to the *Treasury* says something about the importance of Vasubandhu's worldview and his influence on later Buddhist traditions. It is remarkably less common to create an offering of the cosmos based on the Wheel of Time, for example. Vasubandhu's cosmology provides a textual basis on which ritual transformations can be built, even as those transformations alter the intention of his text.

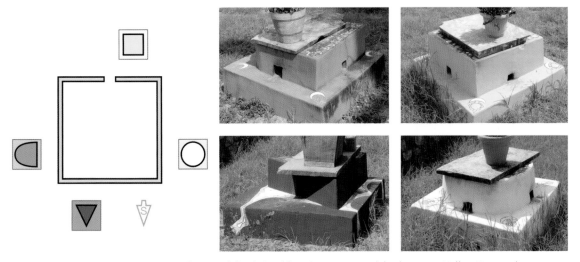

3.4. *Homa* altars around a maṇḍala shrine (drawing not to scale). Khamsum Yulley Namgyal Chorten, Bhutan

KING AŚOKA'S GIFTS AS MODELS OF COSMIC DONATION

Despite the opposition of early Buddhism to Vedic fire sacrifice, other forms of offering were central, especially ones that promote the perfection of generosity.[23] Such practices were vital to the survival of the early Buddhist community of monks and nuns who subsisted on lay donation and royal patronage. The *Legend of Aśoka*[24] emphasizes just such patronage while prefiguring the offering of the cosmos seen in later tantric rituals.[25] Two related gifts, one of the entire world, bookend Aśoka's life narrative, defining notions of giving in the Buddhist community and especially his role as a *cakravartin*, a world-conquering king, whose conception is essential to the later ritual.

Aśoka's narrative begins in a previous life, when, as the young boy Jaya, he met the buddha Śākyamuni. Inspired by the Buddha's appearance but without anything to offer, Jaya piled a handful of dirt into the Buddha's begging bowl with the intention that it should be equivalent to an offering of food and earn him enough merit to be reborn as a great king who could offer immeasurably more. In response, the Buddha predicted that Jaya would be born more than a century later as Aśoka, a *cakravartin* to rule over all four continents and personally distribute the relics of the Buddha in order to promote his teachings.[26] In this passage, Aśoka serves as an exemplar of generosity for both lay and elite patrons of Buddhism, connecting these two statuses through his single offering of dirt. Most importantly, the royal status predicted for Aśoka is of a very particular type, namely, complete rule of the world. Altogether, the passage promotes an ideal of kingship in which universal sovereignty is united with perfect generosity and unmatched support for the Buddhist community and teachings.

The key demonstration of this type of kingship comes just before Aśoka's death, when he donates the entire world to the Buddhist community, an act similar to the later tantric ritual of cosmic offering. After his death, his ministers ransom the earth back in order to maintain the political status quo, but the significance of this final act of Aśoka's life is clear. The donations of dirt and the world define Aśoka's kingship by framing his life, from its seed in a previous life to its end at his death. The gift of dirt even foreshadows the gift of the world in that it causes the kingship through which the latter is possible and is composed of the same basic substance (dirt = earth).[27] In a separate passage, Aśoka describes the logic behind such a gift in much the same way that we see the logic of the tantric offering:

> My son, myself, my house, my wives,
> The whole earth, even the royal treasure —
> there is nothing whatsoever that I have not given up
> for the Teaching of the Dharma King.[28]

Early Buddhism clearly lauds the offering of the world for the teachings of the Buddha even before its tantric ritualization. Without a generalized ritual, however, only Aśoka is able to give such a gift, because he dominates the entire world as a *cakravartin*. Eventually, the relationships between the *cakravartin* ideal and the offering of the cosmos go well beyond the narrative of Aśoka. The *cakravartin*, his material wealth, and his connection to the Buddha are invoked in very specific ways in the cosmic offering ritual.

THE TREASURES OF THE UNIVERSAL SOVEREIGN

In addition to the geographic accounting of Meru and the continents, a specific set of treasures belonging to the *cakravartin* forms the basis of the tantric offering of the cosmos. The presence of these treasures implicitly suggests the practitioner's ownership of the world, making the ritual conceptually possible. Further, in being the greatest, idealized treasures of the person who possesses universal wealth, the *cakravartin* treasures also stand for all the lesser valuables that are too numerous to list during the practice. In addition, the historically close relationship between the ideals of the *cakravartin* and the Buddha allow the offering of the *cakravartin* treasures to suggest an exchange of worldly success (kingship) for religious accomplishment (enlightenment).

The term *cakra-vartin* literally means "wheel-turner" and has a complex relationship to kingship in Indic traditions.[29] In Buddhist usage, it refers to a miraculous wheel (*cakra*) that turns in the sky[30] above a given king, signaling his righteous rule and aiding in his conquest of the four quarters by preceding him to the various continents. Because this king rules the entire world, only one *cakravartin* can exist at any one time, and the presence of the wheel is dependent on his righteousness. The *Lion's Roar on*

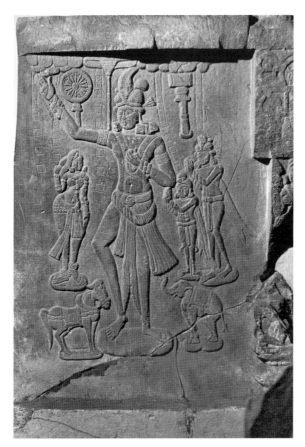

3.5. Low-relief sculpture of the *cakravartin* Māndhātar. 1st century BCE. Jaggayapetta, India. Photograph by John C. Huntington, courtesy of the Huntington Archive of Buddhist and Asian Art

the Wheel Turner,[31] a text from the Pāli canon, tells the story of the *cakravartin* Daḷhanemi, who had conquered the lands in all directions and ruled them righteously. At Daḷhanemi's death, his wheel disappeared, and it was explained to his heir that, unlike other royal treasures, the wheel cannot be inherited. For the wheel to reappear, the new king had to perform specific rites and honor the teachings of the Buddha. When he did so, the wheel reappeared, and the king followed its rolling course to the four quarters with his armies, conquering all and ruling righteously.[32]

While the wheel is obviously the most iconic symbol of the *cakravartin*, it is not his only miraculous treasure. There are a total of seven special emblems belonging to the *cakravartin*: the wheel, the elephant, the horse, the jewel, the woman/wife/queen, the householder/citizen/minister, and the counselor/general. The earliest direct evidence for the concept of a *cakravartin* and his seven treasures is probably a first-century BCE relief sculpture from Jaggayapetta, India, that depicts the *cakravartin* Māndhātar with precisely these objects (fig. 3.5).[33] The large central figure is the *cakravartin*, with (top to bottom) the wheel, woman, and horse on the viewer's left and the jewel, minister, householder, and elephant on the viewer's right.

Māndhātar's military conquest of the world suggests a direct parallel with the buddha's cosmic enthronement atop Meru, although the former's journey ended rather less triumphantly. Becoming a righteous *cakravartin* in his own time, Māndhātar received the seven treasures and performed miracles that brought wealth to his people, making grain, cloth, and even gold rain from the sky. After conquering the four continents of the world, Māndhātar, led by his ambition, ascended the slopes of Meru as well, eventually arriving at the heaven of the Thirty-Three at its peak. The *devas* greeted him as an equal and invited him to share the seat of Indra/Śakra, their ruler, but this is not the end of the story. When he desired to oust Śakra and become the king of the gods himself, Māndhātar lost his supernormal abilities, fell to Jambudvīpa, and experienced

tormenting pain that led to his death.[34] Despite his righteous rule, Māndhātar was not fully enlightened and suffered from poisonous greed. In the examples of Śākyamuni similarly enthroned atop Meru as a spiritual, rather than military, victor (see chap. 2), the Buddha does not share a throne with Śakra but is the sole chief of the world because of his unique enlightenment. Such obvious parallels between the worldly and religious paths make for an easy comparison of the two in which enlightenment is clearly the more desirable outcome.

Similarities between the *cakravartin* and the buddha are well established throughout Buddhist tradition, with enlightenment generally cast as the superior option.[35] One of the key moments in the Buddha's life came just after his birth, when his father, King Śuddhodana, requested a prophecy for his son that was given in terms of a comparison between the *cakravartin* and the buddha. There were precisely two possible outcomes for the youth:[36] "If he lives at home, he will be a *cakravartin* with a fourfold army, . . . endowed with [the] seven jewels. He will . . . subdue this great earth . . . and reign with prosperity and mastery. If, however, he becomes an ascetic without home or city, he will become . . . completely enlightened, a teacher, a buddha in the world."[37] These two futures are the greatest possible achievements for the child—one on the mundane path, the other spiritual. Of course, the son of Śuddhodana followed the latter, but as seen in the *Flower Array Sūtra*, the *Enlightenment of Great Vairocana*, and other sources, the rhetoric of the buddha's domination of the world is never lacking. Many other relationships between the *cakravartin* and the buddha could be listed here, such as that there is only one buddha and one *cakravartin* in the world at any one time or that the physiognomy of the perfected body of the buddha is the same as the body of the idealized *cakravartin*.[38]

Such close relationships between worldly and spiritual conquest allow the treasures of the *cakravartin* to suggest layers of complexity in the cosmic offering. On the one hand, the cosmic equivalence of the *cakravartin* and the buddha make the idealization of the world in the ritual doubly effective. Not only does it result in the perfection of wealth and treasure to be offered, but it also reflects the purification of the world achieved through the enlightenment that the practitioner pursues. On the other hand, the clear preference for the achievements of the buddha over those of the *cakravartin* perfectly encapsulates the idea of trading universal wealth for the buddha's teachings. As in the deity maṇḍala, the process of enlightenment is cast as a cosmic activity, but here the conditions are reversed. Rather than spiritual progress being seen as taking dominion of the cosmos, enlightenment is achieved by giving the universe away.

Creating (the Newar Offering of) the Universe: A Maṇḍala of Treasures

In Nepal, the offering of the cosmos is the centerpiece of a longer rite known as the maṇḍala offering to the teacher (guru),[39] in which the maṇḍala that is offered is the disc of the world itself, the Cakravāla universe. This is the most frequently performed

rite in Newar Buddhism,[40] so its relevance as an expression of cosmological thinking is paramount. Put simply: "All complex rites begin with the guru maṇḍala,"[41] from weddings and life-cycle rites to the esoteric deity maṇḍalas of the *Compendium of Principles* and the *Purification of All Bad Transmigrations*.[42] The guru-maṇḍala offering is generally understood to purify the practitioner before other rites,[43] and indeed it incorporates several elements that further attainment of this goal, such as a confession of sins and a recitation of the hundred-syllable mantra of the buddha Vajrasattva for absolution. The teacher to whom the maṇḍala is offered is the same Vajrasattva, who is considered to be the ultimate guru of the Buddhist priests themselves.

TEXT AND PRODUCTION

The Newar guru-maṇḍala practice includes two stages in which cosmoses are constructed.[44] In the first, the practitioner envisions an elemental cosmos as the seat of Vajrasattva, the recipient of the offerings. Then they manufacture a second[45] Meru cosmos full of treasures by placing grains or flowers[46] in a diagrammatic array, eventually adorning and offering this object to Vajrasattva. Because of their disparate purposes, the cosmologies of these two ritual moments contrast quite clearly. The first, the generation of the seat of Vajrasattva, proceeds like the elemental generation of the deity maṇḍala:

> OM all things are inherently pure, I am inherently pure, my being is the *vajra*-essence of the knowledge of emptiness. (Thus) one should visualize emptiness. . . .
>
> OM let [the practitioner] visualize a mandala of the four elements, wind, fire, water, and earth, arising from their four seed mantras, YAM [RAM LAM and VAM], in the middle of an area empowered with mantras. On top of this mandala [a] Mt. Meru arising from the letter SUM. On top of that a lion-throne of jewels, on top of that a lotus, and on top of that a moon-mandala. On top of that meditate on Vajrasattva who has two arms, one face, is white in colour, holds *vajra* and *vajra*-bell, is adorned with different colored ornaments, with a cloth of five-colours wrapped around his matted locks, his head-dress adorned with Akṣobhya who is dark blue. Thus he should visualize the worshipful guru.[47]

This cosmology emphasizes the emptiness of phenomena and a transformation of the ordinary world for enlightened experience. After generating the seat for Vajrasattva, the practitioner summons him with the same sorts of ritual gestures and recitations used in the construction of a deity maṇḍala.[48]

The second construction of the cosmos, as the object that is offered, is remarkably different. Rather than invoking emptiness and the transformative elements, it

Table 2 Parts of the Treasure-Maṇḍala

1. Great Middle Meru	
2. Middle Meru	
3. Subtle Middle Meru	
4. Pūrvavideha [eastern continent]	
5. Jambūdvīpa [southern continent]	
6. Aparagoḍāvarī [western continent]	Geographic landscape
7. Uttarakuru [northern continent]	
8. Peripheral continent [southeast]	
9. Peripheral continent [southwest]	
10. Peripheral continent [northwest]	
11. Peripheral continent [northeast]	
12. Elephant	
13. Horse	
14. Man	
15. Woman	*Cakravartin* treasures
16. Sword	
17. Wheel	
18. Jewel	
19. All-treasure-receptacle	(additional treasure in same set)
20. Moon	
21. Sun	Sun and moon
22. Homage to the teacher Vajrasattva	

focuses on the complete landscape of the cosmos and the treasures of the *cakravartin* as emblems of the universality of the gift. The offered cosmos is known as the treasure-maṇḍala (*ratna*-maṇḍala) precisely because it comprises lavish wealth. Table 2 lists the twenty-one treasures of the liturgy, with a twenty-second element offering homage to Vajrasattva himself.[49]

The ritual is performed while the practitioner is seated on the ground by placing offering substances directly on the floor or in a shallow bowl. After outlining the

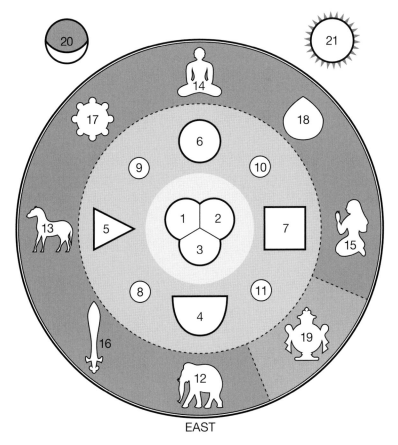

3.6. Ritual placement of the twenty-one parts of the Newar treasure-maṇḍala

maṇḍala with white powder (such as rice flour), the practitioner invokes each of the twenty-one elements while placing a flower or a pinch of dry grain in a sequence of twenty-one different locations, reproducing the physical arrangement of the cosmos (fig. 3.6).

Central Meru is placed first at the very center, and its symbolism is complex. It is represented by not one but three separate offerings (1–3 in the diagram), which may be distributed radially or in a row. The reasons for the tripling of Meru are unclear, and the trio has been explained as representing the upper, middle, and lower reaches of Meru,[50] the Buddhist triple gem (the Buddha, the dharma [teaching], and the saṃgha [community]),[51] or three different buddhas,[52] but they may also be related to the three central channels[53] of the yogic subtle body. Indeed, the treasure-maṇḍala is commonly understood as having two distinct levels of symbolism, one as a representation of the entire physical universe that is presented as a material gift to the deity and another as a representation of the human body of the practitioner and the mechanisms for his or her enlightenment.[54]

After Meru, the practitioner establishes the rest of the cosmic geography and the treasures of the *cakravartin*. The four main continents are placed in the cardinal directions (4–7) and the four subcontinents in the intermediate directions (8–11) around the central mountain. The seven treasures of the *cakravartin* (12–18) are placed in a circle surrounding the geographic elements (the sword takes the place of the general). An eighth treasure, a jewel-vase that represents the collection of all material wealth (19), rounds out the set so that the treasures can be evenly arrayed in the cardinal and intermediate directions. The last elements of the maṇḍala are the sun and the moon (20, 21), which also have symbolism in the subtle body and are worshipped at other points in the guru-offering ritual. The sun and moon are sometimes depicted outside the maṇḍala proper, possibly because they are the only two elements strictly dissociated from the disc of the earth, moving through the sky around Meru and thus difficult to bind within a static representation of the world maṇḍala.

After its completion, the maṇḍala itself is revered before it is offered. It is adorned with additional flowers, incense, fruit, and items pleasing to the five senses. Then it is finally offered in its entirety to Vajrasattva, accompanied by a verse that summarizes the act. There are several slight variants of the formula, which can therefore be loosely translated as follows: "oṃ And thus, with full intention, I offer the treasure-maṇḍala, adorned with four-jeweled Meru, with eight continents (or peaks), and covered with seven (or various) treasures, to the great givers, the teacher, the Buddha, his teachings, and the Buddhist community."[55] In both this verse and the actual construction of the maṇḍala, the central idea is that of a unified landscape strewn with treasures. The seven treasures mentioned in the verse are the treasures of the *cakravartin*, and the emphasis on Meru and the continents recalls the *cakravartin*'s conquest of the four quarters. Imagery of the world strewn with treasure brings to mind Māndhātar's ability to make gold rain from the sky. Mention of Meru's four jeweled sides only adds to the language of wealth.

The world of the *cakravartin* is the perfect material for the offering, because it is characterized by righteous rule and material prosperity, not emptiness and enlightenment. Of course, the purified worlds of enlightened buddhas are also described as jewel-strewn paradises, partially because of the conflation of the buddha with the *cakravartin*, so there is not an absolute distinction. Indeed, later tantric theorization explicitly formulates such offerings as the constructs of an enlightened mind.[56] Still, the appearance of the seven treasures of the *cakravartin* reinforces the definition of this universe by the *cakravartin* ideal. In any case, this cosmos definitively lacks any signs of impurity that would not be suitable in a gift, such as the torments of the hell realms. Such sufferings could diminish the perceived success of the universal ruler and are not a pleasing gift to an honored teacher.

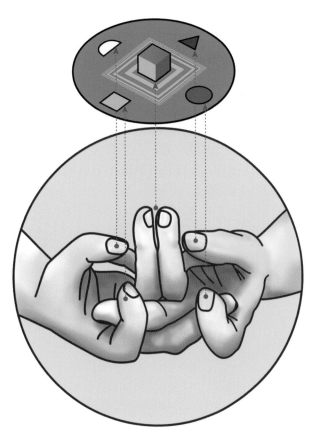

3.7. Relationship of the cosmic offering mudrā to the geography of Meru and the four continents

BODY, SPEECH, AND MIND IN THE RITUAL PERFORMANCE

While the object constructed in the cosmic offering and its textual correspondences invoke the world of the *cakravartin*, other modes of performance express alternative cosmologies that suggest more esoteric levels of interpretation. The actions of tantric rituals are generally divided into three categories relating to the performer's body, speech, and mind.[57] This threefold classification is based on a pre-tantric formula for encapsulating all types of intentional behavior,[58] and its use helps ensure that the practitioner engages in all possible ways for the success of the rite. The construction and offering of the cosmos are complemented by specialized ritual gestures, known as mudrās; powerful verbal invocations, known as mantras and seed syllables; and (theoretically) particular kinds of mental concentration or visualization, which cannot be directly observed.

In terms of bodily action, the ritualist performs a particular mudrā that depicts the cosmos in its own unique way at the moment of offering the completed treasure-maṇḍala (fig. 3.7). The gesture is formed by holding the two hands together in front of

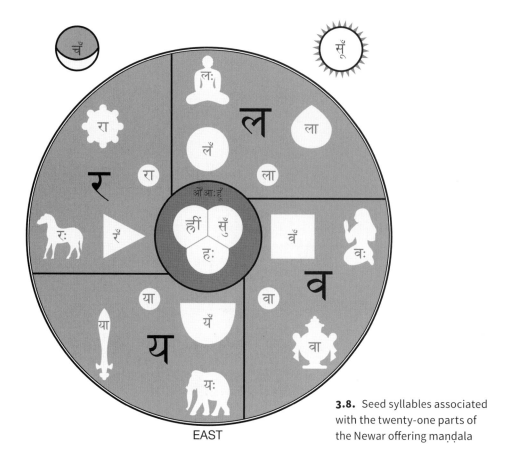

EAST

3.8. Seed syllables associated with the twenty-one parts of the Newar offering maṇḍala

the chest, with palms up. The two ring fingers point upward, back-to-back, forming the towering peak of Meru. The middle fingers and little fingers cross the centerline to lie in the opposite palms, while the index fingers and thumbs press down on these, forming four intersections that represent the four major continents around Meru. This five-part structure represents Meru and the four continents, but it also corresponds to other five-part systems like the five buddhas of the deity maṇḍala. This schema may also be a largely practical matter, since there are a limited number of ways to represent the cosmos with ten fingers, one of which is to pair them symmetrically into a fivefold arrangement.

Verbally, the practitioner also expresses a cosmos through pronunciation of seed syllables during the construction of the twenty-one-part maṇḍala. It is actually the proper pronunciation of the seed syllable or the mantra that effects the ritual, with mantras for deities in particular "considered to *be* the deity."[59] The seed syllables of the twenty-one parts fall into a clear pattern aligned along the cardinal directions (fig. 3.8). All the seed syllables in the east and southeast are governed by the root sound "ya" (य), in the south and southwest by "ra" (र), in the west and northwest by "la" (ल), and in the north and northeast by "va" (व).[60] These are the four semivowels of the Sanskrit

language and also the bases for the seed syllables of the four elements (wind, water, earth, and fire), as seen in the invocation of Vajrasattva above. The systematic use of these syllables across different contexts, such as for both the elements and the cardinal directions, suggests that even the material treasures can be interpreted on more esoteric levels. Not all seed syllables follow the same pattern, however. The seed syllables for the moon and sun, for example, are based on the first syllables of their Sanskrit names, _candra_ and _sūrya_.

The operations of the multiple modes of body, speech, and mind create structural parallels to other meaningful sets, such as the five buddhas of the deity maṇḍala or the four semivowels of the elements. Such overlaps prevent reification of any single, concrete interpretation of this ritual. While the trio of body, speech, and mind is fundamental to tantric ritual performance, let us remain with the cosmological thinking expressed in material and visual representations.

CONSTRUCTED OBJECTS AND VISUAL REPRESENTATIONS

Theoretically, visual representations of the offering could depict anything from the modest physical objects used in the ritual (small piles of grain) to the entire cosmos visualized in full detail (with mountains, continents, and treasures). The balance between these extremes of material object and conceptual ideal is mediated by the performance of the ritual. The flat, relatively unstructured Newar maṇḍala corresponds to depictions that emphasize its enclosed parts, whether piles of grain or the central mountain Meru. In comparison, the Tibetan offering emphasizes a more complex internal structure that visually encodes the immeasurable vastness of the offering.

It is also instructive to consider two very different examples of the modern Newar treasure-maṇḍala, one an ephemeral construction produced in ritual, the other a permanent metal sculpture. Because of this difference in materials, these two object engage in different modes of representation, with the sculpture more explicitly portraying iconographic details. Two types of painted representation of the ritual from the eleventh to thirteenth centuries appear closely related to these modern examples. One portrays nothing more than the ephemeral piles produced in the ritual, while the other depicts Meru and the sun and moon iconically with additional layers of esoteric symbolism, as in the sculpture. While the cosmology of scholasticism or maṇḍala meditation has been shown to vary due to different functions, in these cases, the function of the offering is essentially the same. The major differences in representation are mediated instead by the materiality of the offering and the procedures of its performance.

Modern Newar Treasure-Maṇḍalas

As an object constructed out of piles of powder, flowers, and grain, the traditional Newar treasure-maṇḍala can be nearly unrecognizable as a representation of the cosmos. The physical layout of the twenty-one parts follows a structure in keeping with

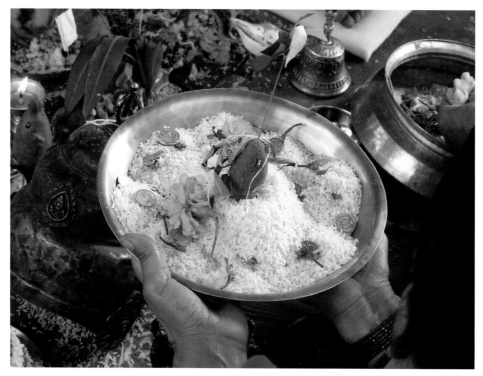

3.9. The Newar treasure-maṇḍala as piles of rice in a bowl. Patan, Nepal. Photograph courtesy of Manik Bajracharya

that of other kinds of maṇḍalas (concentric circles arranged symmetrically), with the exception of tripled Meru and the outlying sun and moon. Even so, the disorder inherent in making a pile of offerings often obscures the underlying structure.[61]

While the treasure-maṇḍala commonly is created on the flat plane of the floor, a version constrained in a bowl presents a clearer arrangement for visual analysis (fig. 3.9). This treasure-maṇḍala is composed of dry rice grains, representing the twenty-one parts of the offering, supplemented with additional coins, flowers, and other materials. One can discern a large central pile of rice that symbolizes Mount Meru, topped with a ball of dough pierced by a five-colored flag. Eight smaller mounds surround the central one, the four at the top of the photograph made more clearly visible by their outline against the rim of the bowl. Small coins cap and intersperse these mounds, additional offerings that presumably mark the locations of the various treasures. The rings of the continents and the treasures of the *cakravartin* seem to have been simplified in the action of piling to a single ring of eight nodules. Without the appurtenances of additional offerings, then, this representation of the cosmos consists essentially in one large, central pile of grain surrounded by eight peripheral piles arranged symmetrically in the octants. Although there is inherent three-dimensionality to this construction, its barest form is a two-dimensional array of nine elements, a circle of piles.

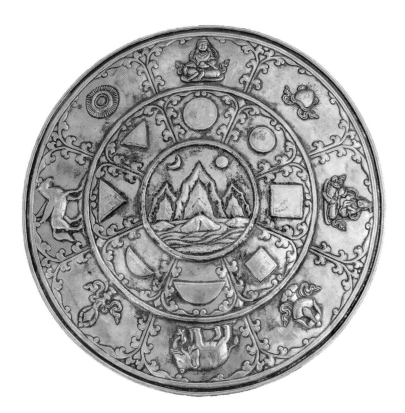

3.10. The Newar treasure-maṇḍala as a sculpture depicting the cosmic geography and treasures of the *cakravartin*. Collection of Naresh Man Bajracharya. Photograph by Sanuraja Vajracharya

While such ephemeral offerings are most common, sculptural maṇḍalas portray the iconography of the individual treasures in addition to their arrangement. Such sculptures, often made of precious metals like silver, are commissioned from artists and given on special occasions to real human teachers. Figure 3.10 illustrates one such maṇḍala that was offered to the Newar priest Naresh Man Bajracharya by his students. While one could create a silver maṇḍala made to look like nine piles of grain, iconography is paramount in this sculpture. The three aspects of Meru are clearly visible as three separate peaks at the center of the disc. Surrounding the peaks are the eight major and minor continents, while the outer ring depicts the treasures of the *cakravartin* plus the treasure vase. Each element takes the same place that it has in the performed ritual (see fig. 3.6), but unlike the piles of grain, each is easily discernible. The sun and moon, rather than being depicted outside the circle of the offering (which would present a sculptural challenge if nothing else), are portrayed in the sky above the elevation view of Meru. The relationship of the sun and moon to the three Meru peaks may also suggest a relationship to the yogic subtle body, as described above. The elevation view of Meru and the sun and moon (compared to the plan view of the continents) also draws special attention to these central features, here presented as a single coherent subject at the heart of the offering.

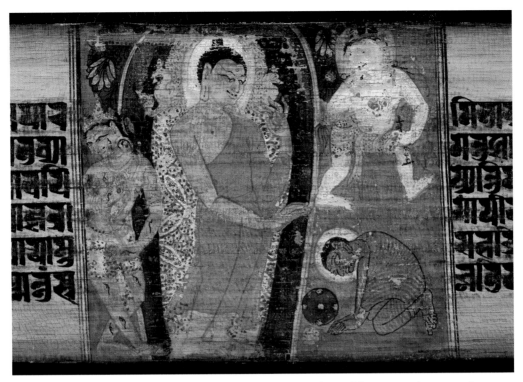

3.11. Pāla manuscript depicting a maṇḍala offering to the Buddha. Late 12th century. Reproduced courtesy of the Royal Asiatic Society of Great Britain and Ireland, Hodgson MS 1, 101v

Early Painted Representations

The modern Newar version of the maṇḍala offering has a remarkably long continuity that allows for comparison at least as far back as the eleventh century, including with textual sources.[62] Visual artifacts suggest a similar continuity and provide a further basis for comparison. The murals from Alchi are particularly noteworthy in presenting two quite disparate ways of visually depicting the cosmic offering. One type shows little more than the piles of grain arrayed in the material offering, while the other extracts Meru, the sun, and the moon to fit a more esoteric context.

To be clear, we can find early depictions of offering maṇḍalas from regions much closer to Nepal than Alchi. An eleventh-century Pāla manuscript in the collection of the Cambridge University Library seems to portray a practice very similar to the modern Newar tradition.[63] In an illustration on its final page, a monk sits beside several ritual objects on tripod stands and a large blue circle. The circle, filled with eight small groupings of colored dots around a larger central one, probably represents a treasure-maṇḍala (perhaps of flowers, given the multiple colors of the dots).[64] A slightly later, twelfth-century Pāla manuscript shows a similar offering being presented to the Buddha by a devotee (fig. 3.11).[65] In this scene from the Buddha's life, the nun Utpalavarṇā (in blue) bows behind a circular blue maṇḍala with a quincunx of dots inside, probably

a simplified depiction of the same offering.[66] Without labels for these illustrations, the identification is not conclusive, but at the very least, they provide a starting point for comparing portrayals of ritual objects in painting. The images are remarkably straight-forward in their representation of the actual materials of the offering, depicting a plan view of the grain or flower maṇḍala. Similar early images of the maṇḍala offering also appear on a painted book cover produced by Newar artists, an eleventh-century painting of Amitāyus in the collection of the Metropolitan Museum of Art, and an eleventh-century western Tibetan manuscript of the *Prajñāpāramitā* from Tholing.[67]

The images at Alchi, in turn, reveal two disparate ways of representing the cosmic offering that relate closely to the modern Newar material products. The first essentially replicates the images just described, presenting a plan view of the nine heaps of grain or flowers. One clear example of this appears in a panel depicting the buddha Akṣobhya on the first floor of the Sumtsek (fig. 3.12). Below the primary figure of Akṣobhya sit two figures, one on the left and one on the right, with an array of ritual paraphernalia between them. At the center is a large blue maṇḍala containing nine objects placed in an arrangement identical to that of the nine piles of rice in the cosmic offering — a larger one in the center surrounded by eight in the octants (fig. 3.13). The status of this arrangement as a ritual maṇḍala is further verified by the stepped pattern of the edges of the blue square on which these objects rest, a traditional way of representing the borders of a maṇḍala. Although this again is not definitively a treasure-maṇḍala, the image at least shows how such a construction could be portrayed in painting of this period.[68]

The greater pictorial context of the Alchi murals provides additional connections between this image and the cosmic offering. A nearby panel of the buddha Amitābha, also in the Sumtsek, shows the treasures of the *cakravartin* in a similar place (fig. 3.14). These are (left to right) the jewel (three-lobed), the horse, the minister, the wheel, the queen, the elephant, and the general. While this painting does not directly reference the maṇḍala, it suggests a thematic link between the *cakravartin* treasures and the cosmic offering.[69] Two similar images of Mañjuśrī in the Sumtsek (east wall, north and south sides) also make for a useful comparison. In the same register below the main figure, these two paintings depict the treasures of the *cakravartin* and a well-known set of eight auspicious items[70] that are included in the later Tibetan version of the maṇḍala offering.

Paintings of such offerings continue to be made with increasingly explicit cosmic imagery, strengthening the continuity of the Alchi murals with the modern treasure-maṇḍala. A fifteenth-century painting of Mahākāla shows a monk performing a ritual in front of a black circle arrayed with the major features of the cosmos (fig. 3.15). Here, the more recent Tibetan-style offering is intended, with twelve total continents in the four directions, colored red, blue, white, and yellow. Despite the difference in the in-ternal items of the offering, the plan-view portrayal amid other ritual objects suggests a link with earlier traditions.[71]

3.12. Akṣobhya panel. 12th–13th century. Sumtsek (north wall, east side), Alchi, Ladakh. Photograph by John C. Huntington, 1980, and courtesy of the Huntington Archive of Buddhist and Asian Art

3.13. Detail of ritual maṇḍala in figure 3.12, Akṣobhya panel. 12th–13th century. Sumtsek (north wall, east side), Alchi, Ladakh. Photograph by John C. Huntington, 1980, and courtesy of the Huntington Archive of Buddhist and Asian Art

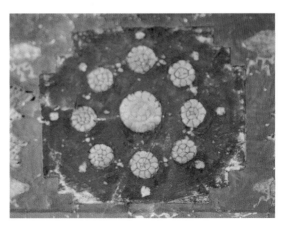

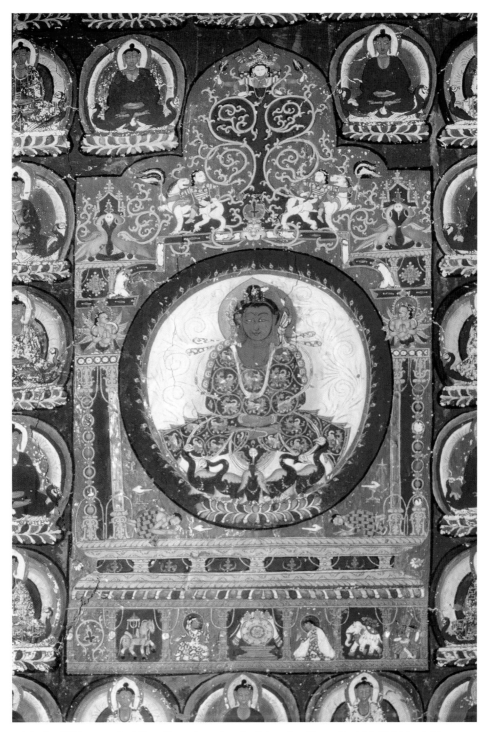

3.14. Amitābha panel. 12th–13th century. Sumtsek (west wall, south side), Alchi, Ladakh. Photograph by John C. Huntington, 1980, and courtesy of the Huntington Archive of Buddhist and Asian Art

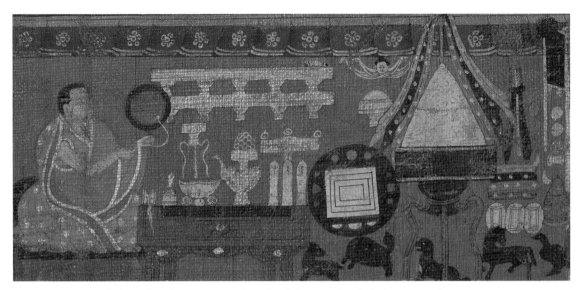

3.15. Detail of ritual performance in a *thangka* of six-armed Mahākāla. Early 15th century. Tibet. Photographer: Peter Horner; © Museum der Kulturen Basel, Switzerland; IId 13682, Essen collection. All rights reserved

The second group of images from Alchi, like the silver Newar platter, depicts explicitly cosmic iconography in elevation view, ignoring the material of the ritual. These images occur only in a single context, namely, at the base of paintings of the deity Mahākāla, a wrathful protector painted above doorways to shrines (on the interior wall) as a guardian of the sacred space. The clearest example of cosmic imagery below Mahākāla is in the Sumtsek (fig. 3.16). At the lowest register of the image appears a triangular altar (pointing downward) surrounded by perimeters of skull cups, *vajras*, and knives. At the center of this altar is a multicolored object, Mount Meru at the center of the cosmic offering (fig. 3.17).[72] The pointed terraces on either side of the central peak identify it as a sacred mountain, and the plants that cover the sides of the mountain suggest a paradisal location. The multicolored panels may even denote the jeweled facets of Meru.[73] Adding to the cosmic symbolism, the sun and moon appear in the sky above this central feature, with the black-line *vajras* inside them suggesting a more esoteric interpretation of the ritual, perhaps related to the subtle body. The image does resemble the central register of the silver Newar platter (see fig. 3.10), except for the tripling of Meru that apparently is limited to the more recent Newar tradition.

Other shrines at Alchi also have images of Mahākāla above their entrances, painted at different times and by different artists, each presenting an interpretation of this cosmic imagery. The mural in Alchi's assembly hall contains only the sun and moon, without Meru, suggesting that the esoteric symbolism of the ritual may be most fundamental (fig. 3.18). Two other murals in the Mañjuśrī shrine and the Translator shrine[74] replicate the image of the Sumtsek somewhat clumsily.

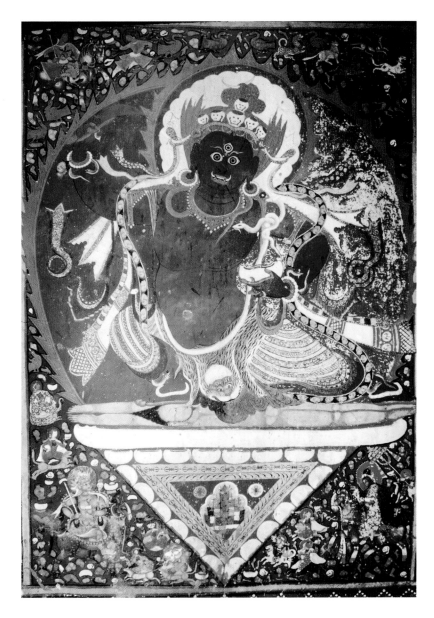

3.16. Mahākāla with altar. 12th–13th century. First floor, interior, above entrance, Sumtsek, Alchi, Ladakh. Photograph by John C. Huntington, 1980, and courtesy of the Huntington Archive of Buddhist and Asian Art

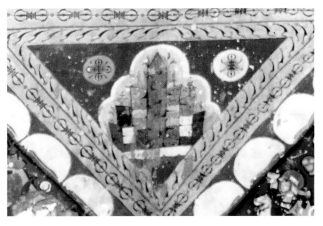

3.17. Detail of the altar below Mahākāla in figure 3.16. 12th–13th century. First floor, interior, above entrance, Sumtsek, Alchi, Ladakh. Photograph by John C. Huntington, 1980, and courtesy of the Huntington Archive of Buddhist and Asian Art

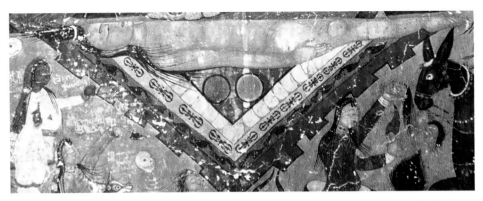

3.18. Altar below Mahākāla. Ca. 12th century. Interior above entrance, assembly hall, Alchi, Ladakh. Photograph by John C. Huntington, 1980, and courtesy of the Huntington Archive of Buddhist and Asian Art

Looking beyond Alchi, we see later examples in which the cosmic offering to Mahākāla becomes easy to recognize. There is the painting from the Essen collection illustrated in figure 3.15, showing a monk offering a Cakravāla maṇḍala to Mahākāla. Even more closely related, in architectural placement at least, is a contemporary offering banner hung above the interior of the entrance to the assembly hall at Lekir monastery, in Ladakh. This banner, located in the place that the mural of Mahākāla would occupy, represents a group of offerings to him centered around a large representation of Meru, the sun, and the moon (fig. 3.19). The peak of Meru is depicted as a palace drawn with red outlines at the top center of the banner, while the sun and moon are small circles within circles to the immediate left and right. Portraying the more recent Tibetan version of the treasure-maṇḍala, this painting shows the palace of Meru atop a pile of smaller peaks that represent the seven ranges of golden mountains and almost fill the central third of the banner. Such imagery of the offering as a massive heap defines later Tibetan tradition. The type of composition on this banner, featuring a wide array of wrathful offerings,[75] also becomes one of the most common places to find images of the cosmic offering in the Tibetan context.

While not all the early images from the Pāla manuscripts, Tholing, and Alchi definitively represent cosmic treasure-maṇḍalas, their similarities are suggestive, creating the opportunity to draw a history of depictions of the ritual that we can compare with later Tibetan developments. The two modern Newar objects, the rice maṇḍala and the silver platter, exhibit two different modes of representation, one in terms of a ritual performed with sacred substances and the other with iconic imagery. These same themes exist in the murals at Alchi, some of which depict circles of rice or flowers in a ritual performance and some of which depict only Meru and/or the sun and moon in the altars below Mahākāla. In later Tibetan traditions, differences in performance and visualization use the internal structure of the cosmic offering to emphasize its height as a towering mountain of treasures.

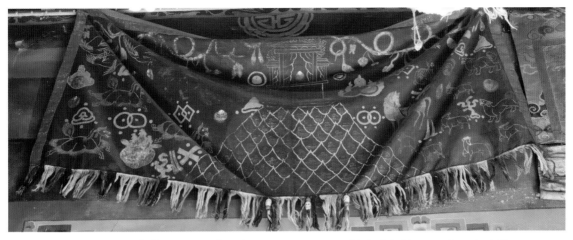

3.19. Banner of offerings. Interior, above entrance, assembly hall, Lekir monastery, Ladakh

Creating (the Tibetan Offering of) the Universe: A Layered Mountain

The cosmic offering is perhaps even more widespread in Tibet than in Nepal. It also commonly occurs as the centerpiece of a longer ritual called an "offering to the teacher,"[76] although this ritual differs somewhat in its details from the Newar practice. The Tibetan offering is probably best known as part of the preliminary practices[77] undertaken before engagement with more esoteric tantric systems. In this context, a student should offer the maṇḍala of the cosmos at least one hundred thousand times. In many monasteries, the text of the ritual is recited daily.[78] The maṇḍala offering is sometimes said to include the essence of all Buddhist rituals and practices except for certain specialized rites.[79]

While we have evidence that the maṇḍala offering was performed as early as the eleventh century, its prominence in artwork increases noticeably following the seventeenth century. During this time, the Panchen Lama Lobsang Chokyi Gyaltsen[80] wrote a guide for the practice that became extremely influential. Gyaltsen is considered to be a reincarnation of Khedrup, the direct disciple of Tsongkhapa (the founder of the Gelug school), reinforcing the significance of this ritual for the guru-disciple relationship. The Panchen Lama's liturgy, along with the contemporaneous rise of Gelug political authority in Tibet,[81] undoubtedly promoted the widespread performance of this ritual, which continues to this day, even beyond the Gelug school. Of course, the Gelug lineages are not the only traditions of the offering to the teacher. The Longchen Nyingthig[82] tradition of the Nyingma school traces its guru offering to Phagpa Lodro Gyaltsen,[83] the thirteenth-century leader of the Sakya[84] school.[85] An eighteenth-century text[86] by Jigme Lingpa,[87] whose influence also popularized the tradition, is another major reference point for the later Nyingma tradition.

3.20. Khedrup presenting the maṇḍala offering at the base of a field of accumulation. Detail of *Field of Accumulation of the Offering to the Teacher.* Late 19th–early 20th century. Tibet. Saint Louis Art Museum, Gift of Margaret M. Hibbard in memory of George E. Hibbard (formerly in the collection of George E. Hibbard), 260:1992

The guru-disciple relationship of Tsongkhapa and Khedrup has become a major theme in artistic depictions of the maṇḍala offering. The portrait of Khedrup presenting the treasure-maṇḍala to his teacher became the model on which more generic images of guru devotion and donorship were based.[88] This artistic tradition takes hold even in lineages not associated with Khedrup or the Gelug, so that the image of a monk holding an offering maṇḍala becomes the preferred icon for representing the devotion of a disciple (fig. 3.20). This has the effect of idealizing the image of a monk offering the treasure-maṇḍala as a model for personal emulation, which also increases the importance and popularity of the cosmic offering and its imagery.

In addition to these specific personages, differences in the structures of Tibetan monasticism (as compared to those in Nepal) may have led to the greater extravagance and popularity of the teacher-offering in Tibet. In the Newar community, tantric practitioners are essentially married priests who undergo temporary ordination as

monks when they are young.[89] Monastic lineage can be based on direct family and caste relationships. The Tibetan system, which maintains a largely celibate monastic community, creates lineal continuity mainly through the guru-disciple relationship, uncle-nephew familiality, and the later system of reincarnate lamas.[90] The relationship between student and teacher, already at the ideological center of all tantric Buddhism, comes to the fore socially and economically in Tibet, promoting the expression of this relationship in ritual and artwork.

While the different schools of Tibetan Buddhism advance their own variations of the maṇḍala offering, most sources describe very similar versions and even acknowledge the alternatives of the other schools as valid. With this in mind, the following analysis compares a broadly Tibetan version of the ritual with the Newar tradition, addressing sectarian differences only when they are cosmologically significant.

RITUAL TEXT AND PRACTICE

As in Nepal, the Tibetan maṇḍala offering frequently combines with other rites, but the two cosmologically significant parts of the ritual are the generation of the recipient maṇḍala and the construction of the treasure-maṇḍala. Both recipient and offered maṇḍalas can appear as ephemeral or durable objects during the ritual performance, and both are commonly represented in other paintings and sculptures. In most cases, the Tibetan cosmologies are significantly more complicated than the Newar versions, having more parts and more internal structure, with correspondingly more layers of interpretation.

The recipients of the offering are commonly generated as an accomplishment[91] maṇḍala or a field of accumulation.[92] The practitioner may create the accomplishment maṇḍala as an ephemeral object by piling heaps of grain on a circular platter, which is then placed on an altar to which the subsequently produced treasure-maṇḍala is offered. Five heaps of grain on the accomplishment maṇḍala can represent the five buddhas at the center of the Vajradhātu maṇḍala (Vairocana, Akṣobhya, Ratnasambhava, Amitābha, and Amoghasiddhi) or a physical simplification of the field of accumulation. Alternatively, the practitioner may generate the recipients through visualization without physical supports.

The field of accumulation contains a host of deities and teachers better understood through visualization or painting than as an ephemeral grain maṇḍala (fig. 3.21).[93] The visualization typically begins with a large, wish-fulfilling tree that arises from an ocean of milk or nectar. The various gurus and deities of one's lineage populate the branches of this tree, filling the directions like the quadrants of a maṇḍala. At the peak of the tree and center of the image sits the root guru, the single teacher or deity to whom the offering is presented, often the founder of a lineage. The Gelug would place Tsongkhapa or Śākyamuni at the center,[94] where the Nyingma school might portray Padmasambhava. At the bottom-right corner of the painting (see detail in fig. 3.20),

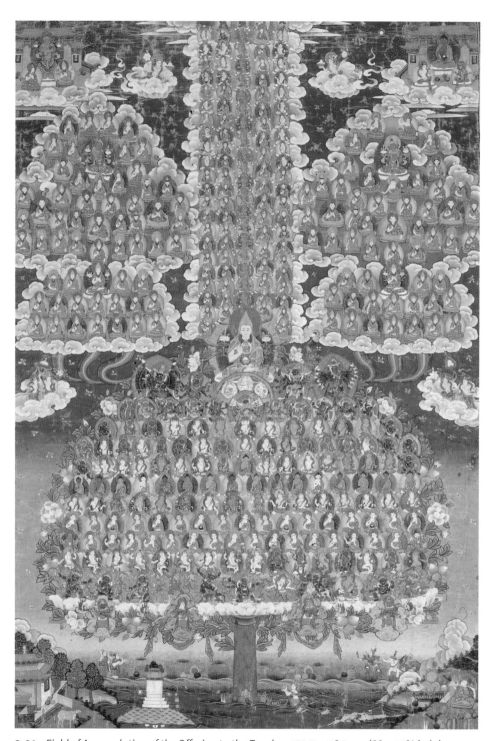

3.21. *Field of Accumulation of the Offering to the Teacher.* 172.7 × 116.2 cm (68 × 45¾ in.); image: 92.1 × 62.2 cm (36¼ × 24½ in.). Late 19th–early 20th century. Tibet. Saint Louis Art Museum, Gift of Margaret M. Hibbard in memory of George E. Hibbard (formerly in the collection of George E. Hibbard), 260:1992

Khedrup presents the maṇḍala to Tsongkhapa, the central figure of this field of accumulation. Also visible in this same bottom register are other jewels and treasures of the maṇḍala offering, including the cosmic geography and the treasures of the *cakravartin* (see fig. 3.38).

Like the recipient maṇḍala, the treasure-maṇḍala can also be constructed ephemerally (which is helpful when it needs to be produced one hundred thousand times) or as a permanent object of art. Even when produced by piling grain, however, the Tibetan tradition requires a sculptural offering platter on which the grain is distributed — unlike the Newar version that can be made on the ground or in a simple bowl. Emphasis on this platter corresponds to a different way of performing the ritual in Tibet and significant elaborations on the cosmology of the ritual, eventually becoming the basis for sophisticated sculptures that three-dimensionally represent each element of the cosmic offering.

As the physical objects of the Tibetan offering are more complex, so, too, is its structure. While the Newar treasure-maṇḍala has twenty-one parts, the paradigmatic Tibetan version has thirty-seven separate elements, with other variations in sets of one, five, seven, nine, thirteen, seventeen, twenty-one, twenty-three, or twenty-five. For the most part, these variations represent alterations to the complete thirty-seven-part maṇḍala, and several of these variants may occur in a single ritual as the offering is reiterated. Although it is regarded as acceptable to produce the treasure-maṇḍala based on alternative cosmologies, such as the Wheel of Time rather than the *abhidharma*,[95] this seems to be done rarely. It is also difficult to identify any paintings or sculptures of offerings that represent the Wheel of Time cosmos explicitly. One commentator suggests that even when the offering maṇḍala is produced in the Wheel of Time tradition, the only difference is the addition of Rāhu and Ketu,[96] two astrological deities in the same category as the sun, moon, and planets, who symbolize eclipses and meteors, respectively.

The fact that the paradigmatic form of the offering maṇḍala has thirty-seven parts is no coincidence. The number thirty-seven has early significance in the set of the thirty-seven factors of enlightenment,[97] a term and list that appear in a variety of Sanskrit and Pāli literature,[98] including Buddhaghosa's *Path of Purification*.[99] While philosophical and practical explanations of these factors differ, the idea of the thirty-seven factors appears across all paths of Buddhism;[100] it also forms the basis for numerous tantric maṇḍalas including the Vajradhātu and Cakrasaṃvara maṇḍalas (major forms of which have thirty-seven deities). The commonality of the thirty-seven-part scheme creates associations between levels of Buddhist practice, from the basics of the path to esoteric meditations. Arriving at this special number in the offering may be one reason, along with the need for symmetry, that some of the sets of treasures included in the thirty-seven-part maṇḍala are incomplete.

To the following typical liturgy for the offering are added numerals (1–37) to identify the thirty-seven parts of the main offering and lowercase Roman numerals (i–vii) to indicate the accompanying seven-part offering:

OM VAJRA BHUMI AH HUM

Great and powerful golden ground,

OM VAJRA REKHE AH HUM

At the edge the iron fence stands around the outer circle.

In the centre (1) Mount Meru, the king of mountains,

Around which are the four continents:

In the east, (2) Purva-Videha, in the south (3) Jambudvipa,

In the west, (4) Apara-godaniya, in the north, (5) Uttarakuru.

Each has two sub-continents:

(6) Deha and (7) Videha, (8) Camara and (9) Apara-camara,

(10) Satha and (11) Uttara-mantrina, (12) Kurava and (13) Kaurava.

(14) The mountain of jewels, (15) the wish-granting tree,

(16) The wish-granting cow, and (17) the harvest unsown.

(18) The precious wheel, (19) the precious jewel,

(20) The precious queen, (21) the precious minister,

(22) The precious elephant, (23) the precious supreme horse,

(24) The precious general, and (25) the great treasure vase.

(26) The goddess of beauty, (27) the goddess of garlands,

(28) The goddess of music, (29) the goddess of dance,

(30) The goddess of flowers, (31) the goddess of incense,

(32) The goddess of light, (33) the goddess of scent.

(34) The sun and (35) the moon, (36) the precious umbrella,

(37) The banner of victory in every direction.

In the centre all treasures of both gods and men,

An excellent collection with nothing left out.

I offer this to you my kind root Guru and lineage Gurus,

To all of you sacred and glorious Gurus;

. . . [worship of specific lineage omitted here]

Please accept with compassion for migrating beings,

And having accepted, out of your great compassion,

Please bestow your blessings on all sentient beings pervading space.

The ground sprinkled with perfume and spread with flowers,

The (i) Great Mountain, (ii–v) four lands, (vi) sun and (vii) moon,

Seen as a Buddha Land and offered thus,

May all beings enjoy such Pure Lands.

I offer without any sense of loss

The objects that give rise to my attachment, hatred, and confusion,

My friends, enemies, and strangers, our bodies and enjoyments;

Please accept these and bless me to be released directly from the three
 poisons.

[I OFFER THIS JEWEL-MAṆḌALA TO THE TEACHER.][101]

Meru and Continents	1 Sumeru	2 Pūrvavideha	3 Jambudvīpa	4 Godānīya	5 Uttarakuru
Subcontinents		6 7 Deha Videha	8 9 Cāmara Aparacāmara	10 11 Śāthā Uttaramantriṇa	12 13 Kurava Kaurava
Continental Treasures		14 Jewel Mountain	15 Wish-granting Tree	16 Wish-granting (Milk) Cow	17 Unsown Harvest
Cakravartin Treasures plus Treasure Vase		18 Wheel	19 Jewel	20 Queen	21 Minister
		22 Elephant	23 Horse	24 General	25 Treasure Vase
Offering Goddesses		26 Beauty/Play	27 Garland	28 Song	29 Dance
		30 Flowers	31 Incense	32 Lamp/Light	33 Perfume
Sun, Moon, Parasol, Banner		34 Sun	35 Moon	36 Parasol	37 Banner

3.22. Categories of treasures in the thirty-seven-part Tibetan treasure-maṇḍala

The offering begins with the invocation of the base layer and boundary of the cosmos, the layer of golden earth and the perimeter Cakravāla mountains (the "iron fence"). Since these are conceptually part of the metal offering platter, they are not included in the list of items installed on the platter. The latter fall into several basic categories of cosmic geography and treasure (fig. 3.22). First come Meru and the four major continents, followed by eight subcontinents. Each major continent is associated with a

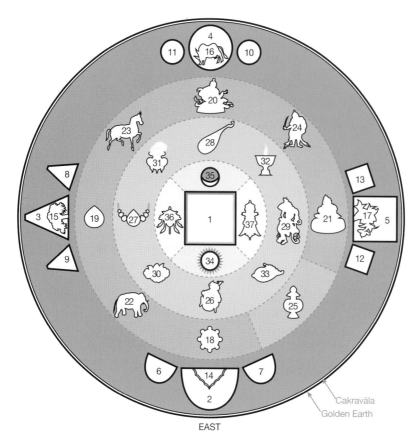

3.23. Ritual placement of the thirty-seven parts of the Tibetan treasure-maṇḍala

particular miraculous wealth, such as a wish-fulfilling tree, a wish-granting cow, or a crop that is harvested without needing to be sown, and these four regional treasures are installed next. With the localized geographic elements settled, the seven treasures of the *cakravartin* and treasure vase appear, making a set of eight as in the Newar version. Following this, eight offering goddesses form another grouping, probably an abridgment of the full set of sixteen,[102] who typically are invoked in the Newar ritual after the maṇḍala has been completed. Then the sun and moon join two additional offerings, a parasol and a banner, to create a set of four. These last two are emblems of royalty and victory from the well-known set of eight auspicious items. Between these and the halving of the number of goddesses, two well-known sets of treasures have been truncated in order to force the treasure-maṇḍala into thirty-seven parts.

The arrangement of these treasures in the treasure-maṇḍala is more complex and rigidly symmetrical than in the Newar version (fig. 3.23). There are no misfit elements like the tripled Meru or outlying sun and moon. The continents form the most exterior ring, encapsulating all the other treasures within the geographic structure of the

EAST

3.24. Ritual placement of the seven parts of a Tibetan offering maṇḍala. After Kongtrul, *The Torch of Certainty*, 117

cosmos. The pairs of subcontinents are tightly bound to their quadrants, rather than filling the intermediate directions, and the continental treasures are installed in their geographic places along with the continents. Proceeding inward, the *cakravartin* treasures and treasure vase receive their own circle, as an independent set, as do the eight offering goddesses, presenting no particular surprises. In the final interior ring, the sun and moon are paired with the parasol and banner, creating a circle of four items symmetrically arrayed in the quadrants. All in all, the thirty-seven-part maṇḍala is significantly more regular and symmetrical than the twenty-one-part maṇḍala.

The seven-part treasure-maṇḍala invoked in the verse can also be created as a physical maṇḍala (see fig. I.5), in which case the arrangement is suitably simpler but sometimes strives to maintain the appearance of symmetry (fig. 3.24). Since the sun and moon are not paired with the parasol and banner, their axis can be rotated 45 degrees so that they fall in the intermediate directions, preventing any two cardinal directions from being overweighted with elements.

The greater internal symmetry of the Tibetan maṇḍalas serves as a framework for more three-dimensional representations in both ritual ephemera and artwork. Despite its highest number of elements compared to other variants, the thirty-seven-part maṇḍala also has the highest-order symmetry, comparable to the simplest, five-part version (fig. 3.25). The seventeen-, thirteen-, and twenty-five-part maṇḍalas have essentially the same structure as the thirty-seven-part maṇḍala, reduced variously by the parasol and banner, sun and moon, eight offering goddesses, and eight items in the ring of *cakravartin* treasures. The seven- and twenty-three-part maṇḍalas have only two-fold symmetry because of the unpaired duo of sun and moon. The twenty-one-part

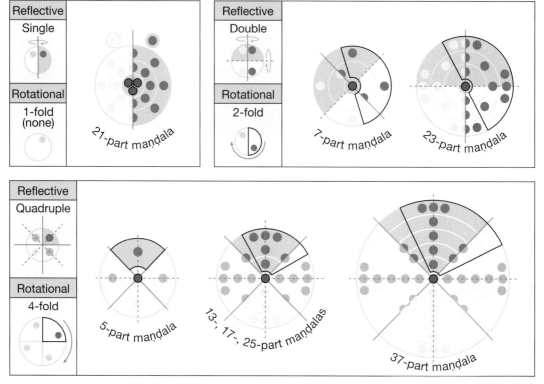

3.25. Symmetries of the various Newar and Tibetan treasure-maṇḍalas

Newar version, with its tripled Meru and outlying sun and moon, is actually the least symmetrical, despite its portrayal in artwork as a circle of nine elements. The regular structure of the thirty-seven-part Tibetan version, akin to the architecture of the three-dimensional maṇḍala palace, contributes to the remarkably different realization of the Tibetan offering of objects in material culture.

MATERIALS AND STRUCTURES OF CREATION

A modern Mongolian offering in the Tibetan Gelug tradition illustrates the essential difference between the ephemeral maṇḍalas of Tibet and their Newar counterparts (compare figs. 3.26 and 3.9). Where the Newar version has a central mound for Meru and eight identifiable piles around the periphery, the Mongolian maṇḍala is a single, massive heap with stacked rings of beads reinforcing the height of the pile. In many cases, these rings are made of sculpted metal that forms a matching set with the ornamented offering platter. When filled with grain and stacked, they create a much more elevated gathering of offerings than could be presented as a natural mound (fig. 3.27). This conception of the offering as a stacked heap distinguishes the Tibetan offering in its performance, materiality, symbolism, and representation in artwork. Most

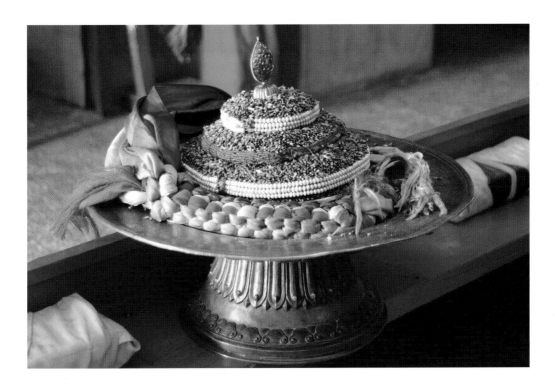

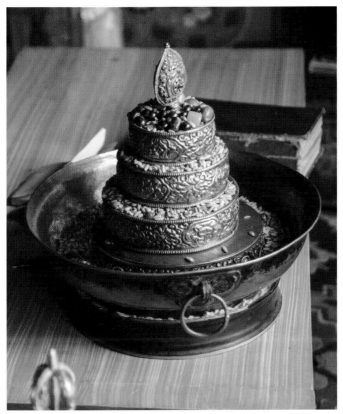

3.26. (*Above*) Heaped treasure-maṇḍala offering. Kālacakra Tantric Institute, Ganden Khiid, Ulaanbaatar, Mongolia

3.27. (*Left*) Stacked treasure-maṇḍala offering. Spituk Gompa, Ladakh

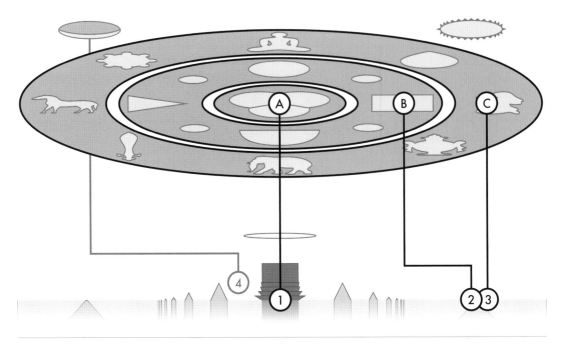

3.28. Newar treasure-maṇḍala mapped to the hierarchical structure of the cosmos

essentially, the arrangement of parts within the offering corresponds to an inherently hierarchical cosmic structure and an overall emphasis on height. The conspicuous verticalization of the object also promotes new layers of symbolism, such as a view of the offering as overflowing in its richness, as well as an identification of the heaped offering with the jeweled and towering Mount Meru.

Figures 3.28 and 3.29 show the flat Newar offering and the inherently verticalized Tibetan structure. The major difference between the two traditions is that the Newar performance proceeds from the center outward in a flat plane, while the Tibetan version builds up layers from the exterior toward an ever-heightened center.

The Newar maṇḍala (fig. 3.28) is created in three separate rings of items, each increasing in diameter beyond the last, plus the sun and moon. Tripled Meru comes first at the center (A), followed by the continents and subcontinents around it (B). The treasures of the *cakravartin* are produced in the most exterior ring (C). Since all the offerings are established on a flat surface that represents the disc of the earth, they are conceived on the same ground plane (1–3) and cannot express a lower elevation with greater exteriority. Although the central mound of Meru can be made taller than the rest of the structure in recognition of its size and significance (see fig. 3.9), the order

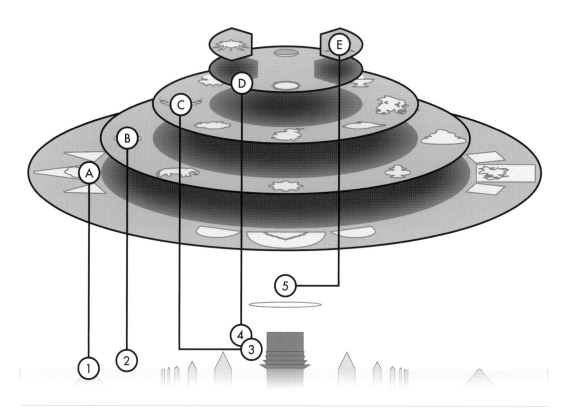

3.29. Tibetan treasure-maṇḍala mapped to the hierarchical structure of the cosmos

of operations within the maṇḍala does not correspond to a vertical hierarchy. Indeed, even the modest elevation of the sun and moon seems to prompt their separation from the structure of the maṇḍala proper (4).

The contrasting Tibetan thirty-seven-part maṇḍala (fig. 3.29) proceeds essentially from the most exterior ring toward the center, conceptually elevating each interior round to suggest inherent verticality. Recalling the diagram of cosmic structural principles in figure 1.14, it makes perfect sense that a movement toward the center would also imply a movement upward. Only central Meru does not fit this pattern, being established first as the central item of the maṇḍala. Following this, the practitioner immediately proceeds to the very exterior to produce the continents, subcontinents, and geographic treasures (A). Proceeding inward, the *cakravartin* treasures occupy the next interior ring (B), followed by the offering goddesses (C), the sun and moon (D), and the parasol and banner (E). At each stage, the ritual movement inward is associated with a structural movement upward, creating an ever-heightening heap. Although the parasol and banner can be paired with the sun and moon for purposes of symmetry, their membership in a separate conceptual set means that it is possible to consider them as an even higher round of offerings.

The increasing elevation of each round of offerings also corresponds to the cosmological locations of the individual treasures themselves. Obviously, the continents and subcontinents, lying on the ground plane, are the most peripheral and base (1). As already mentioned, the wheel-treasure of the *cakravartin* is sometimes said to rest in the sky above the universal monarch, so it is not a stretch to imagine all the treasures of this category similarly aloft, as several commentators suggest.[103] Their greater elevation might also be expressed as a greater interiority in cosmic space, even though they occupy the same geographic region as the continents (2). Next, the offering goddesses are both more interior and at a greater height, being explicitly associated with the terraces of Meru (3).[104] Paintings of the offering goddesses sometimes show them clearly residing on Meru's fourth and highest terrace (see figs. 4.14 and 4.15). The sun and moon, while technically at the same height as Meru's fourth terrace, are less grounded than the goddesses and therefore even more elevated (4). The final offerings of the parasol and victory banner, being associated with the Buddha and the *devas*, are visualized among the divine heavens atop Meru and therefore at the peak of the cosmos (5).[105] Rather than a simple list of treasures filling the universe, the Tibetan offering is a vertical reconstruction of the entire cosmos from its base geography to its heavens (minus, of course, the hell realms). The Newar version, being constructed from the center outward, cannot grow upward in this way, remaining essentially a two-dimensional diagram.

In addition to this conceptual and internal vertical structure, some commentators also identify the constructed tiers of material maṇḍalas with specific levels of cosmic geography, but the details can vary remarkably. In one tradition, the platter and three rings represent the four tiers of Meru, with a finial signifying the palace of Śakra on top.[106] This certainly affirms the visual similarity between the stacked tiers and Meru, strengthening the identification of the treasure-maṇḍala with a literal mountain of wealth. In another tradition, "the base symbolizes the golden ground of the world system; the first ring is the iron fence and continents; the top two or three rings represent the levels of Mount Meru above the ocean; the maṇḍala top symbolizes the precious things in the whole universe."[107] Here, the rings essentially recapitulate the entire cosmos of the offering, even duplicating the continents that are explicitly created with piles of grain. This interpretation is supported when the different rounds of treasures are installed separately in each ring.[108] The first ring can contain the continents and continental treasures, the second the treasures of the *cakravartin*, the third the goddesses on the terraces of Meru, and so on.

Sometimes, the sculpted decorations on the outside of the maṇḍala rings actually represent the separation of the offerings into the tiers of cosmic hierarchy. In an example from Tashi Lhunpo monastery (fig. 3.30), the continents are depicted on the lowest tier, with the *cakravartin* treasures on the tier above them (the upper tiers are obscured by additional offerings). Unfortunately, this practice is far from consistent, and other tiered maṇḍalas may depict other treasures on their tiers. A survey of many

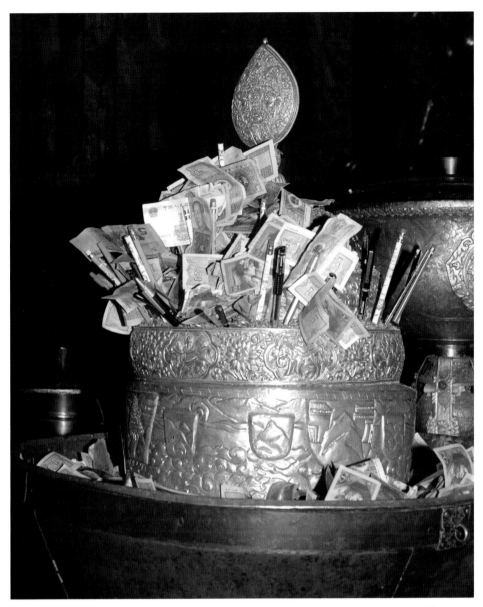

3.30. Treasure-maṇḍala offering with continents depicted on lower tier, treasures of the *cakravartin* on the second tier, and offerings of money and pens added to the top. Tashi Lhunpo monastery. Photograph courtesy of Dina Bangdel

dozens of these sculptures indicates that the cosmic hierarchy usually is maintained in a general way. When they appear at all, the continents are always on the lowest ring or the base platter itself. The *cakravartin* treasures are generally below the offering goddesses. The eight auspicious treasures can appear on almost any level of the sculpture but are among the only treasures that can appear at the very top tiers of the imagery.

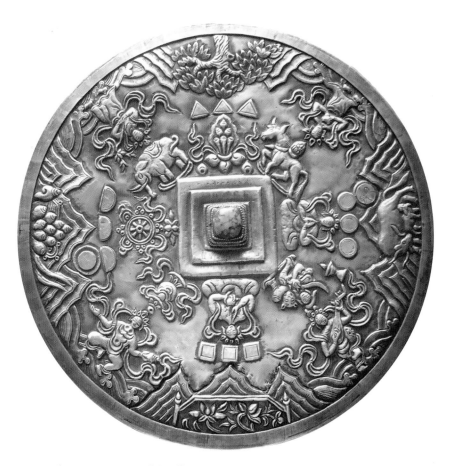

3.31. Silver treasure-maṇḍala offering platter. Leh, Ladakh

Beyond the treasures in the thirty-seven-part liturgy, many other treasures and offering substances also appear to further emphasize the wealth and completeness of the offering object.

The Tibetan tradition also commonly produces treasure-maṇḍalas without any tiers at all, but often with the vertical hierarchy still inherent in the conceptual structure. One way of performing the ritual is to pile grain diagrammatically on the flat base platter. In this case, the maṇḍala does not form a single central heap but still contains within it the cosmology of increasing altitude toward the center. The flat offering maṇḍala can also be created as a sculptural object very similar to the silver Newar platter in figure 3.10. One example from Ladakh, India (fig. 3.31), lays out the continents, treasures, and goddesses in a single plane, with Meru marked by a piece of turquoise. In this case, the treasures do not follow the normal arrangement of cosmic hierarchy, perhaps in part because it is produced on a flat surface with no need for

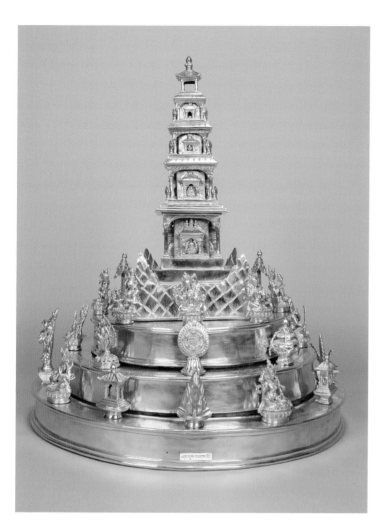

3.32. Three-dimensional treasure-maṇḍala cosmos. 2002. Nepal. Collection of the National Museum of Ethnology, Japan (H0229538)

vertical structure. The treasures of the continents and the offering goddesses (four in the intermediate directions standing in for eight) appear in the very exterior ring. Moving inward, the continents are next, followed by the treasures of the *cakravartin*.

The most elaborate and lavish treasure-maṇḍala objects are highly detailed three-dimensional models of the cosmos as it is conceived through the offering ritual. These were especially popular during the Qing dynasty (1644–1912) and often feature detailed sculptures of all thirty-seven parts of the offering, including an impressively towering Meru in the center.[109] Similar sculptures of the offering cosmos have recently been produced in Nepal, possibly due to the influence of Tibetan tradition. One such maṇḍala belongs to the collection of the National Museum of Ethnology, Japan (fig 3.32). This particular sculpture is labeled with Tibetan inscriptions, and a similar one bearing a Sanskrit inscription was dedicated to one of the shrines at Svayambhū in Kathmandu. Both objects essentially follow the ascending scheme of the Tibetan ritual,

with continents in the exterior ring followed by interior and ascending rings of the *cakravartin* treasures, offering goddesses, and so on.

Despite the opposition between Newar and Tibetan traditions, their occasional conflation is not at all surprising, since the conception of the cosmos behind the offering is nominally the same. Regular historical contact between Newars and Tibetans, combined with the commercial availability of Tibetan-style platters and rings, may have made the Tibetan version appealing to some Newar practitioners. Indeed, at the Newar performance during which the offering in a bowl was photographed (see fig. 3.9), a Tibetan-style offering of sculpted metal rings was also present.[110] The purpose in contrasting "Newar" and "Tibetan" offerings has been not to essentialize either tradition or reify a specific model of offering but rather to characterize different ways of thinking about the cosmic structure of the offering through specific examples.

MULTIPLICATIONS OF SCALE AND SYMBOLISM

The notion of the treasure-maṇḍala as a heaped mountain of treasures helps emphasize the enormity and completeness of the gift of the cosmos, but Tibetan traditions also employ numerous other strategies to the same effect. The very act of assembling the treasure-maṇḍala abbreviates the vastness of the cosmos, necessitating symbols of its regrowth and expansion. Several complementary strategies offset finitude and enhance scope, including meditative visualizations, modifications to the ritual and materials of offering, and the addition of extra symbolic elements to the performance and iconography.

In one sense, no modification to the ritual is necessary, since commentators instruct that no matter how small the offering, the practitioner should visualize the entire cosmos in detail. A Tibetan *thangka* of Milarepa[111] depicts exactly this, showing a figure presenting an offering platter out of which emanates a visualization of the entire Cakravāla cosmos (fig. 3.33). Commentators also mention visualizing numerous valuables beyond the geographic and treasured items of the liturgy, including the seven golden mountains around Meru, the oceans, miraculous medicines, musical instruments, and any other form of wealth one could conceive. Jamgon Kongtrul summarizes this approach quite well: "[As you recite the liturgy,] mentally offer all things which gratify the senses of sight, hearing, smell, taste and touch, as well as [things offered by] the servants of gods and goddesses. In brief, imagine that you are offering all the possessions of gods and men that can possibly be accumulated, as well as all the wonderful things in the ten directions which are not owned by anyone."[112] During the ritual performance, the practitioner may symbolize these additional treasures by spreading an extra handful of grain on top of the thirty-seven heaps already constructed.[113] Despite the utter completeness of this visualized universe, the practitioner also visualizes it multiplying thousands upon thousands of times, creating a triple-thousand-great-thousand world-system of perfected cosmoses. This increases

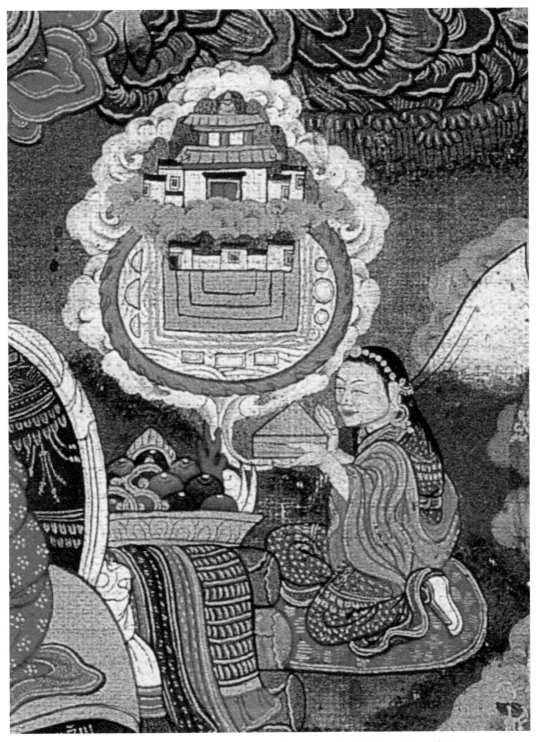

3.33. Cosmos emanating from a maṇḍala offering in a detail of a painting of Milarepa. Collection of the Hwajeong Museum, courtesy of the Hahn Cultural Foundation. After Tanaka, *Art of Thangka*, 111

the material offering to the greatest scale theorized in scholastic literature, the most universal of universes.

Still, this is not enough, and in many practices, a thirty-eighth element fills every atom-size unit of space with additional treasures. This is known as Samantabhadra's cloud of offerings, and it is ritually associated with the placement of the ornamental finial on top of the completed treasure-maṇḍala piles of grain (see figs. 3.26, 3.27, and 3.30).[114] The performance takes its name from the bodhisattva Samantabhadra,[115] who famously concludes the *Flower Array Sūtra* with a set of vows regarding his practice, including the presentation of offerings.[116] The ritual emulates Samantabhadra's own performance with universe-pervading imagery like that of the *Flower Array Sūtra*:[117] "The Bodhisattva Samantabhadra emanated from his heart hundreds of thousands of millions of many-colored [rays of light], equal in number to the grains of dust in unnumbered buddhafields. At the end of each ray, he again visualized a form of himself and from the heart of each emanation, the same number of light rays were projected with another emanation of himself appearing at the end of each until they became unimaginably countless, with each emanation making an inconceivable array of offerings to the Buddhas and Bodhisattvas of the ten directions. Such is Samantabhadra's 'cloud of offerings.'"[118] It is hard to imagine a better expression of truly uncountable offerings than this imagery, in which not only the offerings but the offerer himself literally fills up, purifies, and transmutes all of space.

Beyond visualizing and adding to the specific elements of the offering, material aspects of its construction can also emphasize its increase and vastness. As handfuls of grain are piled on top of one another, the grain cascades into the surrounding layers, suggesting overflowing abundance (at least until it is caught in the large bowl in which the treasure-maṇḍala is constructed) (see fig. 3.27). Gemstones or colorful beads that suggest jewels may substitute for the grain, implying greater wealth (fig. 3.34, left). On special occasions, treasure-maṇḍalas of great size may be produced, towering almost two meters high (fig. 3.34, center). When a treasure-maṇḍala is installed on an altar as a semipermanent offering, visitors to the shrine may add paper money or coins, as well as incense, scarves,[119] and beaded garlands, both increasing and participating in the offering (fig. 3.34, right). In the maṇḍala illustrated in figure 3.30, pens and pencils have even been added in prayer for children's success with school examinations. For permanent, sculptural maṇḍalas, there is also the possibility of adding to their lavishness by paying for more valuable materials, better craftsmanship, and larger size.

The symbolism of the offering can also be multiplied by layering interpretations. Just as the Newar maṇḍala represents both the geographic cosmos and the yogic subtle body of the practitioner, so, too, the Tibetan practice operates on distinct registers. These levels are traditionally known as the outer, inner, secret, and, when a fourth is included, suchness.[120] They refer to increasingly esoteric perspectives on the ritual, from the most worldly to the most enlightened. For the maṇḍala offering, the outer practice invokes the physical cosmos, an offering of shared geography and material

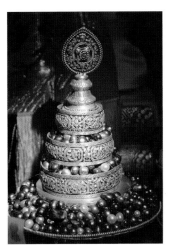

3.34. Various modes of emphasizing opulence in treasure-maṇḍala offerings. From left: Spituk Gompa, Ladakh; Drepung monastery, Lhasa (photograph courtesy of Dina Bangdel); Lamayuru, Ladakh

wealth. In the inner offering, the maṇḍala is one's own physical body, with the skin becoming the golden earth, the torso becoming Meru, the arms and legs becoming the four continents, and so on.[121] The secret offering may differ according to tradition,[122] but it essentially comprises one's mental factors, which are to be purified through the acts of offering and enlightenment.

This system of outer, inner, and secret interpretations is not the only way to add increasingly esoteric layers of meaning to the maṇḍala offering. The Longchen Nyingthig alternatively instructs that three different maṇḍalas are to be offered in sequence, corresponding to the three bodies of the buddha: the Emanation-body, Enjoyment-body, and Truth-body. In this system, the Emanation-body maṇḍala corresponds to the physical universe, the Enjoyment-body maṇḍala to the heaven of Akaniṣṭha, and the Truth-body maṇḍala to purely apprehended reality.[123] The constructed maṇḍalas also differ in their materiality. The Emanation-body maṇḍala has nine heaps of grain, the Enjoyment-body maṇḍala five (for the five buddhas), and the Truth-body maṇḍala only one (a unified realization of truth).

DEPICTIONS IN ARTWORK

Despite all these ways of increasing the vastness of the cosmic offering, the Tibetan version is still best summarized as a single, massive heap of wealth, a mountain of treasures comparable to jeweled Meru. This material product, with all its inherent verticality, is precisely encoded in visual depictions that directly contrast with the plan-view, nine-heap version seen in the Pāla manuscripts and at Alchi. Among three of the most common ways of representing the cosmic offering in painting, two emphasize

its enormous height (see fig. 3.45). In the first, the geography of the cosmos mimics the overflowing heap of grain of the offering, a cosmos-as-heap emphasizing wealth piled high. In the second, Meru stands alone as a monumental gem, a Meru-as-jewel extracted from the surrounding cosmos but standing in for the treasure-maṇḍala as an equivalent mountain of treasures. The third representation actually does employ a plan view but replicates a very particular diagram of the cosmic offering, rather than its production as a ritual product made with grain. In all these cases, the material objects of Tibetan culture mediate the way the cosmos is represented in images of offering.

Because of the deeper correspondence between the Tibetan offering and cosmic structure, depictions of the cosmos in the manner of these offerings also can appear well outside offering contexts. The cosmos-as-heap, in particular, clearly represents the vertical hierarchy of the world in other kinds of ritual and narrative scenes. Representations of this sort became most widespread after the seventeenth- to eighteenth-century popularization of the Panchen Lama's guru-offering ritual, so it seems clear that such cosmological expressions were influenced by this specific ritual practice and its material culture.[124] Such examples illustrate the connections between material objects of offering and the visual representation of the cosmos.

While it is admittedly common to represent the treasure-maṇḍala as nothing more than grain on a tiered platter (see figs. 3.1 and 3.20), two paintings perfectly exemplify the relationship of this pile of offerings to the cosmos understood as a heap of treasures. In one from Mongolia, the conical pile of grain is inscribed with the central features of the cosmos, specifically, Meru, its terraces and palace, the golden mountains, and the ocean (fig. 3.35). The heap of grain and the heap of the cosmos are one and the same, with the cosmos being represented by its most heaplike elements—terraced Meru and its foothills. The continents and other treasures explicitly named in the liturgy are not included.

Compare this to a painting in the collection of the Rubin Museum of Art, which shows the same cosmic offering as a real geography while maintaining the structure of a verticalized heap (fig. 3.36). None of the actual materials used in the ritual performance (metal platter, tiered rings, or grain) are depicted. Instead, the maṇḍala is shown as the physical cosmos, with jeweled mountains, oceans, and continents. This cosmos appears not according to the *abhidharma* measurements, however, but with the same structure as the heaped offering (fig. 3.37). Meru and the golden mountains create a nearly perfect triangle (white line overlay), much like the conical heap of grain on a platter. The central mountains fill the circular cosmos to its very edge, like an overflowing pile of grain. The perimeter, rather than being portrayed as the Cakravāla mountains, is a kind of platform, like the offering platter (black line overlay). Only the terraces of Meru extend above the oval perimeter of the Cakravāla in the picture plane, subtly suggesting both the tiers of the offering rings and the synecdoche of Meru for the offering cosmos. The rows of golden mountains below Meru give the visual impression that Meru is stacked on top of these smaller mountains, rather than surrounded

3.35. Detail of monk holding a treasure-maṇḍala offering platter in a painting of the seventh Dalai Lama. 19th century. Erdene Zuu, Mongolia

by them. The continents and subcontinents are barely visible as line drawings in the four colored quadrants of the oceans.

This idea of the cosmos itself as a collective heap of treasures, a singular object to be offered, became widespread. In images of fields of accumulation, the cosmos-as-heap appears as a singular treasure alongside the other treasures of the maṇḍala offering, rather than containing them. Figure 3.21 shows these items in its lower register (fig. 3.38). At the top of the annotated diagram, the perimeter of the recipient-filled tree is protected by the four guardian kings, establishing it as a purified deity maṇḍala. Directly below the tree are the primary treasures of the *cakravartin*, with the minister, wheel, queen, and jewel on the viewer's left, and the general, elephant, and horse on the viewer's right (along with a treasure vase on each side). To the far left are a set of seven secondary treasures of the *cakravartin*, including the sword, hide, house,

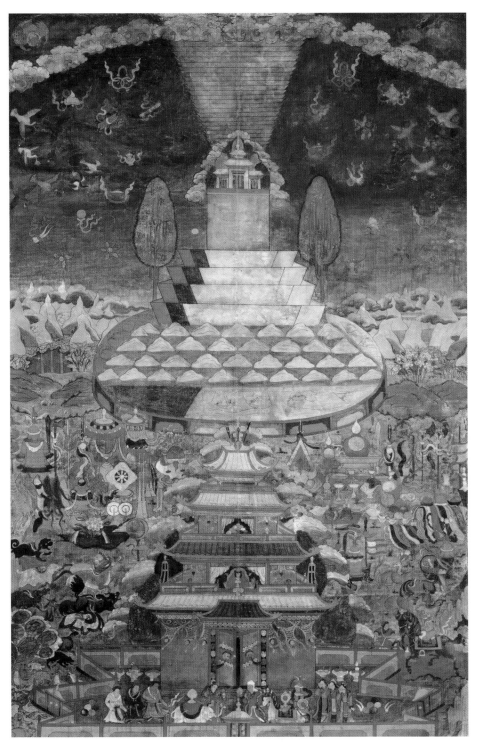

3.36. Various offerings with the cosmos-as-heap. 19th century. Tibet. Collection of the Rubin Museum of Art, Gift of Shelley and Donald Rubin C2006.66.558 (HAR 1038), www.himalayanart .org/items/1038

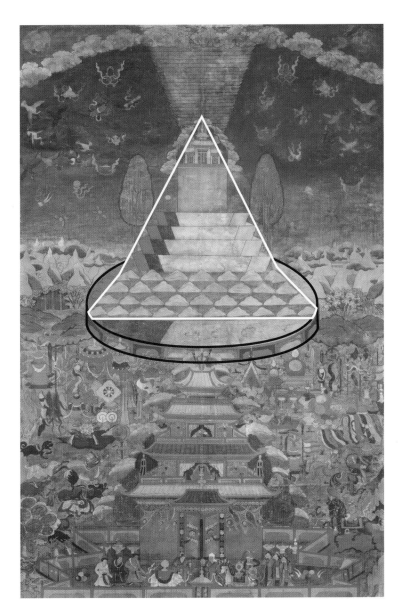

3.37. Annotations on the painting in figure 3.36. 19th century. Tibet. Collection of the Rubin Museum of Art, Gift of Shelley and Donald Rubin C2006.66.558 (HAR 1038), www.himalayanart .org/items/1038. Annotations by author

garment, garden, seat, and shoes, as well as apparently the additional treasure of a cow (probably the wish-granting cow of the continental treasures). To the immediate right is a representation of the cosmos-as-heap, including Meru, the golden mountains, the continents, and the sun and moon. To the far right is the disciple Khedrup, making the treasure-maṇḍala offering. Other treasures surrounding these figures fill out the opulence of the world that is visualized when making the offering.[125] With the exception of Khedrup, all these objects are offered to the figures at the center of the image, with the cosmos-as-heap representing the geographic elements of the treasure-maṇḍala as a singular treasure unto itself.

3.38. Annotations on a detail of offerings in figure 3.21. *Field of Accumulation of the Offering to the Teacher.* Late 19th–early 20th century. Tibet. Saint Louis Art Museum, Gift of Margaret M. Hibbard in memory of George E. Hibbard (formerly in the collection of George E. Hibbard), 260:1992. Annotations by author

As a coherent object, the cosmos-as-heap maintains the basic structure of a pile of grain or increases its verticality even further. In the illustrated field of accumulation, terraced Meru stands tallest in the center, stacked on rows of smaller golden mountains and surrounded by a tiny perimeter of continents and the sun and moon (fig. 3.39). The trapezoidal shape of the heap of golden mountains is maintained, but Meru projects vertically upward at an exaggerated scale. In the image of the cosmic offering from a protector chapel in Bodh Gayā (see fig. I.3), Meru is even more isolated as the central feature. The golden mountains and continents below Meru no longer create the sense of a conical pile but seem compressed by the weight of the immense rectangular prism of Meru, made even more imposing by the reduction of its terraces. Meru's height is almost equal to the diameter of the entire Cakravāla, not at all proportional to the *abhidharma* measurements. The central mountain becomes a faceted gem, rather than a location in a geography.

This Meru-as-jewel can stand for the entire mountainous heap of the treasure-maṇḍala, reducing the offered cosmos to its emblematic central element. A mural from Thikse, Ladakh (fig. 3.40), shows the towering pillar of Meru in an almost generic landscape of hills, probably intended to represent the seven rings of golden mountains. The only recognizable cosmological element, however, is Meru. Such emphasis on towering Meru, the tallest object in the world, only reaffirms the verticalization at the ritual's core.

The inherent verticality of the cosmos-as-heap and Meru-as-jewel is so powerful that such images also appear in contexts unrelated to the treasure-maṇḍala offering. Take, for example, a painting of Tsongkhapa as an emanation of the future buddha Maitreya, from eighteenth- to nineteenth-century Amdo (fig. 3.41),[126] that is structured around the vertical hierarchy of the world. In the center, Tsongkhapa sits in a cloud

3.39. Detail of the cosmos in figure 3.21. *Field of Accumulation of the Offering to the Teacher.* Late 19th– early 20th century. Tibet. Saint Louis Art Museum, Gift of Margaret M. Hibbard in memory of George E. Hibbard (formerly in the collection of George E. Hibbard), 260:1992

emanated from the heavens at the top of the painting. Above him lies Tuṣita heaven, where Maitreya awaits birth as the next buddha. In this unusually linear interpretation of the Cakravāla hierarchy, the cosmos-as-heap at the bottom emphasizes the vertical axis that organizes the image. The seven rings of golden mountains and Cakravāla range appear directly below Meru, as lower planes of existence, rather than around it (although the arrangement of the continents admittedly does not follow). While Khedrup presents a treasure-maṇḍala at the bottom right of the painting, the rest of the image does not reassert the objects of the offering liturgy, suggesting that the cosmos-as-heap here portrays the stacked vertical layers of the inhabited cosmos rather than an offered object.

Beyond the popular cosmos-as-heap and Meru-as-jewel, there are numerous other ways of depicting the cosmos based on the material objects of the offering ritual. An appliqué banner from Drepung monastery, Lhasa, portrays the side view of a three-dimensional, sculptural version of the offering (fig. 3.42). The platter base is an orange

3.40. Meru as an offering. Protector shrine, Thikse monastery, Ladakh

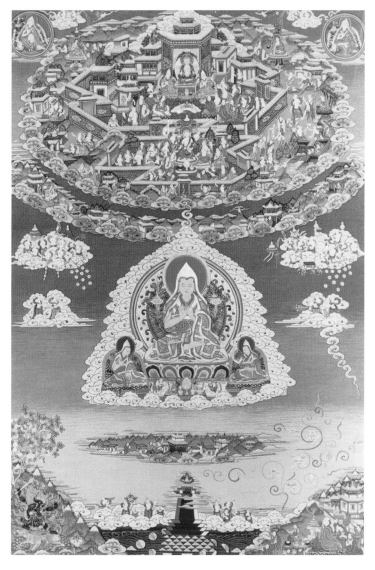

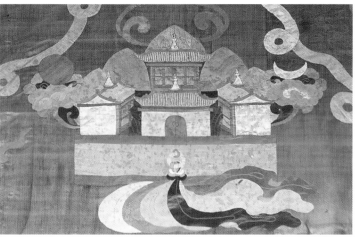

3.41. Tsongkhapa, Maitreya, and the geographic cosmos. 18th–19th century. Amdo. After Liu, *Buddhist Art*, 222

3.42. Detail of the treasure-maṇḍala in a banner of offerings. Drepung monastery, Lhasa. Photograph courtesy of Dina Bangdel

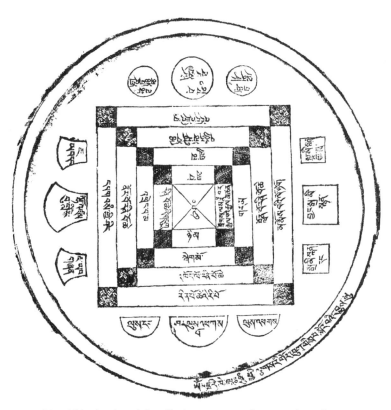

3.43. Wood-block print of the offering cosmos. After Douglas, *Tibetan Tantric Charms*, 70

rectangle, attached with a five-color scarf at the center (compare to fig. 3.26). Buildings atop the base represent Meru's peak and the continents, with green mountains surrounding and the sun and moon perched on clouds. With this combination of features, the image closely matches the more elaborate sculptural maṇḍalas produced in the Qing dynasty.[127]

Other depictions of the cosmos are mediated not through the material of the offering itself but through instructional diagrams of the treasure-maṇḍala popularly distributed as wood-block prints.[128] This diagram arrays the treasures invoked in the ritual in a pattern of concentric squares (fig. 3.43; compare to fig. 3.15) that may suggest the terraces of Meru (see the section titled "The Altar" in chap. 4). Most recognizably, four small black squares appear in the corners of each tier, dividing them into the cardinal and intermediate directions and creating a distinctive radial pattern that has nothing to do with the cosmic geography. This pattern is easily identified in other painted images in which the cosmos-as-treasure is included among other jewels of offering. Visible at the top left of a painting of a copious array of offerings to Vaiśravaṇa (fig. 3.44), this cosmic maṇḍala portrays a world defined not by its geography or its materiality but by the idiosyncrasies of a very particular diagram.

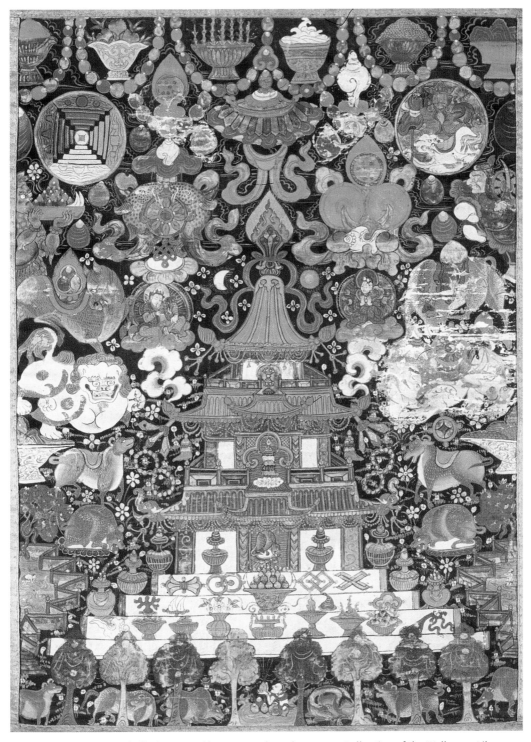

3.44. Array of offerings to Vaiśravaṇa. 18th–19th century. Collection of the Wellcome Library, no. 47097i. https://wellcomecollection.org/works/dbhrw8v6. Used under Creative Commons Attribution Only [CC-BY 4.0] license. https://creativecommons.org/licenses/by/4.0/

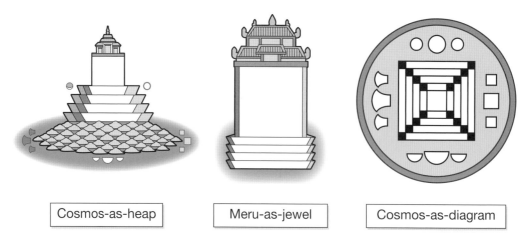

| Cosmos-as-heap | Meru-as-jewel | Cosmos-as-diagram |

3.45. Three common ways of depicting the cosmos as an offering in Tibetan tradition

While there are many more ways to depict the cosmos, the point here has been to illustrate the way that the material objects of offering performances affect the portrayal of the cosmos in other artwork. The types of depictions illustrated in this chapter are among the most widespread images of the cosmos in Tibetan culture, and they exhibit ways of thinking about geography as the material product of a very specific ritual. The cosmos-as-heap, Meru-as-jewel, and cosmos-as-diagram (fig. 3.45) are not mere stylistic variants or accidents of history, but relate to specific cosmological conceptions, ritual actions, and material objects.

Conclusion

Portrayals of the cosmos in the offering clearly express an ideology of wealth and abundance, and within this singular purpose, they are further mediated by specific ritual performances and objects of material culture. Not only does the rhetoric of offering affect how the cosmos is conceived (as the world of the *cakravartin*), but the specific procedures and material products of the offering alter its form (as in the verticalized heap of the Tibetan version). Even though Newar and Tibetan traditions agree on the same basic cosmology, then, the particulars of its expression differ greatly based on ritual and material culture. Indeed, these material performances of the cosmos can be just as influential to cosmological representations as the purpose of the ritual, the intentions of a scholastic author, or the ideology of the deity maṇḍala.

While the ostensible source for the offering cosmology, the *Treasury of Abhidharma*, seems to reject explicit relationships between cosmology and offering established in Vedic and Purāṇic traditions, its cosmology becomes intimately tied to offering in part through the Buddhist *homa* ritual and its geometric altars. The *Legend of Aśoka*, while not explicitly an influence on the later tantric ritual, certainly contains a

precedent for its concept — offering the entire material world in exchange for Buddhist teachings. It also illustrates one of the key paradigms behind the ritual ideology, that of the *cakravartin* ruler who literally owns the world and is thereby able to donate it. The seven miraculous treasures of the *cakravartin* appear in the offering ritual as emblems of the ownership and adornment of the world.

The Newar version of the offering ritual conveys its most essential liturgy, performance, material products, and visual representations. The modern Newar version is simpler than the Tibetan and traceable to earlier, eleventh-century versions, such as the representations in Pāla manuscripts. Both the contemporary material products of the Newar ritual and the paintings at Alchi seemed to highlight two views of the maṇḍala: one, a plan view of the bare material elements of the ritual, a circle of nine heaps of grain, and another, in elevation, the esoteric cosmological iconography of Meru, the sun, and the moon.

The different material realization of the Tibetan offering — as a vertically exaggerated heap rather than a round — correlates more closely to the structure of the Buddhist cosmos and allows for additional layers of symbolism. New metaphors of increase, completeness, and abundance are all suggested by this material practice, even as they are supplemented with additional strategies such as the cloud of Samantabhadra offerings. The resultant depictions mirror these metaphors, portraying the cosmos as an overflowing heap of mountains piled atop a circular platter, or even simply as the towering jewel of Meru, the ultimate mountain of treasures. Although these are not the only ways of depicting the cosmos in Tibetan tradition, they are influential enough to appear beyond the context of the offering ritual, establishing a conception of the Buddhist cosmos as a heaped and towering geography. Indeed, such imagery frequently occurs in the murals and building structures addressed in chapter 4, which focuses on cosmic imagery in architectural contexts rather than primarily ritual or functional terms.

4

Cosmos in Architecture

SACRED SPACE AND MURALS

OSMIC GEOGRAPHY IS INTIMATELY RELATED TO THE PHYSICAL STRUC-
tures and pictorial imagery of Buddhist architecture. Some temples and mon-
asteries are quite explicitly models of the cosmos, while others only subtly
invoke cosmological ideas in the spaces they create. Just as cosmology can act as a
framework for the process of enlightenment or for the opulence of an offering, here,
the Buddhist cosmos serves as a basis for inhabited space, and especially for marking
the differences between ordinary, worldly space and the specialized arena of Buddhist
practice. At times, cosmological architecture refers to the very particular structures
and symbolism of other systems, including both the deity maṇḍala and the treasure-
maṇḍala. Temples and monasteries can be constructed according to the plan of the
Buddhist cosmos or deity maṇḍala, and cosmological imagery of the offering often
appears at the entrances to or within sacred spaces.

In addition to the cosmological aspects of architectural space itself, imagery of the
cosmos frequently occurs on architectural surfaces, in murals. These paintings can
express any of the themes of cosmology presented here—and more—in relation to
specific iconographic and historical contexts. They may index the cosmological struc-
ture of the very spaces they occupy, or they may represent narrative scenes, ritual
practices, or social messages. Despite their remarkable variety of form and function,
cosmological murals are nevertheless connected via the nature and history of their
artistic medium. Each painting relates to other images of the cosmos, both historical
and contemporaneous, through stylistic influences, artistic lineages, and other phe-
nomena. A later painting can duplicate an earlier one, or two murals created at the
same time might enact complementary functions within a single architectural space.

As parts of such iconographic programs, the functions and appearances of cosmological murals are determined in part by their architectural spaces.

The central concern here is thus the relationship of art to art (whether architectural or painted). While these objects must still be contextualized in terms of texts and practices, the visual and physical are paramount for their understanding. Objects and images are not just expressions of ritual practices or illustrations of conceptual ideals but part of a world of created things. In short, the artistic and architectural contexts of cosmological expressions matter, just as do the function of the treasure-maṇḍala for offering and the symbolism of the deity maṇḍala for enlightenment. Images of the cosmos are affected by other images of the cosmos, placement in iconographic programs, and position within architectural structures. The image does not occur in isolation.

The first few examples below introduce themes of cosmological thinking in Buddhist architecture that enable more thorough investigation of specific objects and images. Rather than capturing the full complexity of diverse traditions, then, they lay a groundwork for ways of considering cosmology in sacred space in terms of different strategies and expressions, eventually allowing a more detailed analysis of individual murals painted on specific walls in architectural programs. These murals have varied imagery and relationships to the spaces they occupy, also changing over time in different traditions. Examining all these examples together through the lenses of art and architecture reveals functional variations and historical relationships between specific instances of cosmological imagery.

It is well known that Buddhist architecture often recapitulates both the cosmos and the deity maṇḍala. Within this frame, however, a more precise analysis reveals that the re-creation happens in multiple complementary ways, not necessarily as a singular conceptual program. From the exterior of the monastery to the interior of the central shrine, different strategies reproduce cosmology in the ground plan, building structure, surface decoration, and even furniture. In general, these elements re-create the ideology of the deity maṇḍala within the shrine, establishing the seat of the central buddha sculpture as the peak of Meru. This allows visitors to materially experience the transformative journey from the mundane world of Jambudvīpa to the heavenly realm of enlightened beings as they proceed from the entrance to the heart of the temple. While the overall plan of architecture generally tends to recapitulate the deity maṇḍala, the altar in front of the central image often re-creates the cosmos of the treasure-maṇḍala, layering the two cosmologies together in order to reinforce the exaltation of the image and the path of visitors toward enlightenment. In all these features, spatial context is fundamental. Architectural structures determine the cosmology of sacred space through their placement in specific locations throughout that space.

The cosmology of mural paintings, too, varies according to spatial and functional context. While the subjects of these paintings might be as different as the deity maṇḍala and the treasure-maṇḍala, the shared medium of painting allows us to compare them as related expressions of cosmology. One key functional distinction

among cosmological murals correlates to their placement in specific locations within architectural space. Murals at entranceways conceptually mark thresholds to interior spaces, while paintings in interior halls participate in narrative or other ritual functions. Entranceway murals are themselves incredibly diverse, employing the visual language of *abhidharma* scholasticism, the treasure-maṇḍala offering, and more, but fit into the larger cosmological and iconographic programs of the architectural space. Beyond their architectural location, then, one must also consider their relationships to nearby paintings.

These cosmological murals have also undergone significant changes in their placement, function, and appearance over time. Narrative depictions of the Cakravāla in interior spaces seem to occur significantly before the entranceway murals, which eventually develop in relation to another well-known cosmological image of entranceways, the wheel of existence. This subject, which depicts an existential map of the different states of being, conceptually overlaps with the Cakravāla in that types of beings are intimately connected with places in geography. When juxtaposed, the wheel of existence and Cakravāla are free to complement each other by communicating distinctive cosmological messages, even as their pairing doubly emphasizes the importance of cosmological thinking at entrances. Especially after the seventeenth-century popularization of the offering to the teacher in Tibet, images of the Cakravāla as treasure-maṇḍala perform a ritual function clearly distinct from the didacticism of the wheel of existence while remaining alongside it in architectural space. In the twentieth and twenty-first centuries, greater interest in textual sources has led to detailed illustrations of the Cakravāla based on Vasubandhu's *Treasury of Abhidharma*, often carefully labeled and sometimes even measured to scale. The interior cosmological murals, too, exhibit their own parallel history in narrative and other uses, often becoming more complex and diagrammatic as the structure of the cosmos is deployed with more sophistication.

Spatial context is integral to our understanding of cosmological expression. From a mural at the exterior entrance of a monastery to an altar at the center of the innermost shrine, the relative locations of these objects in space are as much a part of their nature as their physical appearance or material construction. A visitor's movement through a monastery or temple is also a journey of ideas that are realized in iconographic and architectural programs. The introduction occurs at the beginning, and the conclusion takes place at the end. Throughout this journey, cosmological thinking is integral to the intention and experience of these spaces and the murals inside.

Building the Universe: Cosmological Design in Architecture

Buddhist architecture is an incredibly complex topic, but a few key examples can illustrate its essential cosmological ideas.[1] While any given temple or monastery might not embody each principle, it is common for some of these principles to be in play,

perhaps realized in different ways. The following brief overview of a few exceptionally clear examples helps illustrate a broader strategy for considering architecture in precise cosmological terms. More than just identifying correspondences between architecture and cosmology, we can understand cosmology as an architectural language capable of multiple kinds of expressions. This is easy to demonstrate by focusing on examples from four different realms of architectural analysis: ground plan, building structure, surface decoration (murals and sculptures), and interior furniture. In each of these examples, cosmological thinking establishes a specific relationship between the macrocosm of the universe and the microcosm of local construction. Doing so places visitors and practitioners in a context that frames their everyday activities in cosmological terms. Similar to the portrayal of Sarvārthasiddhi's enlightenment as a process of cosmic translocation, the cosmological principles of architecture provide both structure and directionality to the space of Buddhist practice.

Indeed, the relationships between architecture and the tantric deity maṇḍala are numerous and complex. As mentioned previously, the thirteenth-century *Compendium of Rituals* employs the elemental generation of the cosmos as a ritual ground for laying the foundation of a building. In this case, meditation on the maṇḍala occurs before construction, in essence completing the edifice in the abstract before assembling it physically. While most features of the cosmic maṇḍala do not appear explicitly in the final architecture, the building arises in reflection of its imagined ideal. Similarly, the sacred space of the Lotus Light Palace of Padmasambhava has been reconstructed at monasteries throughout the Himalayas, including in Sikkim (see fig. 2.24). Since the translocative and transformative implications of such simulacra have already been discussed, emphasis is placed here on structural and pictorial principles related to geographic cosmology more generally.

GROUND PLAN

Few more explicit examples of cosmology in architecture exist than Samye, the first monastery constructed in Tibet. Samye was built in the eighth century, during the period of the First Diffusion, when the early kings were introducing Buddhism to the region. As the first monastery in Tibet, it represents the key moment of establishing an indigenous monastic lineage—the monastic community being one of the three pillars[2] of Buddhist tradition along with the Buddha and his teachings. While this Buddhist social structure was domesticated through the introduction of monastic ordination, the architecture of Samye relocated Buddhism to the region cosmologically. The ground plan of the complex is said to re-create the major structures of the universe: an encircling barrier wall represents the Cakravāla mountains, peripheral buildings represent the continents, sun, and moon, and the central shrine represents Meru. Although the buildings that stand for the continents do not precisely match the shapes

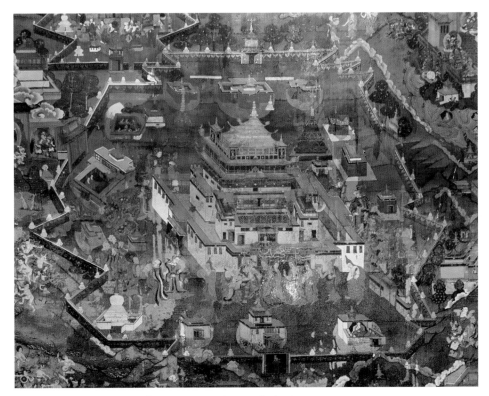

4.1. Samye monastery. 19th century. Interior vestibule, Samye monastery

given in the *Treasury*,[3] four large *chortens*[4] also sit in the intermediate directions, rein-forcing the overall quadripartite division of the interior space. A nineteenth-century mural painting at Samye makes these references explicit (fig. 4.1), with the buildings that represent the continents placed on colored fields in the shapes of the landmasses (circle, semicircle, square, and scapula). A separate, eighteenth-century painting in the Dalai Lama's quarters at Samye also exemplifies the connection with the deity maṇḍala, with a circular boundary dotted by small *chortens* and the large maṇḍala-palace in the center (fig. 4.2).

The earliest textual records of the construction of Samye suggest at least the pos-sibility of an original cosmological plan for the site. The *Testimony of the dBa' Clan*,[5] considered the most historically authoritative text on the subject,[6] describes the pro-cess as follows: "In the site in which the geomantic divination and the rituals had been performed, the dBu rtse (central temple) was built. . . . Then the four *gling*, the eight *gling phran*, . . . and the four *stūpa* were built. . . . [The temple] was surrounded by a black perimeter wall."[7] While *gling* can refer simply to a monastery or part thereof, it also means "continent," and the combination of four *gling* with eight *gling phran* (sub-continents) at least evokes the cosmological scheme.

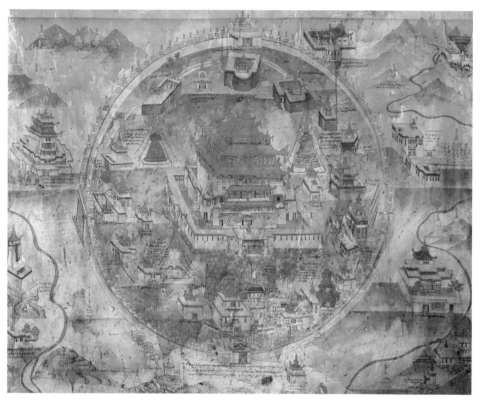

4.2. Samye monastery. 18th century. Dalai Lama's quarters, Samye monastery

The twelfth-century biography of Padmasambhava by Nyang Ral Nyima Oser, in turn, makes the conception explicit: "When laying the foundation stones for the temple, King Trisong Deutsen had the Triple-Storied Central Temple laid in the style of Mount Sumeru. The encircling structure was laid in the style of the seven golden mountains. The two Yaksha Temples were laid in the style of the sun and the moon. The four major and eight minor temples were laid in the style of the continents and subcontinents."[8] The salient features of the Cakravāla cosmos are clearly recognizable. Such a reconstruction helps relocate the center of Buddhist authority to Tibet alongside the introduction of the monastic lineage. The cosmological plan of the site also allows visitors to experience a journey from the outer periphery to the center of the cosmos (the central shrine as Meru), which suggests Sarvārthasiddhi's own transformative journey and makes the very experience of the space a performance of tantric ideology.

BUILDING STRUCTURE

Samye's central building expands on the logic of the plan to articulate both the tantric ideology of enlightenment and a social claim of recentering Buddhism in the region.

Indeed, multiple layers of logic are applied simultaneously to this structure. Most basically, in the plan of the site, the central temple is Meru, as described above. More than that, its three-story structure also refers to the maṇḍala palace that sits atop the peak of Meru. Although its modern reconstructions do not follow a coherent iconographic plan, the three levels originally housed images of Śākyamuni (on the first floor), Vairocana (on the second), and Omniscient Vairocana (on the third), with all three collectively representing the three-body system.[9] Thus, while the site's plan sees the central temple as Meru, climbing its stories represents an ascent beyond Meru through Akaniṣṭha to full enlightenment. Finally, the three stories of the central temple also make a very different kind of cosmological statement about the place of Tibet in the social geography of its world. Early documents describe the three floors as being constructed, respectively, in the styles of Tibet, China, and India,[10] combining the Buddhist traditions of these regions in founding the Buddhist lineage of Tibet.

While Samye's relationship to preexisting Indic architecture is a matter worthy of further study,[11] it is not the only site to be quite conspicuously laid out as a cosmos or deity maṇḍala.[12] In Nepal, some temples are explicitly understood as three-dimensional maṇḍalas, both through their plans and through textual descriptions.[13] Furthermore, exoteric (public) shrines are placed on the first floor and esoteric shrines (for initiates) on the second, again interpreting vertical ascent as a move toward direct encounter with enlightenment.[14] From the period of the Second Diffusion (10th–11th centuries), perhaps the most famous example of the monastery-as-maṇḍala is Tabo, where the main assembly hall re-creates the Vajradhātu maṇḍala.[15] After the eleventh century, however, a variety of changes led to less systematically cosmological constructions in Tibet. Monastic plans tended to grow more organically on hillsides where geometric layout was more difficult, and central shrines shifted toward a rectangular, single-axis plan rather than the square maṇḍala.[16] That being said, the associations of architecture with cosmology do not end but rather adjust to other forms.

SURFACE DECORATION

Another architectural technique used to invoke cosmological imagery is surface decoration, or, generally, the murals, sculptures, fixtures, and other design elements visible on architectural structures. In various ways, these ornaments recall the maṇḍala palace and the center of the cosmos, re-creating the intention embodied at Samye in a variety of ground plans and building structures. One of the simplest approaches is to decorate doorways and walls with the same types of ornaments envisioned on the maṇḍala palace. Paintings at the tops of walls depict rippling banners behind catenary garlands and pendants of gold and jewels (fig. 4.3, top). The same imagery appears in two-dimensional illustrations of deity maṇḍalas within the complex frame that surrounds the central deities and represents the architecture of the maṇḍala palace (fig. 4.3, middle). The same decorations also appear on three-dimensional models of

4.3. Ornaments on the walls of a maṇḍala palace. Top: Wall mural; Jokhang, Lhasa. Middle: Ceiling mural of a maṇḍala; Drug Sang-ngag monastery, Darjeeling, India. Bottom: Miniature model; Akaniṣṭha Cāmara Copper Mountain Lotus Light Palace monastery, Sikkim, India

maṇḍalas, often made with real strung beads (fig. 4.3, bottom). In fact, numerous elements of maṇḍala architecture correspond directly with real shrine construction, from elaborate doorways[17] to the joinery of the wooden pillars and beams.[18]

While these decorations re-create the generic opulence of a maṇḍala palace, others establish the central shrine atop Meru through specific cosmological imagery. Among the most prominent subjects is the set of four Great Kings who protect the cardinal directions. These guardian kings dwell on the highest terrace of Meru (see fig. 1.12), facing the four directions and responsible for defending their respective quadrants of the cosmos. They also encircle and protect the boundaries of other maṇḍalic spaces, such as Padmasambhava's Lotus Light Palace (see fig. 2.22). Standing just outside the celestial palace atop Meru, they establish a sanctified center for deities to inhabit.

Architecturally, the guardian kings often appear in paintings or sculptures outside the entrances to courtyards, shrines, and assembly halls.[19] When such buildings have four entrances opening onto the four cardinal directions, each king can be displayed facing his proper direction.[20] Where there is only one entrance, the four kings can be depicted in a single row, but often in an order that suggests their cosmological arrangement. At the base of a field of accumulation painting (see fig. 3.38), an imagined clockwise progression around the structure leads to the kings in the order of their

4.4. Typical arrangement of guardian kings

SOUTH EAST NORTH WEST

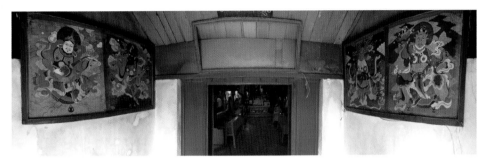

4.5. Four Great Kings in entranceway. Daschan Chokhorling, Ulaanbaatar, Mongolia

cardinal directions (fig. 4.4). Such motion creates a protective circle around the central structure while simultaneously reaffirming its identification with Meru and the deity maṇḍala. In architectural spaces where the kings are depicted in this linear order, the progression through the directions can be performed through the practice of circumambulation (also a sign of respect) before entering the building.

Not all Buddhist buildings are constructed with circumambulation in mind, however, and the four Great Kings can appear in other sequences, often based on the particular structures of the building they serve. A modern example from Daschan Chokhorling, Mongolia, has small paintings of the guardian kings flanking a narrow passageway leading to an assembly hall (fig. 4.5). Attempts at circumambulation here would require awkwardly exiting and reentering a confined space, so the expected order is not maintained (compare the skin color of the figures against the colors in the diagram). Rather, their order can be explained by another example, in which the kings all appear on a single wall, again flanking the entrance in pairs. The murals at Samkar Gompa, Ladakh, which exhibit the same order, are properly read from left to right across the wall, as if the painting were a text (fig. 4.6).[21] This is a common way of arranging the kings, maintained even when the images are not all on the same wall, as at Daschan Chokhorling.

These two are not the only sequences in which the four Great Kings can be depicted, however, and figures 4.7 and 4.8 illustrate a variety of attested examples, along with the name of at least one site where such an arrangement occurs. The paradigmatic circumambulatory arrangement (identical to the one depicted in fig. 4.4) is shown in 4.7A and works whether the kings are depicted on the same wall or on separate walls around the building. The left-to-right arrangement is shown in 4.7B, and, again, the

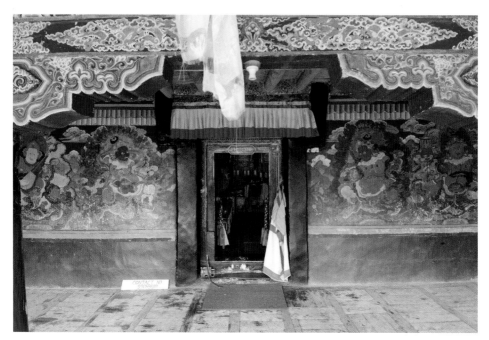

4.6. Four Great Kings flanking entrance to shrine. Samkar Gompa, Ladakh

images need not all appear on the same wall for this sequence to make sense, as long as they are within the same space. In general, figure 4.7 shows a variety of ways of arranging the kings in a single line in which it is at least possible to read them in their correct cardinal directions. Figure 4.8, in contrast, shows arrangements in which it is implausible that the kings will be encountered in the correct sequence or in which they are not depicted in a line at all. Suffice it to say that the kings may appear in a wide variety of arrangements, some of which reflect a clear expression of their roles in relation to the cardinal directions and some of which do not. Rather, another dynamic seems to take over, in which the Great Kings are not associated with the quadrants but function akin to normal, human guards who flank entrances to protected spaces. They are simply paired symmetrically, and even when they seem to exhibit a linear order consistent with their directionality, they may do so by chance.

At the same time, the idea of their functioning as cosmological beings who protect a sacred center is not lost — indeed, this is precisely the function of entrance guardians. So important is this creation of sacred space that a modern Tibetan commentator has said that the set of the guardian kings is one of only three iconographic themes that are absolutely required for any Buddhist temple.[22] Despite their presence in a variety of sequences at architectural entrances, they consistently express correct directionality in other kinds of paintings (such as the field of accumulation), as well as on the faces of *chortens* and *caityas*, indicating a widespread understanding of their precise cosmological roles. While the four Great Kings may be depicted variously depending

Linear Arrangement, Linear Order, Doorway in Center

A

When proceeding clockwise around the building, the correct order of guardians is maintained in the cardinal directions. (Dungong Samten Choling, Darjeeling)

B

The nominally clockwise order is depicted from left to right. (Gyantse, Central Tibet, or the new Rumtek, Sikkim)

C

Begins in the doorway and proceeds clockwise around the interior of the veranda, or as if circling the building counterclockwise. (Norbulingka Institute, Dharamsala, India)

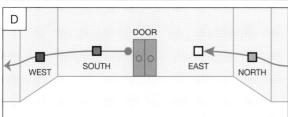

D

Proceeds clockwise around the building as if leaving the door (at the East) led to the Southern guardian. (Shalu, Central Tibet)

Linear Arrangement, Linear Order, Doorway Not in Center

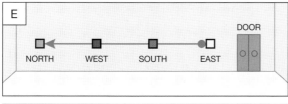

E

When the door is at the end, the sequence can proceed linearly away from the door (also clockwise). (Tramshing Temple, Bumthang, Bhutan)

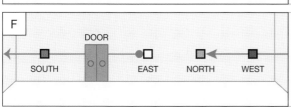

F

Or the arrangement in A is maintained without regard to the placement of the door. (Stakna, Ladakh)

4.7. Linear placements of guardian kings

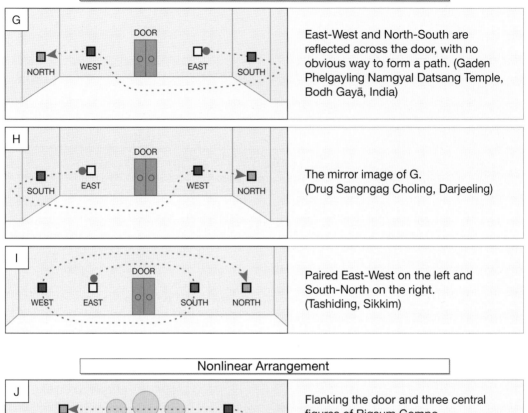

Linear Arrangement, Nonlinear Order

G East-West and North-South are reflected across the door, with no obvious way to form a path. (Gaden Phelgayling Namgyal Datsang Temple, Bodh Gayā, India)

H The mirror image of G. (Drug Sangngag Choling, Darjeeling)

I Paired East-West on the left and South-North on the right. (Tashiding, Sikkim)

Nonlinear Arrangement

J Flanking the door and three central figures of Rigsum Gompo (Avalokiteśvara, Mañjuśrī, and Vajrapāṇi). (Duidul Jyangchub Choiling, Tamang Monastery, Bodh Gayā)

K Placed on four quadrants of the door itself. (Aryapala Meditation Center, Terelj National Park, Mongolia)

4.8. Nonlinear placements of guardian kings

on their architectural circumstances, they must still be understood as establishing a protected space that is identified with Meru and the maṇḍala palace.

THE ALTAR

The transformation of a shrine into the celestial paradise of an enlightened being does not end at the entrance door but culminates inside the shrine itself. Indeed, some interior elements of the shrine repeat cosmological structures that are established on the exterior of the building. One of the subtler and more potent ways in which this occurs is through the configuration of the altar as a simulacrum of Meru just below the shrine image, elevating the deity once again to the peak of the central mountain. Undoubtedly, one of the key features of this altar cosmology is that it is perceived simultaneously with the image itself. The visitor does not need to remember the exterior iconographic or structural program, and indeed the altar can communicate most of the same cosmological message even in the absence of other architectural details. This replication of cosmological hierarchy inside the shrine is not a mere reduplication, however, since the altar typically invokes the treasure-maṇḍala offering rather than the deity-maṇḍala cosmology that defines the exterior architecture. The use of the treasure-maṇḍala here reminds the worshipper that the buddha is not just any deified figure but an enlightened teacher approached through the practice of guru-offering. While furniture like the altar is not always considered architecturally, the significance of such forms in both reiterating and adding to architectural programs is noteworthy.

The relationship between the altar and the treasure-maṇḍala is especially explicit in Tibetan designs after the seventeenth century, suggesting an influence from the popularization of the guru-offering ritual. Altars and paintings of altars after this period make the connection more and more prominent. Because similar influence is lacking in Nepal, Newar shrine spaces do not match the cosmological structuring of Tibetan altars. As can be seen in modern ritual performances in Nepal (fig. 4.9), offerings are frequently placed on platters on the ground or on a low platform in front of the image, without visible reference to the Meru cosmology.[23] The most noteworthy distinction of space in the Newar shrine is between the ritually pure interior and the exterior. Elaborate ornaments around the threshold mark this transition between exterior and interior, with the latter often being a cramped space into which only a select few may enter.[24] The threshold is important in Tibetan buildings, as well, but the frequently greater size of the shrines (in many cases, monastic assembly halls) means there is more room for complex internal structures. The cosmology of the Buddhist altar is not universal, then, but common in Tibetan traditions and important to recognize when it exists.

A comparison of the Newar shrine to the Tibetan-style altar at Dungon Samten Choling in Darjeeling immediately illustrates salient differences (fig. 4.10). The Tibetan altar here (painted red at the bottom center) is a distinct piece of furniture that separates

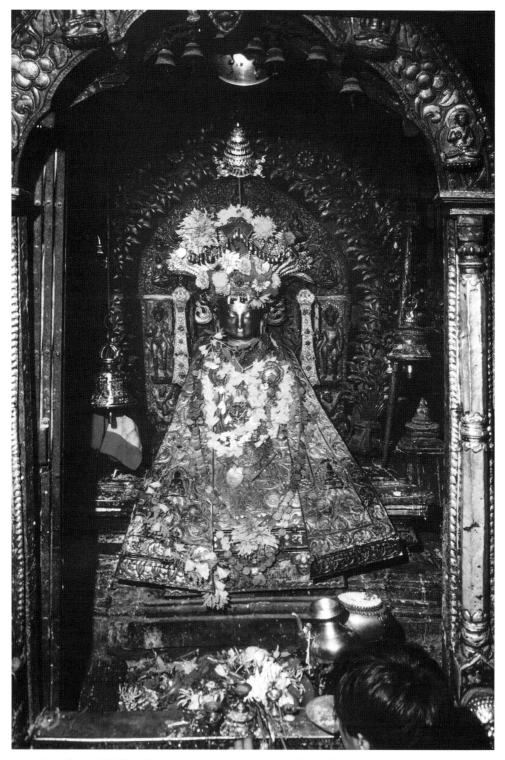

4.9. Main shrine. Bū bāhā, Patan, Nepal. Photograph by John C. Huntington, courtesy of the Huntington Archive of Buddhist and Asian Art

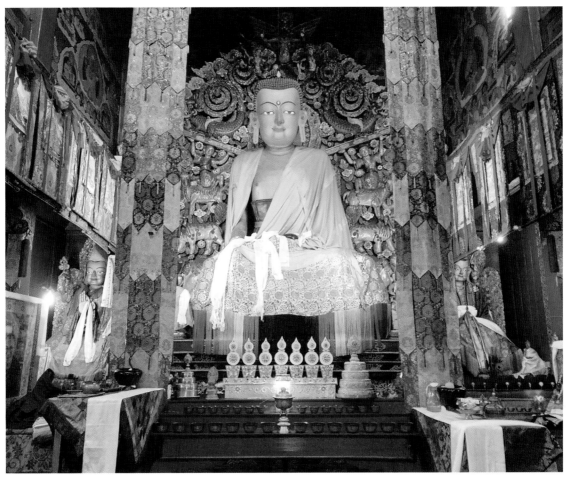

4.10. Assembly hall shrine with altar. Dungon Samten Choling, Darjeeling, India

the viewer from the central sculpture with a tiered structure. The fact that the altar separates the worshipper from the deity, along with the elevated height and increased scale of the image itself, strongly suggests the distinction between the human world in peripheral Jambudvīpa and the perfected realm atop Meru.[25] Regardless of the internal configuration of the altar, this wall of separation, like the vast space that separates Jambudvīpa from Meru in the Buddhist system, reinforces the difference between an ordinary human and the enlightened buddha.

The tiers of an altar can mimic the terraces of Meru, but the story is more complicated than a one-to-one correspondence because the offerings on an altar are not identical to the riches of the treasure-maṇḍala hierarchy. The offerings at Dungon Samten Choling, for example, represent two distinct practices. On the two lower shelves, four sets of seven bowls filled with water represent the seven outer offerings,[26] which do not have an associated cosmology. The top shelf, in contrast, holds two treasure-maṇḍalas

and a set of *tormas*[27] that essentially re-create the cosmic offering. As a higher form of offering that theoretically includes all others, these treasure-maṇḍalas occupy the top tier of the altar, but the altar itself does not obviously re-create the terraced cosmology of the treasure-maṇḍala.

Other altars do precisely mimic the vertical hierarchy of the treasure-maṇḍala, suggesting a conceptual overlap. Indeed, a seventeenth-century painting of the fourth Demo Rinpoche depicts the terraces of an altar entirely conflated with the levels of the treasure-maṇḍala (fig. 4.11). Three tiers of treasures sit in front of the central teacher and represent the three non-geographic categories of treasures in the offering to the teacher, in the same ascending order as found in the treasure-maṇḍala (fig. 4.12; compare to fig. 3.29). At the bottom are the treasures of the *cakravartin* king, which are most associated with the surface of the earth. On the second tier are the offering goddesses, who dwell on the terraces of Meru. At the top are the eight auspicious items, which are imagined above Meru's peak. The tiers of the altar capture the vertical ascent of the Tibetan treasure-maṇḍala. Moreover, the objects on these tiers are not confined to painting but also appear as sculpted offerings on real altars (fig. 4.13, which unfortunately includes only the *cakravartin* treasures and eight auspicious objects). In the painting of Demo Rinpoche, a full representation of the treasure-maṇḍala itself also sits in the very middle of the altar (as a golden sculpture in the middle of the second tier, just below the large black bowl). Whether in painting or as real furniture, the altar has the potential to replicate the structure of the Buddhist cosmos precisely, at least when it is understood as an expansion of the treasure-maṇḍala.

Given such a one-to-one correspondence, even tiered altars that include other kinds of offerings, like the one in Darjeeling, are easily imagined as the terraces of Meru. In the painting of a copious array of offerings to Vaiśravaṇa, the lower half of the image contains a large palace on a white, terraced structure filled with offerings (see fig. 3.44). This terraced structure is clearly Meru and the three-story palace at its peak. The blue and yellow bars at the left and right sides of the terraces indicate the colors of Meru's faces in the south and north (the east face is white). Furthermore, the three-story palace iconically represents the three-body system of the central deity, Vaiśravaṇa, in ascending order, as a mongoose, an umbrella, and a *vajra*. The bottom terrace of Meru holds the seven outer offerings in seven bowls (like the lower tiers of the altar in Darjeeling), including two types of water, flowers, incense, a lamp, perfume, and food (along with an eighth offering of music represented by an Indian lute[28] at the far right). While the other items of offering, such as the treasures of the *cakravartin* and the eight auspicious items, appear individually throughout the rest of the painting, other, similar examples depict these in the terraces above the seven cups, along with the full geography of Meru and the surrounding continents and oceans.[29] In these examples, Meru's terraces are completely assimilated into the terraces of an altar, despite the variance from the vertical levels of the treasure-maṇḍala. This means

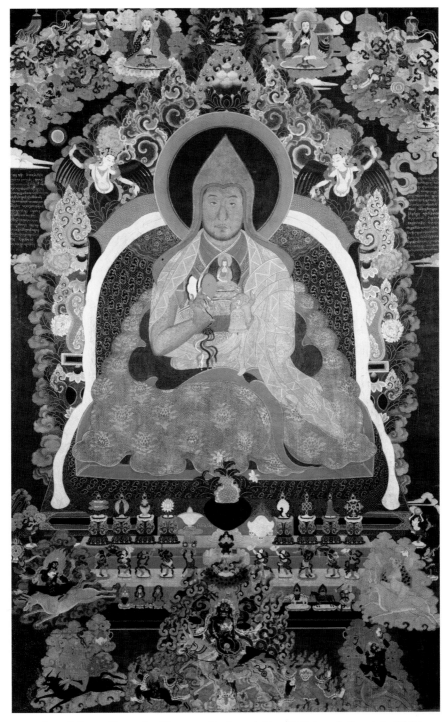

4.11. Fourth Demo Rinpoche, Lhawang Gyeltsen (1631–1668). Inscription dated 1667. Tibet or China. Collection of the Rubin Museum of Art, Gift of the Shelley and Donald Rubin Foundation F1997.45.2 (HAR 578), www.himalayanart.org/items/00578

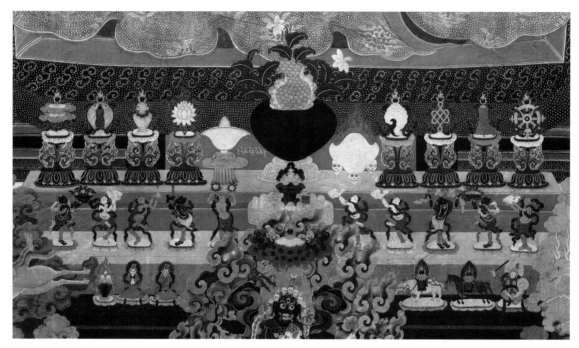

4.12. Detail of the altar in figure 4.11. Inscription dated 1667. Tibet or China. Collection of the Rubin Museum of Art, Gift of the Shelley and Donald Rubin Foundation F1997.45.2 (HAR 578), www.himalayanart.org/items/00578

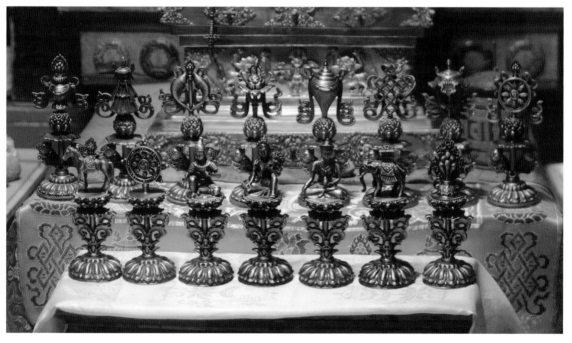

4.13. Altar objects. Daanzanravjaa Museum, Sainshand, Mongolia

4.14. Painting of a Sakya teacher. 20th–21st century. Sakya monastery. Photograph courtesy of Dina Bangdel

that the red, wooden furniture in Darjeeling could also represent the terraces of Meru in precisely the same way.

Such a conflation of the altar and Meru is perhaps most completely expressed in a pair of modern paintings at Sakya[30] monastery, in Tibet. Both center on human teachers of the Sakya lineage and depict in full detail the three-story maṇḍala palace, Meru with its treasure-filled terraces, and the continents and oceans. The overview of the first shows the complete structure, with the three-story palace occupying the top half of the image and the Cakravāla cosmology below (fig. 4.14). At the bottom lie

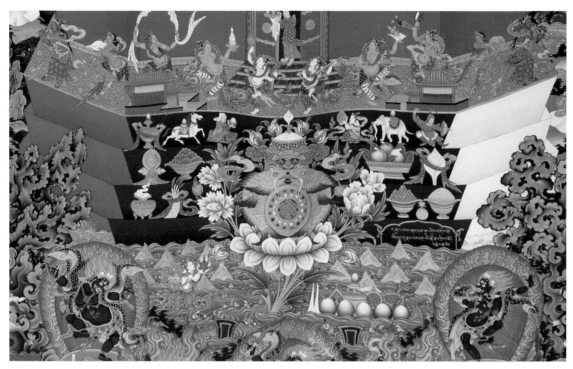

4.15. Detail of Meru's terraces in a painting of a Sakya teacher. 20th–21st century. Sakya monastery. Photograph courtesy of Dina Bangdel

the oceans, golden mountains, and southern continents (blue and shaped like scapulas). Above them rise the four terraces of Meru, layered with treasures, including the treasures of the *cakravartin* on the third tier and the offering goddesses on the fourth. Although this level lies at only half the height of Meru, the top half of this structure is actually the exterior of the red-walled celestial palace (recognizable by its roof, door, and wall ornaments). This allows depiction of the central figure at the same height as the top of Meru, even as he is placed in the interior of the palace, which is shown above the walls and roof, a common pictorial device.

A detail of the second painting, probably from the same workshop, shows the terraces more clearly, especially the goddesses dancing on the highest terrace (fig. 4.15). The *cakravartin* treasures are below them, while the eight auspicious items are shown conjoined atop the pink lotus at the center. These two sets of treasures are not shown in their ordinary cosmological positions, because, according to the logic of this image, offerings must be accumulated on or below the terraces of Meru, which serve as the altar. Perhaps because the goddesses who personify offering are associated with the fourth terrace of Meru, these tiers are considered the places of offering par excellence in the Buddhist cosmos, identical in function to the shrine altar.

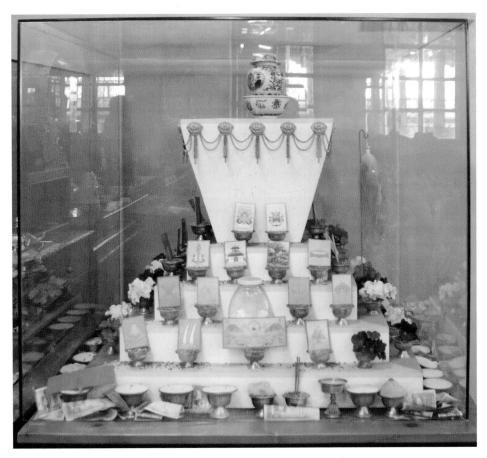

4.16. Altar in the form of Meru. Ganden Khiid, Ulaanbaatar, Mongolia

Given all of this, it is not surprising that one finds altar furniture created as sculptural representations of Buddhist cosmology. An example at Yonghegong was photographed in the 1930s, along with a contemporary reproduction that provided clearer details.[31] The tiers of those altars were decorated with paintings of the increasingly interior spaces of the maṇḍala palace of the buddha Bhaiṣajyaguru, with the outermost and lowest representing the oceans and continents surrounding the center of his cosmos. A modern altar in Mongolia depicts the entirety of Mount Meru sculpted in the round (fig. 4.16). Here, the seven outer offerings are arrayed in bowls at the lowest level, just outside the mountain's terraces, while the higher levels are filled with a variety of wealth that includes the treasures of the *cakravartin* (on the third tier) and the eight auspicious items (on the fourth). This construction duplicates cosmological formations found in other important types of Buddhist material culture, such as *tormas* and thread-crosses,[32] but a discussion of these complicated objects lies too far afield from

the subject at hand.[33] Suffice it to say there is a close relationship between representations of the site of a deity and the tiers of offerings made to that deity, precisely through the structural logic of the Meru cosmos.

The cosmology of altars communicates the translocation of the central deity image to the peak of Meru, a symbolism that can also be reinforced by the size of the image, its elevation above the floor plane, and the throne on which it sits. While the ground plan, building structure, and surface decorations of the architecture also perform similar tasks, the altar is special in that it is viewed at the same time as the deity image and its cosmology is based on the offering maṇḍala, rather than the deity maṇḍala. In addition to reaffirming the distance between the human viewer and the exalted buddha, then, the altar also reminds the visitor of the appropriate ritual stance to take toward the central figure, not just as a deified form, but as one's own enlightened teacher. The visitor's experience of architecture is transformed with cosmic scope via many features of plan, structure, and decoration, but that transformation is also progressively reformulated to different effect at various stages of the journey through that space.

Painting the Universe: Murals of the Geographic World

Murals in architecture serve an even broader range of functions that includes, but is not limited to, concerns of sacred space. Despite their variety, however, they are united by their common medium of painting. Just as with the examination of textual sources, considering variant examples in a single medium allows contextualization of cosmological imagery across many different functions and circumstances. It also helps identify historical changes across image categories that would not be apparent in discussions of any single type.

LOCATING AND INTERPRETING COSMOLOGICAL PAINTINGS IN ARCHITECTURE

It is possible to broadly distinguish two types of architectural locale for murals in which the cosmos is a major subject, based on a conceptual distinction between exterior and interior. This division is a relative one, however, and exterior images may recur at the thresholds to different levels of space within an architectural complex. Predictably, these differences in circumstance also correspond to variations in iconography and function. Cosmological murals in the exterior category generally mark a threshold or introduce a key concept of the sacred space being entered. Images in the interior do not generally perform such a function but can do just about anything else.

Exterior or threshold murals lie at the entrances to courtyards, buildings, or shrines — although the paintings may occur either just outside or just inside the actual doorways. Abstractly, the paintings mark the entrance to a sacred space, but they may do so by performing any of a number of ritual or didactic functions. They may

serve, for example, as geographic explanations of the world, encapsulating the *abhidharma* teachings and perhaps motivating Buddhist practice within the monastery walls. Instructive murals can also depict the locations of key events and people, such as the Buddha's enlightenment at Bodh Gayā (see fig. 2.3). The paintings may also visually introduce the cosmology underlying the structure of the temple, giving visitors a holistic overview of the space they are about to enter. Threshold murals also frequently depict imagery of the treasure-maṇḍala offering, recreating that ritual before the entrance to a shrine space, just as the offering to the teacher is performed before more advanced tantric rites.

Interior Cakravāla murals appear in passageways or on the walls of a shrine and perform a variety of (non-introductory) functions. They may depict Meru or the entire cosmos as the throne of an enlightened figure, the background to a narrative scene, the attribute of an esoteric deity, the geography of a deity maṇḍala, or something else altogether. Given the variety of such images, they are difficult to categorize succinctly. Such murals can differ immeasurably in their details and functions, so, here, emphasis is placed on large, distinctive images of the cosmos that have a particular function in the architectural or iconographic program of a site. Many other images of Meru and the cosmos appear idiosyncratically throughout the Buddhist world, and they are simply too numerous to address in full.

Cosmos at the Threshold: Wheel of Existence and Cakravāla

One cannot discuss cosmologically themed murals at the entrances to sacred spaces without addressing the wheel of existence, an important artistic subject that has received significant scholarly attention.[34] Indeed, the very first illustrations in this book show the paired wheel of existence and Cakravāla cosmos at the entrance to a monastery in Sikkim (see figs. I.1 and I.2). The tradition of painting the wheel of existence at the threshold is both older and more widespread than its pairing with the Cakravāla, so any analysis of the Cakravāla paintings must be framed alongside this larger tradition. The wheel of existence is traditionally considered to function as a didactic introduction to the Buddhist conceptual world at the physical entrance to the monastery,[35] so it is unsurprising that other cosmological subjects, like the Cakravāla, can perform similar tasks.

The wheel of existence, like the Cakravāla image, is a visual depiction of Buddhist cosmology. Rather than focusing on the mountains and continents, however, the wheel of existence portrays different states of existence alongside the causes of birth and suffering in the world. Although types of beings are intimately connected to specific locations in the world, the wheel of existence is not structured according to geography. Rather, it employs a diagrammatic layout in which spatial relationships between different sections communicate conceptual lessons about states of being and their causes. The imagery describes the various mechanisms whereby sentient beings transmigrate through different existences and, ultimately, how one escapes the cycle

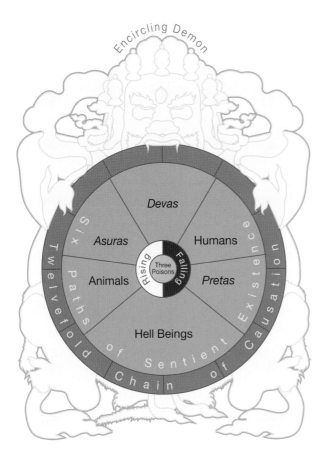

4.17. Overview of the wheel of existence

of births through enlightenment. In this sense, it is an existential map, rather than a geographic one.[36]

The entirety of the wheel is grasped in the clutches of an enormous demon who represents impermanence or death (fig. 4.17). Since all sentient life occurs within the circle, the demon's embrace visually communicates the idea that all life is subject to impermanence, a key Buddhist principle. Within the great circle, there are four concentric registers of imagery. The widest is radially divided into five or six sections, each of which depicts one of the paths that sentient beings can take in birth. These wedges are organized into a vertical hierarchy, with *devas* at the top, hell beings at the bottom, and other types of beings in between. Humans and the *asuras*, *deva*-like beings whose main characteristic is to challenge the *devas* for dominance of the world, usually occupy the upper half. Filling out the lower half are less desirable births as animals and *pretas* (commonly interpreted as starving, ghostlike entities). In capturing all these states of existence, the wheel of existence describes the world as completely as a Cakravāla mural that depicts the continents and mountains but does so in terms of types of beings rather than geographic locations.

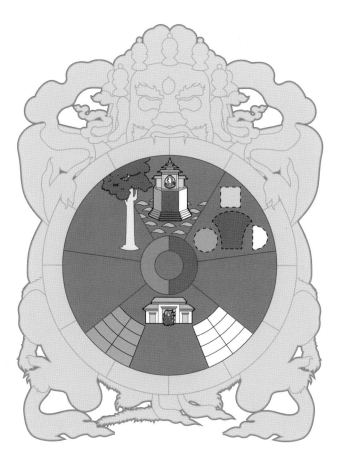

4.18. Geographic imagery in the wheel of existence

This is not to say, however, that there is no geographic information in the wheel of existence, since certain types of beings are directly associated with specific places. While the iconography of the wheel of existence has changed significantly over time, most contemporary images do contain obvious geographic markers (fig. 4.18). The *devas* are almost always depicted in the heaven of the Thirty-Three atop Meru, which is usually surrounded by rings of golden mountains (fig. 4.19). Although the continents are rarely present, they are occasionally depicted in the landscape of the human realm.[37] One such example is found at Thikse monastery, in Ladakh, which portrays the majority of the human realm as Jambudvīpa but also includes a semicircle, a square, and a circle to represent the three other major continents (fig. 4.20). These continents even contain the unique continental treasures cited in the treasure-maṇḍala liturgy, such as the mountain of jewels, the unsown harvest, and the wish-granting cow. Returning to the generic wheel of existence, a large tree often separates the *devas* from the *asuras*, who are sometimes said to live at its base (see figs. 4.18 and 4.19). Finally, in the hell realms, Yama's palace and the divisions of eight hot and eight cold hells often appear (fig. 4.21, in the small boxes at the bottom corners of the hell wedge; also see

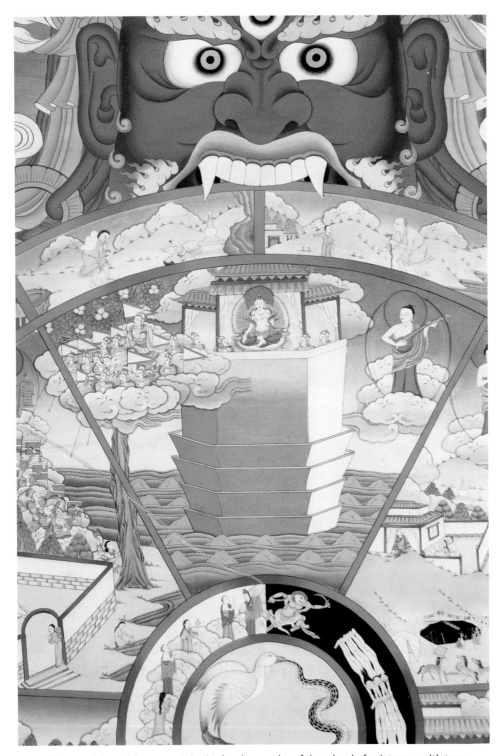

4.19. Meru and the golden mountains in the *deva* realm of the wheel of existence, with tree and *asuras* to the left; detail of figure I.1. 20th–21st century. Main entrance, Zurmang Shedrup monastery, Sikkim, India

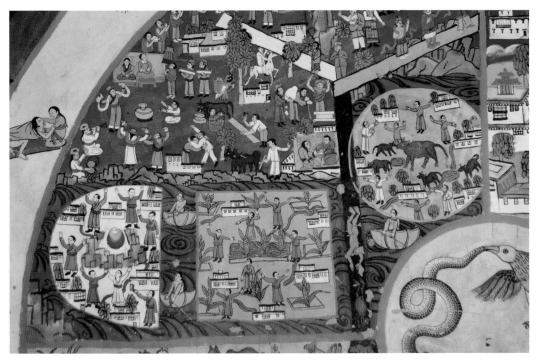

4.20. Continents in the human realm of the wheel of existence. Entrance vestibule to assembly hall, Thikse monastery, Ladakh

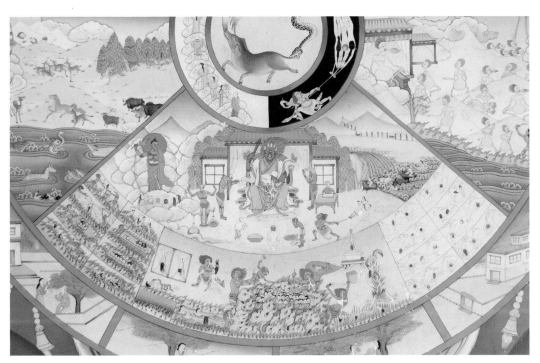

4.21. Yama's palace and the hot and cold hells in the hell realm of the wheel of existence; detail of figure I.1. 20th–21st century. Main entrance, Zurmang Shedrup monastery, Sikkim, India

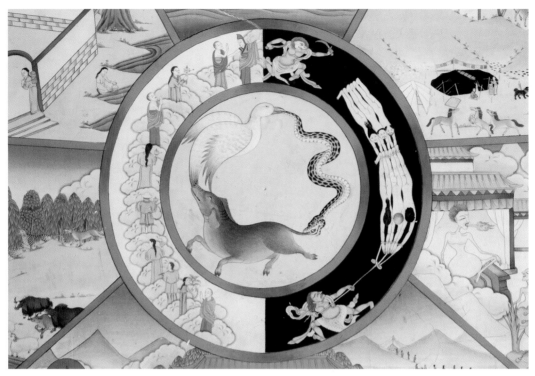

4.22. Center of the wheel of existence; detail of figure I.1. 20th–21st century. Main entrance, Zurmang Shedrup monastery, Sikkim, India

fig. 4.18). The arrangement of all these locational markers is not precisely geographic but a function of the vertical hierarchy of the states of being.

The other three registers depict the causes and processes of birth and death in the six realms of beings. Just inside the six paths, a ring divided into white and black halves shows beings rising and falling through the cycle of births in these states (fig. 4.22). Those in the white half are drawn upward to better births by monks, while the unfortunate beings in the black half are dragged downward by demonic influences. Overall, this ring conveys the impression of an endless circle of clockwise motion up and down through the levels of the wheel. The hub at the center, which drives this motion like an axle, portrays the causes of cyclic existence:[38] three psychological factors that bind sentient beings to worldly births. A bird, snake, and pig represent the three poisons[39] of attraction, aversion, and delusion or ignorance.[40] The outermost register of the wheel (where it "meets the road") depicts the specific mechanisms by which these factors entrap beings within the cycle of rebirths. Here, twelve segments form a twelvefold chain of causation[41] that stems from ignorance and leads to grasping, suffering, birth, and death. The possibility of escape from the cycle of sufferings is represented in varying ways by figures appropriately located outside the circle of the wheel of existence and therefore outside the demon's grasp. A buddha points toward a symbolic white

circle or a block of relevant text, and the paradise of the buddha Amitābha, known as Blissful, also frequently appears.

In portraying an existential map of the states and causes of suffering in the universe, and the solutions to them, the wheel of existence visually introduces the world as Buddhists conceive it, providing a clear motivation for Buddhist practice. Such visual explanations may have been important in spreading the message of Buddhism to a (sometimes illiterate) public audience who might gather at the entrance to a monastery, and indeed this function is explicitly proposed in the canonical textual source for the origination of the wheel.[42] A seventh-century commentary by Guṇaprabha, who describes the overall iconographic program for painting a monastery, lists only the wheel of existence as the key image to appear in the entrance vestibule.[43] At the same time, the actual placement of the wheel in privately patronized monasteries and other restricted circumstances may imply that this function often goes unrealized, since the public might not have access.[44] Still, such a mural is obviously designed with the ideal of didacticism, even if that function is not performed. The diagrammatic structure of the wheel of existence is simply a brilliant illustration for the clear communication of complex ideas.

Given the dramatic ability of the wheel of existence to express Buddhist cosmological principles, what happens to a Cakravāla depicted alongside it? Since the wheel depicts all types of beings in the cosmos, and, to some degree, even their geographic locale (or at least their hierarchy), the Cakravāla mural does not need to replicate this information. Prominent depictions of sentient beings are not widespread in Cakravāla entrance murals, with the notable exceptions of Śakra (as the highest being in the ordinary world) and the Great Kings (usually accompanied by a few generic *nāgas* and animals that dot the landscape).

The presence of the guardian kings is significant because they also frequently appear separately in the architecture of the temple as the protectors of its sacred space. A depiction of the kings in the Cakravāla, seen by the visitor who also encounters them at the entrance to the shrine, directly establishes the identification of the shrine with Meru. Such a configuration occurs at Trongsa Dzong, in Bhutan (fig. 4.23). In these modern paintings, the three Great Kings on the terraces of Meru in the Cakravāla image (fig. 4.24) reinforce the cosmological significance of the four Great Kings who flank the entrance to the monastery (fig. 4.25; see fig. 4.23, the overview, at the left), reminding the viewer that the space they surround is none other than Meru.

The idea that the Cakravāla mural should introduce geospatial principles rather than existential ones when positioned next to the wheel of existence makes perfect sense, given their different approaches to structuring cosmological thinking. Modern Cakravāla murals in Bhutan show a careful consideration of geography, with some providing detailed labels for all the major structures described in the *Treasury of Abhidharma*. Figure 4.26 shows a detail of the seven rings of golden mountains and oceans surrounding Meru from the mural at Trongsa Dzong, with labels noting the names

4.23. Cakravāla mural (center) with Great Kings (far left), offering goddesses (middle left), and treasures of the *cakravartin* (far right). 20th–21st century. Entrance vestibule, Trongsa Dzong, Trongsa, Bhutan

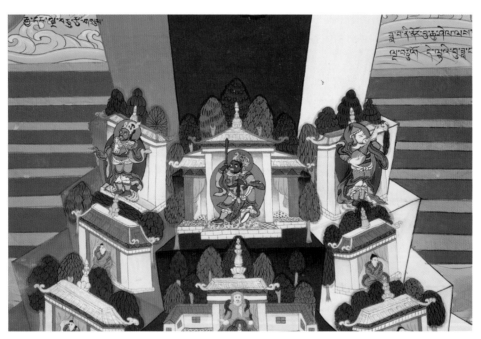

4.24. Great Kings on Meru's terraces in Cakravāla mural; detail of figure 4.23. 20th–21st century. Entrance vestibule, Trongsa Dzong, Trongsa, Bhutan

4.25. Composite of four Great Kings flanking entrance doorway in figure 4.23. 20th–21st century. Entrance vestibule, Trongsa Dzong, Trongsa, Bhutan

and sizes of each feature. Further annotations describe the continents, heavens, and so on. A similarly detailed enumeration, painted in a very different style, adorns the new Rumtek monastery in Sikkim. With the presence of such technical labels, these murals do not just illustrate fundamental concepts for an uninformed public but could serve as detailed guides for monastic students of Buddhist scholasticism. Taken to the extreme, these images become highly sophisticated statements of *abhidharma* geography, just as the wheel of existence deftly portrays the *abhidharma* analysis of the causes and states of existence. As in the Cakravāla mural from Sonada Gompa in Darjeeling, India (see figs. 2.2 and 2.3), this geography can also include distinctive elements of important narratives, such as the location of the Buddha's enlightenment at Bodh Gayā or Padmasambhava's Lotus Light Palace in the subcontinent of Cāmara. These same figures, along with other details associated with the various continents, also appear in a mural at the exterior entrance to the central shrine building at Samye (fig. 4.27).

Geographic didacticism as a means of orienting oneself to a temple or monastery is not simply an arbitrary use of entrance murals but a broader theme expressed in textual inscriptions as well. After all, the depicted cosmos theoretically represents a real geography in which the temple at hand can be precisely located. Even short dedicatory inscriptions frequently exhibit a concern for such geographic emplacement, detailing the regions of Jambudvīpa far better than the small portions of murals in which they are depicted. An inscription from Alchi reads: "In the north part of Jambudvīpa is the Land of Snows, the country of sPu-rgyal's Tibet with its high mountains and pure ground, filled with religious practitioners who possess the Thought of Enlightenment. The patron who founded this precious tiered *vihāra* (monastery) here at Alchi of Ladakh, in Lower Mar-yul of Upper Nga-ri was the teacher Tshul-khrims 'od. He

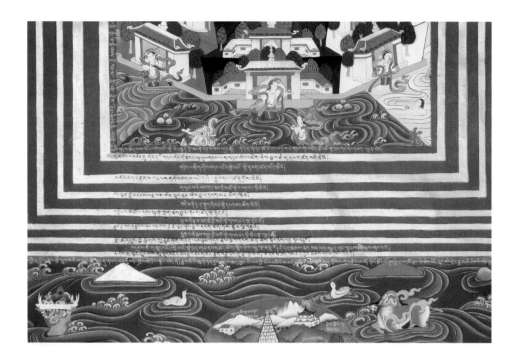

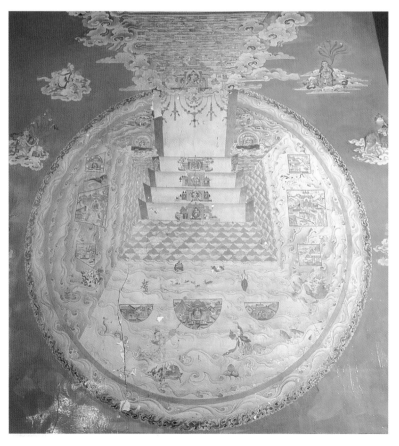

4.26. (*Above*) *Abhidharma* labels in Cakravāla mural; detail of figure 4.23. 20th–21st century. Entrance vestibule, Trongsa Dzong, Trongsa, Bhutan

4.27. (*Left*) Cakravāla mural. Entrance vestibule to the circumambulatory path around the central shrine building, Samye monastery

was of the great aristocratic 'Bro lineage."[45] Such inscriptions locate the site first in Jambudvīpa generally and then more specifically in the landscape of Tibet. This locative impulse also occurs in a wide variety of other texts and literature, including biographies, histories, and pilgrimage guides.[46] More directly, it shows that there is something inherently geographic in the concept of a religious site, matching the use of murals as geographic lessons at the entrances to such sites.

Despite the overwhelming geographic didacticism of some Cakravāla murals, other paintings at the entrance threshold serve the entirely different purpose of representing the treasure-maṇḍala of the cosmic offering, being vague or inaccurate in their geographic details. Such murals emphasize the visual language of the treasure-maṇḍala, especially the cosmos-as-heap and Meru-as-jewel styles, along with other figures such as the treasures of the *cakravartin* and the offering goddesses. The geographically didactic murals seem more common in the eastern Himalayas, such as in Darjeeling, Sikkim, and Bhutan, while the cosmos as offering predominates in the western Himalayas, especially in Ladakh. A perfect example can be found at Rizong monastery, just outside the entrance to the assembly hall, and thus well inside the exterior-most entry to the monastic complex (fig. 4.28). Here, the cosmos-as-heap Cakravāla appears alongside the seven treasures of the *cakravartin* and a row of eight offering goddesses standing in a generic landscape. Clearly, this mural reproduces the treasure-maṇḍala offering at the entrance to the assembly hall, within which more-advanced rituals take place. No labels, narrative details, or other figures disturb the image of the cosmos as a singular jewel to be offered. While the mural of the cosmic offering occurs in an entrance vestibule that is also adorned with a set of guardian kings, who mark the assembly hall as a maṇḍala palace atop Meru, the image of the Cakravāla serves as an object of offering rather than as a guide to the space of the monastery (fig. 4.29). The same type of cosmos-as-heap offering with the treasures of the *cakravartin* also occurs at Samkar Gompa alongside a wheel of existence and the four Great Kings (fig. 4.30).

When such images of the cosmos are pictorially separated from the *cakravartin* treasures and other items of the liturgy, they may be difficult to recognize as offerings, but in many cases, they are indeed. Similar murals also occur as part of the offerings to wrathful deities outside protector shrines, as the Meru-as-jewel from Thikse, Ladakh (fig. 4.31; see fig. 3.40). Here, the white pillar of Meru lies toward the right of the image (just behind the green-and-white cardboard box), while other images of animals, skins, and skull cups fill the rest of the wall. Such images do not provide a geographic lesson but engage in the adornment and ritual life of the monastery.

At least a few themes are common to both the geographically didactic murals and the offering murals of the treasure-maṇḍala. For one, it is very rare for either type to depict the hell realms (the example at Sonada Gompa [see fig. 2.2] is unusual). One reason for this may be that the wheel of existence illustrates this topic so well that it need not be duplicated in the Cakravāla. The omission of the hells also accords with the idealization of the cosmos inherent in the treasure-maṇḍala offering. Both didactic

4.28. Cakravāla with treasures of the *cakravartin* and offering goddesses. Entrance vestibule to assembly hall, Rizong monastery, Ladakh

4.29. Plan (unmeasured) of entrance vestibule in figure 4.28

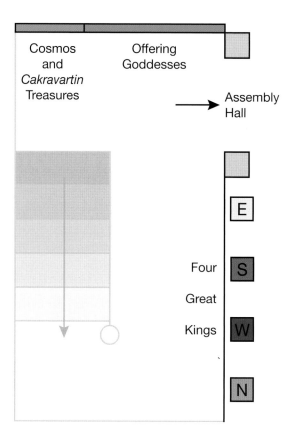

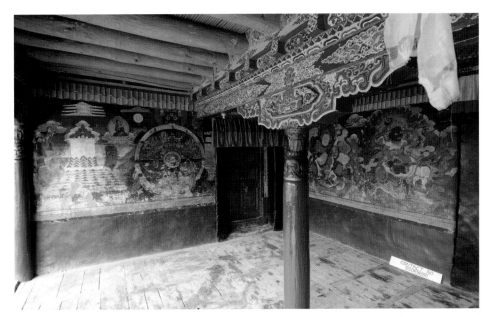

4.30. Entrance vestibule with Cakravāla, treasures of the *cakravartin*, wheel of existence, and guardian kings. Samkar Gompa, Ladakh

4.31. Wrathful offerings. Entrance vestibule to protector shrine, Thikse, Ladakh

and offering murals also frequently contain additional treasures and wealth, such as royal jewels dotting the oceans or floating in the sky next to goddesses. These may be considered parts of the offering or simply indications of the bounty of the idealized Buddhist universe.

Given these overlaps, individual murals commonly take on the roles of both offering and didacticism, such as the carefully labeled Cakravāla at Trongsa Dzong that is flanked by offering goddesses and the treasures of the *cakravartin* (see fig. 4.23). The mural at the new Rumtek in Sikkim, which is similarly filled with didactic labels, also includes images of goddesses lustrating the Cakravāla cosmos and even a monk performing the maṇḍala offering, much as a field of accumulation duplicates the cosmos-as-heap with an image of Khedrup holding a tiered grain maṇḍala. Because the murals are so large and the iconography of the cosmos is so flexible, there is no reason that such murals cannot represent several complementary expressions of cosmological thinking.

Despite such variety, nearly every mural of the Cakravāla at the threshold or in the entrance vestibule shares the common function of marking a transition into learned or sacred space. In this sense, the broad architectural function of the murals is distinguishable from specific iconographies that express different religious purposes, such as *abhidharma* scholasticism or offering. Didactic murals may introduce key concepts of Buddhist philosophy taught inside the monastery walls. Images of the Great Kings and the structure of the cosmos reinforce the identification of the shrine the visitor is about to enter with the maṇḍala palace atop Meru. Paintings of the treasure-maṇḍala offering re-create that practice before one enters a space of higher rituals within the shrine. Despite the variety of these images, they all mark the threshold between exterior and interior spaces in precise cosmological terms via specific religious functions. While these functions may go unrealized, as with the wheel of existence,[47] the cosmological thinking behind them appears consistently in the iconography of the images. Through these forms, the murals cosmologically mark the threshold of sacred architectural space.

Cosmos in the Interior

Once the threshold is passed and the interior is reached, cosmological imagery becomes remarkably more varied. Indeed, it is difficult to characterize any single purpose, iconography, or style of the Cakravāla or Meru, so a few examples must suffice to provide an idea of the scope. Indeed, one could quibble about whether these are even cosmological images per se, but it is important to consider (at least briefly) all cases in which images of the cosmos and Meru are put to specific use in order to contextualize cosmological imagery more broadly. In short, images of the cosmos appear in narrative scenes, deity iconography, maṇḍalas, visionary imagery, and many other forms that show the broad applicability of cosmological thinking to a wide variety of religious circumstances.

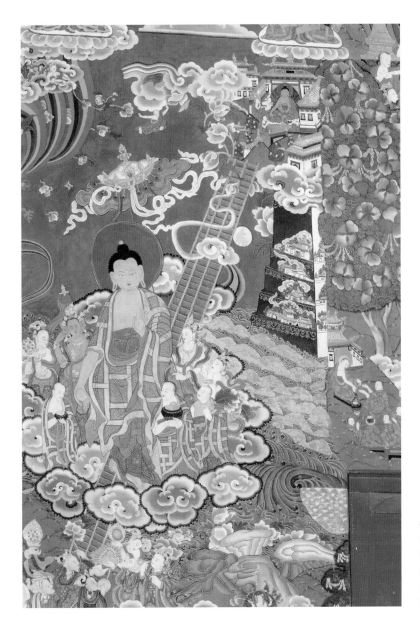

4.32. The Buddha's descent from the heaven of the Thirty-Three. 20th century. Ganden Phelgay monastery, Bodh Gayā, India

Perhaps the most common contemporary images of the cosmos inside shrine spaces occur in narrative scenes, especially narratives of the Buddha's life. Images of Māra's demons attacking Siddhārtha with Meru (see fig. 1.19) or the Buddha extending his body to fill all of space (see figs. 1.20 and 1.21) use the cosmos to illustrate the significance of Śākyamuni's accomplishments rather than depicting it as the main subject. Another such example is the image of the Buddha's famous descent from the heaven of the Thirty-Three, which he visited in order to teach his reborn mother (fig. 4.32). As does the Tibetan version of the offering maṇḍala, this mural emphasizes the extreme

height of Meru, in this case to communicate the Buddha's accomplishment in traveling to and from this difficult-to-access location. The painting depicts only a thin vertical slice of the cosmos, from the single continent at the bottom (a partial white semicircle filled with mountains), through the perimeters of golden mountains, up to Meru and the palace at its peak. The continents at the sides are omitted, and the eastern face of Meru (white) is occluded, forcing the palace at the peak awkwardly to one side of the center. Such adjustments convey Meru's height and the linear path between Meru and Jambudvīpa that the Buddha traveled by means of a triple staircase, imagery of which long predates depictions of Meru in this context.[48] Narrative use of Cakravāla imagery is not limited to the life of the Buddha, however, and is also seen in relation to stories of previous births, such as the life of Māndhātar and other tales.

Looking to nonnarrative examples, interior images of cosmic geography also appear in the iconographies of certain deities. Because of the plethora of deities in local traditions, it is impossible to provide a full list, but any enumeration would encompass both well-known and obscure deities including Hayagrīva (rTa mgrin), Śramaṇa-devī (Lha mo śra-ma-ṇa), Mañjuśrī Nāgarākṣa ('Jam dpal nā-ga-rakṣa), Amitāyus (Tshe dpag med), and Pale Sun-and-Moon (Gaurī/dKar mo nyi zla).[49] The last two are particularly interesting because the cosmic imagery appears not as a background landscape but as hand-held attributes of the deities. With Amitāyus, numerous Cakravāla cosmoses can be depicted as fruit-like productions from the long-life plant that grows in his begging bowl (fig. 4.33). Pale Sun-and-Moon may be an astrological figure because of her strong association with the sun and moon, which appear not only in her name but in her necklace and crown.[50] She holds two iconic representations of the Buddhist cosmos in her hands: in the proper left, a Cakravāla disc with the four continents, and in the proper right, four-terraced Meru (fig. 4.34).[51] As is often the case with the attributes of an esoteric deity, the precise logic by which these images appear is not entirely obvious, but the overall cosmological tone of the deity is quite apparent.

One last context for interior cosmological imagery relates to ritual and visionary experiences. Like the continents in the deity maṇḍala at Alchi (see figs. 2.5–2.7), numerous other examples of cosmic imagery in maṇḍalas exist, sometimes with far more explicit depictions of Meru and the continents, such as at Gyantse in Tibet[52] and Sonada Gompa in Darjeeling.[53] In addition to its use in deity maṇḍalas, however, the cosmos also appears in other kinds of ritual and visionary imagery, notably in the esoteric murals of the Nāga Temple[54] at the Potala palace in Tibet. The origins of this temple are not entirely clear, but it dates to the time of the fifth or sixth Dalai Lama and may be based on the former's visionary experiences.[55] Despite its straightforward purpose of appeasing the local *nāgas*, it contains remarkable imagery associated with the Great Perfection[56] teachings of tantra.[57] On the north wall of the top floor, illustrations of an important Great Perfection text juxtapose the creation of the universe to the transformation of the human body into a vessel for enlightenment (broadly reminiscent of the connection between macrocosm and microcosm in the Wheel of Time

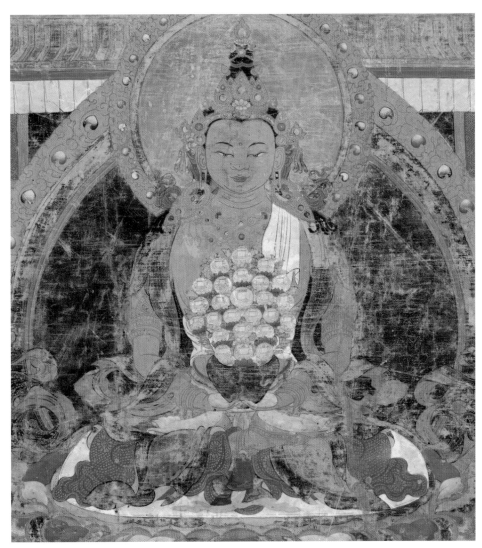

4.33. Amitāyus, detail. 19th century. Tibet. Collection of the Rubin Museum of Art, Gift of the Shelley and Donald Rubin Foundation F1997.26.1 (HAR 345), www.himalayanart.org/items/345

system).[58] A fairly typical *abhidharma* cosmos is depicted alongside the primary elements that form the basis of personal/bodily transformation for enlightenment, while a nearby inscription connects the creation of the universe to the creation of buddhas.[59] Such interior murals of the Cakravāla, hidden in the most isolated of sacred spaces, can communicate esoteric messages about even the highest tantric practices.

Despite this wide range of functions, interior images of the Cakravāla are clearly distinguished from those at thresholds and entrances by their iconography and function. Cosmological images at the entrances to sacred spaces mark the transition into that space, whether through the language of *abhidharma* didacticism, architectural

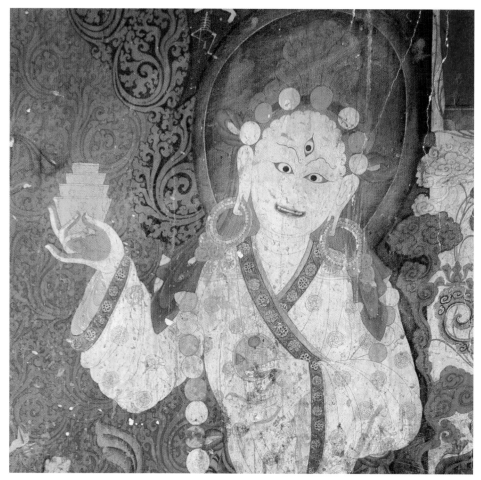

4.34. The goddess Pale Sun-and-Moon. Early 15th century. Gyantse monastery. Photograph courtesy of Dina Bangdel

symbolism, or offering ritual, while interior murals do not. Indeed, it is remarkable that threshold murals maintain such a consistent association with the act of transition, despite their great variety. Cakravāla paintings at entranceways also complement imagery of the wheel of existence, both by performing a similar didactic function for geography (and architecture) and by marking a conceptual transition into the intellectual and sacral world of the monastery.

SOME TOUCHSTONE PAINTINGS IN HISTORY

In addition to placing images of the cosmos in architectural context, it is also important to locate them in history. For example, although we can trace threshold imagery of the cosmic offering back to at least the twelfth to the thirteenth century in Alchi (in the

Mahākāla murals above entrance doorways), only after the seventeenth-century popularization of this ritual does the treasure-maṇḍala iconography appear so regularly juxtaposed to the wheel of existence at monastic entrances. Taking a strictly chronological approach to extant cosmological murals, we can identify noteworthy paintings that tell us about changes in cosmological imagery over time.

In terms of cosmological images at the threshold, the earliest evidence is for the wheel of existence appearing by itself. This is true in the Indic tradition, with a fifth-century example surviving at Ajaṇṭā, and perhaps in Tibet, with a tenth- to eleventh-century image at Tabo appearing alongside other imagery that may or may not be cosmological. Between these touchstones, examples in Central Asia from the fifth to eleventh centuries (at Kizil and Dunhuang) show Cakravāla imagery employed widely in narrative and other interior uses. In Tibet, fourteenth-century murals at Shalu depict narratives like the story of Māndhātar in significantly more diagrammatic ways, apparently prefiguring non-narrative and maṇḍalic uses. By the fifteenth century, Cakravāla imagery is well attested at entrance vestibules, with an especially interesting example at Tholing combining the wheel of existence and Cakravāla in a single image. The popularity of Cakravāla images at entrances continued to increase through the seventeenth and eighteenth centuries under the influence of treasure-maṇḍala imagery, and the nineteenth century evinces an elaboration of landscape elements. In the twentieth to twenty-first centuries, we see a decided turn toward *abhidharma* scholasticism in the murals of the eastern Himalayas, with carefully labeled and even proportionally measured murals in Bhutan. Though it is impossible to capture the full range of Cakravāla imagery that appears from the fifth century to the present, an overview of important touchstones reveals some of the complex history of this subject.

Cave 17, Ajaṇṭā, Western India

The earliest attested cosmological mural represents a wheel of existence from about 450 at Ajaṇṭā, a cave temple site in western India. The entrance veranda of cave 17 contains a large and detailed version of the wheel of existence on the left side wall, precisely the same sort of context in which such imagery continues to appear to the present day (fig. 4.35). Significant damage to the mural has led to a variety of interpretations of its content, which differs noticeably from the modern paradigm.[60] In terms of geography, the most interesting difference is that the mural seems to divide the human realm into four separate wedges of the wheel, one for each major continent.[61] As in contemporary versions (although in a different artistic style), the uppermost division depicts Śakra in a palace atop Meru (fig. 4.36).

The iconographic program surrounding this mural also differs from modern examples. Some suggest that the image facing the wheel of existence at Ajaṇṭā, rather than portraying a Cakravāla, depicts the buddha Śākyamuni teaching about the portrayal of the wheel of existence, as a way of enhancing its didactic character.[62] This narrative of the Buddha's explanation may or may not date to a time as early as Ajaṇṭā;

4.35. (*Above*) Wheel of existence. 5th century. Cave 17, Ajaṇṭā, India
4.36. (*Right*) Śakra's palace; detail of figure 4.35. 5th century. Cave 17, Ajaṇṭā, India

the earliest extant sources are from seventh- to eighth-century recensions of monastic rules that originate in the first or second century.[63] The texts suggest that paintings of the wheel of existence were designed to motivate Buddhist practice by conveying lessons that Śākyamuni's disciple Maudgalyāyana had learned during cosmic travels to the realms of different beings. From the perspective of this origin story, the wheel of existence simply expresses Maudgalyāyana's journeys diagrammatically, rather than narratively. The pairing of the diagram with a narrative scene at cave 17, then, could represent an early juxtaposition of complementary cosmological subjects in a larger iconographic program, much as in later examples in which the wheel is joined with the Cakravāla.

Kizil and Dunhuang, Central Asia

The cave temple sites of Kizil and Dunhuang, while not fitting neatly into the Himalayan cultural spheres addressed so far, provide crucial examples of early cosmological painting. The Mogao caves at Dunhuang, especially, contain numerous Cakravāla images along with shrines and thrones built according to cosmic structure. They provide evidence for the early use of Cakravāla imagery in several different applications, including narrative scenes, the attributes and thrones of deities, and didactic explanations of the *abhidharma*. The majority of these appear in interior mural paintings, except for the *abhidharma* didacticism, which occurs in manuscripts found at Dunhuang. Overall, it is not entirely clear how much influence these examples had on later traditions in the Himalayas, with the possible exception of an hourglass-shaped Meru that became popular in Tibetan art. Like the wheel of existence at Ajaṇṭā, however, these examples from Central Asia show some of the early ways that cosmological imagery appeared and functioned, providing greater context for the developments seen in later murals.

Three examples from Kizil clearly reveal the themes of deity throne and narrative scene: an image of a *deva* seated atop Meru from cave 118 (the Sea-horse cave), a painting of Meru collapsing at the demise of the Buddha in cave 205 (the Māyā cave), and two paintings of Meru at the destruction of the universe in cave 207 (the Painters' cave). While the dating of Kizil is a matter of some debate, recent scholarship places cave 118 in the fifth to sixth centuries, cave 205 in the early sixth century, and cave 207 in the sixth to seventh centuries.[64] The mural in cave 118 shows the heaven of the Thirty-Three with Indra seated on a throne at the center, all of which rests on a vertical depiction of Mount Meru encircled by *nāgas* and flanked by the sun and moon (fig. 4.37).[65] It has been suggested that this scene forms part of a narrative program in the cave that tells the story of King Māndhātar, the *cakravartin* who conquers the world and ascends Meru to share Indra's throne.[66] This is among the earliest examples of Meru portrayed in a distinctive hourglass shape, widest at the top and bottom and narrowest in the middle,[67] a configuration that also appears at Mogao and gained widespread popularity in East Asia.

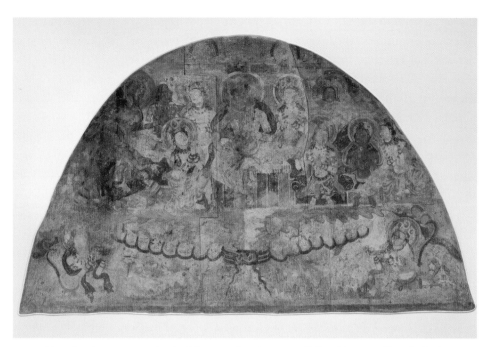

4.37. Meru in a lunette mural. 5th–6th centuries. Cave 118, Kizil. © Museum für Asiatische Kunst, Staatliche Museen zu Berlin (MIK III 8412)

The next example, from Kizil cave 205, is but one of several instances[68] of a narrative scene in which Ajātaśatru hears of the death of the Buddha, a tragedy so cosmic in scope that Meru collapses and the sun and moon are eclipsed (fig. 4.38).[69] Such an image is exceedingly rare in that it shows the cosmos with Meru collapsed to one side, rather than rising up from the center in permanent immobility. Most other visual images of Meru portray the mountain as the stable center of the universe — even when the local geography is being transformed or translocated through tantric rituals. The paintings from cave 207 are similarly unusual in presenting a narrative scene in which the cosmos itself changes, in this case, at the end of the cosmic cycle when the entire universe is destroyed.[70] Seven suns that engulf the world in flames, visible in a row above Meru, identify this scene at the lower left of the image (fig. 4.39).[71] While such images of the cosmos changing or being destroyed are well known in literature (such as the passage describing Meru bowing to the Buddha's place of enlightenment, given in chap. 1), the majority of later visual depictions do not embrace the mutability of the Cakravāla system.

The Mogao caves at Dunhuang also exhibit Meru and Cakravāla imagery of various types and purposes, especially in narrative scenes and the iconography of specific deities. The examples are far too numerous to treat in any detail here, so a few standouts from the eighth to eleventh centuries will have to suffice. Scholars have already written a great deal about the so-called cosmological buddhas, buddha figures whose

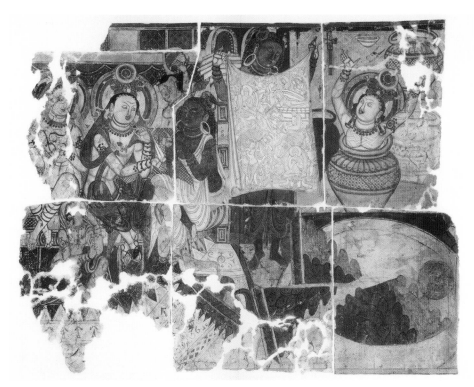

4.38. Collapsed Meru (bottom right). Early 6th century. Cave 205, Kizil. © Museum für Asiatische Kunst, Staatliche Museen zu Berlin. After Grünwedel, *Alt-Kutscha*

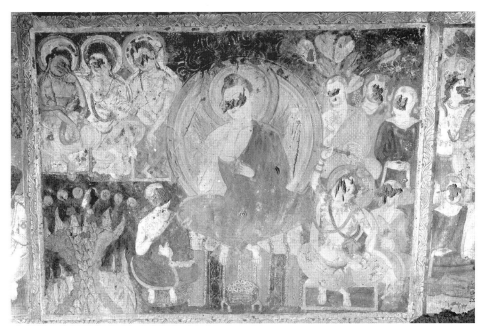

4.39. Destruction of the cosmos at the end of a cosmic cycle (bottom left). 6th–7th centuries. Cave 207, Kizil. © Museum für Asiatische Kunst, Staatliche Museen zu Berlin (B 0812)

bodies are covered with imagery of the cosmos.[72] Other paintings show the familiar Cakravāla geography of worlds that are not our own, a recognition of the multitude of similar worlds accepted in the *abhidharma*. Caves 335 and 61[73] depict a scene from the narrative of the *Teachings of Vimalakīrti*[74] in which Vimalakīrti makes visible the world of his previous birth, the land known as Abhirati and governed by the buddha Akṣobhya.[75] Despite explicitly not being the world of the buddha Śākyamuni, this land contains Meru and the other characteristic features of a cosmos that would be expected from the descriptions of multiple cosmoses in texts such as the *Treasury of Abhidharma*.[76] The scene in cave 335 is particularly dynamic in showing the precise moment when Vimalakīrti lifts this entire cosmos into the palm of his hand.[77]

Images of the Cakravāla cosmos are not just elements of narrative scenes but are also thrones and attributes of individual deities. Mogao cave 14 has an enormous image of the bodhisattva of wisdom, Mañjuśrī, seated on a lotus atop Meru, which is again depicted in an hourglass shape girdled by two *nāgas* and flanked by the sun and moon. The three visible faces of Meru have three different colors, and the mountain is surrounded by seven rings of golden mountains, the cosmic ocean, and the small ring of peripheral Cakravāla mountains.[78] Like the Amitāyus holding a begging bowl filled with Cakravāla cosmoses (see fig. 4.33), Mañjuśrī holds multiple bowls that each contain a small Meru with a buddha on top.[79]

One image of the Cakravāla cosmos from Dunhuang, notable in that it portrays the parts of the world carefully labeled in Chinese, is akin to the *abhidharma* murals from much later periods. This image occurs not in a mural, however, but rather in an illustrated manuscript.[80] The long format of the document emphasizes the vertical layers of heavens and hells, with the large diameter of the cosmos cramped into the narrow width of the page. In general, the text that accompanies the image simply names the parts of the *abhidharma* cosmology, although it has been suggested that the manuscript might have served as a model for practice as well.[81] Such a radically diagrammatic and text-based image of the cosmos significantly departs from the narrative and iconographic images that predominate at Dunhuang and Kizil, representing an early phase of scholastic visualizations of cosmology.

Tabo, Western Tibet

Returning to the Himalayan sphere, cosmological imagery appears in the earliest phases of mural painting that survive, in this case, at the tenth- to eleventh-century site of Tabo, which was constructed by Yeshe O during the Second Diffusion. The wheel of existence is recognizable here, alongside a mural that may or may not represent the geographic universe. The entrance vestibule[82] outside the main assembly hall contains a wheel of existence dating from the earliest phase of painting at the site.[83] The main shrine beyond the vestibule re-creates the Vajradhātu maṇḍala in sculpture, with Vairocana surrounded by images of all the other deities. As such, it has been

4.40. Entrance vestibule mural tentatively identified as cosmological. 10th–11th centuries. Tabo. Photograph by Christian Luczanits, 1991, collection of the Western Himalayan Archive Vienna (CL91 18,29)

noted that this is the earliest example of a wheel of existence standing at the threshold to a tantric maṇḍala shrine space.[84] Like the iconographies of the more modern entrance vestibules, the images of the wheel of existence, guardian deities, and patrons in the entrance at Tabo perform similar threshold-marking functions that have been characterized as "preface, protection, and patronage."[85] In other words, the cosmological imagery conceptually prepares the practitioner for meditation within the shrine, the deities guard the boundaries of the maṇḍala, and the images of patrons orient the visitor to viewing the site in its social and historical contexts.

On the opposite side of the main entrance from the wheel of existence lies a mural that has been tentatively identified as a "cosmological picture."[86] If this identification is correct, it may suggest a pairing of wheel of existence and Cakravāla even at this early period. Unfortunately, the second mural is heavily damaged and difficult to reconcile with more familiar images of the geographic cosmos (fig. 4.40). What remains appears to depict some generic architecture and landscape, with small bodies of water, plants, buildings, and doors. A figure resembling a bodhisattva or *deva* rests inside part of this architectural scene but defies specific identification. The modest remains of this

painting may show the appearance of Cakravāla imagery at the entrance threshold in this earlier period, but not conclusively. Murals of the wheel of existence, however, clearly occur even in this early phase of Tibetan art, including the one at Tabo and a twelfth-century portrayal at nearby Pedongpo.[87]

Shalu, Central Tibet

The fourteenth century saw continued use of the interior, narrative Cakravāla imagery, but distinctly more diagrammatic in form. Two murals in the circumambulatory paths at Shalu[88] represent two versions of the story of a *cakravartin* who shares the throne of Indra, one of them the familiar Māndhātar.[89] The images emphasize the cosmic nature of the *cakravartin*'s accomplishment by presenting small figures in a large, fully detailed cosmological landscape. These images also represent an important stylistic development in imagery of the Cakravāla, with the world being depicted more diagrammatically as a circular cosmos radially filled with continents around an enormous, rectilinear mountain (fig. 4.41).[90] One of these murals seems to depict three of the four guardian kings in the three visible continents (fig. 4.42), recognizable by their skin color (red, white, and blue) and hand-held attributes (umbrella, lute, and sword). Each continent also possesses the full set of *cakravartin* treasures (wheel, horse, elephant, etc.), with a fourth set at the top of the mural presumably belonging to the western continent obscured by Meru.[91] Because it is the human *cakravartin*, not the divine Great Kings, who possesses these treasures and conquers each of the continents, the symbolism here is not entirely clear. Both murals show Indra and the *cakravartin* sharing the throne at the peak of Meru.

The diagrammatic representations of the Cakravāla at Shalu exhibit several features that do not seem common in surviving examples from before this period. Most obviously, the square-within-a-circle design recalls the structure of the maṇḍala, as does the fact that east is placed at the bottom of the diagram.[92] In figure 4.42, the Great Kings in the three continents face inward toward the center (rather than being upright), as do deities in some maṇḍala assemblies, further suggesting that the spatial principles underlying this image are maṇḍalic in addition to being narrative.[93] While the Shalu murals are not related to the ritual of offering to the guru, this same mural also includes a strong visual connection between the Cakravāla geometry and the treasures of the *cakravartin*, precisely the same combination that would denote the treasure-maṇḍala offering in other murals. Perhaps this early envisioning of the cosmos as a maṇḍala that includes the treasures of the *cakravartin* made the later images of the treasure-maṇḍala easier for artists to develop. Because of the relative rarity of examples of Cakravāla murals from this period, it is difficult to generalize more broadly about the place of the Shalu paintings in the tradition of cosmic imagery, but they do seem to represent a move toward maṇḍalic structure and *cakravartin* imagery in the Cakravāla that is absent in earlier examples.[94]

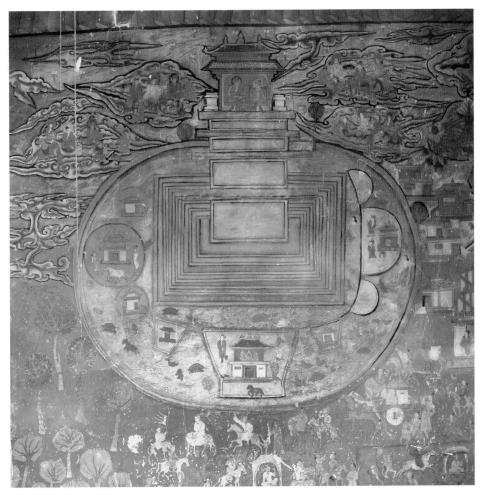

4.41. Cosmos in a narrative scene. 14th century. Outer wall of the northern corner of the circumambulatory path around the second-floor Prajñāpāramitā shrine, Shalu monastery. Photograph courtesy of Sarah Richardson (2009), supported by the Social Sciences and Humanities Research Council of Canada

Tholing, Western Tibet

Moving from the interior of the monastery back to the entrance vestibule, a similarly transitional image occurs at Tholing.[95] There, the artists combined the Cakravāla and the wheel of existence in a single, complex image (fig. 4.43). While it is impossible to generalize from a single, unusual example, this mural could potentially represent an early stage of combined Cakravāla–wheel-of-existence painting that later splits into two images, each performing different functions at the entrance. Although Tholing was founded in the eleventh century, the entranceway mural is a later addition,

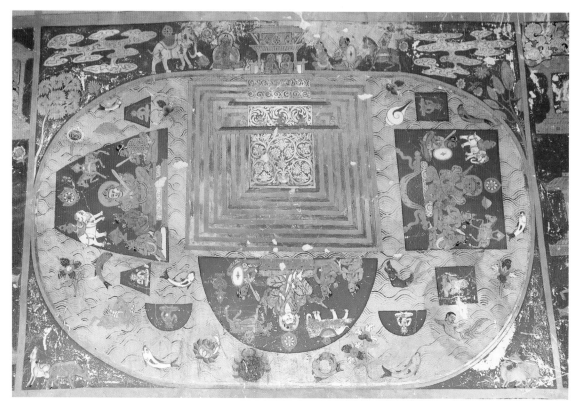

4.42. Cosmos in a narrative scene. 14th century. Great circumambulatory path, first floor, Shalu monastery. Photograph courtesy of Sarah Richardson (2009), supported by the Social Sciences and Humanities Research Council of Canada

perhaps around the fifteenth century[96] but not after the sixteenth.[97] Combined with the Shalu murals, this could also indicate a broader reenvisioning of the geographic cosmos through the fourteenth to fifteenth centuries in Tibet. The maṇḍalic restructuring seen at Shalu, for example, also makes the Cakravāla easier to integrate with the diagrammatic layout of the wheel of existence.

The painting at Tholing combines features that, in later examples, would unequivocally suggest either the wheel of existence or the Cakravāla, but not both. Like the modern wheel of existence, the circle of the diagram is held in the hands and mouth of a demonic figure. Rather than radial divisions inside the wheel, however, the interior contains the vertically layered organization of the Cakravāla. In the center stands Meru, topped by Śakra in his palace in the heaven of the Thirty-Three. The lower three sides of Meru are surrounded by rectilinear approximations of the seven rings of golden mountains rising to the height of Meru's middle terrace. At the corners are the sun and moon, which orbit Meru at this same altitude. Twelve continents in the usual shapes surround these central features in the four cardinal directions. Unlike

4.43. Geographic cosmos combined with the wheel of existence. 15th–16th centuries. Entrance vestibule, Tholing monastery, Western Tibet. Photograph courtesy of Helmut Neumann

the mural at Shalu, the southern continent of Jambudvīpa lies at the bottom of the diagram, closest to the viewer, because it is our shared human realm.

While this familiar geography takes up the middle of the circle (white background), the upper and lower registers depict the realms above and below the continents and oceans. The top segment of the circle (black background) contains several narrow rows filled with humanoid heads, symbolizing the inhabitants of the many heavens above Meru. The bottom segment (partially red and orange background) is more difficult to make out but seems to be divided into several sections that depict the hell realms, animals, and possibly *pretas*. Unlike other threshold images of the Cakravāla, then, this image may depict the fivefold division of paths of rebirth as a version of the wheel of existence. Furthermore, just below Meru at the very center of the image lies a small circle that depicts the three psychological poisons, the centerpiece of the modern wheel of existence, in the forms of a bird, a snake, and a pig.

The mural at Tholing is unquestionably a direct combination of the wheel of existence ideology and the Cakravāla geography. It is difficult to say whether this represents

4.44. Cakravāla cosmos. 19th century. Outer circumambulatory path, central shrine building, Samye monastery

a distinct stage in the evolution of Cakravāla imagery from the wheel of existence, a more general example of increasing diagrammaticity in cosmological imagery, or simply an idiosyncratic example. After this period, however, the Cakravāla appears regularly at thresholds and entrances, a significant expansion beyond appearances in narratives and interior scenes such as at Shalu, Dunhuang, and Kizil.

Samye, Central Tibet

As has already been described, a dramatic increase in treasure-maṇḍala imagery occurred after the seventeenth century, especially in entranceway murals. Rather than revisit such paintings here, we can proceed to other developments in cosmological imagery in subsequent periods. A mural from the exterior circumambulatory path of the central shrine at Samye, painted in the nineteenth century, exhibits significant stylistic influence from Chinese art and a move toward thinking of the Cakravāla as an expansive landscape rather than a container for beings (fig. 4.44). The depiction

of Meru as a rocky mass clearly refers to Chinese landscape painting traditions. As is common in later images, the great ocean in which the continents rest divides into four different colors in the four cardinal directions. Unusually, the golden mountains that surround Meru extend all the way to the edges of the Cakravāla, apparently a visual conflation of the mountains with the peaked waves of the ocean. As is also common in later paintings, images of architecture and landscape replace depictions of individual beings in the continents (see figs. 4.41–4.43 for comparison). This suggests that the Cakravāla is understood more as a geography or landscape than a collection of containers for specific beings, perhaps an indication of the increasing division of function between Cakravāla images and the wheel of existence.

Punakha and Simtokha Dzongs, Bhutan

Advancing nearly to the present, several paintings in Bhutan evince a nearly unprecedented concern for portraying the descriptions of textual sources such as the *Treasury of Abhidharma* and the Wheel of Time corpus. The eastern Himalayas seem to be an epicenter for greater textual engagement in cosmological threshold murals, with careful labeling of the names and measurements of every feature listed in the *abhidharma*. Among several examples, a few stand out for their visual representation of textual elements. First, an example from Punakha Dzong depicts an immense circle of blue clouds outside the Cakravāla mountains (fig. 4.45), representing the disc of wind on which the physical cosmos forms. While paintings of the Wheel of Time cosmology regularly show the elemental substrata of the cosmos, including both wind and fire, *abhidharma* murals rarely depict this circle of wind, although other examples do exist at Trongsa Dzong and Samye (see fig. 4.27). Furthermore, the examples at Punakha and Trongsa Dzongs portray the circle of wind as much larger than the other features of the cosmos, reflecting the measurements in the *Treasury*. The one at Trongsa Dzong, in particular, most accurately depicts the wind as extending infinitely to the very edges of the mural.

Another example from Simtokha Dzong takes proportional measurement to its utmost, accurately depicting the geography of the cosmos to scale as described in the *Treasury* (fig. 4.46). While Meru itself appears in elevation, the rest of the cosmos is depicted in a measured plan, as evidenced by the linear decrease in sizes of the golden mountain ranges (compare to fig. 1.9). The continents, being minuscule in proportion to the other elements of the cosmos, are not visible in the photograph.[98] Outside the rings of golden mountains, an interlocking network of circles and arcs represents astral paths. In its rare precision, this mural illustrates just how much most other Cakravāla imagery differs from the textual sources.

Bhutanese artists also somewhat unusually depict the Wheel of Time cosmos alongside the *abhidharma* cosmos in separate murals. One such Wheel of Time painting occurs at Punakha Dzong alongside the *abhidharma* cosmos (see fig. 4.45) and a wheel of existence (fig. 4.47). Although there is some conflation in this mural between

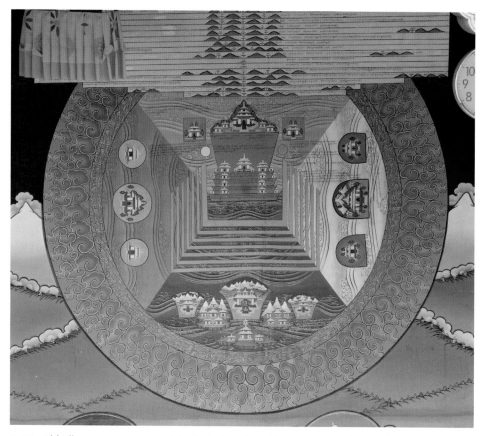

4.45. *Abhidharma* cosmos mural. 20th–21st century. Entrance veranda to main assembly hall, Punakha Dzong, Punakha, Bhutan

the *abhidharma* and Wheel of Time cosmologies, circular Meru is visible in the center, surrounded by circular rings of mountains and oceans (the thin red, yellow, white, and blue stripes) and the twelve continents in a plain blue circle that represents the sea of Greater Jambudvīpa. Outside this circle, a larger ocean filled with waves represents the disc of water, which is surrounded by the discs of fire (red) and wind (green).

Conclusion

This brief history of cosmological murals regrettably omits consideration of at least one key element, the agency of the artists themselves. Whereas texts can often be attributed to specific authors with known agendas, for many artworks, even their creators' names are lost to time. Pursuing a view of the artistic process in general, one might attempt to consult the textual manuals that provide detailed instructions for portraying buddha figures and other forms,[99] but these sources are most often silent about the depiction of cosmic geography.[100] In many cases, it is likely that an individual artist's style of

4.46. Proportional Cakravāla mural. Simtokha Dzong, Bhutan. Photograph courtesy of Dorji Yangki

representing the cosmos was simply copied from his or her teacher without textual or ideological explanation.[101] It remains, then, to look at the larger historical scope of artistic lineages and historical moments in which variant images of the cosmos arose, tracing developments from the first known fully cosmological mural, the wheel of existence at Ajaṇṭā, to Cakravāla murals across southern and Central Asia.

Looking over this history, it is easy to see the variety of uses to which cosmic imagery has been put. Subtler are the connections that these images have to one another and to the architectural and iconographic contexts that surround them. The earliest cosmological murals in both India (at Ajaṇṭā) and Tibet (at Tabo) are images of the

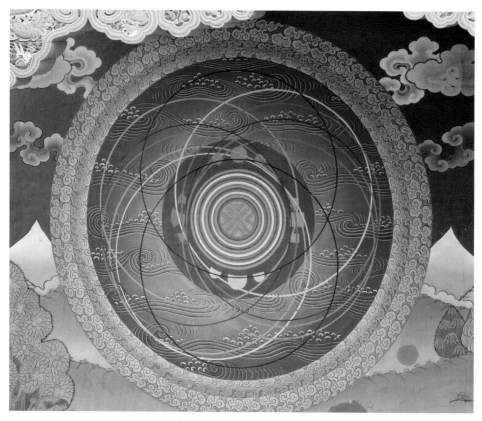

4.47. Wheel of Time cosmos mural. 20th–21st centuries. Entrance veranda to main assembly hall, Punakha Dzong, Punakha, Bhutan

wheel of existence, not the Cakravāla, but these two subjects are intimately related. Indeed, at Tholing, the two were combined in a single painting, perhaps representing one phase in the relationship between these images that ended with later murals juxtaposing them. At the same time, a parallel story can be told for interior images of the cosmos, beginning with the Central Asian sites of Kizil and Dunhuang. Here, images of Meru abound in narrative scenes, including dynamic vignettes of destruction vastly different from the normal, stable portrayal of the world. Later, at Shalu, the narrative cosmos appears more diagrammatically, perhaps indicating a new visualization of the world as a maṇḍala that furthers its connection with other diagrams, such as the wheel of existence, and other iconographies, including the treasures of the *cakravartin*. In the past century, this move toward diagrammaticity has advanced even further, with images in Bhutan portraying radically textual versions of the *abhidharma* cosmos, including an exceedingly rare proportional image.

Among all of these variations, a clear distinction can be made between interior and exterior uses of the Cakravāla. While both can serve many different functions, the latter almost always marks a conceptual transition in space between exterior and interior,

in other words, a threshold. This is where the Cakravāla most often appears with the wheel of existence, and indeed this juxtaposition of cosmological images allows entrance murals to mark several different conceptual thresholds simultaneously. The wheel of existence and some Cakravāla murals introduce the philosophical analysis of the Buddhist world that underlies education and rituals within a monastery. The Cakravāla may also serve a ritual role, as a rehearsal of the treasure-maṇḍala offering to the teacher. While the treasure-maṇḍala does occur with Mahākāla in the murals at Alchi, only after the seventeenth-century popularization of this ritual do murals of the entire Cakravāla, as a ritual subject, come into their own. Like the actual performance of the offering to the teacher, these murals precede more esoteric rituals performed in the shrine interior.

This clear-cut distinction between interior and exterior depictions of the cosmos expresses the central idea that architectural context affects cosmological expression. Not only does the function of a cosmological mural depend on its location within a temple, but cosmological thinking infuses the design of monastic space in complex layers. Perhaps the most famous example is Samye, which is understood to have an explicitly cosmographic plan. Even in this most explicit case, however, we find different expressions of cosmic structure, with the three-story central building embodying Meru in the ground plan, the maṇḍala palace in the shrine space, and the confluence of Indian, Tibetan, and Chinese traditions in the decorations. When the plan of the site and building is not so specifically cosmological, additional architectural features such as murals of the guardian kings reiterate the identification of the shrine with the maṇḍala palace. The modest tiered altar in front of the image, too, recapitulates Meru's terraces, using the structure of the treasure-maṇḍala to reify cosmology in the very act of making an offering to the central image.

Clearly, cosmological thinking is intimately connected to the experience of sacred space. Like the meditations on the tantric maṇḍala, movement through architecture provides a transformative experience that ends with direct access to an enlightened buddha at the center of the cosmos. This journey is foreshadowed by cosmic imagery at the entrances to the space and reiterated at various points along the way through murals and other structures. Further imagery of the cosmos in the interior reflects changing narrative and ritual needs beyond mere introduction at the entrances. While cosmological imagery is not the only, or even the most common, type of imagery in architecture, it is certainly central to conceptions of lived and sacred space.

Conclusion

PORTRAITS OF LANDSCAPES

IN CONCLUDING, LET US COME FULL CIRCLE AND RETURN TO THE PAIR OF murals that introduced this book, a wheel of existence (see fig. I.1) and a Cakravāla cosmos (see fig. I.2). At the time, the complexity of the latter image was only hinted at, but we can now clearly see reflections of varied cosmological topics in its details. As with every other image or text of the cosmos, this depiction of the Cakravāla is a unique combination of ideas in a single context, in this case, at the entrance to a modern monastic courtyard in Sikkim, across from a wheel of existence.

In addressing textual expressions as putative sources for cosmology, we saw that the text most closely associated with this mural, Vasubandhu's *Treasury of Abhidharma*, only partially corresponds to the image. Some features align well, including the terraced central Meru and a ring of clouds at the outer edge representing the disc of wind above which the cosmos forms. Other details differ significantly. The seven ranges of golden mountains, though described in the text as square and progressive in height, appear here as circular and uniform in size. While Meru does hold different types of beings in its tiered realms, reflecting the connection of life and place in the *Treasury* (see fig. 1.12), the continents and heavens depict dwellings rather than creatures, identifying geography with landscape as commonly seen in nineteenth- and twentieth-century murals (see figs. 4.44 and 4.45). Other details reveal the transmission of the *Treasury* as a text through history. The southern continent, Jambudvīpa (at the bottom center of the image), appears in the scapular shape of Tibetan tradition, rather than as a near triangle (fig. C.1). The western and eastern continents contain icons of the traditional etymologies of their names as described in commentarial literature.[1] The western continent, Bountiful Cow,[2] depicts the wish-granting cow also seen in the offering

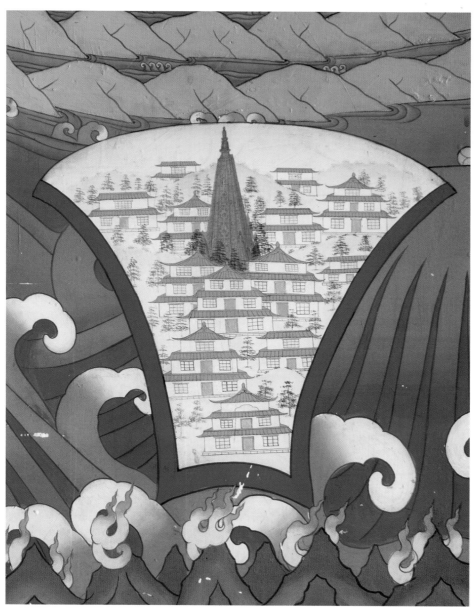

C.1. The southern continent, Jambudvīpa; detail of figure I.2. 20th–21st century. Main entrance, Zurmang Shedrup monastery, Sikkim, India

maṇḍala (fig. C.2). The eastern continent, Superior Body,[3] shows a powerful and bejeweled human male (fig. C.3). All things considered, the mural easily invokes the *Treasury* but also evinces influence from numerous other textual and artistic traditions.

As a non-tantric painting, the mural does not explicitly depict the meditative and ritual ideology of the deity maṇḍala, but certain key elements of the cosmology of

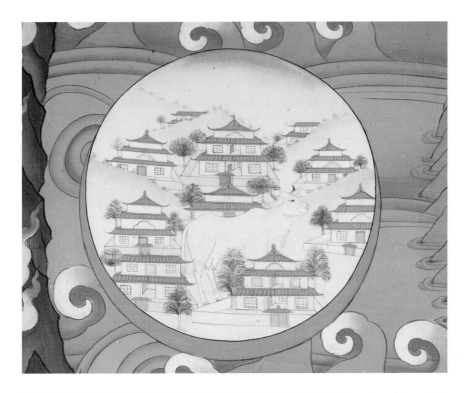

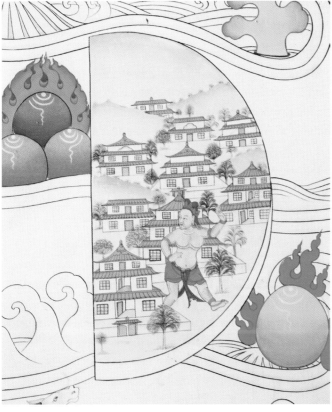

C.2. (*Above*) The western continent; detail of figure I.2. 20th–21st century. Main entrance, Zurmang Shedrup monastery, Sikkim, India

C.3. (*Left*) The eastern continent; detail of figure I.2. 20th–21st century. Main entrance, Zurmang Shedrup monastery, Sikkim, India

enlightenment do appear. Most obvious are the prominently featured Great Kings, the largest and most detailed figures in the image (see fig. 1.12). As protectors of the four directions, these figures also establish a barrier around the sacred space at the center of the cosmos. The peak of Meru depicts Śakra and his palace at the apex of the world—the location eventually appropriated by the buddha as a cosmic indicator of his enlightened status. In this mural, however, the place of enlightenment lies decisively within the human continent Jambudvīpa. Departing from the pattern of the western and eastern continents, which iconically represent their names, Jambudvīpa does not contain its eponymous Jambu tree. Rather, it portrays the architecture of the temple at Bodh Gayā, which marks the site of the historical Buddha's awakening (see fig. C.1). As with the similar mural in figure 2.3, this reference could also be considered an influence of the Buddha's biographical narrative on cosmological imagery, similar to the examples from *Extensive Play*.

The mural also does not explicitly depict the treasure-maṇḍala of the offering ritual, but its world is idealized in similar ways. Perhaps most notable is the absence (as usual) of the hells and hell beings, which appear vividly in the complementary wheel of existence across the way. Also reminiscent of the offering to the teacher, eight enormous symbols of royal wealth (in gold) fill the empty blue background of the wall, while similar jewels crowd the oceans. A royal parasol surmounting Śakra's palace recalls the auspicious treasures above Meru in the thirty-seven-part offering. As mentioned, the wish-granting cow in the western continent also evokes the liturgy of the treasure-maṇḍala. Overall, the mural, containing some items of the treasure-maṇḍala without invoking it completely, gives the impression of an opulent cosmos.

This mural also exemplifies several relationships between cosmology and architecture. The painting lies at the very exterior entrance to the monastery, encountered just before the main courtyard, and provides an introduction to the visitor's experience of the rest of the space. Although the guardian kings do not reappear at the interior entrance to the shrine itself, their prominence in this Cakravāla mural may imply some of the same protective function at this outer threshold. The walled palace of Śakra atop Meru, though not actually a maṇḍala palace, certainly recalls similar depictions of Buddhist deities in their abodes. The architecture of the monastery itself also reiterates both the structure of the cosmos depicted in the mural and the deity maṇḍala. Like the maṇḍala atop Meru, so distant from Jambudvīpa, the multistory central building is reached by visitors after a long procession through the courtyard and ascent up several stairways (fig. C.4). The central image of the first-floor assembly hall represents Śākyamuni on a Sumeru throne adorned with *tormas* and treasure-maṇḍalas, recapitulating both the cosmology of the buddha at the apex of the universe and the altar as a treasure-maṇḍala (fig. C.5). As in a maṇḍala palace, the higher floors of the central building lead upward through the three-body forms, with the central shrine of the second floor dedicated to Vajradhara, the Truth-body form of the Kagyu[4] school (fig. C.6).

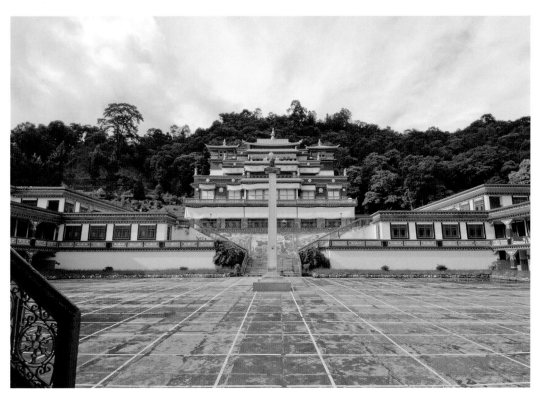

C.4. Main courtyard with shrine building at rear. Zurmang Shedrup monastery, Sikkim, India

The Cakravāla mural at Zurmang illustrates the complex network of ideas in which Buddhist cosmology participates, even as it functions uniquely within its own particular context. Amalgamating imagery from several different didactic and ritual themes, the painting reveals the Buddhist worldview as a complex and flexible framework for expression. Entrance-threshold murals such as this one are particularly free in the adoption of distinct types of imagery, since traditions of their depiction vary so much. At the same time, this very identification of the mural with the entrance threshold also illustrates the uniqueness of this type of image among others in heterogeneous contexts. It would be hard to imagine a treasure-maṇḍala offering, for example, that looked just like this painting at Zurmang. In these ways, this mural is both incredibly specific to its context and exemplary of the broader relevance of cosmological thinking to diverse contexts. This mural, then, like the *Treasury* or any other single depiction of the Buddhist cosmos, provides its own particular window onto the grander world of Buddhist cosmological thinking. While individual portrayals may complement or contradict one another, taken as a whole, they reveal the diverse interconnections between cosmology and other aspects of religion.

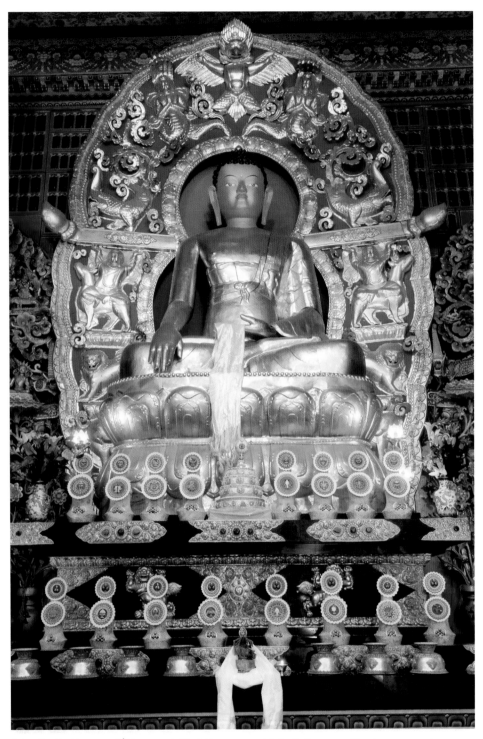

C.5. Central image of Śākyamuni. First-floor assembly hall, Zurmang Shedrup monastery, Sikkim, India

C.6. Central image of Vajradhara. Second-floor shrine, Zurmang Shedrup monastery, Sikkim, India

This returns us to the essential idea that thinking about the spaces and places we inhabit is a fundamental mode of human cognition and therefore also of religious expression. First, we saw numerous ways in which the definition of the world around us also defines our selves. The Hindu Purāṇas construct a universe around human history, while Vasubandhu's *Treasury of Abhidharma* highlights the distance of humans from the center of the world. In the Wheel of Time, detailed correspondences between the outer cosmos and the inner human body literally define one in terms of the other, creating a powerful system of ritual efficacy. Examining tantric traditions more closely, we looked beyond mere definition of the self to examine its active transformation. Tantric maṇḍalas employ geographic translocation within the cosmic system to processes of personal enlightenment. By ritually transcending one's sense of place (from Jambudvīpa to Meru and Akaniṣṭha), one also surpasses the limits of the ordinary mind. The cosmos of offering ritual, in contrast, engenders specific identification with the *cakravartin*, or universal sovereign. By creating a cosmic offering of absolute wealth, the ritual emphasizes relationships between worldly activity and enlightenment, especially the perfection of generosity and the support of Buddhist

teachings. Further relationships between cosmological imagery and human selves arise within inhabited architectural spaces. By laying out a shrine in the form of a cosmos or placing cosmological murals at key points in its space, the individual's experience of that space is transformed — in some cases so that the space itself may transform the visitor. By traversing the path to the shrine (like the journey from Jambudvīpa to Meru) or experiencing the treasure-maṇḍala altar (re-creating the offering), practitioners understand their place in the Buddhist world and rehearse attitudes that may eventually lead to their awakening.

Like Carl Sagan's "Pale Blue Dot," each vision of the world helps practitioners think about how they define themselves and their roles in relation to others. By seeing the world in very particular ways, individuals can imagine their own enlightenment, perfect their generosity, dwell in spaces of religious practice, and otherwise understand themselves as parts of a larger Buddhist world. They can engage in a cosmology of the self that complements the cosmology of the outer world, comprehending their place within the world by understanding the world itself. In this regard, no set of examples can be exhaustive or definitive. There are undoubtedly many other ways of envisioning the world and oneself in relation to it — many other ways of applying cosmological thinking to the circumstances at hand. The point is simply that such cosmological thinking must be considered as a fundamental mode of religious and human engagement.

Navigating the Future

This book may very well provoke more questions than it answers. These final words, therefore, are not a conclusion but rather an introduction (or invitation) to further inquiry. While some of the foregoing examples might help future scholars analyze particular depictions of the Buddhist world, they also reveal greater issues at stake in the realms of interdisciplinary methodology, Buddhist studies, and religious studies more generally.

Combining evidence from text, art, and practice has illustrated the importance of using varied methods to explore even a single subject, geographic models of the world. Proceeding through progressive comparisons of text and text, text and image, image and practice, and image and image, we saw both thematic similarities across alternative modes of expression and differences between these broader themes. The treasure-maṇḍala offering, for example, conveys wealth whether depicted in the rice grains of the physical performance, the liturgical invocation of the treasures of the *cakravartin*, or the silver and gold sculptures that represent its complete cosmology. Even in a single ritual liturgy, however, the opulent materiality of the treasure-maṇḍala differs greatly from the maṇḍala of the recipient of the offering, which emphasizes the elemental generation of an enlightened being from emptiness. Historical and cross-cultural comparisons also reveal the influence of particular traditions on portrayals of the cosmos

that change dramatically even as their textual precedents do not, such as the Newar and Tibetan variations of the offering, both claiming the *Treasury* as their source.

Such detailed explorations of textual, ritual, and artistic examples help retrieve cosmology from its relative obscurity in Buddhist studies and from the controversies of Structuralism in religious studies more broadly. By laying out a new way of thinking about cosmological depictions in terms of their details and contexts, rather than some abstract ideal, it is possible to see the great range of expression that cosmological thinking allows. There is no single, Structuralist model that captures the complexity of Buddhist cosmological depictions, yet the conceptual structures at work in models of the world remain significant. Indeed, the notion that specific spatial structures can express varied and particular ideas provides the key to understanding the broad reach of Buddhist cosmology as a framework for diverse ideologies and practices. Nothing limits this type of analysis to Buddhism, however, and similar arguments can undoubtedly be made for other religions across the world. Regardless of how a particular tradition conceives of its cosmos, there is a potential for using descriptions of space and place to define the self. Indeed, this is a fundamental mode of human engagement with the world.

Obviously, then, much work remains to be done. Even within the realm of Buddhist studies, cosmological thinking can be explored in other functional and historical contexts. Inside the Himalayas, there are rituals, texts, and art forms in which cosmological thinking plays very different roles than the few addressed here.[5] Other regions of Buddhist Asia have also been important sites of cosmological thinking. Recently, scholars have described fascinating moments of encounter between traditional Buddhist cosmology and the scientific cosmology of the West, such as in Sri Lanka, Japan, and China.[6] Neither does Buddhism have any special claim on these topics. Indeed, Jainism may focus even more strongly on cosmological modeling and ritual structure, providing rich opportunities for comparison.[7] Likewise, broader investigations outside the religions of Asia can teach us even more about the very human questions of how we deal with space and place.[8]

Recognizing cosmology as central to the Buddhism of the Himalayas has given us the opportunity to reexamine and redefine numerous other traditions and realms of ideas. By thinking not just *about* cosmology but *with* it — as a mode of cognition — we may further understand some of the great philosophies and practices that have dominated Buddhist religiosity for centuries. On the first page of this book, we entered a monastery by directly encountering the cosmology of Buddhism at its threshold. On this last page, we have finally passed through that doorway to begin living in the world of cosmological thinking inside.

NOTES

INTRODUCTION: ORIENTING SPACE AND SELF

1 T: dPal karma zur mang bshad sgrub chos 'khor gling
2 S: *bhava-cakra, saṃsāra-cakra*; T: *srid pa'i 'khor lo*
3 T: bSam yas
4 T: sPu na kha rdzong
5 T: dPe thub dgon pa
6 T: Bod dgon dga' ldan 'phel rgyas gling rnam rgyal grwa tshang
7 For more on this particular painting at Zurmang, see the conclusion.
8 T: 'Brug gsang sngags chos gling dgon
9 See also Pollock, *Language of the Gods*, 185–222.
10 Levinson, *Space in Language and Cognition*, 113–46.
11 Ibid., 146–68.
12 Sagan, *Pale Blue Dot*, 6.
13 Doniger, *The Hindus*, 117–19.
14 S: *Traibhūmi-kathā* (Sermon on the Three Worlds)
15 Reynolds and Reynolds, *Three Worlds according to King Ruang*, 5–7. Another text that presents an introduction to Buddhism for the lay reader through cosmology, this time from the Tibetan tradition, is *Prince Jiṅ-Gim's Textbook of Tibetan Buddhism*. rGyal-mtshan, *Prince Jiṅ-Gim's Textbook*, 5.
16 A few examples of excellent scholarship relating cosmology to other Buddhist ideas include Tambiah, *Buddhism and the Spirit Cults*, 34; Gethin, "Cosmology and Meditation"; Strong, *Legend of King Aśoka*, 147; and Teiser, *Reinventing the Wheel*.
17 Sagan, *Pale Blue Dot*, 6 (emphasis in original).
18 For one of the classic arguments against the textual historical approach, see Schopen, "Archaeology and Protestant Presuppositions."
19 Dreyfus, *Sound of Two Hands*, 32–33.
20 Eliade, *Images and Symbols*, 27–56.
21 Mus, *Barabudur: Esquisse*, 1:100.
22 Strong, "Making Merit," 84.

1. COSMOS IN TEXTS: EXPLAINING THE BLUENESS OF THE SKY

1 S: Meru, Sumeru; P: Sineru; T: Ri rab
2 S: *śveta, pīta, kṛṣṇa*, and *rakta*. *Vāyu Purāṇa* 1.34.47.
3 The same word is used for "social class" and "color" in Sanskrit: *varṇa*. These concepts are intimately connected in Sanskrit literature, not solely through the colors of Meru's sides.
4 S: *brāhmaṇa, vaiśya, śūdra*, and *kṣatriya*. *Vāyu Purāṇa* 1.34.16–19. Sharma, *Vāyu Mahāpurāṇa*, 223.

5 Vasubandhu's *Abhidharma-kośa* (Treasury of Abhidharma) and its *bhāṣyam* (auto-commentary). T: *Chos mngon pa'i mdzod*

6 S: *vaidūrya*. For more on the controversial geologic interpretation of this mineral, see Winder, "Vaiḍūrya," and Master, "Indo-Aryan and Dravidian," 304–6.

7 *Treasury of Abhidharma* (hereafter *Treasury*) 3.50. Vasubandhu, *Abhidharmakośam*, 1:401. La Vallée Poussin, *Abhidharmakośabhāṣyam*, 2:452–53. Subsequent citations of the *Treasury* locate passages either by verse number alone or in reference to Pruden's English translation (La Vallée Poussin, *Abhidharmakośabhāṣyam*), when it suffices, since the latter is most accessible to a diverse audience of readers. The Sanskrit edition (Vasubandhu, *Abhidharmakośam*) is cited when translated or referred to directly.

8 S: *karman*; T: *las*

9 La Vallée Poussin, *Abhidharmakośabhāṣyam*, 2:453.

10 S: Kāla-cakra; T: Dus kyi 'khor lo

11 S: *indra-nīla*

12 Khedrup Norsang Gyatso, *Ornament of Stainless Light*, 83. Tayé, *Myriad Worlds*, 149.

13 Newman, "Outer Wheel of Time," 503–6.

14 P: *Visuddhi-magga*

15 S: *Lalita-vistara*; T: *rGya cher rol pa*

16 Jamison and Brereton date the *Ṛg Veda* to 1400–1000 BCE. *The Rigveda*, 1:5.

17 Sanskrit terms for "earth," "sky," and "intermediate realm" in the Veda include *pṛthivī, dyaus,* and *antarikṣa*. The Brāhmaṇas equate these with *bhūr* (earth), *svar* (sky or heaven), and *bhuvaḥ* (intermediate realm). See González-Reimann, "Cosmic Cycles," 422–23.

18 Jamison and Brereton, *The Rigveda*, 50–51.

19 MacDonnell, *Vedic Mythology*, 9. Griffith's nineteenth-century translation has references to this arrangement, for example, in *Ṛg Veda* 1.160.1, 3.55.20, and 6.8.2. Jamison and Brereton's *The Rigveda* does not maintain this interpretation in all places, although its translation of 3.55.20 still employs the language of bowls. Griffith, *Hymns of the Rgveda*. Jamison and Brereton, *The Rigveda*, 546.

20 *Ṛg Veda* 1.160.1.

21 Ibid., 10.89.4. On the subject of the distance between these two wheels, the *Ṛg Veda* is silent, but the *Aitreya Brāhmaṇa* indicates a distance of a thousand-day journey by horse, and the *Pañcaviṃśa Brāhmaṇa* specifies the height of one thousand cows standing on top of one another. Sircar, *Cosmography and Geography*, 10.

22 Griffith's *Hymns of the Rgveda* has examples in *Ṛg Veda* 7.72.5, 8.4.1, and 10.36.14. Again, Jamison and Brereton's *The Rigveda* revises his interpretation substantially but maintains references to the cardinal directions in some places, including 7.72.5.

23 *Ṛg Veda* 10.89.4. Jamison and Brereton, *The Rigveda*, 1536. Griffith's translation reads, "I will send forth my songs in flow unceasing, like water from the ocean's depths, to Indra, who to his car on both its sides securely hath fixed the earth and heaven as with an axle." *Hymns of the Rgveda*, 515.

24 Smith, *Classifying the Universe*.

25 The first appearance of Mount Meru seems to be in the *Taittirīya Āraṇyaka*. McKay, *Kailas Histories*, 44. The Hindu epics also deal with cosmological material, most notably a description of the world in the *Bhīṣma-parvan* of the *Mahābhārata* that is very similar to the Purāṇic model addressed in the next section. See Cherniak, *Mahābhārata*, 49–103. There is some debate as to whether the *Mahābhārata* passage predates or postdates the Purāṇic texts. Brockington, *The Sanskrit Epics*, 145–46.

26 Despite seeming to be the earlier of the two Purāṇic models, this four-continent description may have been influenced by Pāli Buddhist works. Sircar, *Cosmography and Geography*, 38.

27 Estimates for the dates of the Purāṇas vary widely. Two published proposals for the *Vāyu Purāṇa* are around 350, in Collins, *The Iconography and Ritual*, 36, and around the fifth century, in Tagare, *The Vāyu Purāṇa*, lxii.

28 *Vāyu Purāṇa* 1.34.37–96. The following summary draws primarily on Sharma, *Vāyu Mahāpurāṇa*, and Vyāsa, *Puranic Cosmology*.

29 The *yojana* is a traditional unit of linear measure that refers to different distances at different times and places in Indian history. Many sources cite two classic tables of conversion, one of which interprets a *yojana* as approximately nine miles and another about half that number. See Gombrich, "Ancient Indian Cosmology," 127.

30 *Vāyu Purāṇa* 1.34.52–63. Sharma, *Vāyu Mahāpurāṇa*, 226. The *Vāyu Purāṇa* addresses this kind of ambiguity with frank uncertainty: "Every sage thought of [Meru] as having the same form as it appeared to have, viewing from his side, and no sage could view the Meru in full. Only Brahmā knows it in full." Vyāsa, *Puranic Cosmology*, 12.

31 *Vāyu Purāṇa* 1.34.60. Sharma, *Vāyu Mahāpurāṇa*, 226.

32 My adaptation of *Vāyu Purāṇa* 1.42:80–81, based on Sharma, *Vāyu Mahāpurāṇa*, 263, and Vyāsa, *Puranic Cosmology*, 56.

33 For more on the specific relationships between cosmological passages in the various Purāṇas, see Kirfel, *Das Purāṇa*.

34 Joshi, *Matsya Mahāpurāṇa*, 1:367.

35 *Vāyu Purāṇa* 1.41.

36 Ibid. 1.42.

37 For example, ibid. 1.8.13–17.

38 In this context, humankind is considered to be those who are descendants of the progenitor Manu, divided into four classes (*varṇas*), and obligated to perform ritual actions (*karman*).

39 It is a matter of debate whether the Purāṇic model predates the *Treasury of Abhidharma* or the Purāṇic idea of Meru surrounded by seven rings of continents arises from earlier Buddhist sources that describe seven rings of mountains. González-Reimann, "Cosmic Cycles," 427; Sircar, *Cosmography and Geography*, 38.

40 For more detail, see Babb, *Absent Lord*, 38–41; Glasenapp, *Jainism*, 249–70.

41 Caillat and Kumar, *The Jain Cosmology*, 20.

42 1 *rajju* ≈ 3×10^{13} *yojanas*; 1 light-year = 9.46×10^{12} kilometers = 5.88×10^{12} miles.

43 Jaini, *Jaina Path of Purification*, 30.

44 Umasvati, *That Which Is*, 85.

45 Hegewald, "Images of the Cosmos," 60.

46 Granoff, *Victorious Ones*, 35–39.

47 Ibid., 43–45, 86.

48 *Treasury* 3.96. La Vallée Poussin, *Abhidharmakośabhāṣyam*, 2:484.

49 Particularly the *Aṅguttara*, *Majjhima*, and *Dīgha Nikāyas*.

50 Gethin, "Cosmology and Meditation," 186.

51 Marasinghe, *Gods in Early Buddhism*, 56.

52 Ibid., 62. See also Gethin, "Cosmology and Meditation."

53 For more information on the cosmological content of the Nikāyas, see Marasinghe, *Gods in Early Buddhism*, esp. 43–62.

54 Buddhaghosa, *The Path of Purification*, xxx.

55 P: *anussati*; S: *anusmṛti*; T: *rjes su dran pa*

56 Marasinghe, *Gods in Early Buddhism*, 272.

57 *The Path of Purification* 7.4–25, 26–29, 30–32, and 33–35, respectively.

58 P: *loka-vidū*; *Path of Purification* 7.36–45. Buddhaghosa, *The Path of Purification*, 217–21.

59 *The Path of Purification* 7.44. Vasubandhu makes a similar claim about the multiplicity

of worlds in the *Treasury of Abhidharma*, but in the section on the three *dhātus* (realms) rather than the section on geographic cosmology. This distinction is important because the claim is raised in the context of the innumerability of beings in the three realms and the indistinguishability of similar states of existence between different universes — essentially a claim about the infinity of sentient existence rather than of the Buddha's knowledge. For this passage, which occurs in the commentary following *Treasury* 3.3, see La Vallée Poussin, *Abhidharmakośabhāṣyam*, 2:370; Vasubandhu, *Abhidharmakośam*, 1:307.

60 Buddhaghosa, *The Path of Purification*, 219n14.

61 *The Path of Purification* 7.36, identified as a passage from the *Samyutta Nikāya*. Buddhaghosa, *The Path of Purification*, 217.

62 *The Treasury of Abhidharma* is actually two works: a root text and the author's auto-commentary (*bhāṣyam*) on his own composition.

63 Gold, *Paving the Great Way*, 22.

64 S: *kośa* (treasury)

65 Kapstein, "Just Where on Jambudvīpa Are We?" 337.

66 Gold, *Paving the Great Way*, 91.

67 In Buddhist philosophy, the term *karman* has the technical sense of an intentional action that engages in the causal processes of existence, thereby producing good, bad, or neutral consequences.

68 S: *loka-nirdeśa*

69 S: *dhātu*

70 S: *kāma-dhātu*

71 S: *gati*

72 S: *rūpa-dhātu*

73 S: *ārūpya-dhātu*

74 La Vallée Poussin, *Abhidharmakośabhāṣyam*, 2:366.

75 Ibid., 2:370.

76 S: *pratītya-samutpāda*

77 *Treasury* 3.45.

78 *Treasury* 3.46. Vasubandhu gives two alternative explanations. The first attributes this phenomenon directly to the actions of beings, and the second to the motion of the winds, which implicitly also depend on the actions of beings.

79 *Treasury* 3.46, my translation. Vasubandhu, *Abhidharmakośam*, 1:400.

80 S: *cakra*

81 S: *naraka-pāla* (guardian of hell)

82 *Treasury* 3.58–59.

83 La Vallée Poussin's translation lists the jewels "respectively, from north to west" (*respectivement, du nord à l'ouest*), but this line is not found in the Sanskrit edition, which reads "respectively, on the four sides" (*yathāsaṃkhyaṃ caturṣu pārśveṣu*). La Vallée Poussin, *L'Abhidharmakośa*, 2:142; Vasubandhu, *Abhidharmakośam*, 1:401.

84 The Sanskrit word here, *sphaṭika*, generally denotes a kind of quartz that is described as being white or clear in other texts.

85 The spellings *cakravāla*, *cakravāḷa*, *cakravāḍa*, and *cakkavāla* are regional variants of the same word.

86 Vasubandhu, *Abhidharmakośam*, 1:402.

87 *Treasury* 3.51–52, my translation. Vasubandhu, *Abhidharmakośam*, 1:403.

88 See also Sadakata, *Buddhist Cosmology*, 28.

89 *Treasury* 3.52–53, my translation. Vasubandhu, *Abhidharmakośam*, 1:403.

90 See also Sadakata, *Buddhist Cosmology*, 191n6.

91 S: *toraṇa*

92 The shape even more closely resembles the *soma* cart of Vedic sacrifice. See Staal, *Agni*, 100.

93 Gary Tubb, personal communication, 2011.

94 Walter, "Scapula Cosmography."

95 See, for example, Doniger, *The Hindus*, 61; Sadakata, *Buddhist Cosmology*, 31.

96 Another early source translated into Chinese does specify that Jambudvīpa "is narrow in the South and broad in the North." Howard, *Imagery of the Cosmological Buddha*, 117.

97 In a system such as this, in which quadrilateral symmetry is so important, other types of rotation seem unlikely.

98 The lowermost hell, Avīci, lies 20,000 yojanas below Jambudvīpa, with a diameter of 20,000 *yojanas*, far greater than the 2,000-yojana sides of Jambudvīpa. To fix this discrepancy, the continents are described as wider at their bases, like heaps of grain. See *Treasury* 3.59. The centered Jambudvīpa of the seven-continent Purāṇic model, by contrast, is many times larger than the hells.

99 McGovern, *Manual of Buddhist Philosophy*, 56.

100 *Treasury* 3.60, my translation. Vasubandhu, *Abhidharmakośam*, 1:409.

101 *Treasury* 3.62, my translation. Vasubandhu, *Abhidharmakośam*, 1:410.

102 *Treasury* 3.62, my translation. Vasubandhu, *Abhidharmakośam*, 1:410.

103 S: (respectively) Karoṭapāṇi, Mālādhāra, Sadāmada, Mahārājikadeva. *Treasury* 3.63–64, my translation. Vasubandhu, *Abhidharmakośam*, 1.410–11.

104 Vasubandhu also notes that beings in the class of Great Kings dwell on all of the seven golden mountain ranges, making them the largest class of the *devas*. *Treasury* 3.64.

105 Vasubandhu does not mention the *asuras*, a commonly accepted sixth path of birth, or their dwelling place. The contemporaneous *Yogācārabhūmi* notes that they live "in the water under Mount Sumeru." Kajiyama, "Buddhist Cosmology," 193.

106 S: Trāyas-triṃśa

107 Pruden's English translation of La Vallée Poussin's French edition of the *Treasury* incorrectly describes this place as being adorned by a "sun [that] is soft to the touch, like the leaf of the cotton tree; it rises and falls to facilitate its progress" (La Vallée Poussin, *Abhidharmakośabhāṣyam*, 2:463). La Vallée Poussin (translating from Chinese) actually has "Ce sol est doux au toucher, comme la feuille de l'arbre à coton; il monte et descend pour faciliter la marche" (La Vallée Poussin, *L'Abhidharmakośa*, 2:162), which more closely matches Śāstri's Sanskrit, "tacca bhūmitalaṃ tūlapicuvat mṛdusaṃsparśam pādakṣepotkṣepābhyāṃ natonnatam" (*Treasury* 3.66, at Vasubandhu, *Abhidharmakośam*, 1:412). A better translation would be "And that surface of the earth is soft to the touch, like a tuft of cotton, raised and lowered by the upstroke and downstroke of feet." Vasubandhu later clearly indicates that there is no sun above the Yugandhara mountains, which poses obstacles for the inhabitants: "There is no sun or moon above Yugandhara; how is a day of the gods determined, and how are the gods illumined? Day and night are marked by the flowers which open or close, like the *kumuda* and the *padma* in the world of humans; by the birds that sing or that are silent; and by sleep which ends or begins. Furthermore the gods themselves are luminous" (La Vallée Poussin, *Abhidharmakośabhāṣyam*, 2:471).

108 La Vallée Poussin, *Abhidharmakośabhāṣyam*, 2:467.

109 *Treasury* 3.72, my translation. Vasubandhu, *Abhidharmakośam*, 1:416.

110 La Vallée Poussin, *Abhidharmakośabhāṣyam*, 2:469.

111 The term "thousand world-system" is sometimes translated with the Greek *chiliocosm*.

112 La Vallée Poussin, *Abhidharmakośabhāṣyam*, 2:471–72.

113 For examples, see fig. 4.39 and Hiyama, "Wall Paintings," 124.

114 La Vallée Poussin, *Abhidharmakośabhāṣyam*, 2:476–78.

115 Newman, "Outer Wheel of Time," 75, 110–11.

116 Ibid., 118.

117 Ibid., 110.

118 S: *Śrī-Kālacakra-laghu-tantra*; T: *dPal dus kyi 'khor lo bsdus pa'i rgyud*

119 S: *Vimala-prabhā*; T: *Dri me 'od*

120 T: *Dri med 'od kyi rgyan*

121 T: mKhas grub nor bzang rgya mtsho (1423–1513)

122 T: 'Jam mgon kong sprul blo gro mtha' yas (1813–1899)

123 T: *Shes bya kun khyab mdzod*

124 Berzin, *Taking the Kalachakra Initiation*, 42.

125 Wallace, *The Kālacakratantra*, 41–42.

126 T: *phyi nang gzhan gsum* (three[fold] outer, inner, [and] other)

127 Roger Jackson, "Kalachakra in Context," 31.

128 For more on the relation between the Inner and the Outer Wheel of Time, see Wallace, *The Inner Kālacakratantra*, esp. chap. 5.

129 Roger Jackson, "Kalachakra in Context," 31.

130 Khedrup Norsang Gyatso, *Ornament of Stainless Light*, 89.

131 Newman, "Outer Wheel of Time," 472.

132 Nance, "Mindsets and Commentarial Conventions," 224–26.

133 Newman, "Outer Wheel of Time," 474–75.

134 This is commonly understood as the Buddha's skillful method (*upāya*) in teaching what is most efficacious rather than what is true. See, for example, Pye, *Skilful Means*.

135 *Asuras* are *deva*-like beings who vie with the *devas* for rule. *Nāgas* are hooded serpents that represent water and the underworld and are often associated with guarding the repository of jewels buried in the earth.

136 Upadhyaya, "*Vimalaprabhāṭīkā*" of Kalki Śrī Puṇḍarīka, 67.

137 Tayé, *Myriad Worlds*, 148.

138 See helpful diagrams at Brauen, *Mandala*, 156–57.

139 Newman, "Outer Wheel of Time," 130. Wallace, *The Inner Kālacakratantra*, 70.

140 By calculation, this width is slightly over 888 *yojanas*. Khedrup Norsang Gyatso, *Ornament of Stainless Light*, 81.

141 Tayé, *Myriad Worlds*, 152.

142 S: *daśākāro vaśi* (the powerful ten-syllabled one); T: *rnam bcu dbang ldan* (the ten-part powerful one)

143 The bottom seven graphemes are characters in the *lanydza* or *rañjanā* script and can be pronounced as syllables comprising a consonant followed by a vowel. The top three symbols are not independently pronounceable but modify vowels through nasalization or continuation. The crest or flame can be associated with *nāda*, a nasalization of vowels used in yoga practice. Brauen, *Mandala*, 248.

144 S: *bīja*

145 As Newman notes, *iko yaṇaci* is the Sanskrit grammatical rule at Pāṇini's *Aṣṭādhyāyī* 6.1.77. It instructs that certain vowels are replaced by related semi-vowels when another vowel follows, rather than leaving two vowels in immediate sequence. In the case of the Wheel of Time mantra, this means that I, Ṛ, U, and Ḷ are changed to YA, RA, VA, and LA because they are followed by an inherent A. "Outer Wheel of Time," 429.

146 Ibid., 428–29.

147 *Anusvāra* indicates nasal continuation of a vowel. *Visarga* marks unvoiced continuation. *Bindu* and *anusvāra* are conflated because both are shaped like a dot.

148 For one expression of the cosmology of the deity maṇḍala in the Wheel of Time, see Wallace, *The Kālacakra Tantra*, 27–30.

149 The difficult association of sun/*visarga*/crescent and moon/*anusvāra*/circle is not a matter of Newman's translation, which matches the Sanskrit of Upadhyaya's critical edition: "*candrād binduḥ, sūryādvisargaḥ . . . visargo arddhacandrākāro bindurvṛtto.*" "*Vimalaprabhāṭīkā*" of *Kalki Śrī Puṇḍarīka*, 55–56.

150 Dreyfus, *Sound of Two Hands*, 114, 118.

151 Roger Jackson, "Kalachakra in Context," 40.

152 Ibid., 40.

153 The text was compiled in Sanskrit in the seventh to eighth centuries and translated into Tibetan in the ninth century. Afterward, it became the most widely known source for the life of the Buddha in Tibet. Goswami, *Lalitavistara*, v; Dharmachakra Translation Committee, *The Play in Full*, xiii–xiv.

154 T: *mDzangs blun*. The origins of this text are unusually complex, probably stemming from a Khotanese oral tradition rather than an Indic textual one, with prominent versions in Chinese and Mongolian. Mair, "Linguistic and Textual Antecedents," 1–95.

155 *Extensive Play*, 15.57. Vaidya and Tripathi, *Lalita-vistara*, 177. Translation adapted from Goswami, *Lalitavistara*, 204.

156 *Extensive Play*, 15.21, my translation. Vaidya and Tripathi, *Lalita-vistara*, 166.

157 *Extensive Play*, 19, my translation. Vaidya and Tripathi, *Lalita-vistara*, 226.

158 *Extensive Play*, 21, my translation. Vaidya and Tripathi, *Lalita-vistara*, 264.

159 T: *sDe dge*

160 Chos kyi 'byung gnas, "mDo rgya cher rol pa."

161 Precedent for this kind of imagery seems to go back at least to the fifteenth to sixteenth centuries at Tsaparang. For illustrations, see Tucci, *Temples of Western Tibet and Their Artistic Symbolism: Tsaparang*, plate 127; Ham, *Guge*, 338–39; Jin, *Zhongguo bi hua quan ji*, 80.

162 Although images of multiple cosmoses appear in artwork, these depictions merely repeat instances of a single cosmos.

163 *Extensive Play*, 24, my translation. Vaidya's "Lalitavistaraḥ" felicitously inserts a "y" ([*y*]*annvahamimāni*) not found in the printed version in Vaidya and Tripathi, *Lalita-vistara*, 318.

164 For a non-Buddhist parallel, see Buitenen, *The Mahābhārata*, 18–19.

165 Goswami, *Lalitavistara*, 346.

166 *Extensive Play*, 25.

167 Frye, *Sutra of the Wise*, 56.

168 Ibid., 56.

169 Thanks to John Strong for sharing his unpublished reading of this subject (2015).

170 T: Tsong kha pa blo bzang grags pa (1357–1419)

171 T: *smon lam chen mo*

2. COSMOS IN THE MAṆḌALA: SALVATION THROUGH GEOGRAPHY

1 The oldest visual representations of maṇḍalas do not have this now common square-within-a-circle design. See, for example, the maṇḍala of the eight great bodhisattvas in cave 12 of Ellora, illustrated in Leidy and Thurman, *Mandala*, 31. For more on the historical development of maṇḍala imagery, see Luczanits, "On the Earliest Mandalas," 111–27.

2 For details on maṇḍala conception and iconography using the Wheel of Time system as an example, see Brauen, *The Mandala*, and Brauen, *Mandala*.

3 S: *rājādhirāja*. Davidson, *Indian Esoteric Buddhism*, 131–44.

4 For a good summary of the problems associated with application of the term "tantra," see Urban, *Tantra*, esp. 28–31. Despite such controversy, the term is widely accepted in contemporary scholarship.

5 For example, Kohn, *Lord of the Dance*.

6 For example, Gyatrul, *Generating the Deity*, 56–57.

7 Leidy and Thurman, *Mandala*, 17.

8 S: *Sarva-tathāgata-tattva-saṃgraha*; T: *De bzhin gshegs pa thams cad kyi de kho na nyid bsdus pa*

9 The *Guhya-samāja Tantra*, for example, invokes tantric sexual symbolism in having its primary buddha "dwelling in the vagina of the Vajra Consort of the Essence of the Body, Speech and Mind of all the Tathāgatas." Thus, general references to "tantric cosmology" here are intended only to contrast the geographic cosmology of the early tantras with other modes of cosmological thinking, such as *abhidharma* scholasticism or offering rituals, not to posit a homogeneous cosmology underlying all tantric traditions. Fremantle, "A Critical Study," 27.

10 S: *trikāya*; T: *sku gsum pa*

11 The term "mesocosm" is applied here much as it was introduced by Paul Mus in his monumental *Barabudur*. Mus, *Barabudur: Esquisse*, 1:100; for an English translation, see Mus, *Barabudur: Sketch*, 112. John Strong suggests that to Mus's use of "mesocosm" may be added the terms "protocosm" (for worldly existence) and "metacosm" (for the divine), but for the present argument, theorization about the upper and lower reaches of this trio is unnecessary. Strong, "Making Merit," 84.

12 T: Zangs mdog dpal ri

13 S: *vajrāsana*

14 La Vallée Poussin, *Abhidharmakośabhāṣyam*, 2:455.

15 Here, the Sanskrit mentions the *bodhi-maṇḍa* rather than the *vajrāsana*, but the unique importance of the site is similar. Vaidya and Tripathi, *Lalita-vistara*, 226.

16 The purpose here is not a history of early tantra but an examination of particularly cosmological issues. For a concise summary of some key arguments about the early development of the tantric maṇḍala in India, see Samuel, *The Origins of Yoga*, 224–28.

17 The *Compendium of Principles* is not the first appearance of Vairocana in Buddhist literature. Vairocana is also central to both the influential *Flower Ornament Sūtra* (S: *Avataṃsaka sūtra*, T: *Me tog rna rgyan phal mo che*) (ca. 1st–2nd century) and the *Enlightenment of Great Vairocana* (7th century), but neither possesses the cosmological turn that is fundamental to the *Compendium of Principles*. Cleary, *The Flower Ornament Scripture*; Hodge, *The Maha-Vairocana-Abhisambodhi Tantra*.

18 For example, see Yamada, *Sarva-tathāgata-tattva-saṅgraha*, 7.

19 Weinberger, "Significance of Yoga Tantra," 56.

20 S: *bodhi-maṇḍa*

21 The narrative summarized here is translated verbatim in Todaro, "An Annotated Translation," 140–259. An edition that may be more accessible to some readers is a translation of Amoghavajra's Chinese-language rendition of the first part of the *Compendium of Principles*, the *Adamantine Pinnacle Sutra*, in Giebel, *Two Esoteric Sutras*, 23–25.

22 S: *Niṣpanna-yogāvalī*; T: *rDzogs pa'i rnal 'byor gyi phreng ba*

23 Bhattacharyya, *Niṣpannayogāvalī*, 44; my translation.

24 S: *Vajrāvalī*; T: *rDo rje phreng ba*

25 S: *bhāvya*

26 S: *lekhya*

27 Mori, *Vajrāvalī*, 10.

28 Ibid., 269; my translation.

29 T: A lci chos 'khor. The dating of Alchi's phases of construction is a complex matter, with much of the construction probably taking place in the twelfth to thirteenth centuries. For more, see Luczanits and Neuwirth, "Development of the Alchi Temple," 79; Luczanits, *Buddhist Sculpture in Clay*, 125–95; and Denwood, "Dating of the Sumtsek Temple."

30 T: *phyi dar*

31 T: Ye shes 'od (ca. 947–1024)

32 T: Gu ge

33 T: Rin chen bzang po (958–1055)

34 Including both the *Compendium of Principles* and Ānandagarbha's commentary the *Tattvālokakarī*. Tucci, *Temples of Western Tibet: Spiti and Kunavar*, 39.

35 Goepper, *Alchi*, 15.

36 S: *Sarva-durgati-pariśodhana*; T: *Ngan song thams cad yongs su sbyong ba*

37 The New Schools (T: gSar ma) use a four-part classificatory system of action tantras (S: *kriyā-tantra*; T: *bya rgyud*), performance tantra (S: *cārya-tantra*; T: *spyod rgyud*), yoga tantra (S: *yoga-tantra*; T: *rnal 'byor rgyud*), and highest yoga tantra *(S: anuttara-yoga-tantra; T: bla med rnal 'byor rgyud)*. The Old School (T: rNying ma) has its own separate, nine-part system. The four-part system may have entered Tibet as early as the tenth century or been a Tibetan invention of as late as the twelfth century. Dalton, "A Crisis of Doxography," 118.

38 A similar situation is succinctly described for the *Gathering of Intentions Sūtra* (T: *dGongs pa 'dus pa'i mdo*) as follows: "In [the form of large annual festivals], the *Gathering of Intentions* has been preserved into the modern day, yet the tantra itself plays an incongruous role. On the one hand, it defines the ritual space for, and thus the basic structure of, the entire festival; on the other hand, its own rituals are strangely absent from the proceedings. This incongruity reflects the tensions inherent in canonization and preservation." Dalton, *The Gathering of Intentions*, xxii.

39 S: Sarva-vid Vairocana; T: Kun rig rnam par snang mdzad

40 Snellgrove and Skorupski, *Cultural Heritage of Ladakh*, 1:39.

41 Interestingly, the maṇḍala is also flanked by depictions relating to the paths of birth, including the hell and *preta* realms, making it comparable to cosmic geographies that incorporate the wheel of existence, such as the mural at Tholing (see fig. 4.43).

42 S: *dik-pāla*

43 See Wessels-Mevissen, *Gods of the Directions*.

44 Another important group of Yoga Tantra maṇḍalas that exhibits imagery of the geographic cosmology occurs on the fifth floor of Gyantse's (T: rGyal rtse) Kumbum (T: *sku 'bum*). Here, a large set of maṇḍalas invokes the continents, sun and moon, and other geographic imagery. It may be that there is some special relationship between the Yoga Tantras and geographic imagery, and more research needs to be done in this area. For illustrations, see Tachikawa and Masaki, *Chibetto Bukkyō Zuzō Kenkyū*, 38, 45, 65, 68–69, 76–77, 79, 81–82, 84–85, 106–7, 109.

45 Mus also identifies the notion of the buddha at the center of the universe with much earlier Indic traditions in which the cosmos is conceptually recentered around a divine king. *Barabudur: Esquisse*, 1:229; for an English translation, see Mus, *Barabuḍur: Sketch*, 262.

46 The relevant Sanskrit term is *buddha-kṣetra* (buddha-field), a name for the world purified by the presence and actions of a buddha.

47 S: *Gaṇḍa-vyūha Sūtra*; T: *sDong po bkod pa*. Composed sometime between the first to early fifth centuries. Gifford, *Buddhist Practice*, 7.

48 McMahan, *Empty Vision*, 118.

49 S: *Mahā-Vairocana-abhisaṃbodhi*[*-vikurvitādhiṣṭhāna-vaipulya-sūtrendra-rāja*], T: *rNam par snang mdzad chen po mngon par rdzogs par byang chub pa* [*rnam par sprul pa byin gyis rlob pa shin tu rgyas pa mdo sde'i dbang po'i rgyal po*]

50 Hodge, *The Maha-Vairocana-Abhisambodhi Tantra*, 30.

51 Huntington and Huntington, *Art of Ancient India*, 123.

52 Strong, *Relics of the Buddha*, 65.

53 S: *dharma-cakra*

54 Buswell and Lopez, *Princeton Dictionary of Buddhism*, 814.

55 S: *vinaya*; T: *'dul ba*

56 "'Dul ba rnam par 'byed pa," folios 108B and following; my translation. Chinese and Tibetan translations of this text exist from the eighth and ninth centuries, respectively, but a complete Sanskrit version is not known at this time.

57 S: *Avadāna-kalpalatā*

58 See, for example, Rhie and Thurman, *Worlds of Transformation*, 147–49.

59 For more information on this text, see Howard, *Imagery of the Cosmological Buddha*, 6–12.

60 Ibid., 15–16.

61 S: *Divyāvadāna*

62 Rotman, *Divine Stories*, 279.

63 Numerous examples can also be found at Dunhuang, including the paintings shown in Howard, *Imagery of the Cosmological Buddha*, figs. 48–49; Whitfield, Whitfield, and Agnew, *Cave Temples of Mogao*, 88–89.

64 T: *gsum brtsegs* (three-story [building])

65 Nagao has proposed analysis of the themes of ascent and descent in the very different context of Mahāyāna Buddhism. His explanation of these notions generally contrast with tantric cosmological translocation in either (1) being sequential activities undertaken by a single agent or (2) representing simultaneous, mutually-opposing ideas. In the tantric case, neither of these characterizations directly applies. Nagao, "Ascent and Descent."

66 "[evaṃ mayā śru]tam ekasmin samaye . . ." Yamada, *Sarva-tathāgata-tattva-saṅgraha*, 3.

67 "Akaniṣṭhadevarājasya bhavane vijahāra"; ibid., 3.

68 Gethin, "Cosmology and Meditation," 205–11.

69 S: [Larger] *Sukhāvatī-vyūha Sūtra*

70 Gomez, *The Land of Bliss*, 37.

71 Asaṅga, *Summary of the Great Vehicle*, xiii.

72 Griffiths et al., *The Realm of Awakening*.

73 S: *dharma-kāya*, T: *chos sku*

74 As the most esoteric of the three bodies, the Truth-body undergoes a significant shift in interpretation over the centuries, from a direct reference to the enlightened qualities of a buddha to a "metaphysical or cosmic ultimate." This distinction is not fundamental to the present argument, which focuses on the relationship between the latter two types of bodies. See Williams, *Mahāyāna Buddhism*, 172–86.

75 S: *sambhoga-kāya*; T: *longs sku*

76 S: *nirmāṇa-kāya*; T: *sprul sku*

77 T: mKhas grub dge legs dpal bzang po (1385–1438)

78 The five certainties are the confidence that (1) the place of the teaching is none other than Akaniṣṭha heaven; (2) the teaching itself is Mahāyāna and not Hīnayāna; (3) the teacher is none other than a perfect Enjoyment-body buddha with the characteristic thirty-two major and eighty minor marks of a buddha; (4) the audience consists only of bodhisattvas of the tenth and highest stage; (5) the teaching persists as long as the cycle of *saṃsāra* is not ended. Paraphrased from Lessing and Wayman, *Introduction*, 21–23.

79 Ibid., 215.

80 Jamgon Kongtrul suggests that "most yoga tantra masters speak of there being a minor Vairochana, the one who emanated as the mandala on the summit of Mount Meru and other locations and taught [yoga tantra]; and Great Vairochana, possessed of the five certainties, who dwells in the Great [Akaniṣṭha] and who is the basis for [all other] emanations." Tayé, *Treasury of Knowledge: Book Six*, 133. See also Snellgrove, *Indo-Tibetan Buddhism*, 221.

81 For example, in White, "*Dakkhiṇa* and *Agnicayana*," 195.

82 Wayman remarks that "the maṇḍala can be understood to represent the palace of the Akaniṣṭha heaven, where . . . Gautama was initiated as a Complete Buddha with the body called [Enjoyment-body]." *The Buddhist Tantras*, 91. Indeed, traditional commentaries support this view, and it makes sense that the goal of creating the maṇḍala atop Meru is complete enlightenment in Akaniṣṭha. However, this explanation overlooks the important rhetoric of the descent of Akaniṣṭha-Vairocana to the summit of Meru and Sumeru's function as a mesocosm that connects Jambudvīpa with the desired goal of Akaniṣṭha.

83 The linguistic distinctions and overlaps between the terms "stūpa" and *caitya* have a long and complex history that is not important to the discussion here. For a brief characterization in relation to the presence or absence of relics, see Rhi, "Images, Relics, and Jewels," 169–211.

84 On Java, see Mus, *Barabudur: Esquisse*. On Sri Lanka, see Trainor, *Relics, Ritual, and Representation*, 98–99.

85 Harvey, "Symbolism of the Early Stūpa."

86 See, for example, the different views expressed in Irwin, "Stūpa and the Cosmic Axis," and Fussman, "Symbolisms of the Buddhist Stūpa."

87 Dorjee, *Stūpa and Its Technology*, 160.

88 Rospatt, "On the Conception," 121–47.

89 S: *sūtra-pātana*

90 S: *pāda-sthāpana*

91 S: *ratna-nyāsa*

92 See examples at Gutschow, *The Nepalese Caitya*, 278–83.

93 Bangdel, "Manifesting the Mandala," 9.

94 Slusser, *Nepal Mandala*, 275.

95 Gellner, *Monk, Householder*, 21.

96 Rospatt, "The Sacred Origins," 50–58, 62.

97 Min Bahadur Shakya, *Iconography of Nepalese Buddhism*, 10.

98 Rospatt, "On the Conception," 140.

99 Rospatt, "The Sacred Origins," 35.

100 Ibid., 62.

101 Bangdel, "Manifesting the Mandala," 225–30, 251.

102 Rospatt, "The Sacred Origins," 58–59.

103 This summary follows translations in Hem Raj Shakya, *Svayambhū Mahācaitya*; Bajracharya and Smith, *Mythological History*.

104 S: Vidyādhara Śarmā Saṃskārita Yaśodhara Mahāvihāra. Locke, *Buddhist Monasteries of Nepal*, 154.

105 Gutschow, *The Nepalese Caitya*, 294.

106 Ibid., 301.

107 See Slusser, *Nepal Mandala*, 274.

108 Ibid., 157.

109 Rospatt, "The Sacred Origins," 62.

110 Gutschow argues that the *nāga* represents the waters of the primordial ocean typically associated with Hindu beliefs, on which the great serpent Śeṣa serves as a couch for the god Viṣṇu. *The Nepalese Caitya*, 129. The close association of Meru with *nāgas* being wrapped

around it could also suggest an interpretation of the local Kathmandu mountain range as Meru, again aligning the center of the valley with the center of the universe.

111 For another approach to the geography of Nepal as a mesocosm, see Levy, *Mesocosm*.

112 Kongtrul has an interesting summary of a variety of ways of generating the celestial palace at Tayé, *Treasury of Knowledge: Book Eight*, 92.

113 Skorupski, *The Sarvadurgatipariśodhana Tantra*, 26–27. The relevant passage exists in a thirteenth-century Tibetan text (Skorupski's version B), but his translation also relies on a seventeenth-century Sanskrit manuscript of the same text. Ibid., xviii–xix, 160–61.

114 An illustrated eleventh-century manuscript depicts the correlation between elemental cosmos and subtle body in Heller, "Two Early Tibetan Ritual Diagrams."

115 Bhattacharyya, *Niṣpannayogāvalī*, 44; my translation.

116 Skorupski's Sanskrit manuscript A is a 1965 copy of a manuscript dated to 1217. Skorupski, *Kriyāsaṃgraha*, 1.

117 S: *Kriyā-saṃgraha*

118 Skorupski, *Kriyāsaṃgraha*, 60.

119 T: *snga dar*

120 T: rNying ma

121 T: Nyang ral nyi ma 'od zer (1124–1192)

122 Tsogyal and Öser, *The Lotus-Born*, 151.

123 T: Padma 'od kyi pho brang

124 Dudjom, *The Nyingma School*, 520–21.

125 For a good overview of sacred mountain ideology in Indic culture going all the way back to the *Ṛg Veda*, see McKay, *Kailas Histories*, 25–146.

126 Bogin, "Locating the Copper-Colored Mountain," 4. Padmasambhava's biography identifies the demon-inhabited land to which he departs in various ways, including as Cāmara, Laṅkā, India, and Uḍḍiyāna (T: U rgyan), the land of his origin. See Tsogyal and Öser, *The Lotus-Born*, 148, 152, 155, 208.

127 Technically it is usually Uḍḍiyāna that is included in this five-part system, not the Copper Mountain itself, which may or may not be considered as part of Uḍḍiyāna. rGyal-mtshan, *Prince Jiṅ-Gim's Textbook*, 16; Bogin, "Locating the Copper-Colored Mountain," 4.

128 Chou, "Reimagining the Buddhist Universe," 423–24.

129 T: dMag zlog(?)

130 Lamsam and Wangchuk, *Zangdok Palri*, 27.

131 T: 'Og min rnga yab zangs mdog dpal ri padma 'od kyi pho brang chen po

132 In Tibet, Amitāyus can be considered the Enjoyment-body form of Amitābha when the latter is conceived as an Emanation-body. Since here Amitābha is meant to represent the Truth-body, Amitāyus may have been substituted as a "higher" form of the buddha Amitābha. In other contexts, however, there is a clear separation between Amitāyus, who is mainly worshipped as a longevity deity, and Amitābha, who is not. A careful parsing of the malleable relationships between these two figures is not necessary to the argument here.

133 See illustrations in Lamsam and Wangchuk, *Zangdok Palri*, esp. title page, 82, 84–85.

134 See a nineteenth-century example in Mullin, *Buddha in Paradise*, 69.

135 See, for example, Lin, *Building a Sacred Mountain*.

3. COSMOS IN OFFERING: PILING A MOUNTAIN OF TREASURES

1 S: *dāna-pāramitā*

2 Makransky, "Offering (*mChod pa*)," 322.

3 For example, Beyer, *The Cult of Tārā*, 148.

4 S: *Aśokāvadāna*

5 T: *'khor los bsgyur ba*

6 Staal, *Agni*, 1–2.

7 S: *agni-hotra*. Ibid., 40–41.

8 S: *agni-cayana*. Ibid., 1–3.

9 The more formal *śrauta* rites require the full ritual enclosure with three fires. Simple daily householder rituals require only a single fire. Payne, "Introduction," 24.

10 Gombrich, *What the Buddha Thought*, 39.

11 P: *Aṅguttara Nikāya*

12 Gombrich, "Recovering the Buddha's Message," 16; Gombrich, *What the Buddha Thought*, 112; Bodhi, *The Numerical Discourses*, 1030–31.

13 The triangle may relate to the *soma* cart of Vedic sacrifice; see Staal, *Agni*, 100.

14 The *Treasury of Abhidharma* says that the shapes of these continents correspond to the shapes of the faces of the inhabitants in each region, a logic that accords with its connection between places and beings. *Treasury* 3.55.

15 Hodge, *The Maha-Vairocana-Abhisambodhi Tantra*, 381.

16 Skorupski, "*Jyotirmañjarī* of Abhayākaragupta," 184–85.

17 S: *Jyotirmañjarī*

18 Skorupski, "Buddhist Permutations," 92–93.

19 Halkias, "Fire Rituals," 230.

20 T: Khams gsum yul lha rnam rgyal mchod rten

21 The shapes of the eastern and western continents are the reverse of the normal *abhidharma* arrangement.

22 La Vallée Poussin, *Abhidharmakośabhāṣyam*, 2:454.

23 Skorupski, "Buddhist Permutations," 85.

24 King Aśoka lived in the third century BCE, but the text in its available form dates from around the second century CE. Strong, *Legend of King Aśoka*, 3, 27.

25 Waddell presents an early claim that Aśoka's gifts serve as precedent for the ritual offering of the cosmos. *Tibetan Buddhism*, 397; first published in 1895 as *The Buddhism of Tibet, or Lamaism*.

26 Summarized from Strong, *Legend of King Aśoka*, 200–203.

27 Ibid., 63.

28 Ibid., 243.

29 See, for example, Mahony, "Cakravartin."

30 Goswami, *Lalitavistara*, 20.

31 P: *Cakkavatti-Sīhanāda Sutta*

32 Summarized from Walshe, "The Cakkavatti-Sīhanāda Sutta," 395–98.

33 Zin, "Māndhātar, the Universal Monarch," 149.

34 Summarized from Rotman, *Divine Stories*, 348–66.

35 John Strong has argued that Aśoka's status should be understood as equivalent to the buddhahood of the Buddha, even to the point of being considered a kind of enlightenment. Strong, *Legend of King Aśoka*, 61.

36 Goswami, *Lalitavistara*, 19.

37 Adapted from ibid., 99–100, and Vaidya, "Lalitavistaraḥ."

38 For the specific characteristics of the body of the great man (S: *mahā-puruṣa*) who can be either a *cakravartin* or a buddha, see Walshe, "Mahâpadāna Sutta," 205–6. Aśoka is a notable exception to the physically perfect *cakravartin*. Strong, *Legend of King Aśoka*, 64. See additional comparisons, for example, in Mus, *Barabuḍur: Sketch*, 270, and Strong, *Relics of the Buddha*, 100.

39 S: [various terms include] *guru-maṇḍala-arcana* (maṇḍala homage to the teacher), *guru-maṇḍala-pūjā* (offering of the maṇḍala to the teacher), and *guru-pūjā* (offering to the teacher)

40 Gellner, *Monk, Householder*, 149.

41 Ibid., 148.

42 Gellner, "Ritualized Devotion," 163.

43 Locke, *Karunamaya*, 81.

44 For more on this ritual in general, see, among others, Manik Bajracharya, "Gurumaṇḍala Pūjā"; Gellner, "Ritualized Devotion,"161–97; Gellner, *Monk, Householder*, 148–51; Locke, *Karunamaya*, 81–87; Shima, *A Newar Buddhist Temple*, 25–91; and Sharkey, *Buddhist Daily Ritual*, 284–88.

45 Although Gellner notes that there is a conflation between the offering itself and the recipient of the offering in some rituals, the point here is precisely to distinguish the different cosmologies pertaining to the object and the receiver. Gellner, *Monk, Householder*, 149.

46 Sharkey, *Buddhist Daily Ritual*, 285; Locke, *Karunamaya*, 86.

47 Adapted from Gellner, "Ritualized Devotion," 174–75.

48 Ibid., 176.

49 This summary is based on several contemporary ritual manuals (S: vidhi) from Nepal, especially Sarvajñaratna Vajrācārya, *Vajrayāna Pūjāvidhi Saṃgraha*, 6, and Naresh Man Bajracharya, *Badrīratnakṛtaḥ Cāryagītiviśuddhisaṃgrahaḥ*, 11.

50 Gellner, "Ritualized Devotion," 177.

51 Manik Bajracharya, "Gurumaṇḍala Pūjā," 142(31).

52 Namely, Vairocana, Amoghasiddhi, and Amitābha. Stablein, *Healing Image*, 97.

53 S: *nāḍī*

54 See, for example, Gellner, "Ritualized Devotion," 179; Sharkey, *Buddhist Daily Ritual*, 286; Locke, *Karunamaya*, 86.

55 My translation, based especially on Naresh Man Bajracharya, *Badrīratnakṛtaḥ Cāryagītiviśuddhisaṃgrahaḥ*, 12; Manik Bajracharya, "Gurumaṇḍala Pūjā," 133(40); and Gellner, "Ritualized Devotion," 179. The most significant variant of this verse mentions eight peaks of Meru rather than eight continents. This phrase could potentially refer to the eight peaks that surmount Meru at the corners and sides of its upper plateau but is commonly interpreted as the peak of Meru plus the seven golden mountain ranges that surround it.

56 Makransky, "Offering (mChod pa)," 323.

57 S: *kāya-vāk-citta*; T: *sku gsung thugs*

58 Holt, "Assisting the Dead," 158.

59 Gellner, *Monk, Householder*, 147 (emphasis in original).

60 In each quadrant, variations on the root syllable are created by the three standard Sanskrit extensions of the inherent short-a vowel: lengthening ("ya" to "yā" [या]), nasal continuation [anusvāra] ("ya" to "yaṃ" [यं]), and unvoiced continuation [visarga] ("ya" to "yaḥ" [यः]).

61 For photographs of the ritual performance, see Shima, *A Newar Buddhist Temple*, 25–91, esp. a detail of the maṇḍala on p. 49.

62 Gellner compares later liturgical texts to the *Collection of Rituals* (S: *Kriyā-samuccaya*), placing the date of the latter in the early eleventh century. Gellner, "Ritualized Devotion," 161. La Vallée Poussin also dates a manuscript of the *Ādi-karma-pradīpa* containing the treasure-maṇḍala offering to about 1097 (Newar Saṃvat 218), but this claim is disputed. La Vallée Poussin, *Bouddhisme*, 184.

63 "Pañcarakṣā (MS Add.1688)."

64 Kim, "Book of Buddhist Goddesses," 277.

65 Kim, *Receptacle of the Sacred*, 168.

66 Weissenborn, *Buchkunst aus Nālandā*, 36–37, 164.

67 See Kossak, Singer, and Bruce-Gardner, *Sacred Visions*, 50–51, 134–35; Pal and Meech-Pekarik, *Buddhist Book Illuminations*, 139–42; and Huntington and Bangdel, *The Circle of Bliss*, 124–25. The image in the bottom-right corner of the Amitāyus painting in *Sacred Visions* is particularly interesting for replicating the juxtaposition of the treasure-maṇḍala to the seven outer offerings of the altar (discussed in chap. 4).

68 Other murals at Alchi show different ways of depicting ritual maṇḍalas in plan view. The elements can be arrayed in sets of five, nine, thirteen, or seventeen, in either squares or circles. Sometimes the objects in the maṇḍala are depicted in different colors or are clearly identifiable as flowers.

69 For a thirteenth-century Tibetan example that clearly juxtaposes the treasures of the *cakravartin* with the maṇḍala offering, see the bottom register of "Vajrasattva (Buddhist Deity)."

70 S: *aṣṭa-maṅgala*; T: *bkra shis rtags brgyad*

71 Compare to the Tholing *Prajñāpāramitā* manuscript illustration mentioned previously (Pal and Meech-Pekarik, *Buddhist Book Illuminations*, 139–42; Huntington and Bangdel, *The Circle of Bliss*, 124–25) and painting 1995.233 in the collection of the Metropolitan Museum of Art, which depicts two maṇḍalas of nine flowers alongside similar ritual implements. "Chakrasamvara Mandala."

72 This image has been likened to a "male organ" or a "heap of precious gems of different colours or even a mountain." Tsering, *Alchi*, 6; Goepper, *Alchi*, 34.

73 For comparison, see the eleventh-century manuscript depiction of Sumeru in an elemental maṇḍala. Heller, "Two Early Tibetan Ritual Diagrams"; for a color reproduction, see Hofer, *Bodies in Balance*, 35, fig. 2.4.

74 T: Lo tsa ba lha khang

75 T: [various names include] *rgyan tshogs* (collection of adornments), *mchod rdzas* (worship items), *bskang rdzas* (fulfillment items). Skorupski, *Body, Speech, and Mind*, 49.

76 T: *bla ma mchod pa*

77 T: *sngon 'gro*

78 Barker, "Lama Chöpa," 1.

79 Willson, *Rites and Prayers*, 133.

80 T: Pan chen bla ma blo bzang chos kyi rgyal mtshan (1570–1662)

81 Gyaltsen was the tutor to the fifth Dalai Lama (nGa dbang blo bzang rgya mtsho) (1617–1682), who, along with his regent, Desi Sangye Gyatso (sDe srid sangs rgyas rgya mtsho) (1653–1705), centralized both political and religious authority in the seventeenth century.

82 T: kLong chen snying thig

83 T: 'Phags pa blo gros rgyal mtshan (1235–1280)

84 T: Sa skya

85 Kazi, *Kün-zang La-may Zhal-lung*, 399.

86 T: *dGongs 'dus rnam bshad*

87 T: 'Jigs med gling pa (1730–1785)

88 Linrothe, "Creativity, Freedom and Control," 30.

89 Gellner, *Monk, Householder*, 58.

90 T: *sprul sku*

91 T: *sgrub pa'i*

92 T: *tshogs zhing*

93 Kongtrul even instructs that the practitioner should sit in front of an image of the deities so as to aid visualization. Kongtrul, *The Torch of Certainty*, 53.

94 For an overview of distinctions in the Gelug systems, as well as historical developments in iconography, see Lunardo, "dGe lugs pa *tshogs zhing*," 63–82; Lunardo, "Tshogs zhing," 314–28.

95 Kongtrul, *The Torch of Certainty*, 97.

96 Rangdrol, "4. Mandala Offering." T: g.Yu khog bya bral ba chos dbyings rang grol (1872–1952).

97 S: *bodhi-pakṣa*; T: *byang chub phyogs*

98 Dayal, *The Bodhisattva Doctrine*, 80–81.

99 22.33–44. Buddhaghosa, *The Path of Purification*, 792–96.

100 Here, "all paths" means the triyāna (three vehicles): Hīnayāna, Mahāyāna, and Vajrayāna. Skorupski, *Practices Conducive to Enlightenment*, 10.

101 Kelsang Gyatso, *Great Treasury of Merit*, 315–16.

102 Gellner, "Ritualized Devotion," 192n47. See also Beyer, *The Cult of Tārā*, 159.

103 Some versions of the *cakravartin* story also place other treasures in the sky, such as the elephant. Walshe, "Mahāsudassana Sutta," 281. See also Kongtrul, *The Torch of Certainty*, 100; Wangchen, *Awakening the Mind*, 66.

104 Wangchen, *Awakening the Mind*, 68.

105 Kongtrul, *The Torch of Certainty*, 102.

106 Tharchin, *Commentary on Guru Yoga*, 73.

107 Wangchen, *Awakening the Mind*, 65.

108 Ibid., 67.

109 For one example, see Brauen, *Mandala*, 67.

110 Manik Bajracharya, personal communication, 2015.

111 T: Mi la ras pa (1040–1123)

112 Kongtrul, *The Torch of Certainty*, 104.

113 Tharchin, *Commentary on Guru Yoga*, 73.

114 Wangchen, *Awakening the Mind*, 68.

115 T: Kun tu bzang po

116 Cleary, *The Flower Ornament Scripture*, 3:379–94.

117 See McMahan, *Empty Vision*, 129.

118 Pelden, *Nectar of Manjushri's Speech*, 78.

119 T: *kha btags*

120 T: *phyi, nang, gsang, de kho na nyid*

121 Tharchin, *Commentary on Guru Yoga*, 76–78. The inner maṇḍala offering is also associated with the Tibetan practice of *gcod*, which centers on a visualized dismemberment and offering of one's own body. Lingpa, *The Dzogchen*, 61.

122 Bentor, "Fourfold Meditation," 41.

123 Lingpa, *The Dzogchen*, 12–13.

124 For an example of the Tibetan-style treasure-maṇḍala depicted in plan view as piles of grain before the Panchen Lama's practice was popularized, see Xiang, *Precious Deposits*, 146. The difference between this and the Newar version is obvious in the groupings of three treasures at the periphery of the quadrants, representing the trios of major and minor continents.

125 Kongtrul, *The Torch of Certainty*, 93–105.

126 David Jackson, *The Place of Provenance*, 124.

127 Compare Brauen, *Mandala*, 67; Berliner, *The Emperor's Private Paradise*, cat. no. 64.

128 Such diagrams may also have served as amulets. Douglas, *Tibetan Tantric Charms*, plate 70.

4. COSMOS IN ARCHITECTURE: SACRED SPACE AND MURALS

1 Readers interested in learning more about Buddhist architecture may benefit from the following sources: Alexander, *The Temples of Lhasa*; Henss, *Cultural Monuments of Tibet*; Khosla, *Buddhist Monasteries*; Korn, *Traditional Architecture*; Pichard and Lagirarde, *The Buddhist Monastery*; and Slusser, *Nepal Mandala*.

2 S: *tri-ratna* (three jewels); T: *dkon mchog gsum*

3 Chayet, "Le Monastère de bSam-Yas," 24.

4 T: *mchod rten*; S: *stūpa*

5 T: *dBa' bzhed*

6 Wangdu and Diemberger, *dBa' bzhed*, x.

7 Ibid., 65–67.

8 Tsogyal and Öser, *The Lotus-Born*, 71.

9 Henss, *Cultural Monuments of Tibet*, 1:389. For a detailed iconographic description, see Akester, *Jamyang Kyhentse Wangpo's Guide*, 305–28.

10 Tsogyal and Öser, *The Lotus-Born*, 73.

11 Chayet, "Le Monastère de bSam-Yas."

12 See, for example, Alexander, *The Temples of Lhasa*, 285.

13 Slusser, *Nepal Mandala*, 145.

14 Bangdel, "Manifesting the Mandala," 108–9.

15 Klimburg-Salter, *Tabo*, 95–108; Luczanits, *Buddhist Sculpture in Clay*, 33–56.

16 Pommaret, "Buddhist Monasteries in Tibet," 283–304.

17 For descriptions of the maṇḍalic ornamentation on Nepalese doorways, see Slusser, *Nepal Mandala*, 145.

18 For a diagram and brief explanation, see Gyatsho, *Gateway to the Temple*, 36–41.

19 The examples here focus on Tibetan traditions, in which imagery of the kings is both more prominent and more complex than it is elsewhere. In Nepal, the guardian kings often appear at the base of exterior wooden struts that support the roof of the main shrine building or on small metal plaques at the corners or sides of the building. For example, see Bangdel, "Manifesting the Mandala," 226.

20 As, for example, at the National Memorial Chorten in Thimpu, Bhutan.

21 Both Sanskrit and Tibetan are read left to right.

22 Gyatsho, *Gateway to the Temple*, 49–52. The other two essentials are an image of the Buddha and interior paintings of a suitable iconographic program.

23 For a detailed description and additional images, see Sharkey, *Buddhist Daily Ritual*, 80–85.

24 Ibid., 78–79.

25 Recall also the discussion of the Sumeru throne in chapter 2. For more on this and its relationship to the altar and guardian kings, see Lessing, *Yung-Ho-Kung*, 17–18.

26 Beyer, *The Cult of Tārā*, 148.

27 T: *gtor ma*

28 S: *vīṇā*

29 For example, Meinert and Terentyev, *Buddha in the Yurt*, 2:689.

30 T: *Sa skya*

31 For illustrations and explanation, see Birnbaum, *The Healing Buddha*, plates 10 and 11, pp. 95–96.

32 T: *mdos*

33 Note, for example, the vase on top for the invitation of the deity, which is also commonly seen in *torma* designs. For more information, see Nebesky-Wojkowitz, *Oracles and Demons*, 343–97; Tucci, *Tibetan Painted Scrolls*, 2:740; Kelényi, "Analysis," 188.

34 See the extensive bibliography in Teiser, *Reinventing the Wheel*.

35 Ibid., 145.

36 The following describes only a brief outline of the contemporary paradigm. For extensive analysis of historical variations in the wheel of existence, see Teiser, *Reinventing the Wheel*. For more explanation of the modern configuration, see Tharchin, *King Udrayana*.

37 The canonical textual source for the wheel of existence explicitly states that the four

continents should be depicted in the human realm, although this is rarely done in contemporary Himalayan images. Teiser, *Reinventing the Wheel*, 55.

38 S: *saṃsāra*

39 S: *triviṣa*; T: *dug gsum*; also known in Sanskrit as the three *kleśas* (mental afflictions)

40 S: (respectively) *rāga, dveṣa, moha/avidyā*

41 The twelve sections represent the twelve *nidānas*, which characterize causation understood as *pratītya-samutpāda*. For references, see the bibliographies in Skorupski, "Buddhist Theories of Causality."

42 Teiser, *Reinventing the Wheel*, 56.

43 Mejor, "Painting the 'Wheel of Transmigration,'" 681.

44 Teiser, *Reinventing the Wheel*, 100.

45 Snellgrove and Skorupski, *Cultural Heritage of Ladakh*, 2:148.

46 For examples, see Dietz, "Cosmogony," 435–38; Wylie, *The Geography of Tibet*.

47 For example, Gyatsho mentions the inclusion of murals of the *abhidharma* cosmos without describing their use. *Gateway to the Temple*, 48–50.

48 For examples from Gandhāra, see Kurita, *Gandhāran Art*. For more on the history of depictions of the descent from the heaven of the Thirty-Three, see Allinger, "Descent of the Buddha."

49 For illustrations of some of these deities, see Willson and Brauen, *Deities of Tibetan Buddhism*, 87, 109, 166.

50 Tucci, "Oriental Notes."

51 Important depictions of this goddess can be found at Gyantse, Samye, and Sakya monasteries. A *sādhana* for Pale Sun-and-Moon describes Meru in the right hand and the four continents in the left, without mentioning the Cakravāla disc, although possibly as a metonym for it. See "Rin chen gter mdzod chen mo." See also Tucci, *Gyantse and Its Monasteries*, part 1, 153, 157–58, and the accompanying figures in part 3.

52 See illustrations of the murals on the fifth floor of Gyantse's Kumbum in Tachikawa and Masaki, *Chibetto Bukkyō Zuzō Kenkyū*, 38, 45, 65, 68–69, 76–77, 79, 81–82, 84–85, 106–7, 109.

53 For an iconography nearly identical to the one at Sonada Gompa, see Bartholomew and Johnston, *The Dragon's Gift*, 250–51.

54 T: *klu khang*

55 Winkler, "The *rDzogs chen* Murals," 322–24.

56 T: rDzogs chen

57 Winkler, "The *rDzogs chen* Murals," 325–28.

58 For an illustration of this scene, see Luczanits, "Locating Great Perfection," 110.

59 Baker and Laird, *Dalai Lama's Secret Temple*, 58–65.

60 See Teiser, *Reinventing the Wheel*, 76–103.

61 Ibid., 91–94.

62 Leela Aditi Wood, "Ajanta Cave 17 Inscription," 110.

63 Teiser, *Reinventing the Wheel*, 50.

64 Howard, "In Support of a New Chronology," 70; Vignato, "Archaeological Survey of Kizil," 403–5.

65 Howard, *Imagery of the Cosmological Buddha*, 36. See also Le Coq, *Die buddhistische Spaetantike*, plate 2; Grünwedel, *Altbuddhistische Kultstätten*, fig. 243.

66 Hiyama, "A New Identification."

67 Ibid., 148.

68 See, for example, Grünwedel, *Alt-Kutscha*, II 73–74.

69 Ghose, *Kizil on the Silk Road*, 109–10.

70 Thanks to Satomi Hiyama for sharing her manuscript "The Buddha's Sermon Scenes in Kizil Cave 207." See also Hiyama, "The Wall Paintings," 124; La Vallée Poussin, *Abhidharma-kośabhāṣyam*, 2:475–95.

71 Grünwedel, *Alt-Kutscha*, II 24–25. See also La Vallée Poussin, *Abhidharmakośabhāṣyam*, 2:477.

72 See especially works by Angela Howard, including Howard and Vignato, *Archaeological and Visual Sources*; Howard, "The Monumental 'Cosmological Buddha'"; Howard, *Imagery of the Cosmological Buddha*; and Howard, "Rethinking the Cosmological Buddha."

73 Howard, *Imagery of the Cosmological Buddha*, 78.

74 S: *Vimalakīrti-nirdeśa*

75 Watson, *The Vimalakirti Sutra*, 132–34.

76 La Vallée Poussin, *Abhidharmakośabhāṣyam*, 2:468–69. This is especially interesting because the *Akṣobhya-vyūha*, a text that had been translated into Chinese by the second century, casts Abhirati as an early form of the purified landscape (S: *buddha-kṣetra*) popularized in Pure Land Buddhism, in which the actions of the resident Buddha so equalize the forms of existence in the realm that Meru, as a signifier of cosmic hierarchy, disappears. Nattier, "The Realm of Akṣobhya," 80–81.

77 See an illustration in Eugene Wang, *Shaping the Lotus Sutra*, 136.

78 See illustration in Whitfield, Whitfield, and Agnew, *Cave Temples of Mogao*, 88–89.

79 Michelle Wang, "The Thousand-Armed Mañjuśrī," 87.

80 The manuscript is P. 2824. Images and description are available at "Pelliot chinois 2824," International Dunhuang Project. See also "Pelliot chinois 2824," Bibliothèque nationale de France.

81 For this argument and detailed illustrations, see Wang-Toutain, "Deux diagrammes."

82 T: *sgo khang*

83 Klimburg-Salter, *Tabo*, 77.

84 Teiser, *Reinventing the Wheel*, 193.

85 Ibid., 216.

86 Klimburg-Salter, *Tabo*, 80–81.

87 Neumann, "The Wheel of Life."

88 T: *Zhwa lu*

89 The mural from the great circumambulatory (T: *skor lam chen mo*) on the first floor has been identified as the story of Māndhātar from *One Hundred Birth Stories* (T: *Skyes rabs brgya pa*), by the third Karmapa, Rangjung Dorje (T: *Rang byung rdo rje*) (1284–1339). The mural on the second-floor circumambulatory around the Prajñāpāramitā shrine (T: *yum chen mo skor lam*) has been identified as the story of one of several kings whose biographies follow the same narrative, as given in the *Sūtra on the Meeting of the Father and Son* (S: *Pīta-putra-samāgam-sūtra*; T: *Yab dang sras mjal ba zhes bya ba theg pa chen po'i mdo*). Richardson, "Painted Books," 11. Benjamin Wood, "The Power of Symbols," 11.

90 At the time of the fourteenth-century renovation of Shalu, artists were beginning to innovate away from the traditional Newar style, with additional influence from the Yuan court. Ricca and Fournier, "The Paintings"; Vitali, *Early Temples*, 105–10.

91 In each set of treasures, the jewel treasure is replaced by a different item (a treasure vase or a bowl of precious substances).

92 In fact, another image of Meru in the Cakravāla does appear at Shalu at the base of a highly unusual, text-filled maṇḍala of Avalokiteśvara that requires extensive further study. See Henss, *Cultural Monuments of Tibet*, 2:605.

93 Luczanits, "On the Earliest Mandalas," 121–22.

94 Another important cosmological image from the Yuan dynasty shows exactly the same developments of maṇḍalic structure and adornment with treasure imagery. "Cosmological Mandala." See also Huntington and Bangdel, *The Circle of Bliss*, 74–75.

95 T: mTho lding

96 Vitali, *Records of Tho-Ling*, 14, 124–28; Luczanits, "Note on Tholing Monastery," 76.

97 Neumann, "The Wheel of Life," 81.

98 Unfortunately, it has not been possible to visit this mural in person and confirm whether they are depicted at all.

99 This genre has a long history in Indic, Himalayan, and Tibetan cultures, and scholars debate how much or little each text might have been used by specific artists at different times in history. See, for example, Nardi, *The Theory of Citrasūtras*, 3, and Cüppers et al., *Handbook of Tibetan Iconometry*, 4–5.

100 For two unusual, modern examples that do include depictions of the cosmos, see Konchog, *The Path to Liberation*, figs. 1–3, and Phun tshogs rdo rje, *Bod kyi ri mo*, 172. The former represents the *abhidharma* measurements of Vasubandhu, while the latter portrays the thirty-seven-part treasure-maṇḍala offering.

101 Contemporary painter Tsering Wangdus (T: Tshe ring dbang 'dus), personal communication, 2011.

CONCLUSION: PORTRAITS OF LANDSCAPES

1 Tayé, *Myriad Worlds*, 113.

2 S: Godānīya; T: Ba lang spyod

3 S: Videha; T: Lus 'phags

4 T: bKa' brgyud

5 For example, see Kelényi, "Myth of the Cosmic Turtle."

6 For examples, see Lopez, *Buddhism & Science*, 39–72; Hammerstrom, *Science of Chinese Buddhism*, 50–79.

7 See, for example, Granoff, "Cosmographs and Cosmic Jinas"; Hegewald, "Visual and Conceptual Links."

8 Many volumes on comparative cosmology exist, including Blacker and Loewe, *Ancient Cosmologies*; Campion, *Astrology and Cosmology*; Harley and Woodward, *The History of Cartography*; and, from a popular perspective with comparative illustrations, Haddad and Duprat, *Mondes*.

BIBLIOGRAPHY

Akester, Matthew. *Jamyang Kyhentse Wangpo's Guide to Central Tibet*. Chicago: Serindia, 2016.

Alexander, Andre. *The Temples of Lhasa: Tibetan Buddhist Architecture from the 7th to the 21st Centuries*. Tibet Heritage Fund's Conservation Inventory 1. Chicago: Serindia, 2005.

Allan, Nigel. *Pearls of the Orient: Asian Treasures from the Wellcome Trust*. London: Serindia, 2003.

Allinger, Eva. "The Descent of the Buddha from the Heaven of the Trayastriṃśa Gods: One of the Eight Great Events in the Life of the Buddha." In *From Turfan to Ajanta: Festschrift for Dieter Schlingloff on the Occasion of His Eightieth Birthday*, edited by Eli Franco and Monika Zin, vol. 1. Lumbini: Lumbini International Research Institute, 2010.

Andolfatto, David. *An Inventory of the Buddhist Sites of the Kathmandu Valley (Nepal): Description and Consideration of Their Conservation State*. Paris: Oriental Cultural Heritage Sites Protection Alliance (Alliance de Protection du Patrimoine Culturel Asiatic — APPCA), 2012.

Asaṅga. *The Summary of the Great Vehicle*. Translated by John P. Keenan. Rev. 2nd ed. Berkeley: Numata Center for Buddhist Translation and Research, 1992.

Babb, Lawrence A. *Absent Lord: Ascetics and Kings in a Jain Ritual Culture*. Berkeley: University of California Press, 1996.

Bajracharya, Mana Bajra, and Warren W. Smith. *Mythological History of the Nepal Valley from the Svayambhu Purana; and Naga and Serpent Symbolism*. Kathmandu: Avalok Publishers, 1978.

Bajracharya, Manik. "Gurumaṇḍala Pūjā." *Bunkenkai Kiyo: Journal of the Graduate School of Humanities*, no. 17 (2006): 146(27)–30(43).

Bajracharya, Naresh Man. *Badrīratnakṛtaḥ cāryagītiviśuddhisaṃgrahaḥ*. Kathmandu: Prem Kumārī Bajrācārya, 2003.

Baker, Ian, and Thomas Laird. *The Dalai Lama's Secret Temple: Tantric Wall Paintings from Tibet*. New York: Thames & Hudson, 2000.

Banerjee, Biswanath. *A Critical Edition of Śri Kālacakratantra-Rāja*. Calcutta: Asiatic Society, 1985.

Bangdel, Dina. "Manifesting the Mandala: A Study of the Core Iconographic Program of Newar Buddhist Monasteries in Nepal." PhD diss., The Ohio State University, 1999.

Barker, David Read. "Lama Chöpa: A Ritual Text of the Gelugpa Sect in Tibet." PhD diss., New School for Social Research, 1975.

Bartholomew, Terese Tse, and John Johnston. *The Dragon's Gift: The Sacred Arts of Bhutan*. Chicago: Serindia, 2008.

Belvalkar, Shripad Krishna. *The Bhīṣhmaparvan: Being the Sixth Book of the Mahābhārata, the Great Epic of India*. Poona: Bhandarkar Oriental Research Institute, 1947.

Bentor, Yael. "Fourfold Meditation: Outer, Inner, Secret, and Suchness." In *Religion and Secular Culture in Tibet*. PIATS 2000: Tibetan Studies: Proceedings of the Ninth Seminar of the International Association for Tibetan Studies, Leiden 2000. Leiden: Brill, 2002.

Berliner, Nancy Zeng. *The Emperor's Private Paradise: Treasures from the Forbidden City*. Salem, MA: Peabody Essex Museum and Yale University Press, 2010.

Berzin, Alexander. *Taking the Kalachakra Initiation*. Ithaca, NY: Snow Lion Publications, 1997.

Beyer, Stephan. *The Cult of Tārā: Magic and Ritual in Tibet*. Berkeley: University of California Press, 1973.

Bhattacharyya, Benoytosh. *Niṣpannayogāvalī of Mahāpaṇḍita Abhayākaragupta*. Gaekwad's Oriental Series, 109. Baroda: Oriental Institute, 1949.

Birnbaum, Raoul. *The Healing Buddha*. Boulder, CO: Shambhala, 1979.

Blacker, Carmen, and Michael Loewe, eds. *Ancient Cosmologies*. London: Allen and Unwin, 1975.

Bodhi, trans. *The Numerical Discourses of the Buddha: A Translation of the Aṅguttara Nikāya*. Boston: Wisdom, 2012.

Bogin, Benjamin. "Locating the Copper-Colored Mountain: Buddhist Cosmology, Himalayan Geography, and Maps of Imagined Worlds." *Himalaya, the Journal of the Association for Nepal and Himalayan Studies* 34, no. 2.

Brauen, Martin. *Mandala: Sacred Circle in Tibetan Buddhism*. Stuttgart: Arnoldsche Art Publishers, 2009.

———. *The Mandala: Sacred Circle in Tibetan Buddhism*. Boston: Shambhala, 1998.

Brockington, J. L. *The Sanskrit Epics*. Leiden and Boston: Brill, 1998.

Buddhaghosa. *The Path of Purification (Visuddhimagga)*. Translated by Ñyāṇamoli. 2nd ed. Colombo: A. Semage, 1964.

"Buddhaghosa: Visuddhimagga, Annotated Version." GRETIL — Göttingen Register of Electronic Texts in Indian Languages, Niedersächsische Staats und Universitätsbibliothek Göttingen. http://gretil.sub.uni-goettingen.de/gretil/2_pali/4_comm/buvismou.htm.

Buitenen, J. A. B. van, trans. *The Mahābhārata*. Vol. 2. Chicago: University of Chicago Press, 1981.

Buswell, Robert E., and Donald S. Lopez. *The Princeton Dictionary of Buddhism*. Princeton: Princeton University Press, 2014.

Caillat, Colette, and Ravi Kumar. *The Jain Cosmology*. Basel: Ravi Kumar, 1981.

Campion, Nicholas. *Astrology and Cosmology in the World's Religions*. New York: New York University Press, 2012.

"Chakrasamvara Mandala." Accession number 1995.233, The Metropolitan Museum of Art. Accessed June 7, 2016. https://www.metmuseum.org/art/collection/search/38021.

Chayet, Anne. "Le Monastère de bSam-Yas: Sources Architecturales." *Arts Asiatiques* 43 (1988): 19–29.

Cherniak, Alex, trans. *Mahābhārata: Book Six, Bhīṣma, Volume One*. New York: New York University Press, 2008.

Chos kyi 'byung gnas. "mDo rgya cher rol pa." In *bKa' 'gyur (sDe dge par phud)*, vol. 46: 3–434. TBRC W22084. Delhi: Delhi Karmapae Ghodhey Gyalwae Sungrab Partum Khang, 1976–79. http://tbrc.org/link?RID=O1GS12980|O1GS129804CZ209517$W22084.

Chou, Wen-Shing. "Reimagining the Buddhist Universe: Pilgrimage and Cosmography in the Court of the Thirteenth Dalai Lama (1876–1933)." *Journal of Asian Studies* 73, no. 2 (2014): 419–45.

Cleary, Thomas. *The Flower Ornament Scripture: A Translation of the Avatamsaka Sutra*. 3 vols. Boston: Shambhala, 1984.

Collins, Charles Dillard. *The Iconography and Ritual of Śiva at Elephanta*. Albany: State University of New York Press, 1988.

Cornu, Philippe. *Tibetan Astrology*. Translated by Hamish Gregor. Boston: Shambhala, 2002.

"Cosmological Mandala with Mount Meru." Accession number 1989.140, The Metropolitan Museum of Art. https://www.metmuseum.org/art/collection/search/39738.

Cüppers, Christoph, Leonard W. J. van der Kuijp, Ulrich Pagel, and Dobis Tsering Gyal. *Handbook of Tibetan Iconometry: A Guide to the Arts of the 17th Century*. Leiden: Brill, 2012.

Dalton, Jacob. "A Crisis of Doxography: How Tibetans Organized Tantra during the 8th–12th Centuries." *Journal of the International Association of Buddhist Studies* 28, no. 1 (2005).

———. *The Gathering of Intentions: A History of a Tibetan Tantra*. New York: Columbia University Press, 2016.

Davidson, Ronald M. *Indian Esoteric Buddhism: A Social History of the Tantric Movement*. New York: Columbia University Press, 2002.

Dayal, Har. *The Bodhisattva Doctrine in Buddhist Sanskrit Literature*. Delhi: Motilal Banarsidass, 1932.

Denis, Eugène. "La *Lokapaññatti* et les Idées Cosmologiques du Bouddhisme Ancien." Paris: Université Paris-Sorbonne, 1976.

Denwood, Philip. "The Dating of the Sumtsek Temple at Alchi." In *Art and Architecture in Ladakh: Cross-Cultural Transmissions in the Himalayas and Karakoram*, edited by Erberto Lo Bue and John Bray. Tibetan Studies 35. Leiden: Brill, 2014.

Dharmachakra Translation Committee, trans. *The Play in Full (Lalitavistara)*. 84,000: Translating the Words of the Buddha. Accessed October 30, 2015. http://read.84000.co/translation /UT22084-046-001.html.

Dietz, Siglinde. "Cosmogony as Presented in Tibetan Historical Literature and Its Sources." In *Tibetan Studies: Proceedings of the 5th Seminar of the International Association for Tibetan Studies*, vol. 2, *Language, History and Culture*, edited by Shōren Ihara and Zuihō Yamaguchi, 435–438. Narita, Japan: Naritasan Shinshoji,1992.

Doniger, Wendy. *The Hindus: An Alternative History*. New York: Penguin, 2009.

Dorjee, Pema. *Stūpa and Its Technology: A Tibeto-Buddhist Perspective*. Delhi: Indira Gandhi National Centre for the Arts, 1996.

Douglas, Nik. *Tibetan Tantric Charms and Amulets*. Mineola, NY: Dover Publications, 2002.

Dreyfus, Georges B. J. *The Sound of Two Hands Clapping*. Berkeley: University of California Press, 2003.

Dudjom. *The Nyingma School of Tibetan Buddhism: Its Fundamentals and History*. Translated by Gyurme Dorje and Matthew Kapstein. Boston: Wisdom Publications, 2002.

"'Dul ba rnam par 'byed pa." Vol. Nya. Asian Classics Input Project. www.asianclassics.org/.

Eliade, Mircea. *Images and Symbols: Studies in Religious Symbolism*. Translated by Philip Mairet. New York: Sheed & Ward, 1961.

Fiordalis, David V. "The Buddha's Great Miracle at Śrāvastī: A Translation from the Tibetan Mūlasarvāstivāda-Vinaya." *Asian Literature in Translation* 2, no. 3 (2014): 1–33.

Fremantle, Francesca. "A Critical Study of the *Guhyasamaja Tantra*." PhD diss., University of London, 1971.

Frye, Stanley. *Sutra of the Wise and Foolish*. Dharmsala: The Library of Tibetan Works and Archives, 1981.

Fussman, Gérard. "Symbolisms of the Buddhist Stūpa." *Journal of the International Association of Buddhist Studies* 9, no. 2 (1986): 37–53.

Gellner, David N. *Monk, Householder, and Tantric Priest: Newar Buddhism and Its Hierarchy of Ritual*. Cambridge: Cambridge University Press, 1992.

———. "Ritualized Devotion, Altruism, and Meditation: The Offering of the Guru Maṇḍala in Newar Buddhism." *Indo-Iranian Journal* 34 (1991): 161–97.

Gethin, Rupert. *The Buddhist Path to Awakening*. Brill's Indological Library. Leiden: E. J. Brill, 1992.

———. "Cosmology and Meditation: From the *Aggañña Sutta* to the Mahāyāna." *History of Religions* 36, no. 3 (1997): 183–219.

Ghose, Rajeshwari, ed. *Kizil on the Silk Road: Crossroads of Commerce & Meeting of Minds*. Mumbai: Marg Publications, 2008.

Giebel, Rolf W. *Two Esoteric Sutras*. Berkeley: Numata Center for Buddhist Translation and Research, 2001.

Gifford, Julie A. *Buddhist Practice and Visual Culture: The Visual Rhetoric of Borobudur*. London and New York: Routledge, 2011.

Glasenapp, Helmuth von. *Jainism: An Indian Religion of Salvation*. Translated by Shridhar B. Shrotri. Delhi: Motilal Banarsidass Publishers, 1999.

Goepper, Roger. *Alchi: Ladakh's Hidden Buddhist Sanctuary: The Sumtsek*. Boston: Shambhala Limited Editions, 1996.

Gold, Jonathan C. *Paving the Great Way: Vasubandhu's Unifying Buddhist Philosophy*. New York: Columbia University Press, 2014.

Gombrich, Richard. "Ancient Indian Cosmology." In *Ancient Cosmologies*, edited by Carmen Blacker and Michael Loewe. London: Allen and Unwin, 1975.

———. "Recovering the Buddha's Message." In *The Buddhist Forum*, vol. 1, *Seminar Papers 1987–1988*, edited by Tadeusz Skorupski, 5–20. London: School of Oriental and African Studies, 1990.

———. *What the Buddha Thought*. London: Equinox, 2009.

Gomez, Luis O. *The Land of Bliss: The Paradise of the Buddha of Measureless Light: Sanskrit and Chinese Versions*. Honolulu: University of Hawai'i Press, 1996.

González-Reimann, Luis. "Cosmic Cycles, Cosmology, and Cosmography." *Brill Encyclopedia of Hinduism*. Leiden: Brill, 2009.

Goswami, Bijoya. *Lalitavistara*. Kolkata: Asiatic Society, 2001.

Granoff, Phyllis. "Cosmographs and Cosmic Jinas." In *From Turfan to Ajanta: Festschrift for Dieter Schlingloff on the Occasion of His Eightieth Birthday*, edited by Eli Franco and Monika Zin, vol. 1. Lumbini: Lumbini International Research Institute, 2010.

———, ed. *Victorious Ones: Jain Images of Perfection*. New York: Rubin Museum of Art, 2009.

Griffith, Ralph T. H. *The Hymns of the Rgveda*. The Chowkhamba Sanskrit Series, 35. Varanasi, 1963.

Griffiths, Paul J., Noriaki Hakayama, John P. Keenan, and Paul L. Swanson. *The Realm of Awakening: A Translation and Study of the Tenth Chapter of Asaṅga's Mahāyānasaṅgraha*. New York: Oxford University Press, 1989.

Grünwedel, Albert. *Altbuddhistische Kultstätten in Chinesisch-Turkistan*. Berlin: Reimer, 1912.

———. *Alt-Kutscha: Archäologische Und Religionsgeschichtliche Forschungen an Tempera-Gemälden Aus Buddhistischen Höhlen Der Ersten Acht Jahrhunderte Nach Christi Geburt*. Berlin: Otto Elsner Verlagsgesellschaft, 1920.

Gutschow, Niels. *The Nepalese Caitya: 1500 Years of Buddhist Votive Architecture in the Kathmandu Valley*. Stuttgart: Axel Menges, 1997.

Gyal-tsan, Lo-Zang Ch'o-kyi, and Alexander Berzin. *The Guru Puja (bla-ma mChod-pa)*. Dharamsala: Library of Tibetan Works and Archives, 2003.

Gyatrul. *Generating the Deity*. Translated by Sangye Khandro. Ithaca, NY: Snow Lion Publications, 1996.

Gyatsho, Thubten Legshay. *Gateway to the Temple: Manual of Tibetan Monastic Customs, Art, Building, and Celebrations*. Bibliotheca Himalayica, series 3, no. 12. Kathmandu: Ratna Pustak Bhandar, 1979.

Gyatso, Kelsang. *Great Treasury of Merit: A Commentary to the Practice of Offering to the Spiritual Guide*. London: Tharpa Publications, 1992.

Gyatso, Khedrup Norsang. *Ornament of Stainless Light: An Exposition of the Kālacakra Tantra*. Translated by Gavin Kilty. The Library of Tibetan Classics. Boston: Wisdom Publications, 2004.

Gyatso, Tenzin. *The Union of Bliss and Emptiness: A Commentary of the Lama Choepa Guru Yoga Practice*. Ithaca, NY: Snow Lion, 1988.

Haddad, Leïla, and Guillaume Duprat. *Mondes: Mythes et images de l'univers*. Paris: Seuil, 2006.

Halkias, Georgios T. "Fire Rituals by the Queen of Siddhas: The *Aparimitāyur-Homa-Vidhi-Nāma* in the Tengyur." In *Homa Variations*, edited by Richard K. Payne and Michael Witzel, 225–45. New York: Oxford University Press, 2016.

Ham, Peter van. *Guge: Ages of Gold, the West Tibetan Masterpieces*. Munich: Hirmer, 2017.

Hammerstrom, Erik J. *The Science of Chinese Buddhism: Early Twentieth-Century Engagements*. New York: Columbia University Press, 2015.

Harley, J. B., and David Woodward, eds. *The History of Cartography*. Chicago: University of Chicago, 1987.

Harvey, Peter. "The Symbolism of the Early Stūpa." *Journal of the International Association of Buddhist Studies* 7, no. 2 (1984): 67–93.

Hegewald, Julia A. B. "Images of the Cosmos: Sacred and Ritual Space in Jaina Temple Architecture in India." In *Heaven on Earth: Temples, Ritual, and Cosmic Symbolism in the Ancient World*, 55–88. Chicago: The Oriental Institute of the University of Chicago, 2012.

———. "Visual and Conceptual Links between Jaina Cosmological, Mythological and Ritual Instruments." *International Journal of Jaina Studies* 6, no. 1 (2010): 1–20.

Heller, Amy. "Two Early Tibetan Ritual Diagrams for Cakra Meditations." *Tibet Journal* 34/35, nos. 3/2 (2009): 59–70.

Henning, Edward. *Kālacakra and the Tibetan Calendar*. New York: American Institute of Buddhist Studies, 2007.

———. "The Kālacakra World Model Is Not Mechanical." Kālacakra.org. New Delhi, India, 2009. www.kalacakra.org/calendar/kc_model.htm.

———. "Orbital Confusion." Kālacakra.org. Accessed August 17, 2016. www.kalacakra.org/phyinang/golconf.htm.

Henss, Michael. *The Cultural Monuments of Tibet: The Central Regions*. 2 vols. Munich: Prestel, 2014.

Hiyama, Satomi. "The Buddha's Sermon Scenes in Kizil Cave 207 ('the Painters' Cave')." Manuscript. Munich, 2013.

———. "A New Identification of the Murals in Kizil Cave 118: The Story of King Māndhātar." *Journal of Inner Asian Art and Archaeology* 5 (2010).

———. "The Wall Paintings of the 'Painters' Cave' (Kizil Cave 207)." PhD diss., Freien Universität Berlin, 2014.

Hodge, Stephen. *The Maha-Vairocana-Abhisambodhi Tantra with Buddhaguhya's Commentary*. London: Routledge-Curzon, 2003.

Hofer, Theresia. *Bodies in Balance: The Art of Tibetan Medicine*. Seattle: University of Washington Press, 2014.

Holt, John C. "Assisting the Dead by Venerating the Living." In *Buddhism: Critical Concepts in Religious Studies*, edited by Paul Williams, 1:147–68. London: Routledge, 2005.

Howard, Angela F. *The Imagery of the Cosmological Buddha*. Studies in South Asian Culture 13. Leiden: E. J. Brill, 1986.

———. "In Support of a New Chronology for the Kizil Mural Paintings." *Archives of Asian Art* 44 (1991): 68–83.

———. "The Monumental 'Cosmological Buddha' in the Freer Gallery of Art: Chronology and Style." *Ars Orientalis* 14 (1984): 53–73.

———. "Rethinking the Cosmological Buddha." In *From Turfan to Ajanta: Festschrift for Dieter Schlingloff on the Occasion of His Eightieth Birthday*, edited by Eli Franco and Monika Zin, vol. 1. Lumbini: Lumbini International Research Institute, 2010.

Howard, Angela F., and Giuseppe Vignato. *Archaeological and Visual Sources of Meditation in the Ancient Monasteries of Kuca*. Boston: Brill, 2014.

Huntington, John C., and Dina Bangdel. *The Circle of Bliss: Buddhist Meditational Art*. Chicago: Serindia, 2003.

Huntington, Susan L., and John C. Huntington. *The Art of Ancient India: Buddhist, Hindu, Jain*. New York: Weatherhill, 1985.

Irwin, John. "The Stūpa and the Cosmic Axis (*Yūpa-Yaṣṭi*)." In *Ācārya-Vandanā: D.R. Bhandarkar Birth Centenary Volume*, edited by Bandyopadhyay. Calcutta: University of Calcutta, 1984.

Jackson, David Paul. *The Place of Provenance: Regional Styles in Tibetan Painting*. New York: Rubin Museum of Art, 2012.

Jackson, Roger R. "Kalachakra in Context." In *The Wheel of Time: The Kalachakra in Context*, edited by Beth Simon, 1–50. Ithaca, NY: Snow Lion Publications, 1985.

Jaini, Padmanabh S. *The Jaina Path of Purification*. Berkeley: University of California Press, 1979.

Jamison, Stephanie W., and Joel P. Brereton. *The Rigveda: The Earliest Religious Poetry of India*. New York: Oxford University, 2014.

Jin Weinuo. *Zhongguo bi hua quan ji, 32: Zang chuan si yuan 2*. Tianjin Shi: Tianjin ren min mei shu chu ban she, 1992.

Joshi, K. L. *Matsya Mahāpurāṇa*. 2 vols. Delhi: Parimal Publications, 2007.

Kajiyama, Yūichi. "Buddhist Cosmology as Presented in the *Yogācārabhūmi*." In *Wisdom, Compassion, and the Search for Understanding: The Buddhist Studies Legacy of Gadjin M. Nagao*, 183–99. Honolulu: University of Hawai'i Press, 2000.

Kapstein, Matthew T. "Just Where on Jambudvīpa Are We? New Geographical Knowledge and Old Cosmological Schemes in Eighteenth-Century Tibet." In *Forms of Knowledge in Early Modern Asia: Explorations in the Intellectual History of India and Tibet, 1500–1800*, 336–64. Durham: Duke University Press, 2011.

Kazi, Sonam T. *Kün-zang La-may Zhal-lung: The Oral Instruction of Kün-zang La-ma on the Preliminary Practices of Dzog-ch'en Long-ch'en Nying-tig*. Nga-gyur Nying-may Sung-rab English Translation Series. Upper Montclair, NJ: Diamond-Lotus Publishing, 1993.

Kelényi, Béla. "Analysis of a *Mdos* Ritual Text Connected with the *Rlung rta* Tradition." In *This World and the Next: Contributions on Tibetan Religion, Science and Society*, 177–96. PIATS 2006: Proceedings of the Eleventh Seminar of the International Association for Tibetan Studies 27, 2006.

———. "The Myth of the Cosmic Turtle according to the Late Astrological Tradition." In *Impressions of Bhutan and Tibetan Art*, edited by John Ardussi and Henk Blezer, 69–90. Tibetan Studies 3. Leiden: Brill, 2002.

Khosla, Romi. *Buddhist Monasteries in the Western Himalaya*. Kathmandu: Ratna Pustak Bhandar, 1979.

Kim, Jinah. "A Book of Buddhist Goddesses: Illustrated Manuscripts of the *Pañcarakṣā Sūtra* and Their Ritual Use." *Artibus Asiae* 70, no. 2 (2010): 259–329.

———. *Receptacle of the Sacred: Illustrated Manuscripts and the Buddhist Book Cult in South Asia*. Berkeley: University of California Press, 2013.

Kirfel, Willibald. *Das Purāṇa vom Weltgebäude (Bhuvanavinyāsa): Die kosmographischen Traktate der Purāṇa's, Versuch einer Textgeschichte*. Bonn: Selbstverlag des Orientalischen Seminars der Universität Bonn, 1954.

Klimburg-Salter, Deborah E. *Tabo, a Lamp for the Kingdom: Early Indo-Tibetan Buddhist Art in the Western Himalaya*. New York: Thames & Hudson, 1997.

Kohn, Richard J. *Lord of the Dance: The Mani Rimdu Festival in Tibet and Nepal*. New York: SUNY Press, 2001.

Konchog. *The Path to Liberation: The Tsering Art School Manual for the Basic Gradual Stages of Study of Deity Drawing*. New Delhi: Shechen Publications, 2005.

Kongtrul, Jamgon. *The Torch of Certainty*. Translated by Judith Hanson. Boulder, CO: Shambhala, 1977.

Korn, Wolfgang. *The Traditional Architecture of the Kathmandu Valley*. Kathmandu: Ratna Postak Bhanda, 1976.

Kossak, Steven, Jane Casey Singer, and Robert Bruce-Gardner. *Sacred Visions: Early Paintings from Central Tibet*. New York: The Metropolitan Museum of Art, 1998.

Kurita, Isao. *Gandhāran Art*. Vol. 1, *The Buddha's Life Story*. Tokyo: Nigensha, 1988.

La Vallée Poussin, Louis de. *Abhidharmakośabhāṣyam*. Translated by Leo M. Pruden. 4 vols. Berkeley: Asian Humanities Press, 1990.

———. *Bouddhisme: Études et matériaux — Ādikarmapradīpa & Bodhicaryāvatāraṭīkā*. London: Luzac & Co., 1989.

———. *L'Abhidharmakośa de Vasubandhu*. 6 vols. Paris: Paul Geuthner, 1923.

Lamsam, Supawan Pui, and Kesang Choden Tashi Wangchuk, eds. *Zangdok Palri: The Lotus Light Palace of Guru Rinpoche*. Bangkok: Gatshel Publishing, 2012.

Le Coq, Albert von. *Die buddhistische Spaetantike in Mittelasien*. Vol. 4, *Atlas zu den Wandmalereien*. Berlin: Reimer, 1924.

Leidy, Denise Patry, and Robert A. F. Thurman. *Mandala: The Architecture of Enlightenment*. New York: Asia Society Galleries, Tibet House, Shambala, 1997.

Lessing, Ferdinand Diederich. "Miscellaneous Lamaist Notes I: Notes on the Thanksgiving Offering." In *Ritual and Symbol: Collected Essays on Lamaism and Chinese Symbolism*. Asian Folklore and Social Lifes Monographs 91. Taipei: The Orient Cultural Service, 1976.

———. *Yung-Ho-Kung: An Iconography of the Lamaist Cathedral in Peking, with Notes on Lamaist Mythology and Cult*. Reports from the Scientific Expedition to the North-Western Provinces of China under the Leadership of Dr. Sven Hedin; Sino-Swedish Expedition 18. Stockholm: Elanders Boktryckeri Aktiebolag, 1942.

Lessing, Ferdinand Diederich, and Alex Wayman. *Introduction to the Buddhist Tantric Systems*. New York: Samuel Weiser, 1980.

Levinson, Stephen C. *Space in Language and Cognition: Explorations in Cognitive Diversity*. Cambridge: Cambridge University Press, 2003.

Levy, Robert I. *Mesocosm: Hinduism and the Organization of a Traditional Newar City in Nepal*. Delhi: Motilal Banarsidass Publishers, 1990.

Lin, Wei-Cheng. *Building a Sacred Mountain: The Buddhist Architecture of China's Mount Wutai*. Seattle: University of Washington Press, 2014.

Lingpa, Jigme. *The Dzogchen: Preliminary Practice of the Innermost Essence (Long-chen Nying-thig Ngön-dro)*. Dharamsala: Library of Tibetan Works and Archives, 1982.

Linrothe, Rob. "Creativity, Freedom and Control in the Contemporary Renaissance of Reb Gong Painting." *Tibet Journal* 26, nos. 3/4 (2001): 5–90.

Liu, Lizhong. *Buddhist Art of the Tibetan Plateau*. Hong Kong and San Francisco: Joint Publishing Company and China Books and Periodicals, 1988.

Lo Bue, Erberto. "Traditional Tibetan Painting in Ladakh in the Twentieth Century." *International Folklore Review: Folklore Studies from Overseas* 3 (1983): 52–72.

Locke, John K. *Buddhist Monasteries of Nepal: A Survey of the Bāhās and Bahīs of the Kathmandu Valley*. Kathmandu: Sahayogi Press, 1985.

———. *Karunamaya: The Cult of Avalokitesvara-Matsyendranath in the Valley of Nepal*. Kathmandu: Sahayogi Prakashan, 1980.

Lopez, Donald S. *Buddhism & Science: A Guide for the Perplexed*. Chicago: University of Chicago Press, 2008.

Luczanits, Christian. *Buddhist Sculpture in Clay: Early Western Himalayan Art, Late 10th to Early 13th Centuries.* Chicago: Serindia Publications, 2004.

———. "Locating Great Perfection: The Murals of the Lhasa Lukhang." *Orientations* 42, no. 2 (2011): 102–11.

———. "A Note on Tholing Monastery." *Orientations* 27, no. 6 (1996): 76–77.

———. "On the Earliest Mandalas in a Buddhist Context." In *Mahayana Buddhism: History and Culture,* edited by Darrol Bryant and Susan Bryant, 111–27. New Delhi: Tibet House, 2008.

Luczanits, Christian, and Holger Neuwirth. "The Development of the Alchi Temple Complex: An Interdisciplinary Approach." In *Heritage Conservation and Research in India,* edited by Kathrin Schmidt. Vienna: Böhlau Verlag, 2010.

Lunardo, Filippo. "The dGe lugs pa *tshogs zhing*: The Difficulty in Understanding the Transmission Lineage of the *Bla ma mchod pa* Instructions." In *Tibetan Art between Past and Present: Studies Dedicated to Luciano Petech,* Proceedings of the Conference Held in Rome on the 3rd November 2010, 63–82. Alla Rivista Degli Studi Orientali, Nuova Serie 84. Pisa: Fabrizio Serra Editore, 2012.

———. "*Tshogs zhing*: A Wall Painting in the New 'Du khang of Spituk (Dpe thub)." In *Art and Architecture in Ladakh: Cross-Cultural Transmissions in the Himalayas and Karakoram,* edited by Erberto Lo Bue and John Bray. Tibetan Studies 35. Leiden: Brill, 2014.

MacDonnell, A. A. *Vedic Mythology.* Strasbourg: Karl J. Trübner, 1897.

Mahony, William K. "Cakravartin." *The Encyclopedia of Religion.* New York: MacMillan Publishing Company, 1987.

Mair, Victor H. "The Linguistic and Textual Antecedents of *The Sūtra of the Wise and the Foolish* (Hsien-yü ching)." *Sino-Platonic Papers,* no. 38 (April 1993): 1–95.

Makransky, John. "Offering (*mChod pa*) in Tibetan Ritual Literature." In *Tibetan Literature: Studies in Genre,* edited by José Ignacio Cabezón and Roger R. Jackson. Ithaca, NY: Snow Lion, 1996.

Marasinghe, M. M. J. *Gods in Early Buddhism: A Study of Their Social and Mythological Milieu as Depicted in the Nikāyas of the Pāli Canon.* Kelaniya: University of Sri Lanka, 1974.

Master, Alfred. "Indo-Aryan and Dravidian." *Bulletin of the School of Oriental and African Studies,* University of London 11, no. 2 (1944): 297–307.

McGovern, William Montgomery. *A Manual of Buddhist Philosophy.* Lucknow: Oriental Reprinters, 1976.

McKay, Alex. *Kailas Histories: Renunciate Traditions and the Construction of Himalayan Sacred Geography.* Leiden: Brill, 2015.

McMahan, David L. *Empty Vision: Metaphor and Visionary Imagery in Mahayana Buddhism.* London: Routledge Curzon, 2002.

Meinert, Carmen, and Andrey Terentyev. *Buddha in the Yurt: Buddhist Art from Mongolia.* 2 vols. Munich: Hirmer, 2011.

Mejor, Marek. "Painting the 'Wheel of Transmigration' (*saṃsāra-cakra*): A Note on the Textual Transmission." In *From Turfan to Ajanta: Festschrift for Dieter Schlingloff on the Occasion of His Eightieth Birthday,* edited by Eli Franco and Monika Zin, vol. 2. Lumbini: Lumbini International Research Institute, 2010.

Mori, Masahide. *Vajrāvalī of Abhayākaragupta.* Buddhica Britannica. Vol. 1. Tring, UK: The Institute of Buddhist Studies, 2009.

Mullin, Glenn H. *Buddha in Paradise: A Celebration in Himalayan Art.* New York: Rubin Museum of Art, 2007.

Mus, Paul. *Barabudur: Esquisse d'une histoire du Bouddhisme fondée sur la critique archéologique des textes.* 2 vols. Hanoi: Imprimerie d'Extrême-Orient, 1935.

———. *Barabudur: Sketch of a History of Buddhism Based on Archaeological Criticism of the Texts.*

Translated by Alexander W. MacDonald. New Delhi: Indira Gandhi National Centre for the Arts and Sterling Publishers, 1998.

Nagao, G. M. "Ascent and Descent: Two-Directional Activity in Buddhist Thought." In *Mādhyamika and Yogācāra: A Study of Mahāyāna Philosophies*, edited by L. S. Kawamura and G. M. Nagao, 201–7. SUNY Series in Buddhist Studies. Albany: State University of New York Press, 1991.

Ñāṇamoli and Bodhi, trans. *The Middle Length Discourses of the Buddha: A New Translation of the Majjhima Nikāya*. Boston: Wisdom, 1995.

Nance, Richard F. "Mindsets and Commentarial Conventions among Indian Buddhists." *Journal of the American Academy of Religion* 83, no. 1 (March 2015): 210–35.

Nardi, Isabella. *The Theory of Citrasūtras in Indian Painting: A Critical Re-evaluation of Their Uses and Interpretations*. New York: Routledge, 2006.

National Museum of India and National Commission for Cultural Affairs (Bhutan). *The Living Religious and Cultural Traditions of Bhutan: Catalogue*. New Delhi: National Museum, 2001.

Nattier, Jan. "The Realm of Akṣobhya: A Missing Piece in the History of Pure Land Buddhism." *Journal of the International Association of Buddhist Studies* 23, no. 1 (2000): 71–102.

Nebesky-Wojkowitz, René de. *Oracles and Demons of Tibet: The Cult and Iconography of the Tibetan Protective Deities*. Kathmandu: Book Faith India, 1996.

Neumann, Helmut. "The Wheel of Life in the Twelfth Century Western Tibetan Cave Temple of Pedongpo." In *Buddhist Art and Tibetan Patronage: Ninth to Fourteenth Centuries*, edited by Deborah Klimburg and Eva Allinger. PIATS 2000: Tibetan Studies: Proceedings of the Ninth Seminar of the International Association for Tibetan Studies, Leiden 2000. Leiden: Brill, 2002.

Newman, John Ronald. "The Outer Wheel of Time: Vajrayāna Buddhist Cosmology in the Kālacakra Tantra." PhD diss., University of Wisconsin, 1987.

Norman, K. R. *Pāli Literature: Including the Canonical Literature in Prakrit and Sanskrit of All the Hīnayāna Schools of Buddhism*. Vol. 7, fasc. 2, of *A History of Indian Literature*, edited by Jan Gonda. Wiesbaden: Otto Harrassowitz, 1983.

Olivelle, Patrick. *The Early Upaniṣads: Annotated Text and Translation*. New York: Oxford University Press, 1998.

Pal, Pratapaditya, and Julia Meech-Pekarik. *Buddhist Book Illuminations*. New York: Ravi Kumar, 1988.

"Pañcarakṣā (MS Add.1688)." Cambridge Digital Library. Accessed August 22, 2016. http://cudl.lib.cam.ac.uk/view/MS-ADD-01688/139.

Payne, Richard K. "Introduction." In *Homa Variations*, edited by Richard K. Payne and Michael Witzel, 1–44. New York: Oxford University Press, 2016.

Pelden, Kunzang. *The Nectar of Manjushri's Speech: A Detailed Commentary on Shantideva's Way of the Bodhisattva*. Boston: Shambhala, 2007.

"Pelliot chinois 2824." Bibliothèque nationale de France: Archives et manuscrits. Accessed September 27, 2016. http://archivesetmanuscrits.bnf.fr/ark:/12148/cc8831s/cd0e39415.

"Pelliot chinois 2824." International Dunhuang Project. Accessed September 27, 2016. http://idp.bl.uk/.

Phun tshogs rdo rje. *Bod kyi ri mo'i sgyu rtsal las lha sku'i thig rtsa dang śin tshon sogs kyi rmang gzhi'i shes bya 'gro phan blo gsar dga' skyed ces bya ba bzhugs so*. Lhasa: Mi rigs dpe skrun khang, 2006.

Pichard, Pierre, and François Lagirarde, eds. *The Buddhist Monastery: A Cross-Cultural Survey*. Paris: École française d'Extrême-Orient, 2013.

Pingree, David. "The Purāṇas and Jyotiḥśāstra: Astronomy." *Journal of the American Oriental Society* 110, no. 2 (June 1990): 274–80.

Pollock, Sheldon. *The Language of the Gods in the World of Men*. Berkeley: University of California Press, 2006.

Pommaret, Françoise. "Buddhist Monasteries in Tibet." In *The Buddhist Monastery: A Cross-Cultural Survey*, edited by Pierre Pichard and François Lagirarde, 283–304. Paris: École française d'Extrême-Orient, 2013.

Pye, Michael. *Skilful Means: A Concept in Mahayana Buddhism*. London: Routledge, 2003.

Rangdrol, Yukhok Chatralwa Chöying. "4. Mandala Offering." Lotsawa House. Accessed June 8, 2016. www.lotsawahouse.org/tibetan-masters/yukhok-chatralwa/ngondro-compendium-4.

Reynolds, Frank E., and Mani B. Reynolds, trans. *Three Worlds according to King Ruang: A Thai Buddhist Cosmology*. Berkeley: University of California Press, 1982.

rGyal-mtshan, 'Phags-pa Blo-gros. *Prince Jiṅ-Gim's Textbook of Tibetan Buddhism: The Śes-bya Rab-gsal (Jñeya-prakāśa)*. Translated by Constance Hoog. Leiden: E. J. Brill, 1983.

Rhi, Juhyung. "Images, Relics, and Jewels: The Assimilation of Images in the Buddhist Relic Cult of Gandhāra: Or Vice Versa." *Artibus Asiae* 65, no. 2 (January 1, 2005): 169–211.

Rhie, Marylin M., and Robert A. F. Thurman. *Worlds of Transformation: Tibetan Art of Wisdom and Compassion*. New York: Tibet House New York, 1999.

Ricca, Franco, and Lionel Fournier. "The Paintings in the Zhwa lu sGo gsum lha khang and bSe sgo ma lha khang: Stylistic Differences." *Tibet Journal* 26, nos. 3/4 (2001): 103–48.

Richardson, Sarah. "Painted Books for Plaster Walls: Visual Words in the Fourteenth-Century Murals at the Tibetan Buddhist Temple of Shalu." PhD diss., University of Toronto, 2016.

"Rin chen gter mdzod chen mo." Tibetan Buddhist Resource Center. Accessed September 19, 2016. https://www.tbrc.org/#!rid=W1KG14.

Rospatt, Alexander von. "On the Conception of the Stūpa in Vajrayāna Buddhism: The Example of the Svayambhūcaitya of Kathmandu." *Journal of the Nepal Research Center* 11 (1999): 121–47.

———. "Remarks on the Consecration Ceremony in Kuladatta's *Kriyāsaṃgrahapañjikā* and Its Development in Newar Buddhism." In *Hindu and Buddhist Initiations in India and Nepal*, 197–260. Wiesbaden: Harrasowitz, 2010.

———. "The Sacred Origins of the Svayambhūcaitya and the Nepal Valley: Foreign Speculation and Local Myth." *Journal of the Nepal Research Center* 13 (2009): 33–91.

Rotman, Andy. *Divine Stories: Divyāvadāna Part I*. Boston: Wisdom Publications, 2008.

Sadakata, Akira. *Buddhist Cosmology: Philosophy and Origins*. Translated by Gaynor Sekimori. Tokyo: Kosei Publishing Company, 2004.

Sagan, Carl. *Pale Blue Dot: A Vision of the Human Future in Space*. New York: Random House, 1994.

Samuel, Geoffrey. *The Origins of Yoga and Tantra: Indic Religions to the Thirteenth Century*. Cambridge: Cambridge University Press, 2008.

Sanderson, Alexis. "The Śaiva Age: The Rise and Dominance of Śaivism during the Medieval Period." In *Genesis and Development of Tantrism*, edited by Shingo Einoo, 41–349. Institute of Oriental Culture Special Series 23. Tokyo: Institute of Oriental Culture, University of Tokyo, 2009.

Sankaranarayanan, Kalpakam, Kazunobu Matsudu, and Motohiro Yoritomi. *Lokaprajñapti: A Critical Exposition of Buddhist Cosmology*. Mumbai: Somaiya Publications, 2002.

Schopen, Gregory. "Archaeology and Protestant Presuppositions in the Study of Indian Buddhism." In *Bones, Stones, and Buddhist Monks: Collected Papers on the Archaeology, Epigraphy, and Texts of Monastic Buddhism in India*. Honolulu: University of Hawai'i Press, 1997.

Shakya, Hem Raj. *Svayambhū Mahācaitya: The Self-Arisen Great Caitya of Nepal*. Translated by Min Bahadur Shakya. Kathmandu: Svayambhu Vikash Mandal, 2004.

Shakya, Min Bahadur. *The Iconography of Nepalese Buddhism*. Kathmandu: Handicraft Association of Nepal, 1994.

——. *Samantabhadra bodhisattva dhyānacaryā dharma sūtra (The Sutra of Meditation on the Bodhisattva Samantabhadra)*. Lalitpur, Nepal: Siddhi Indra Smṛti Guṭhī, 2008.

Sharkey, Gregory. *Buddhist Daily Ritual: The Nitya Puja in Kathmandu Valley Shrines*. Bangkok: Orchid Press, 2001.

Sharma, Sudarshan Kumar. *Vāyu Mahāpurāṇa: An Exhaustive Introduction, Sanskrit Text, English Translation, Scholarly Notes and Index of Verses*. 2 vols. Delhi: Parimal Publications, 2008.

Shima, Iwao. *A Newar Buddhist Temple Mantrasiddhi Mahāvihāra and A Photographic Presentation of Gurumandalapūjā*. Tokyo: Institute for the Study of Languages and Cultures of Asia and Africa, 1991.

Sircar, D. C. *Cosmography and Geography in Early Indian Literature*. Calcutta: Indian Studies: Past & Present, 1967.

Skorupski, Tadeusz. *Body, Speech, and Mind: Buddhist Art from Tibet, Nepal, Mongolia and China*. London: Spink, 1998.

——. "Buddhist Permutations and Symbolism of Fire." In *Homa Variations*, edited by Richard K. Payne and Michael Witzel, 67–125. New York: Oxford University Press, 2016.

——. "Buddhist Theories of Causality (karma, *pratītyasamutpāda, hetu, pratyaya*)." *Oxford Bibliographies in Buddhism*. Oxford: Oxford University Press, 2016.

——. "*Jyotirmañjarī* of Abhayākaragupta." *Buddhist Forum* 4 (2001): 183–221.

——. *Kriyāsaṃgraha: Compendium of Buddhist Rituals*. Buddhica Britannica Series Continua 10. Tring, UK: The Institute of Buddhist Studies, 2002.

——. *Practices Conducive to Enlightenment: The Thirty-Seven Bodhipākṣikas and Other Practices according to Nāgārjuna's Mahāprajñāpāramitā-Śāstra*. London: SOAS, University of London, 2009.

——. *The Sarvadurgatipariśodhana Tantra: Elimination of All Evil Destinies*. Delhi: Motilal Banarsidass, 1983.

Slusser, Mary Shepherd. *Nepal Mandala: A Cultural Study of the Kathmandu Valley*. 2 vols. Princeton: Princeton University Press, 1982.

Smith, Brian K. *Classifying the Universe: The Ancient Indian Varṇa System and the Origins of Caste*. New York and Oxford: Oxford University Press, 1994.

Snellgrove, David L. *Indo-Tibetan Buddhism: Indian Buddhists and Their Tibetan Successors*. Boston: Shambhala, 2002.

Snellgrove, David L., and Tadeusz Skorupski. *The Cultural Heritage of Ladakh*. 2 vols. Boulder, CO: Prajna Press, 1977.

Staal, Frits. *Agni: The Vedic Ritual of the Fire Altar*. Delhi: Motilal Banarsidass, 1986.

Stablein, William. *Healing Image: The Great Black One*. Berkeley: SLG Books, 1991.

Strong, John. *The Legend of King Aśoka: A Study and Translation of the "Aśokāvadāna."* Princeton: Princeton University Press, 1983.

——. "Making Merit in the *Aśokāvadāna*: A Study of Buddhist Acts of Offering in the Post-Parinirvāna Age." PhD diss., University of Chicago, 1977.

——. *Relics of the Buddha*. Princeton: Princeton University Press, 2004.

Tachikawa Musashi and Akira Masaki. *Chibetto Bukkyō zuzō kenkyū—Penkoruchūde buttō*. Suita-shi: Kokuritsu Minzokugaku Hakubutsukan, 1997.

Tagare, Ganesh Vasudeo. *The Vāyu Purāṇa: Ancient Indian Tradition and Mythology*. Delhi: Motilal Banarsidass, 1987.

Tambiah, Stanley Jeyaraja. *Buddhism and the Spirit Cults in North-East Thailand*. Cambridge Studies in Social Anthropology 2. Cambridge: Cambridge University Press, 1970.

Tanaka, Kimiaki. *Art of Thangka from the Hahn Kwang-ho Collection*. Vol. 5. Seoul: The Hahn Cultural Foundation, 2005.

Tayé, Jamgön Kongtrul Lodrö. *Myriad Worlds: Buddhist Cosmology in Abhidharma, Kālacakra, and Dzog-chen.* Ithaca, NY: Snow Lion Publications, 1995.

———. *The Treasury of Knowledge: Book Six, Part Four: Systems of Buddhist Tantra.* Translated by Elio Guarisco and Ingrid McLeod. Ithaca, NY: Snow Lion Publications, 2005.

———. *The Treasury of Knowledge: Book Eight, Part Three: The Elements of Tantric Practice, A General Exposition of the Process of Meditation in the Indestructible Way of Secret Mantra.* Translated by Elio Guarisco and Ingrid McLeod. Ithaca, NY: Snow Lion, 2008.

Teiser, Stephen F. *Reinventing the Wheel: Paintings of Rebirth in Medieval Buddhist Temples.* Seattle: University of Washington Press, 2006.

———. "The Wheel of Rebirth in Buddhist Temples." *Arts Asiatiques* 63 (2008): 139–52.

Tharchin, Lobsang. *A Commentary on Guru Yoga & Offering of the Mandala.* Ithaca, NY: Snow Lion Publications, 1981.

———. *King Udrayana and the Wheel of Life: The History and Meaning of the Buddhist Teaching of Dependent Origination.* Howell, NJ: Mahayana Sutra and Tantra Press, 1984.

Todaro, Dale Allen. "An Annotated Translation of the *Tattvasamgraha* (Part 1) with an Explanation of the Role of the *Tattvasamgraha* Lineage in the Teachings of Kukai." PhD diss., Columbia University, 1985.

Trainor, Kevin. *Relics, Ritual, and Representation in Buddhism: Rematerializing the Sri Lankan Theravāda Tradition.* Cambridge: Cambridge University Press, 1997.

Tsering, Nawang. *Alchi, the Living Heritage of Ladakh: 1000 Years of Buddhist Art.* Leh, Ladakh, and New Delhi: Central Institute of Buddhist Studies, National Museum, and Likir Monastery, 2009.

Tsogyal, Yeshe, and Nyang Ral Nyima Öser. *The Lotus-Born: The Life Story of Padmasambhava.* Translated by Erik Pema Kunsang. Boundhanath: Rangjung Yeshe Publications, 2004.

Tucci, Giuseppe. *Gyantse and Its Monasteries.* 3 parts. Śata-Piṭaka Series 351–53. New Delhi: Aditya Prakashan, 1989.

———. "Oriental Notes: The Tibetan 'White-Sun-Moon' and Cognate Deities." *East and West* 14, nos. 3/4 (1963): 133–45.

———. *The Temples of Western Tibet and Their Artistic Symbolism: The Monasteries of Spiti and Kunavar (Indo-Tibetica III.1).* Edited by Lokesh Chandra. Śata-Piṭaka Series 349. New Delhi: Aditya Prakashan, 1988.

———. *The Temples of Western Tibet and Their Artistic Symbolism: Tsaparang (Indo-Tibetica III.2).* Edited by Lokesh Chandra. Śata-Piṭaka Series 350. New Delhi: Aditya Prakashan, 1988.

———. *Tibetan Painted Scrolls.* 2nd ed. 3 vols. Bangkok: SDI Publications, 1999.

Umasvati. *That Which Is: Tattvartha Sutra.* Translated by Nathmal Tatia. New Haven: Yale University Press, 2010.

Upadhyaya, Jagannatha. *"Vimalaprabhāṭīkā" of Kalki Śrī Puṇḍarīka on "Śrī Laghukālacakratantrarāja" by Śrī Mañjuśrīyaśa.* Vol. 1. Bibliotheca Indo-Tibetica 11. Varanasi: Central Institute of Higher Tibetan Studies, 1986.

Urban, Hugh B. *Tantra: Sex, Secrecy, Politics, and Power in the Study of Religion.* Berkeley: University of California Press, 2003.

Vaidya, P. L. "Lalitavistaraḥ." The Mithila Institute of Post-graduate Studies and Research in Sanskrit Learning, 1958. www.dsbcproject.org/canon-text/book/45.

Vaidya, P. L., and Sridhar Tripathi, eds. *Lalita-vistara.* Darbhanga: Mithila Institute of Post-graduate Studies and Research in Sanskrit Learning, 1987.

Vajrācārya, Sarvajñaratna. *Vajrayāna pūjāvidhi saṃgraha: A Collection of Bajrayan Buddhist Worshipping Procedure.* Kathmandu: Nepāla bauddha Saṃskṛti saṃrakṣaṇa kendra mhyapi, 2005.

Vajrācārya, Vikāsaratna. *Aṣṭamīvrata pūjāvidhi.* Kathmandu: Nepāla bauddha Saṃskṛti saṃrakṣaṇa kendra mhyapi, 2008.

"Vajrasattva (Buddhist Deity)–White (Solitary)." Himalayan Art Resources. Accessed August 22, 2016. www.himalayanart.org/items/99627.

Vasubandhu. *Abhidharmakośam (svopajñabhāṣyasahitaṃ sphuṭārthavyākhyopetaṃ ca)*. Edited by Swāmī Dwārikādās Śāstri. 2 vols. Bauddha Bharati 5–8. Varanasi: Bauddha Bharati, 1998.

Vignato, Giuseppe. "Archaeological Survey of Kizil: Its Groups of Caves, Districts, Chronology and Buddhist Schools." *East and West* 56, no. 4 (2006): 359–416.

Vitali, Roberto. *Early Temples of Central Tibet*. London: Serindia, 1990.

———. *Records of Tho-Ling: A Literary and Visual Reconstruction of the "Mother" Monastery in Gu-Ge*. New Delhi: High Asia, 1999.

Vyāsa, Kṛṣṇa-Dvaipāyana. *Puranic Cosmology*. Edited by Danavir Goswami. Vol. 1. Kansas City, MO: Rupanuga Vedic College, 2007.

Waddell, L. A. *The Buddhism of Tibet, or Lamaism*. London: W. H. Allen, 1895.

———. *Tibetan Buddhism, with Its Mystic Cults, Symbolism and Mythology, and in Its Relation to Indian Buddhism*. New York: Dover Publications, 1972.

Wallace, Vesna. *The Inner Kālacakratantra: A Buddhist Tantric View of the Individual*. Oxford: Oxford University Press, 2001.

———. *The Kālacakra Tantra: The Chapter on Sādhanā together with the Vimalaprabhā Commentary*. New York: Tibet House New York, 2010.

———. *The Kālacakratantra: The Chapter on the Individual together with the Vimalaprabhā*. New York: American Institute of Buddhist Studies, 2004.

Walshe, Maurice. "The Cakkavatti-Sīhanāda Sutta: The Lion's Roar on the Turning of the Wheel." In *The Long Discourses of the Buddha: A Translation of the Dīgha Nikāya*, 395–405. Boston: Wisdom Publications, 1995.

———. "Mahâpadāna Sutta: The Great Discourse on Lineage." In *The Long Discourses of the Buddha: A Translation of the Dīgha Nikāya*, 199–221. Boston: Wisdom Publications, 1995.

———. "Mahāsudassana Sutta: A King's Renunciation." In *The Long Discourses of the Buddha: A Translation of the Dīgha Nikāya*, 279–90. Boston: Wisdom Publications, 1995.

Walter, Michael. "Scapula Cosmography and Divination in Tibet." *Kailash* 18, nos. 3/4 (1996): 107–14.

Wang, Eugene Y. *Shaping the Lotus Sutra: Buddhist Visual Culture in Medieval China*. Seattle and London: University of Washington Press, 2005.

Wang, Michelle C. "The Thousand-Armed Mañjuśrī at Dunhuang and Paired Images in Buddhist Visual Culture." *Archives of Asian Art* 66, no. 1 (2016): 81–105.

Wangchen, Namgyal. *Awakening the Mind: Basic Buddhist Meditations*. Boston: Wisdom Publications, 1995.

Wangdu, Pasang, and Hildegard Diemberger. *dBa' bzhed: The Royal Narrative Concerning the Bringing of the Buddha's Doctrine to Tibet*. Vienna: Verlag der Österreichischen Akademie der Wissenschaften, 2000.

Wang-Toutain, Françoise. "Deux diagrammes de cosmologie bouddhique." In *La fabrique du lisible: La mise en texte des manusrits de la Chine ancienne et médiévale*, edited by Jean-Pierre Drège, 291–308. Paris: Collège de France, 2014.

Watson, Burton. *The Vimalakirti Sutra*. New York: Columbia University Press, 2000.

Watt, Jeff. "Subject: Mount Sumeru (Painting & Sculpture)." Himalayan Art Resources. https://www.himalayanart.org/search/set.cfm?setID=1063.

Wayman, Alex. *The Buddhist Tantras: Light on Indo-Tibetan Esotericism*. London: Kegan Paul International, 1973.

Weinberger, Steven Neal. "The Significance of Yoga Tantra and the *Compendium of Principles (Tattvasaṃgraha Tantra)* within Tantric Buddhism in India and Tibet." PhD diss., University of Virginia, 2003.

Weissenborn, Karen. *Buchkunst aus Nālandā: Die "Aṣṭasāhasrikā Prajñāpāramita"-Handschrift in der Royal Asiatic Society, London (Ms. Hodgson 1) und ihre Stellung in der Pāla-Buchmalerei des 11–12 Jahrhunderts*. Wiener studien zur Tibetologie und buddhismuskunde 77. Vienna: Arbeitskreis für Tibetische und Buddhistische Studien, Universität Wien, 2012.

Wessels-Mevissen, Corinna. *The Gods of the Directions in Ancient India: Origin and Early Development in Art and Literature (until c. 1000 A.D.)*. Berlin: Dietrich Reimer Verlag, 2001.

White, David Gordon. "*Dakkhiṇa* and *Agnicayana*: An Extended Application of Paul Mus's Typology." *History of Religions* 26, no. 2 (1986): 188–213.

Whitfield, Roderick, Susan Whitfield, and Neville Agnew. *Cave Temples of Mogao at Dunhuang: Art and History on the Silk Road*. 2nd ed. Los Angeles: Getty Conservation Institute, 2015.

Williams, Paul. *Mahāyāna Buddhism: The Doctrinal Foundations*. London: Routledge, 1989.

Willson, Martin. *Rites and Prayers*. London: Wisdom Publications, 1985.

Willson, Martin, and Martin Brauen, eds. *Deities of Tibetan Buddhism: The Zürich Paintings of the Icons Worthwhile to See (Bris sku mthoṅ ba don ldan)*. Boston: Wisdom Publications, 2000.

Winder, Marianne. "Vaiḍūrya." In *Studies on Indian Medical History*, 85–94. Delhi: Motilal Banarsidass, 2001.

Winkler, Jakob. "The *rDzogs chen* Murals of the kLu khang in Lhasa." In *Religion and Secular Culture in Tibet: Tibetan Studies II*, edited by Henk Blezer. PIATS 2000: Tibetan Studies: Proceedings of the Ninth Seminar of the International Association for Tibetan Studies, Leiden 2000. Leiden: Brill, 2002.

Wood, Benjamin. "The Power of Symbols and Silence: World-System Paintings and Inscription Editing in the Zhwa lu Skor lams." Manuscript, 2007.

Wood, Leela Aditi. "The Ajanta Cave 17 Inscription as a Preface to the Local King's Vihāra History, Religious Story and Homology." In *The Vākāṭaka Heritage: Indian Culture at the Crossroads*, edited by Hans T. Bakker. Groningen: Egbert Forsten, 2004.

Wylie, Turrell V. *The Geography of Tibet according to the "'Dzam-gling-rgyas-bshad."* Serie Orientale Roma 25. Roma: Istituto Italiano per il Medio ed Estremo Oriente, 1962.

Xiang Hongjia, trans. *Precious Deposits: Historical Relics of Tibet China*. Vol. 1, *Prehistoric Age and Tubo Period*. Beijing: Morning Glory Publishers, 2000.

Yamada, Isshi. *Sarva-tathāgata-tattva-saṅgraha nāma Mahāyāna-sūtra*. Śata-Piṭaka Series: Indo-Asian Literatures 262. New Delhi: Sharada Rani, 1981.

Zin, Monika. "Māndhātar, the Universal Monarch, and the Meaning of Representations of the Cakravartin in the Amaravati School, and of the Kings on the Kanaganahalli Stūpa." In *Buddhist Narrative in Asia and Beyond: In Honour of HRH Princess Maha Chakri Sirindhorn on Her Fifty-Fifth Birth Anniversary*, edited by Peter Skilling and Justin McDaniel, vol. 1, 149–64. Bangkok: Institute of Thai Studies, 2012.

Zwalf, W. *A Catalogue of the Gandhara Sculpture in the British Museum*. 2 vols. London: British Museum Press, 1996.

INDEX

A

Abhayākaragupta: *Garland of Perfected Yogas*, 69–70; *Garland of Vajras*, 70; *Inflorescence of Light*, 114; instructions for maṇḍalas, 69–70, 71

abhidharma, 30–31, 32; cosmology, 43, 54, 75, 114, 139, 214; in manuscripts from Dunhuang, 211, 214; murals illustrating, 43, 191, 199, 200*fig.*, 204, 207, 209, 221–22, 223*fig.*, 254n47. See also *Treasury of Abhidharma*

Abhirati, 214, 255n76

Abridged Wheel of Time Tantra, 46

accomplishment maṇḍalas, 137. *See also* fields of accumulation

ādi-buddha, 87–88, 97

Ādi-karma-pradīpa, 250n62

Aitreya Brāhmaṇa, 238n21

Ajaṇṭā cave 17, 209–11, 210*fig.*, 223

Ajātaśatru, 212

Akaniṣṭha Cāmara Copper Mountain Lotus Light Palace monastery (Sikkim), 100–102, 102*fig.*; model of Padmasambhava's Lotus Light Palace, 103*fig.*, 175–76, 176*fig.*; Samantabhadra and Samantabhadrī, 104*fig.*

Akaniṣṭha heaven: emanation of buddhas on lotuses to, 78; and the five certainties, 246n78, 247n80; in translocative processes, 82–84, 106*fig.*; in *Treasury of Abhidharma*, 44; Vairocana's descent from, 65, 80–83, 247nn80,82

Akṣobhya, 69, 75, 85, 137, 214; in panel from Sumtsek, 129, 130*fig.*

Akṣobhya-vyūha, 255n76

Alchi religious complex (Ladakh): Akṣobhya panel, 129, 130*fig.*; Amithābha panel, 131*fig.*; Buddha atop Meru imagery, 77, 79, 79*fig.*; construction of, 245n29; inscription from, 199–201; Mahākāla imagery, 132, 133*fig.*, 134*fig.*, 207–8, 225, 251n72; Maitreya sculpture with Śākyamuni atop Meru platform with

encircling *nāgas*, 79, 79*fig.*; maṇḍala imagery in murals at, 70–75, 72*fig.*, 73*fig.*, 74*fig.*, 75*fig.*, 90, 92, 105, 128, 129, 167, 206, 245n41, 251n68; Manjuśrī shrine, 132; Translator shrine, 132

All Powerful Ten mantra, 49, 51–54, 52*fig.*, 53*fig.*, 242n145

altars: in the form of Meru from Ganden Khiid (Mongolia), 189*fig.*; with Mahākāla at Alchi, 132, 133*fig.*, 134*fig.*; main shrine of Bū bāhā (Nepal), 182*fig.*; objects at Daanzanravjaa Museum (Mongolia), 186*fig.*; in painting of fourth Demo Rinpoche, 184, 186*fig.*; with representation of Meru, 184–90; seven outer offerings of the altar, 183–84, 189, 251n67; Tibetan and Newar compared, 181–83; and the treasure-maṇḍala, 181, 183–84, 190, 225, 230. See also *homa* altars; offerings; Vedic ritual

Alternative Wheel of Time, 47

Amdo, painting of Tsongkhapa, Maitreya, and the geographic cosmos, 160–61, 163*fig.*

Amitābha: and Amitāyus, 100, 248n132; Dharmākara as, 81–82; on exterior of Vajrayāna *caityas*, 85; panel from Sumtsek, 129, 131*fig.*; paradise of, 197; as Truth-body, 100; and the Vajradhātu maṇḍala, 69

Amitāyus: and Amitābha, 100, 248n132; with begging bowl filled with Cakravāla cosmoses, 206, 207*fig.*, 214; in interior cosmological imagery, 206, 207*fig.*; painting in *Sacred Visions*, 251n67; shrine to, in Sikkim, 100, 102

Amoghasiddhi, 69, 75, 85, 90, 137

Ānanda, 80

architecture. *See* Buddhist architecture

Array of the Blissful Sūtra, 81–82

artistic agency, 222–23

artistic lineages, 223

Asaṅga, 82

Aśoka, King, 112, 115–16, 249nn24,25,35,38. See also *Legend of Aśoka*

asuras, 48, 78, 192–93, 194*fig.*, 241n105; defined, 242n135

authoritative texts, 13, 14, 17–18

Avalokiteśvara, 66, 90, 98, 100, 102, 255n92

Avaracāmara (Aparacāmara), 98

Avīci, 241n98

B

Bhadrāśva, 22*fig.*, 23

Bhaiṣajyaguru, maṇḍala place of, 189

Bhārata, 22*fig.*, 23, 24

Bhārhut railing (Indian Museum, Kolkata), 38

Bhutan: Cakravāla imagery from, 201, 209, 224; Lotus Light Palace imagery from, 102. *See also* Khamsum Yulley Namgyal Chorten; Punakha Dzong; Simtokha Dzong; Trongsa Dzong

Bodh Gayā: located in Jambudvīpa, 67, 98; mural of the Buddha's descent from the heaven of the Thirty-Three, 205*fig.*; murals depicting Buddha's enlightenment, 69*fig.*, 191, 199, 230; murals of the Cakravāla cosmos as weapon, 56*fig.*; protector chapel, Ganden Phelgay monastery, 6*fig.*; as symbol of enlightenment, 105

body of the great man, 249n38

Bountiful Cow continent, 227–28. *See also* Godānīya

Brahmā, 57, 57*fig.*, 74, 75

Brāhmaṇas, 238n17

Brahmanism, 17

Bū bāhā (Nepal): *caitya*, 90–92, 91*fig.*, 92*fig.*, 93*fig.*; main shrine, 182*fig.*

Buddha: atop Meru, 64–65, 75–80, 76*fig.*, 78*fig.*, 79*fig.*, 118, 181; biographies of, 54; death of, 212; defeat of Māra, 55, 56*fig.*, 57, 205; descent from heaven of the Thirty-Three, 205–6, 205*fig.*; enlightenment of, 80–83, 93, 230; extending body to fill all space, 57, 205; as knower of worlds, 27–28, 29–30; miracles of, 57, 58*fig.*, 59*fig.*; recollection of, 27; relationship to *cakravartin*, 118; seats for, 67, 77–79; three bodies of, 66, 80, 82–84, 83*fig.*, 98–100, 155, 175, 246n74. *See also* Śākyamuni; Sarvārthasiddhi; Vairocana

Buddhaghosa. See *Path of Purification* (Buddhaghosa)

buddha-kṣetra (buddha-field), 245n46. *See also* purified landscape

buddha-maṇḍala atop Meru's peak, 64–66, 75–76, 105. *See also* maṇḍala

Buddha's hair relic, 77

Buddhist architecture: altars in, 181–90; building structure, 174–75; cosmological thinking in, 169–70, 171–72, 225, 230, 234; elemental generation in, 96; entranceway, 176–78; ground plan, 172–74; iconographic requisites, 178, 253n22; maṇḍalas and, 96–97, 170, 172, 175; murals and, 190; monasteries based on Copper Mountain palace, 100–102, 172; surface decoration, 175–81, 253n19. *See also* altars; murals: entranceway

Buddhist studies: approach to cosmology, 6–8; textual bias in, 12–13

C

caityas: Bū bāhā (Nepal), 90–92, 91*fig.*, 92*fig.*, 93*fig.*; consecration of, 85, 87*fig.*, 88*fig.*; with guardian kings, 86*fig.*; in Nepal, 80, 84, 85–90, 86*fig.*, 90, 106; and stūpas, 84, 85, 247n83; Vajrayāna, 85–88. *See also* stūpas; Svayambhū *caitya*

Cakrasaṃvara maṇḍala, 139

Cakravāḍa mountains, 35, 42, 46. *See also* Cakravāla

Cakravāḍa world-system, 44, 46. *See also* Cakravāla

Cakravāla: depiction at entranceway to Zurmang Shedrup monastery in Sikkim, 3–4, 5*fig.*, 227–31; from Ganden Phelgay monastery, 4, 6*fig.*; juxtaposed with wheel of existence, 3, 191, 197, 203*fig.*, 211, 215, 217–20, 219*fig.*, 221, 225; mural depictions of, 171, 197–201, 198*fig.*, 200*fig.*, 204–8, 209, 211–22; mural from Sonada Gompa, 68*fig.*, 69*fig.*; in offering ritual, 6, 6*fig.*, 118, 141, 152, 153*fig.*; poster with labeled geographic realms, 5, 7*fig.*; replaced with Kathmandu geography, 92; as *torma* from Drug Sang-ngag monastery, 7*fig.*, use of imagery, 4, 55; as weapon used by Māra's demons, 55, 56*fig. See also* continents; cosmos; Meru; treasure-maṇḍala; Samye monastery: ground plan of

cakravartin: Aśoka as, 112, 115, 116; body of, 118, 249n38; in cosmos of offering ritual, 233; Daḷhanemi, 117; Māndhātar with his treasures, 117, 117*fig.*; meaning of, 116; similarities to the buddha, 118; stories of, in Cakravāla imagery,

Ganden Phelgay monastery (Bodh Gayā): Cakra-
vāla cosmos as weapon, 56*fig.*; Cakravāla
offering, 4, 6*fig.*

Gandhāra, 77, 254n48

Gaṅgā river, 23–24

Garland of Perfected Yogas, 69–70, 95

Garland of Vajras, 70

Garuḍa, 74–75, 77

Gathering of Intentions Sūtra, 245n38

gcod, 252n121

Gellner, David, 250nn45,62

Gelug school, 135, 137, 144. *See also* Tsongkhapa

generosity, 109, 115, 233, 234

Glorious Copper Mountain. *See* Copper
Mountain

Godānīya, 37, 40, 41. *See also* Bountiful Cow
continent; continents

Great Kings: arrangements of, 177–78, 179*fig.*,
180*fig.*; as cosmological feature of stūpas
in Nepal, 85, 86*fig.*; depicted at Mak Dhog
monastery, 98, 100*fig.*; depicted in murals, 177,
197, 198*fig.*, 199*fig.*, 201, 204, 216, 230; dwell-
ing place of, 42, 44, 241n104; in entranceway
of Daschan Chokhorling, Ulaanbaatar, 177,
177*fig.*; life spans of, 44; offerings to the Bud-
dha, 56, 57, 59*fig.*, 76; in surface decoration,
176–81. *See also* four guardian kings

Great Perfection teachings, 206

Great Prayer Festival (Tibet), 57

Greater Jambudvīpa, 49–50, 222

guardian kings. *See* four guardian kings; Great
Kings

Guge, 70

Guhya-samāja Tantra, 244n9

Guṇaprabha, commentaries of, 197

guru-disciple relationship, 109, 135, 136–37. *See
also* maṇḍala offering to the teacher

guru maṇḍala. *See* maṇḍala offering to the
teacher

Gutschow, Niels, 247n110

Gyantse monastery (Tibet), 206, 245n44, 254n51;
mural depicting Pale Sun-and-Moon,
208*fig.*

H

Haḍḍa (Afghanistan), 77, 105; Buddha on a Meru
throne encircled by *nāgas*, 78*fig.*

Hakha bāhā (Nepal), *caitya* with guardian kings,
86*fig.*

Hayagrīva, 206

heaven of the Thirty-Three, 42, 44, 75, 117; Bud-
dha's descent from, 205–6, 205*fig.*; Buddha's
hair relic at, 77; depictions of, 193, 211, 218

hell: absent from offering cosmos, 110; beings of,
44; guardians of, 34; realms of, 40, 193, 195*fig.*,
201; in *Treasury of Abhidharma*, 40, 241n98

Hemis monastery (Ladakh), poster for sale at, 5,
7*fig.*

homa altars, 114, 166; at Khamsum Yulley Nam-
gyal Chorten (Bhutan), 114, 115*fig.*

human body, 26, 46–47, 49, 61, 95, 121, 206, 233

humankind: four classes of, 239n38; place in the
cosmos, 10, 24–27; progenitor of, 24, 239n38

I

iko yaṇaci, 51, 242n145

Indra, 20, 42, 74–75, 211, 216. *See also* Śakra

Inflorescence of Light, 114. *See also*
Abhayākaragupta

Inner Wheel of Time, 47

inscriptions, geographic didacticism in, 199–201

intentional actions, 18, 32, 123, 240n67. *See also*
karma/*karman*

intermediate directions, 23, 32, 40, 70, 90, 122,
143, 151, 164, 173

intermediate realm, 20, 238n17. *See also* interme-
diate directions

islands, 23, 72. *See also* Cāmara; continents

J

Jain cosmology, 24–27, 26*fig.*, 49, 60*fig.*, 235

Jambu tree, 230

Jambudvīpa: in Buddhaghosa's *Path of Purifi-
cation*, 29; color of, 35; depicted in murals,
69*fig.*, 72, 74, 219, 227, 228*fig.*, 230; in didactic
inscriptions, 199–201; Greater, 49–50, 222; in
Jain cosmology, 24–25; Lesser, 49; life spans
in, 44; in Padmasambhava's biography, 98; in
the *Purāṇas*, 23, 24; separation from Meru,
represented in altar, 183; shape of, 38–39,
39*fig.*, 241n96; as site of Buddha's enlighten-
ment, 67; in tantric Buddhism, 80, 82, 83; in
translocative processes, 106*fig.*; in *Treasury of
Abhidharma*, 37–38, 40, 41; in Wheel of Time
corpus, 49

Jamgon Kongtrul Lodro Taye, 152, 247n80,
248n112, 251n93; *Encyclopedia of Knowledge*,
46

treasure-maṇḍala (*continued*)

Spituk Gompa (Ladakh), 145*fig.*; symmetries of, 143, 144*fig.*; in textual sources, 250n62; thirty-seven-part Tibetan, 137–44, 141*fig.*, 142*fig.*, 147, 151, 256n100; and the three bodies of the Buddha, 155; three-dimensional models of the cosmos, 151, 151*fig.*; Tibetan, mapped to hierarchical cosmos, 146, 147*fig.*; twenty-one-parts of, 120, 121*fig.*, 139, 143–44; visualization of, 152–54, 159. *See also* maṇḍala offering to the teacher; offerings; treasures of the *cakravartin*

treasures of the *cakravartin*, 116–17, 252n103; on altars, 184, 189; in Cakravāla mural from entrance vestibule at Rizong monastery, 202*fig.*; in Cakravāla mural from Trongsa Dzong, 198*fig.*; depicted in Newar treasure-maṇḍala as sculpture, 127*fig.*; in murals, 129, 203*fig.*, 216; in paintings at Sakya monastery, 188; in Sumtsek panel, 129, 131*fig.*; in treasure-maṇḍala, 120, 122, 126–27, 142, 146–47, 148–49, 157–59, 167, 251n69

Treasury of Abhidharma (Vasubandhu): as analysis of elements of reality, 30–31; auto-commentary of, 238n5, 240n62; basis for illustrations of Cakravāla, 171, 197, 221; center and periphery in, 42, 45–46; concept of *abhidharma* in, 30–31, 32; continents in, 37–40, 45, 49, 114, 249n14; contrasted with Purāṇas and Wheel of Time, 21, 47–48, 60*fig.*; cosmic cycle of creation and destruction of the universe, 44–45; dating of, 21, 239n39; description of oceans, 36–37; description of the physical world, 32; elements in, 95; elevation of the cosmos described in, 33*fig.*; four faces of Meru in, 17, 18, 19*fig.*, 31, 45; four quadrants in, 45; heavens of Meru in, 42–44; hell realms in, 40, 45–46, 241n98; human realms in, 24, 25*fig.*, 233; measurements of mountains in, 38*fig.*; multiplicity of worlds in, 31–32, 44, 239–40n59; perspective view of geographic cosmos of, 43*fig.*; plan of the cosmos as described in, 36*fig.*; popularity in Tibet, 54; processes of meditation reflected in, 44–45; size of the cosmos in, 35, 37, 61, 256n100; as source for cosmic geography, 30, 31, 34–37, 46, 227, 228; as source for offering cosmology, 112, 113, 114, 166, 235; structural principles of, 16, 34, 45–46, 45*fig.*, 147; sun and moon in, 40–41, 241n107; on the terraces of Meru, 41–42, 44; theme of nature of

causality, 17–18, 24, 30, 31–32; three discs, 32; three realms in, 31, 42, 43, 46; time in, 44–45; world of beings and world of locations in, 28, 31, 32–34, 240n78

triple gem (three pillars of Buddhism), 121, 172

Trisong Deutsen, King, 174

Trongsa Dzong (Bhutan): Cakravāla mural with Great Kings, 197–99, 198*fig.*, 199*fig.*, 200*fig.*, 204; depiction of circle of wind, 221

Truth-body, 82, 83*fig.*, 100, 102, 155, 230, 246n74, 248n132

Tsaparang, 243n161

Tsongkhapa: as emanation of Maitreya, 160–61, 163*fig.*; Great Prayer Festival of, 57; guru of Kedrup, 135; maṇḍala offering from Khedrup, 136, 136*fig.*, 139; in Tibetan guru maṇḍala, 137

twelve *nidānas*, 254n41. *See also* twelvefold chain of causation

twelvefold chain of causation, 32, 196, 254n41

U

Uḍḍiyāna, 248nn126,127

uncle-nephew familiality, 137

units of length, 23, 25, 239n29

Upananda, 77, 78

upāya, 242n134

Utpalavarṇā, 128

Uttarakuru, 120, 140, 141*fig. See also* Kuru

V

Vaikuṇṭha Caturmurtī, 74

Vairocana: in *Compendium of Principles*, 67–69, 71, 76, 79, 80–81, 244n17; descent from Akaniṣṭha, 80–81, 82, 83, 247n82; in *Enlightenment of Great Vairocana*, 76; in *Garland of Perfected Yogas*, 69–70; and monastic space, 96–97, 175, 214; multiple bodies of, 82–83, 98, 175; represented by dome of *caityas*, 85; ritual tradition, 71; in Vajradhātu maṇḍala, 69, 137, 214. *See also Enlightenment of Great Vairocana*; Vajradhātu maṇḍala

Vaiśravaṇa, 42, 184; array of offerings to, 164, 165*fig. See also* four guardian kings

Vajra mountains, 50

Vajradhara, image at Zurmang Shedrup monastery, 230, 233*fig.*

Vajradhātu, 69, 81. *See also* Vairocana

Vajradhātu maṇḍala, 69–70, 100, 139, 214; and *caityas* in Nepal, 90, 92; five central buddhas

of, 88–89, 137; re-created in architecture of Tabo, 175; and Vajrayāna *caityas*, 85–90, 88*fig.*

Vajrapāṇi, 90

Vajrasattva, Newar offering to, 119–20, 122

varṇas, 237n3, 239n38

Vasubandhu, 15, 19, 30, 31. See also *Treasury of Abhidharma*

Vāyu Purāṇa, 17, 24, 239n27; four-continent universe-as-lotus-flower model in, 21–23, 22*fig.*, 239n30; location of human realms in, 25*fig.* See also *Purāṇas*

Vedic ritual, 113–14, 249n9; altars in, 113*fig.*

Videha, 38, 39–40, 41. *See also* Pūrvavideha; Superior Body continent

Vikramaśīla monastery, 69

Vimalakīrti, 214

Vine of Stories (Kṣemendra), 77

Vipaśvin, 88, 89

Virūḍhaka, 42. *See also* four guardian kings

Virūpākṣa, 42. *See also* four guardian kings

Viṣṇu, 74–75, 247n110

Viṣṇu Purāṇa, 23, 24

visualization of the cosmos, 94–95, 152–54

Voyager space probe, 10

W

water, 18, 23, 29, 32, 47, 48, 51, 90, 183. See also *nāgas*

water maṇḍala, 49–50. *See also* elemental generation

Wayman, Alex, 247n82

wheel of existence, 191–92; from Ajaṇṭā cave 17, 209–11, 210*fig.*, 223; depiction of continents in, 193, 195*fig.*, 253–54n37; *deva* realm, 194*fig.*; didactic narrative, 209–11; encircling demon, 192, 192*fig.*; in entranceway mural at Zurmang Shedrup monastery, 3, 4*fig.*, 191, 196*fig.*, 227; in entranceway murals, 171, 191, 197, 203*fig.*, 209; hell realms, 193–96, 195*fig.*; human realm, 192, 193, 195*fig.*; as map of cycle of existence, 191, 196–97, 219; overview of, 192*fig.*; paired with Cakravāla, 3, 191, 197, 211, 215, 217–20, 219*fig.*, 221, 223–25; spatial imagery in, 191–92, 193–96, 193*fig.*; at Tabo, 214–16; three psychological poisons in, 196, 219; types of beings and their realms, 192–96

wheel of the *cakravartin*, 116–17, 148

Wheel of Time corpus: contrasted with *Treasury of Abhidharma*, 47–48; cosmological model of, 19, 48–54, 48*fig.*, 50*fig.*, 60*fig.*; depicted in murals, 221–22, 224*fig.*; five elements of, 18; four faces of Meru in, 18, 19*fig.*; hidden kingdom of Shambala, 98; Jain influences, 25, 49; Jambudvīpa in, 49; and meditation, 47; Meru in, 49, 51; and offering maṇḍalas, 139; overlapping symbolism, 49, 51–54; physical body as microcosm of the universe, 46–47, 49, 206, 233; root text of, 46; size of the cosmos in, 47, 49, 61; *Stainless Light* commentary, 46, 47; structural thinking in, 16; and tantric practice, 47, 48; ten-syllable mantra, 49, 51–54, 52*fig.*, 53*fig.*, 242n145; three basic categories in, 47, 49; as unified theory for enlightenment, 46

wind, 32, 40, 45, 47, 48, 50, 221, 227

The Wise and the Foolish, 54

wish-granting cow, 140, 141*fig.*, 142, 159, 193, 227, 230

Wutaishan, 98

Y

Yama, palace of, 40, 193, 195*fig.*

Yāmas, heaven of, 44

Yeshe O, King, 70–71, 214

Yoga Tantras, 71, 82, 245nn37,44, 247n80

Yogācāra, 82

Yogācārabhūmi, 241n105

yogic subtle body, 47, 51, 121, 122, 127, 132, 154, 248n114

yojana (unit of length), 21, 25, 239n29

Yonghegong, 189

Yugandhara, 36–37, 38*fig.*, 40, 241n107

Z

Zurmang Shedrup monastery (Sikkim): Cakravāla cosmos mural at main entrance, 3–5, 5*fig.*, 36, 42*fig.*, 191, 227, 228*fig.*, 229*fig.*; central image of Śākyamuni, 232*fig.*; central image of Vajradhara, 233*fig.*; four terraces of Meru and their inhabitants detail, 42*fig.*; main courtyard with shrine building at rear, 231*fig.*; Meru and golden mountains in *deva* realm of wheel of existence, 194*fig.*; murals at entranceway including wheel of existence, 3, 4, 4*fig.*, 5*fig.*, 191, 194*fig.*, 195*fig.*, 196*fig.*, 227–31; Yama's palace and hot and cold hells in wheel of existence, 195*fig.*

GLOBAL
SOUTH
ASIA

Padma Kaimal, K. Sivaramakrishnan, and Anand A. Yang,
SERIES EDITORS

GLOBAL SOUTH ASIA takes an interdisciplinary approach to the
humanities and social sciences in its exploration of how South Asia,
through its global influence, is and has been shaping the world.